Talking Cities
The Micropolitics of Urban Space
Die Mikropolitik des urbanen Raums

Edited by / *Herausgegeben von*
F. Ferguson & urban drift

Birkhäuser – Publishers for Architecture
Birkhäuser – Verlag für Architektu
Basel · Boston · Ber

URBANDRIFT

presents / *präsentiert:* Talking Cities – The Micropolitics of Urban Space / *Die Mikropolitik des urbanen Raums*
This magazine accompanies the exhibition Talking Cities as part of ENTRY2006 / *Dieses Magazin begleitet*
die Ausstellung Talking Cities als Teil der ENTRY2006.

ENTRY2006

Perspectives and Visions in Design / *Perspektiven und Visionen im Design*
at the Zeche Zollverein, Essen, Germany / *auf Zeche Zollverein, Essen, Deutschland*
August 26th to December 3rd, 2006 / *26. August bis 3. Dezember 2006*

Talking Cities

The Exhibition at ENTRY2006 – Perspectives and Visions in Design
Die Ausstellung zur ENTRY2006 – Perspektiven und Visionen im Design

Talking Cities features innovative international design, architecture and spatial interventions in a trans-disciplinary exhibition and event platform. The participants stretch the boundaries of architecture and urban design and shift our perceptions of contemporary city spaces. It is a dense collage of statements and designs that exemplify the dialogue on reconfiguring and reactivating the marginal, residual and public spaces of our cities. Talking Cities investigates the fragmented conditions that make up our present day urban realities.

Talking Cities vereint innovatives, internationales Design, Architektur und räumliche Interventionen in einer multidisziplinären Ausstellungs- und Eventplattform. Die Ausstellungsteilnehmer erweitern die Grenzen von Architektur und Städtebau und verändern unsere Wahrnehmung der zeitgenössischen Stadt. Mit einer dichten Collage aus Statements und Konzepten wird der Dialog über die Neustrukturierung und Reaktivierung der marginalen, verwaisten und öffentlichen Räume unserer Städte greifbar gemacht. Talking Cities wird neue Sichtweisen auf die fragmentierten Bedingungen aufdecken, die unsere alltäglichen urbanen Realitäten ausmachen.

www.talkingcities.net www.entry-2006.com

Contents Inhalt

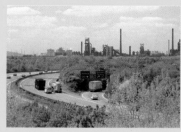

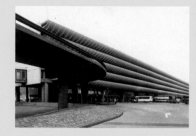

Talking Cities

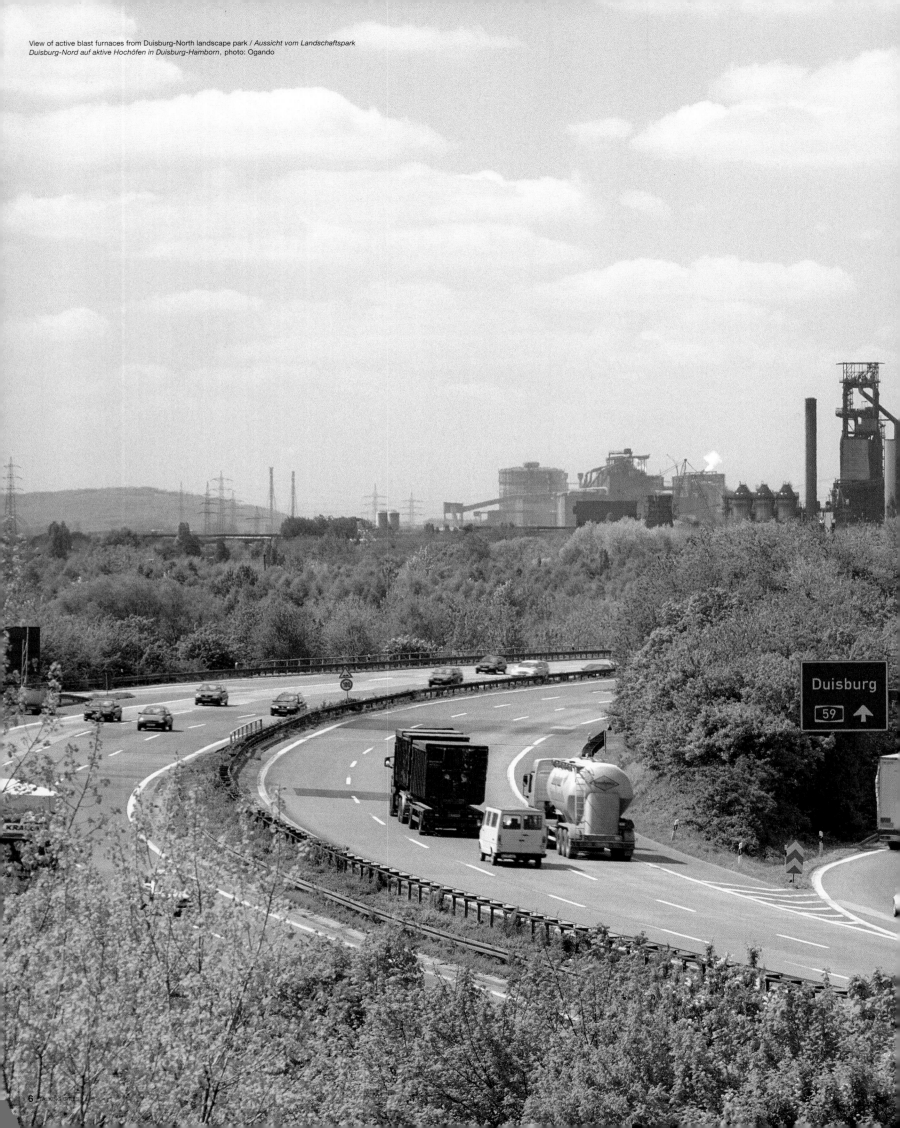

View of active blast furnaces from Duisburg-North landscape park / *Aussicht vom Landschaftspark Duisburg-Nord auf aktive Hochöfen in Duisburg-Hamborn*, photo: Ogando

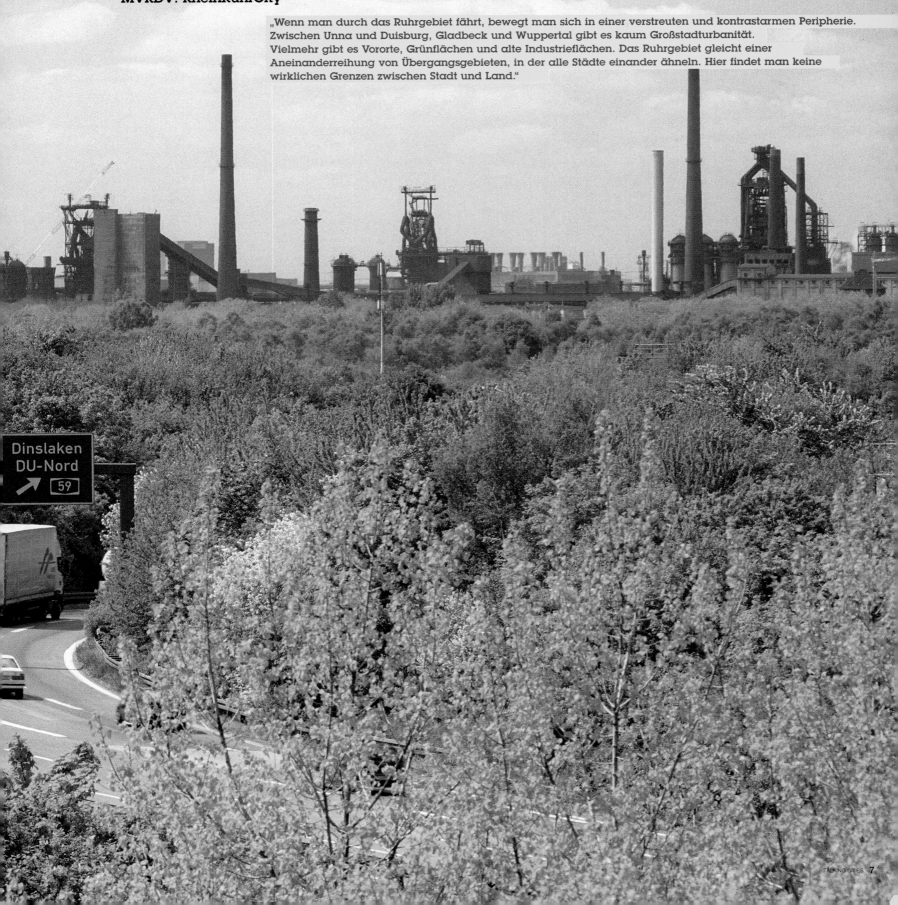

"If one drives through the Ruhr District, one moves through a dispersed and low-contrast periphery. Between Unna and Duisburg, Gladbeck and Wuppertal, there is hardly any big city urbanity. It consists rather of suburbs, green spaces and old industrial sites. The Ruhr District resembles a lining up of in-between areas, where all the cities resemble each other. Here, one does not find real borders between city and country."
MVRDV: RheinRuhrCity

„Wenn man durch das Ruhrgebiet fährt, bewegt man sich in einer verstreuten und kontrastarmen Peripherie. Zwischen Unna und Duisburg, Gladbeck und Wuppertal gibt es kaum Großstadturbanität. Vielmehr gibt es Vororte, Grünflächen und alte Industrieflächen. Das Ruhrgebiet gleicht einer Aneinanderreihung von Übergangsgebieten, in der alle Städte einander ähneln. Hier findet man keine wirklichen Grenzen zwischen Stadt und Land."

Dinslaken
DU-Nord
↗ 59

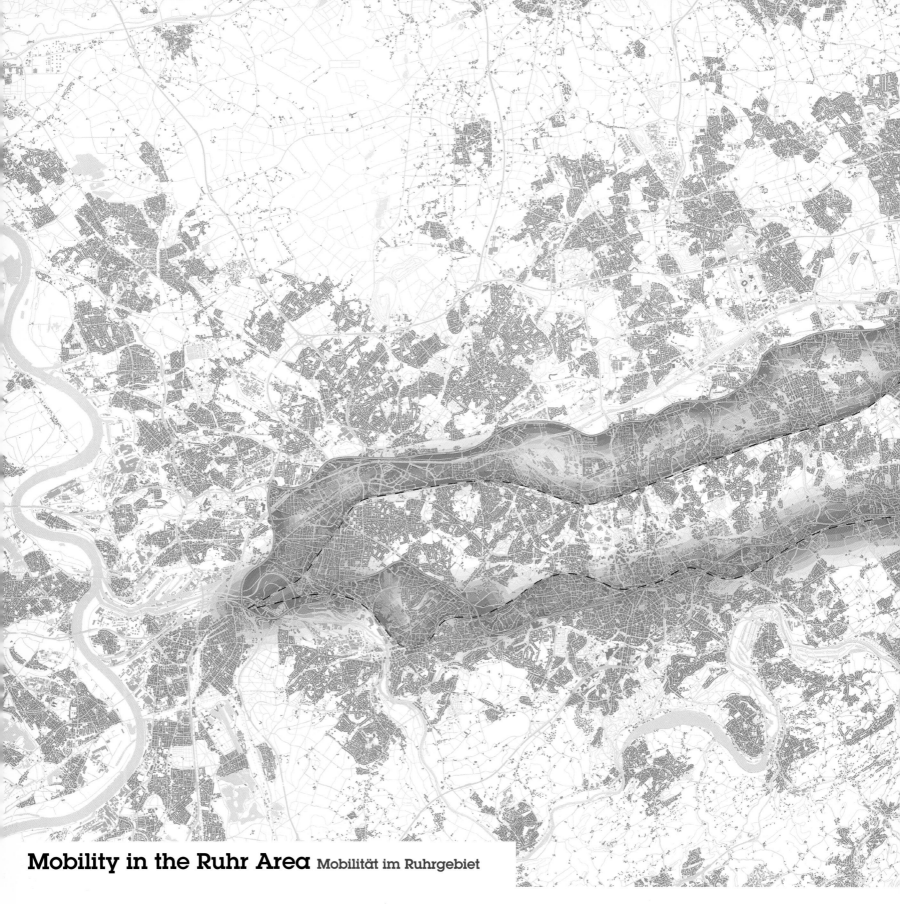

Mobility in the Ruhr Area Mobilität im Ruhrgebiet

National, regional and local roads
Straßen des überörtlichen Verkehrs

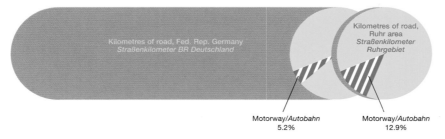

Kilometres of road, Fed. Rep. Germany
Straßenkilometer BR Deutschland

Kilometres of road, Ruhr area
Straßenkilometer Ruhrgebiet

Motorway/*Autobahn*
5.2%

Motorway/*Autobahn*
12.9%

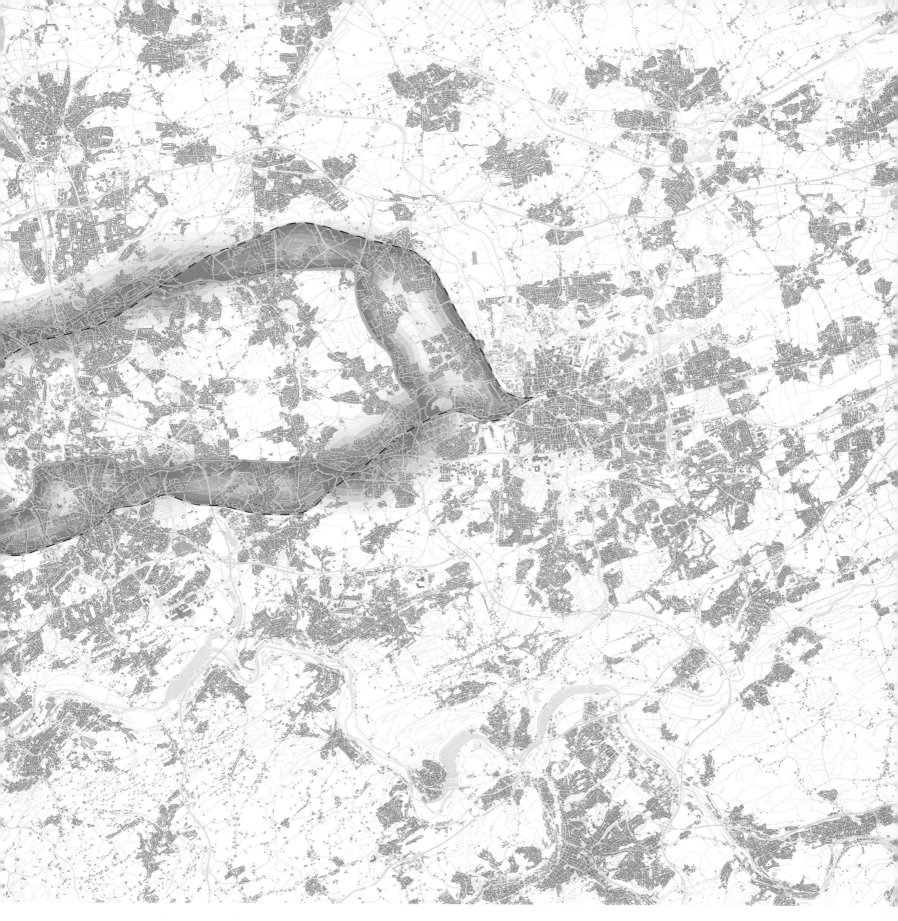

Car density 2004
Kfz-Dichte 2004

Fed. Rep. Germany
151 cars per sq. km.

BR Deutschland
151 Kfz pro qkm

Ruhr area
700 cars per sq. km.

Ruhrgebiet
700 Kfz pro qkm

[↑] 1A Ruhr city – Commuter belt: mobility analysis in the Ruhr area. A ring-shaped "top location" zone is defined by 30 min transit distance to motorway exits and main station access within the Ruhr area / *1A Ruhrstadt – Ringstadt, Analyse über Mobilität im Ruhrgebiet. Die Verfügbarkeit von Autobahnausfahrten und Hauptbahnhöfen definiert eine Eins-a-Lage innerhalb des Ruhrgebietes. Innerhalb der resultierenden Ringfigur ist jedes Ziel innerhalb von 30 Minuten mit dem Auto oder der Bahn zu erreichen.* Map / Karte: Florian Steinbeck, www.a42.org, AdbK Nürnberg

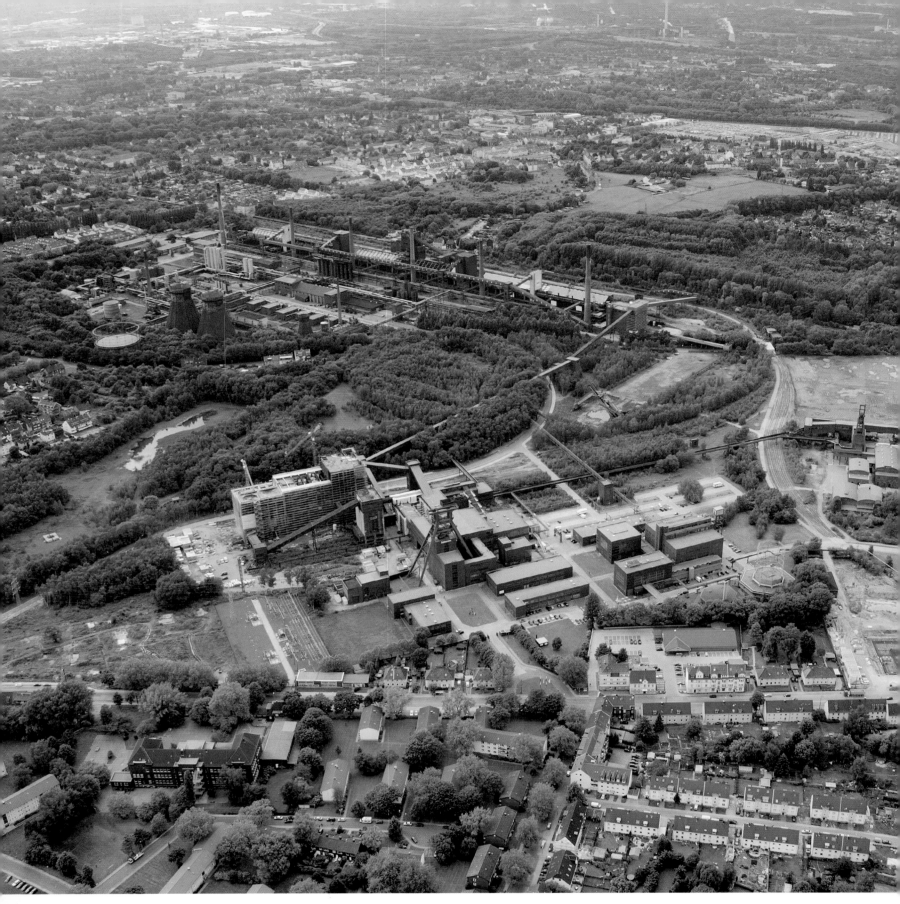

[↑] Zeche Zollverein, Essen 2005, aerial view / *Luftbild*: Hans Blossey

[→] "Shaft XII", decommissioned in 1986 / *„Schacht XII", 1986 stillgelegt*,
 Zeche Zollverein Essen, photo: Manfred Vollmer

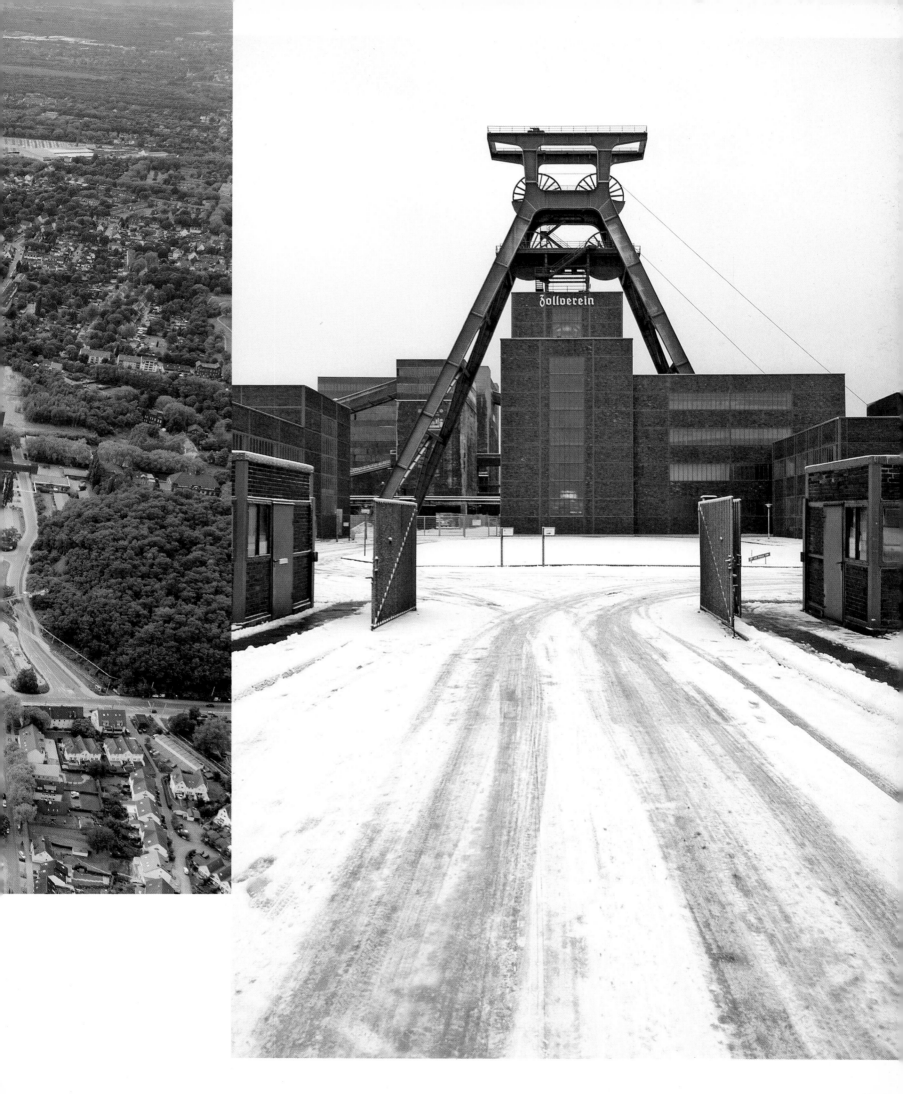

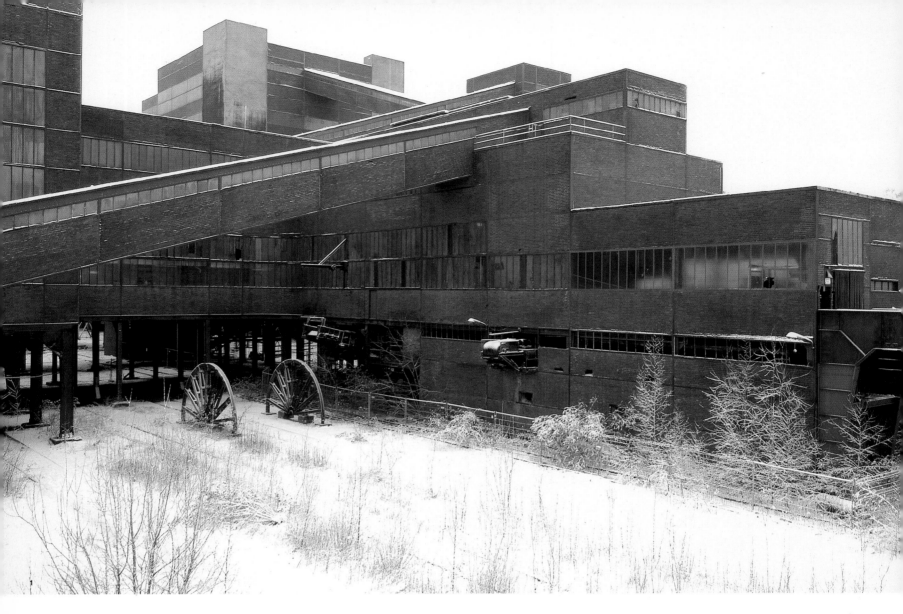

The Zeche Zollverein

Gerhard Seltmann, CEO of the Zollverein exhibitions association and ENTRY2006.
Gerhard Seltmann, Geschäftsführer der Ausstellungsgesellschaft Zollverein und Veranstalter der ENTRY2006.

The Zollverein colliery pit XII is the best known industrial monument in the Ruhr valley area. The unmistakeable outline of its pithead winding gear is a motif much beloved of the media and amateur photographers alike, while its architecture attracts visitors from all over the world.

Any mention of the Zollverein is likely to include three things: world cultural heritage, industrial culture and design. This can give the impression that design as an activity is being used rather laboriously to give the site a new function. World cultural heritage and industrial culture, on the other hand, are seen as responsibilities, tourism factors, or extra burdens, depending on one's viewpoint.

Yet it is precisely this combination of the three that gives the Zollverein such a unique and strong identity: nowhere else in the world has an industrial site been developed by designers and engineers working together so consistently on everything from the streetlamps and buildings to the machine park. Here, "design" means contemplating the roots and past uses of the place in terms of design solutions for the future. That is why industrial culture at the Zollverein means more than just preserving buildings to remind us of bygone days. It is a kind of "world heritage site for design", promoting new approaches to design, international platforms for interdisciplinary debate about design quality, presentation spaces and specialist courses in the fields of design and architecture.

The "New Zollverein" is growing fast. People from all walks of life come here to see it or just to hang out. The site is a huge tourist attraction, with more than half a million visitors each

Die Zeche Zollverein XII ist das wohl bekannteste Industriedenkmal im Ruhrgebiet. Der charakteristische Förderturm ist beliebtes Motiv für Medien und private Photoalben, die Architektur beeindruckt Besucher aus aller Welt.

Drei Schlagworte bestimmen alle Reden und Berichte über Zollverein: Weltkulturerbe, Industriekultur, Design. Oft entsteht dann der Eindruck, das Thema Design sei so etwas wie der mühsame Versuch, dem Areal eine neue Funktion zu geben. Das Weltkulturerbe und die Industriekultur werden je nach Standpunkt als Verpflichtung, touristisches Potenzial oder auch als Belastung empfunden.

Und doch ist es genau dieser Dreiklang, der Zollverein zu einem einzigartigen und unverwechselbaren Ort macht: Nirgendwo sonst auf der Welt gibt es eine Industrieanlage, die von den Straßenlaternen über die Gebäude bis hin zum Maschinenpark in konsequenter Zusammenarbeit von Gestaltern und Ingenieuren entwickelt wurde. Design auf Zollverein bedeutet also Besinnung auf die Wurzeln und Nutzung des Ortes für die Gestaltungsaufgaben der Zukunft. Und darum ist Industriekultur auf Zollverein eben mehr als die Bewahrung von baulichen Zeugen einer vergangenen Zeit. Es entsteht neues Design im „Weltkulturerbe des Designs", es entstehen internationale Plattformen für den interdisziplinären Diskurs über Gestaltqualität, es entstehen Orte der Präsentation und der Weiterbildung im Bereich des Designs und der Architektur.

Das „Neue Zollverein" wächst heran. Es ist Aufenthaltsort und Ziel für viele Menschen mit ganz unterschiedlichen Interessen: Das Neue Zollverein ist eine touristische Attraktion - mehr als eine halbe Million Menschen jährlich besuchen das Weltkulturerbe oder

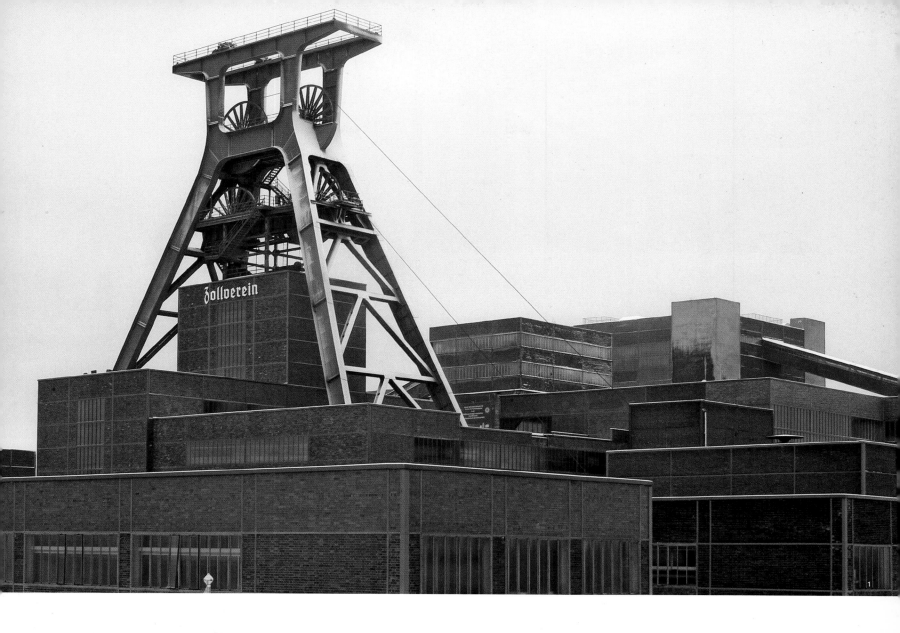

[1,2] UNESCO world culture heritage site Zeche Zollverein, Essen / *UNESCO Weltkulturerbe Zeche Zollverein, Essen* Architects / *Architekten:* Fritz Schupp and Martin Kremmer, photos: Thomas Mayer

year, including those who attend events. It has created jobs too: Run by the Zollverein Foundation, several of its buildings already house eighty businesses with around a thousand employees, many of them in creative service industries. Institutions of international calibre are present in the form of the North-Rhine Westphalia Design Centre and the Zollverein School of Business and Design; they will be joined in 2007 by the new Ruhr Museum.

In 2006, the New Zollverein will enter the international spotlight with spectacular architecture and a high-profile event. The Zollverein School is due to move into its new building, designed by the Japanese architects SANAA. This is an outstanding example of forward-looking architecture in the educational field. Another project under completion is the conversion of the former coal washery for the Ruhr Museum. Designed by the architects OMA from Rotterdam, it shows just how fascinating old industrial buildings can be for visitors if reused imaginatively.

The coal washery begins its new existence with an internationally curated exhibition about perspectives and visions in design. ENTRY2006 runs from 26th August until 3rd December and also offers around sixty events at different places on the site. It takes a wide-ranging look at the stages involved in industrial research, from the first experimental design to the product or environment of tomorrow.

Zollverein is a model project. Many different people and organisations have come together to open up new ground in the spirit of experiment demonstrated by their forerunners here. They are all good reasons to visit Zollverein, and be part of the effort to preserve our cultural heritage and give it new life.

nehmen an Veranstaltungen teil. Das Neue Zollverein bietet Arbeitsplätze - 80 Unternehmen mit rund 1.000 Beschäftigten haben sich bereits auf den verschiedenen Standorten angesiedelt, darunter viele aus dem Bereich der kreativen Dienstleistungen. Mit dem Design Zentrum Nordrhein-Westfalen und der Zollverein School of Business and Design sind Institutionen mit internationaler Ausstrahlung präsent, im Jahr 2007 kommt das neue Ruhrmuseum hinzu.

Im Jahr 2006 wird das Neue Zollverein mit spektakulärer Architektur und einem außergewöhnlichen Ereignis in das Blickfeld einer internationalen Öffentlichkeit treten. Die Zollverein School bezieht den Neubau der japanischen Architektengruppe SANAA, ein herausragendes Beispiel zukunftsorientierter Architektur für Bildungseinrichtungen. Fertig gestellt wird auch die umgebaute ehemalige Kohlenwäsche als künftiger Sitz des Ruhrmuseums. Das Projekt des Büros OMA aus Rotterdam dokumentiert eindrucksvoll, wie faszinierend die Umnutzung ehemaliger Industriegebäude für die Besucher sein kann. Erster Nutzer der Kohlenwäsche wird vom 26. August bis 3. Dezember die ENTRY2006 mit einer international kuratierten Ausstellung zu Perspektiven in Design und Architektur sein. In der Kohlenwäsche und mit rund 60 weiteren Veranstaltungen auf dem gesamten Areal zeigt die ENTRY2006 viele Beispiele für die Kette von industrieller Forschung über erste Designexperimente bis hin zu den Produkten und Lebensräumen von morgen.

Zollverein ist ein Modell. Viele Akteure sind daran beteiligt, im Sinne des experimentellen Geistes der Gründer neue Wege zu gehen und Neues zu schaffen. Sie alle laden dazu ein, Zollverein zu besuchen, teilzuhaben an dem Versuch, das kulturelle Erbe zu bewahren und mit neuem Leben zu füllen.

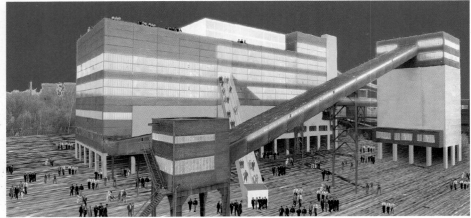

Zeche Zollverein: OMA's Master Plan

The Zeche Zollverein finally stopped coal production in 1986. For ten years this imposing 100-hectare site near Essen stood empty until the local authorities purchased it and began to think about a change of use. In 2001 UNESCO declared the Zollverein to be a world heritage industrial monument and a master plan for a 200 million euro redevelopment into a new regional cultural centre – proposed by Floris Alkemade and Rem Koolhaas from the Rotterdam architecture firm Office for Metropolitan Architecture (OMA) – was put into effect. The expected completion date is 2010. Die Zeche Zollverein stellte 1986 den Kohleabbau endgültig ein. Zehn Jahre lang lag das eindrucksvolle 100 Hektar große Gelände in der Nähe von Essen brach, bevor es von den Landesbehörden gekauft und über eine neue Nutzung nachgedacht wurde. 2001 erklärte die UNESCO die Zeche Zollverein zum Weltkulturerbe; beinahe gleichzeitig begann die fast 200 Millionen Euro teure Weiterentwicklung des Geländes hin zu einem regionalen, kulturellen Zentrum – auf der Basis eines von Floris Alkemade und Rem Koolhaas vom Rotterdamer Architekturbüro „Office for Metropolitan Architecture" (OMA) entworfenen Masterplans. Die Fertigstellung ist für 2010 geplant.

[↖] Future coal washery design / *künftiges Design der Kohlenwäsche*, collage © OMA (Office for Metropolitan Architecture)

[↑] Coal washery / *Kohlenwäsche*, Zeche Zollverein, Essen 2006, photo: Christian Hiller

[→] Coal washery / *Kohlenwäsche*, Zeche Zollverein, Essen 2004, photo: Thomas Mayer

OMA's master plan consists of a band around the former historic site containing all the necessary new buildings and facilities in what Alkemade likens to a "walled city". The band will house new functions to inform and attract visitors. This allocation of new programme to the periphery is intended to allow the old buildings to retain their grandeur and impact for the visitor: "Coming from the city", says Alkemade, "you cross this layer of modernity and enter an area where the scale, the function and the history of the buildings is completely different. In that way you can combine existing and new without creating conflict in which they both lose their identity". For OMA it is not so much about preserving the architecture and the buildings, as the meaning of the site: "It was always like a motor, the key point of gravity, the identity of the Ruhr area". Their aim has been to come up with a reprogramming concept that both maintains the buildings and attempts to "give back that function of a motor".

The master plan also stipulates that the former system of rail tracks within the Zollverein area should be maintained as public space connecting the buildings and that the system of sky bridges which once conveyed coal from one part of the site to another should also be used for visitors along with a 1,000 metre former mine shaft for trips underground. New roads and an extension of the existing motorway through a tunnel entering and exiting the site will allow easier access.

At the time of writing, the "reprogramming" of the Zeche Zollverein is well underway. Various other offices have taken over individual aspects of the project, such as the new Zollverein School of Management & Design by SANAA architects. OMA is converting the old coal washery building (*Kohlenwäsche*) into a museum space. The building was erected in 1932 and is a classic exercise in

Der Masterplan von OMA besteht im Wesentlichen aus einer Bebauungszone rund um das historische Gelände, die alle notwendigen neuen Gebäude und Anlagen beinhaltet – Alkemade vergleicht das mit einer „umhüllten Stadt". Diese Zone wird neue Funktionen beherbergen, um Besucher zu informieren und anzuziehen. Die Verortung eines neuen Programms in der Peripherie soll es ermöglichen, dass die Pracht der alten Gebäude in ihrer Wirkung auf den Besucher beibehalten wird: „Von der Stadt her kommend", beschreibt Alkemade, „durchquert man diese Schicht der Moderne und betritt einen Bereich, in dem Maßstab, Funktion und Geschichte der Gebäude vollkommen anders sind. Auf diese Weise kann man das Bestehende und das Neue miteinander verbinden, ohne einen Konflikt zu schaffen, in dem beide ihre Identität verlieren." Es geht für OMA nicht so sehr um die Erhaltung der Architektur und der Gebäude als um die Bedeutung des Areals: „Es war immer wie ein Motor, der entscheidende Faktor für die Anziehungskraft und die Identität des Ruhrgebiets." Ihr Ziel ist es gewesen, ein Konzept zur Neuprogrammierung zu entwickeln, das die Gebäude erhält und zugleich versucht, „diese Funktion eines Motors zurückzugeben."

Der Masterplan legt auch fest, dass das ehemalige Eisenbahnschienensystem auf dem Gelände des Zollvereins als öffentlicher Raum, der die Gebäude miteinander verbindet, erhalten bleiben soll. Das System der Förderbandbrücken, das einst die Kohle von einem Teil des Areals zum anderen beförderte, soll, ebenso wie ein 1.000 Meter langer ehemaliger Schacht für Untertagefahrten, von den Besuchern genutzt werden. Neue Straßen und eine Verlängerung der bestehenden Autobahn durch einen Tunnel, über den das Gelände befahren und wieder verlassen werden kann, werden die Zufahrt erleichtern.

Während dieser Artikel geschrieben wird, ist die „Neuprogrammierung" der Zeche Zollverein voll im Gange. Einzelne Aspekte des Projektes wurden von verschiedenen Architekturbüros übernommen, so der Neubau für die

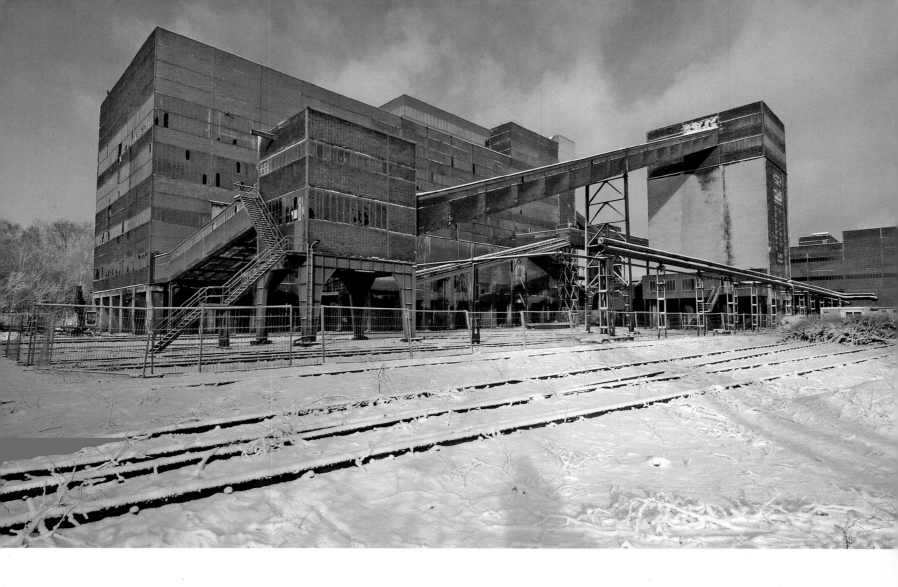

form strictly following function. It houses a huge pair of identical machines that ensured continuous 24 hour production of coking coal, alongside simultaneous maintenance and modernisation, processing up to 12,000 tonnes of coal daily for 54 years.

The coal washery (which is also the venue for ENTRY2006 and the Talking Cities exhibition) was originally only intended to last for 20 to 30 years. The combination of being a "temporary" construction and processing coal and water, which corroded all the steel, has meant a great deal of restoration was necessary. The original 10 cm thick façade needed to be replaced and doubled in thickness for museum conditions, but in such a way as to satisfy the building preservation authorities and preserve the aesthetics of the interior. Space had to be made inside the building but without inhibiting the symmetry and impact of the huge machines. Floors like the bunker level, for example, were opened up by removing all the concrete coal storage bunkers that had made it previously inaccessible. Intriguingly for such a "heavy" building, the coal washery is built on stilts to allow for the trains passing underneath. In order to preserve this architectural feature, OMA placed the visitors' centre up on the 24th level and created a new access by constructing a huge new escalator that echoes the original sky bridges. Visitors can now enter the building like the coal before them, trickling down through the floors under the force of gravity and soaking up experience along the way. SL

Zollverein School of Management and Design des Architekturbüros SANAA. OMA selbst baut gerade das Gebäude der ehemaligen Kohlenwäsche in ein Museum um. Das Gebäude wurde 1932 errichtet und steht als klassisches Beispiel für „form follows function" – eine Form, die streng ihrer Funktion folgt. Zwei riesengroße identische Maschinen sind hier untergebracht, die die ununterbrochene 24-Stunden-Produktion von Kokskohle gewährleisteten. Unter ständiger Instandhaltung und Modernisierung wurden hier 54 Jahre lang bis zu 12.000 Tonnen Kohle täglich gefördert.

Die Kohlenwäscherei (die auch der Veranstaltungsort für die ENTRY2006 und die Talking-Cities-Ausstellung ist) sollte ursprünglich nur etwa 20 bis 30 Jahre lang bestehen bleiben. Die Kombination aus „temporärer" Bauweise und die Aufbereitung von Kohle und Wasser, das den gesamten Stahl korrodieren ließ, hat umfangreiche Restaurierungsarbeiten notwendig gemacht. Um die Vorgaben für ein Museum zu erfüllen, musste die Fassade, die ursprünglich 10 cm dick war, ersetzt und verdoppelt werden – jedoch auf eine Art und Weise, die sowohl der Zustimmung der Denkmalschutzbehörde bedurfte als auch die Ästhetik des Innenraumes erhalten würde. Im Gebäude musste Raum geschaffen werden, ohne die Symmetrie und die ästhetische Wirkung der gewaltigen Maschinen zu beeinträchtigen. Etagen wie die „Bunkerebene" wurden aufgemacht, indem alle Kohlebunker aus Zement, die den Zugang bisher versperrten, entkernt wurden. Erstaunlicherweise für so ein massives Gebäude ist die Kohlenwäscherei auf Stelzen gebaut – damit die Züge darunter durchfahren konnten. Um dieses architektonische Charakteristikum zu erhalten, hat OMA den Eingang zum Besucherzentrum in die Ebene 24 gelegt und mit einer großen neuen Rolltreppe erschlossen, die der originalen Bandbrücke folgt. Auf dem gleichen Weg wie früher die Kohle werden nun die Besucher das Gebäude betreten und – sozusagen der Schwerkraft folgend – durch die Stockwerke nach unten sickern, während sie gleichzeitig die Erlebnisse aufsaugen. SL

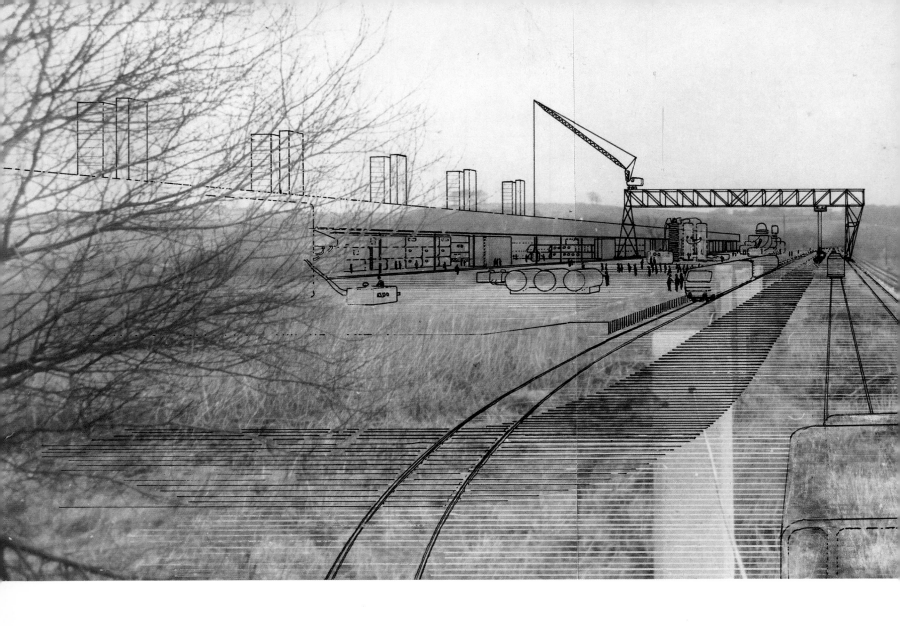

The Potteries Thinkbelt

Cedric Price (1934–2003) was one of architecture's most innovative, influential and radical thinkers. He built practically nothing yet his influence on the thinking of architects such as Richard Rogers and Rem Koolhaas has had far-reaching effects (The Pompidou Centre, for example, in Paris would have been unthinkable without him). He was interested in lightweight structures with a fixed, short lifespan, driven by technology and derived from industry rather than civic architecture. Price strove to appropriate architecture as a catalyst to redefine the standard relationships between people and their built environment: Architecture must "allow us to think the unthinkable" he once said. Whereas his now famous "Fun Palace for Joan Littlewood" design (1961) was intended to bring delight and fulfilment to deprived areas of east London, his "Potteries Thinkbelt" (1964) was to bring education and opportunity to the declining Staffordshire pottery towns.

The "Thinkbelt" was also a critique of the British university system and a response to the large number of new campus universities being built in the 1960s. Price proposed providing a mobile learning resource for 20,000 students that used the infrastructure of a declining industrial zone. Using the derelict rail network and large areas of unused land, mostly former clay pits and coal-workings, he proposed a community of learning that simultaneously encouraged economic growth and a recovery route from the social collapse and unemployment in the area.

Cedric Price (1934–2003) war einer der innovativsten, einflussreichsten und radikalsten Denker auf dem Gebiet der Architektur. Obwohl er so gut wie nichts tatsächlich gebaut hat, hatte sein Einfluss auf das Denken von Architekten wie Richard Rogers und Rem Koolhaas weit reichende Auswirkungen (das Centre Pompidou in Paris zum Beispiel wäre ohne ihn undenkbar gewesen). Er interessierte sich für leichtgewichtige Konstruktionen mit einer festgelegten, kurzen Lebensdauer, angetrieben von technologischen Konzepten und eher von der industriellen Ästhetik inspiriert als von der zivilen Architektur. Price strebte danach, die Architektur als Katalysator zu nutzen, um die üblichen Beziehungen zwischen den Menschen und ihrer gebauten Umgebung neu zu definieren: ihm zufolge sollte Architektur „uns erlauben, das Undenkbare zu denken". Während er mit seinem inzwischen berühmten Entwurf „Fun Palace for Joan Littlewood" (1961) beabsichtigte, Freude und Erfüllung in die sozial benachteiligten Gebiete in den Osten Londons zu bringen, wollte er mit dem „Potteries Thinkbelt" (1964) den verfallenden Töpferstädten der Grafschaft Staffordshire Bildung und neue Entwicklungschancen bieten.

Der „Thinkbelt" war auch eine Kritik am britischen Universitätssystem und eine Reaktion auf die vielen neuen Campus-Universitäten, die in den 1960er Jahren gebaut wurden. Price schlug vor, eine mobile Lerneinrichtung für 20.000 Studenten zu schaffen, die die Infrastruktur eines im Niedergang befindlichen Industriegebietes nutzte. Er entwarf die Idee einer Lerngemeinschaft, die – indem das heruntergekommene Eisenbahnnetz und große Flächen brach liegenden Landes, meist ehemalige Lehmgruben und Kohleabbaugebiete, genutzt werden - gleichzeitig das wirtschaftliche Wachstum fördern und einen Ausweg aus dem sozialen Zerfall und der Arbeitslosigkeit in der Gegend anbieten sollte.

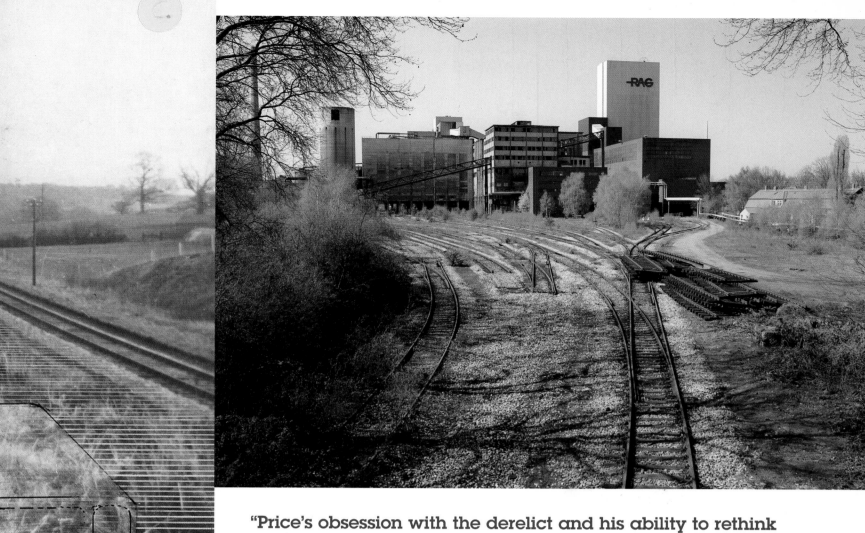

"Price's obsession with the derelict and his ability to rethink the derelict … could be a first step of re-thinking the whole notion of the past … [With the] 'Potteries Thinkbelt', I would say is the first time in the 20th century, where a modern architect thinks about the past in a really profound way. At this point he is beginning to scratch the surface of weakness in a way that we have not been able to do since." Rem Koolhaas at the "Fun Palace" conference held in the condemned shell of the "Palast der Republik", Berlin 2004.

„Price's Obsession für das Verfallene und seine Fähigkeiten, das Verfallene zu überdenken … könnte ein erster Schritt dahingehend sein, die ganze Auffassung der Vergangenheit neu zu überdenken … Ich würde sagen, dass mit dem ‚Potteries Thinkbelt' zum ersten Mal im 20. Jahrhundert ein moderner Architekt wirklich tiefgründig über die Vergangenheit nachdenkt. Hier beginnt er, so an der Oberfläche der Schwäche zu kratzen, wie es uns seither nicht möglich war."

"[Cedric Price's] famous proposal for the 'Potteries Thinkbelt' … was not something new, but it was a way of re-inhabiting an existing condition that was no longer functional. In this way, 'Potteries Thinkbelt' dealt with a dysfunctional abundance; the abject; the ruin. Price found a way to inscribe a new programme into it, to re-use the entire infrastructure of a previous system for a new system." Rem Koolhaas, ibid.

„[Cedric Prices] berühmter Vorschlag für den ‚Potteries Thinkbelt' war nichts Neues, aber es stellte eine Art Wiederbelebung eines bestehenden Zustandes dar, der nicht mehr funktional war. So befasste sich der ‚Potteries Thinkbelt' mit dem dysfunktionalen Überfluss, dem Elend, dem Verfall. Price fand einen Weg, ihm ein neues Programm zu geben, die gesamte Infrastruktur eines früheren Systems für ein neues System wiederzuverwenden."

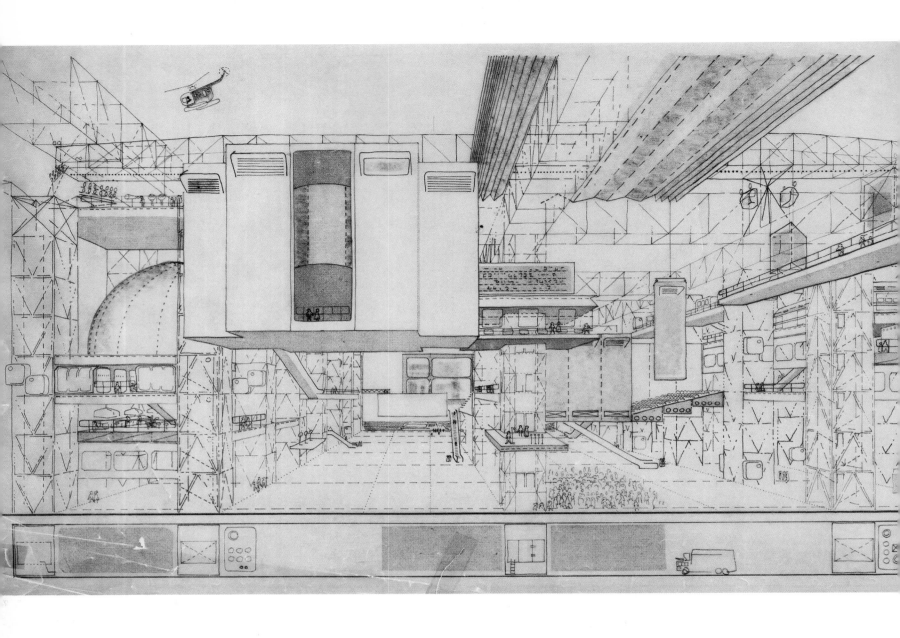

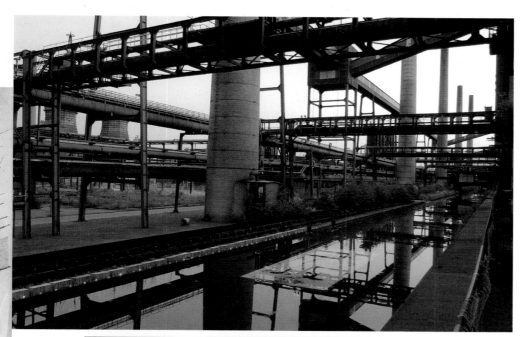

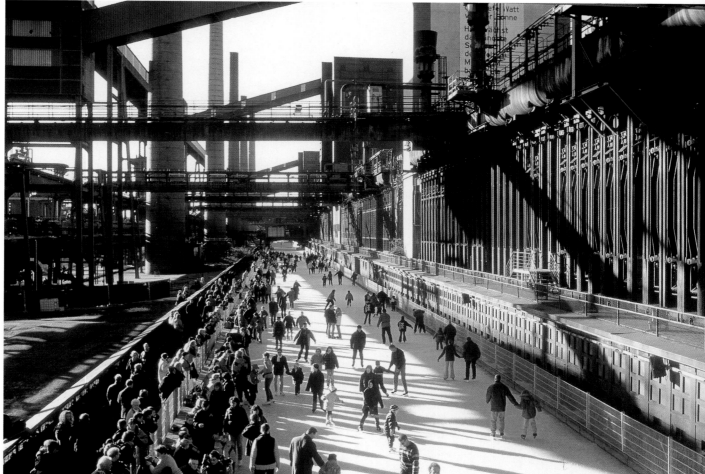

[↖] Cedric Price's "Fun Palace" concept / *Cedric Prices Konzept für den „Fun Palace",* 1960/61,
Digital image 2005 © MoMA, New York / Scala, Florence

[↑] Zeche Zollverein, 2003, photo: Thomas Mayer

[↗] Coking plant skating rink / *Eisbahn an der Kokerei,* Zeche Zollverein, Essen 2001/02,
photo: Manfred Vollmer

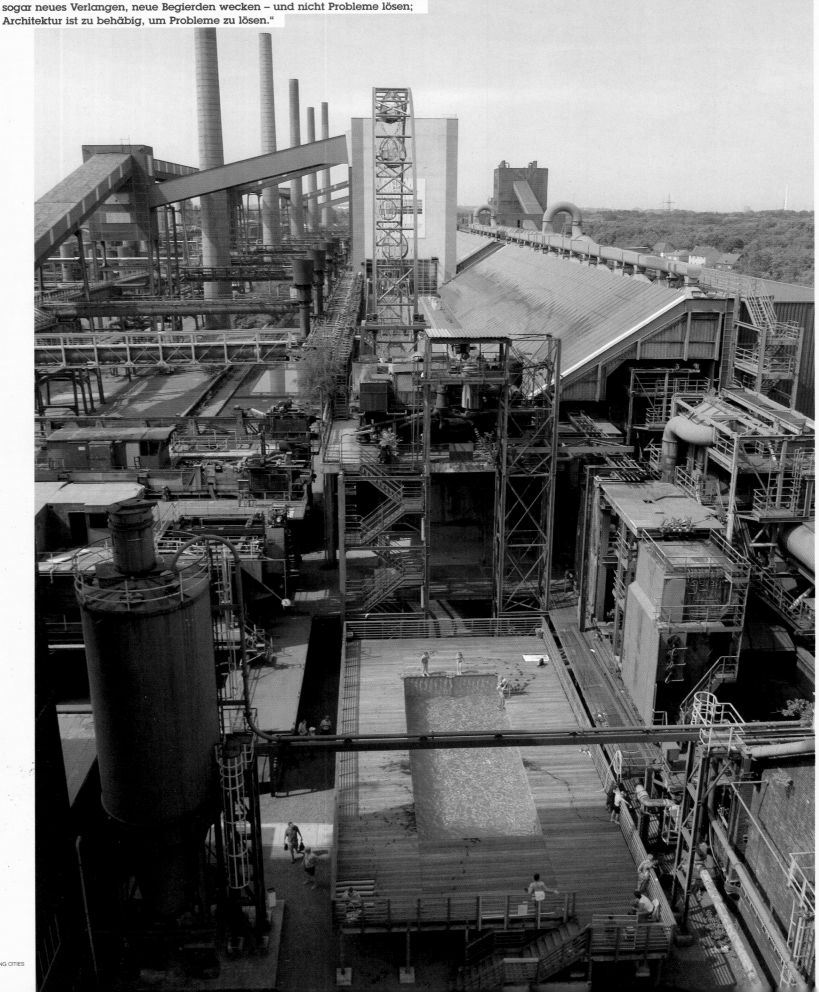

"So that is another rule for the whole nature of architecture; it must actually create new appetites, new hungers – not solve problems; architecture is too slow to solve problems." Cedric Price, 2000

„Daher ist dies eine weitere Regel für die Architektur an sich; sie muss sogar neues Verlangen, neue Begierden wecken – und nicht Probleme lösen; Architektur ist zu behäbig, um Probleme zu lösen."

Talking Cities
The Micropolitics of Urban Space

Talking Cities – Die Mikropolitik des urbanen Raums As part of the architecture and design forum ENTRY2006, Talking Cities is an international exhibition and event platform that reacts to the themes engendered by the newly transformed Zeche Zollverein. This is a world heritage monument in progress, one which awaits a dynamic re-definition and re-appropriation by the public. The former industrial complex is now to be the setting for a presentation of architectural and urban design projects that stretch the term "architecture" by proposing a redefinition of the potentials and capacities of architecture and design as disciplines, including the practice of building and beyond, to that of a social and communicative tool. Talking Cities will confront the issue of dealing proactively rather than retroactively with the architectural monument and the contemporary city's margins. *Talking Cities, eine internationale Ausstellungs- und Eventplattform eingebettet in das Architektur- und Designforum ENTRY2006, ist eine Reaktion auf die Motive der neu gestalteten Zeche Zollverein. Die Zeche stellt ein sich im ständigen Wandel befindliches Weltkulturerbe dar, welches einer dynamischen Neudefinition und Wiederverwendung durch die Öffentlichkeit entgegensieht. Dieser ehemalige Industriekomplex bildet nun den Rahmen für die Präsentation von architektonischen und urbanen Designprojekten, die den Begriff „Architektur" ausdehnen, indem sie eine Neudefinition der Potenziale und Fähigkeiten der Disziplinen Architektur und Design, einschließlich der baulichen Praxis und darüber hinaus, als soziales und kommunikatives Instrument vorschlagen. Talking Cities wird den Umgang mit dem Thema Baudenkmal und den heutigen Stadtbegrenzungen proaktiv statt retroaktiv gegenüberstellen.*

Introduction by Talking Cities curator Francesca Ferguson *Einleitung der Kuratorin von Talking Cities Francesca Ferguson*

During my first encounter with the Zeche Zollverein I was overawed by the elegance of an industrial architecture designed as a highly efficient machine, but a closer look revealed the fragility of this industrial behemoth. Fritz Schupp and Martin Kremmer had designed a Bauhausian masterpiece with an originally intended lifespan of 30 years at most – for as long as coal-powered energy remained a profitable enterprise. The Zollverein's classification as a world heritage site seemed a contradiction in terms. The "works swimming pool", installed by the artist/architect collective phantombüro in the coking plant (see opposite) acts as an ironic, even sardonic gesture towards a site seemingly held in suspension, heralding a post-industrial age of leisure. In the background a fairground wheel has also been implanted amongst the infrastructure.

To me, this collage of machine, ruin, monument and play distinctly echoed the spirit of that carnivalesque and technocratic blend inherent to the late Cedric Price's never realised "Fun Palace" proposal of 1961. Price's "Fun Palace" sketches, when aligned with photographs showing ice skaters amongst the giant steel machinery, with the birch trees and pale greenery stealthily engulfing the industrial remains, suddenly mirror reality. OMA, commissioned with the masterplan for the conversion of the coal washery Zollverein, refer to the site as being "behind the looking glass" – a place you step inside, and where the commonplace no longer applies.

These latent paradoxes that become apparent with the ultimate transformation of the Zollverein site are underscored when one explores the urban landscape that surrounds it: In its sheer scale, almost a city within the peripheral landscape of Essen, the Zollverein is indeed a space to be stepped into if one wants to avoid facing up to some of the glaring economic realities at its borders. Here you find the nondescript social housing estates of Katernberg, one of the poorest areas in Germany, and the boarded-up shop fronts with their old-fashioned signage and retro window displays that almost mock the stateliness of the industrial monument that was once the main economic provider for Essen and Gelsenkirchen.

The idea of implanting a cultural event such as ENTRY2006 into the Zollverein, one that is to draw attention to achievements in architecture and design, becomes far more complex and multi-layered as soon as one focuses on the contradictions within and around the site itself: The preservation of what was once intended to be temporary, its cultural re-naming as a motor for economic change in the area, and the fragmented landscape of the conurbation that surrounds Zollverein – the Ruhrgebiet itself – already weighed down with the process of redefining its own industrial heritage.

Architecture and urban design that engages with the issues of ruin and redundancy has been hitherto under-represented within an overall design discourse. Rem Koolhaas declares this lack of an attitude about the past as a weakness in modern architecture. Cedric Price was one of the first in his profession to think profoundly about the past. His famous proposal in 1964 for turning a declining potteries factory area in Staffordshire into a "thinkbelt" (page 16) – a basis for education and

Bei meiner ersten Begegnung mit der Zeche Zollverein war ich von der Eleganz der Industriearchitektur, gestaltet als hocheffiziente Maschine, tief beeindruckt. Bei näherem Hinsehen wurde mir jedoch die Fragilität dieses industriellen Riesen bewusst. Fritz Schupp und Martin Kremmer hatten ein vom Bauhaus inspiriertes Meisterstück entworfen, das eine ursprünglich geplante Lebensdauer von höchstens 30 Jahren haben sollte - solange, wie die Kohleenergie ein profitables Geschäft blieb. Die Einstufung von Zollverein als Weltkulturerbe schien daher ein Widerspruch in sich zu sein. Das „Werksschwimmbad", das vom Künstler-/ Architektenkollektiv „phantombüro" in der Kokerei installiert wurde, ist so auch als eine sardonische Geste an einen Standort zu verstehen, der scheinbar in der Schwebe gehalten wird und die postindustrielle Freizeitära verkündet. Im Hintergrund wurde zudem ein Riesenrad in die Infrastruktur integriert.

Für mich fand sich in dieser Collage aus Maschine, Ruine, Denkmal und Spiel der Geist der karnevalesken, technokratischen Mischung des „Fun Palace" wieder, eines nie realisierten Entwurfs des verstorbenen Cedric Price von 1961. Plötzlich spiegeln Prices Skizzen für den „Fun Palace" in der Zusammenstellung mit Fotos von Eisläufern inmitten der gigantischen Stahlmaschinerie, wo Birken und blassgrünes Laub in einem schleichenden Prozess die Industrieruine erobern, die Realität wider. OMA, mit der Erstellung des Bebauungsplans für den Umbau der Kohlenwäscherei Zollverein beauftragt, beschreibt die Zeche als eine Art „umhüllte Stadt". Durch die Planung der Architektur in der Peripherie des Gebäudes bewahren sie den Geist des Ursprünglichen - man tritt dort in eine andere Modernität ein, in der das Alltägliche keine Gültigkeit mehr hat.

Diese latenten Paradoxe, die mit der endgültigen Umgestaltung der Zeche Zollverein zutage treten, werden noch unterstrichen, wenn man die urbane Landschaft in ihrer Umgebung näher betrachtet: Aufgrund ihrer schieren Größe wirkt die Zeche Zollverein beinahe wie eine eigene Stadt in der peripheren Landschaft von Essen und es ist in der Tat ein Ort, den man betreten kann, um einigen der wirtschaftlich am härtesten betroffenen Realitäten an ihren Grenzen nicht ins Auge sehen zu müssen: die kargen Wohnsiedlungen von Katernberg, einer der ärmsten Gegenden Deutschlands, vernagelte Ladenfenster mit altmodischen Beschilderungen und Schaufensterauslagen aus einer anderen Zeit, die beinahe die Pracht des Industriedenkmals, das einst der größte Arbeitgeber Essens und Gelsenkirchens war, verblassen lassen.

Die Idee, ein Kulturevent wie die ENTRY2006 in den Zollverein zu implementieren, das die Aufmerksamkeit auf die Errungenschaften in Architektur und Design lenken soll, wird noch sehr viel komplexer und vielschichtiger, sobald man sich den Widersprüchen innerhalb der Zeche und in ihrer Umgebung zuwendet: die Erhaltung dessen, was ursprünglich nur von temporärer Dauer sein sollte, seine kulturelle Umwidmung als Motor des wirtschaftlichen Wandels in der Region und die fragmentierte und zersiedelte Landschaft des Ballungsraums, der die Zeche Zollverein umgibt - das Ruhrgebiet - , das bereits selbst an der Neubestimmung des eigenen industriellen Erbes schwer zu tragen hat.

Eine Architektur und städtebauliche Gestaltung, die sich mit der Thematik des Verfalls und der Redundanz befasst, war bisher im allgemeinen Design-Diskurs unterrepräsentiert. Rem Koolhaas bezeichnet diesen Mangel eines Standpunkts zur Vergangenheit als Schwäche der modernen Architektur. Cedric Price war einer der ersten

change – "dealt with a dysfunctional abundance, the abject, the ruin. He transformed a previous programme into a new programme by taking the derelict and using it as a basis for his new work." (Rem Koolhaas, Palast der Republik lecture, Berlin 2005)

The conceptual focus generated by the setting for the exhibition Talking Cities thus becomes a foundation for architectural and design practice that confronts the derelict, the abject and that which has lost its former meaning. The questions then asked by the Talking Cities protagonists regarding the specific urban and suburban conditions within which they operate are: how do we re-engage, reposition, re-ignite spaces that are undervalued, in transition, or at the margins of perception?

In his essay (page 27) Peter Lewis draws attention to Price's definition of cities as concentrates. In this respect, Talking Cities is also a concentrate, one of propositions, designs, and explorations. The dialogic (Mikhail Bakhtin, The Dialogic Imagination: Four Essays, ed. Michael Holquist, University of Texas Press 1975) proposes action on another scale: micro-topic interventions and itineraries create an overlay or plug-in that is both useful and affordable. The breakdown of industrial production requires not spectacle and awe of the monumental, the ruin, but action that draws upon the potential of individuation; the possibility of inscribing new realities upon outlived monuments, and reconfiguring them with another human/pragmatic scale. Hans Ulrich Obrist saw Cedric Price's agenda as creating a "Laboratory of delight, a university of the streets" (H.U. Obrist, lecture on Utopia Stations 2005) and it is with both the experimental and the educational in mind that Talking Cities creates a community of practitioners delighting in the state of transition.

Dispersed urbanity

"Doubt, delight and change" – Cedric Price's mantra – also becomes the basis for the collective statement within Talking Cities from artists, designers, architects and filmmakers – one which takes inspiration from a dispersed urbanity. "The architect ought to be an improvisor rather than someone who wants to rule" – declared Archigram's Peter Cook (Deutschlandschaft, ed. F. Ferguson, Hatje Cantz 2004) and it is design as customisation, tuning and plugging-in that unites the protagonists in a conversation on contemporary urban landscapes. Far removed from the grandiose mega-visions of the modernist movement, designers are increasingly acknowledging the need to review what such eras have left behind and to extract what is adaptable, "tunable" or re-usable from that which is declared to be redundant.

Talking Cities thus takes its inspiration, and develops its central themes, not only from the Zollverein site itself and the conceptual links it engenders, but also from the wider setting of the surrounding Ruhr area as emblematic of a contemporary condition: A dense scattering of towns and cities, the borders of which are – to the outsider – not self-evident. The agglomeration, the suburbanisation of the contemporary city becomes a main point of departure for current practice. These are urbanised and peripheral landscapes where industrial monument, housing estates, suburban allotments, business districts and shopping malls coalesce. The architectural historian Susanne Hauser refers to such territories as being "an-aesthetic" (page 42), meaning that we simply lack the language and the tools to perceive them, i.e. they lack classical imagery.

It is subjective itineraries that trace and analyse such "edge" landscapes. The politics of détournement, of derive, also come into play as a design method and a tool, a precursor to interventions and design. As soon as one embraces and defines the territories and landscapes that constitute our contemporary condition, the opportunities for a re-positioning of design culture within becomes real. The Italian architects IaN+ (page 62) and studio.eu (page 66) scour border zones and urban ring roads, proposing designs for urban voids – empty spaces walled in by buildings. This practice delights in a radical reversal of the mundane, the unplanned to manifest an alternative urban design strategy.

Design practice within the collective statement Talking Cities also represents a fundamental shift in scale. Taking as read the existing social and economic realities within their own urban context – defunct social housing projects at the cities" margins, brownfield sites, and undervalued public spaces – the interventions and temporary strategies implemented are micropolitical acts. Evidence of individuation, the freedom to adapt existing structures on a smaller-scale, is seen by the protagonists as a guarantee of freedom.

seines Fachs, der tief greifende Gedanken über die Vergangenheit anstellte. Sein berühmter Ansatz von 1964, das Areal einer Keramikfabrik in Staffordshire in einen „Thinkbelt" (Seite 16) zu verwandeln - eine Ausgangsebene für Bildung und Veränderung - „befasste sich mit dem dysfunktionalen Überfluss, dem Verfall, dem Verworfenen. Er transformierte das Ursprüngliche in ein Neues, indem er das Verfallene aufgriff und als Basis für seine neue Arbeit verwendete." (Rem Koolhaas, Vortrag im Palast der Republik, Berlin 2005)

Der konzeptuelle Schwerpunkt, der durch den Rahmen der Ausstellung Talking Cities gebildet wird, ist damit die Grundlage für eine architektonische und gestalterische Praxis, die dem Verfallenen, dem Verworfenen und dem, was seine frühere Bedeutung verloren hat, gegenübersteht. Die Protagonisten von Talking Cities stellen sich im Zusammenhang mit den spezifischen urbanen und suburbanen Bedingungen, unter denen sie agieren, folgende Frage: Wie schaffen wir es, unterbewertete Räume, Räume im Wandel oder solche am Rande der Wahrnehmung wieder einzubinden, neu zu positionieren und ihnen neues Leben einzuhauchen?

In seinem Essay (Seite 27) bezieht sich Peter Lewis auf Prices Definition von Städten als Konzentrate. So gesehen ist Talking Cities auch ein Konzentrat, ein Konzentrat aus Vorschlägen, Entwürfen und Untersuchungen. In der Dialogik (Mikhail Bakhtin, The Dialogic Imagination: Four Essays, Hrsg. Michael Holquist, University of Texas Press 1975) werden Maßnahmen in einem anderen Maßstab vorgeschlagen: mikrotopische Interventionen und subjektive Raumerkundungen kreieren eine Überlagerung oder eine Art Verbindung, die sowohl benutzbar als auch bezahlbar ist. Der Zusammenbruch der industriellen Produktion erfordert nicht Spektakel oder Ehrfurcht vor dem Denkmal und dem Verfall, sondern Maßnahmen, die sich auf das Potenzial zur Individualisierung stützen, auf die Möglichkeit, Denkmäler, die ausgedient haben, mit neuen Realitäten zu versehen und sie in einem anderen menschlichen/pragmatischen Maßstab neu zu gestalten. Laut Hans Ulrich Obrist war es Cedric Prices Vorstellung, ein „Labor der Freude", eine Universität der Straßen" zu schaffen (H.U. Obrist, Vortrag über „Utopia Stations" 2005) und mit Berücksichtigung sowohl des Experimentellen wie auch Aufklärerischen schafft Talking Cities eine Gesellschaft solcher, die den Zustand des Übergangs als Bereicherung empfinden.

Verstreute Urbanität

„Zweifel, Freude und Veränderung" - das Mantra von Cedric Price - wird zur Basis für die kollektive Aussage der Künstler, Designer, Architekten und Filmemacher von Talking Cities - einer Aussage, die von einer fragmentierten Urbanität inspiriert ist. „Der Architekt sollte eher jemand sein, der improvisiert, als jemand, der bestimmen möchte" - erklärte Peter Cook (Deutschlandschaft, Hrsg. F. Ferguson, Hatje Cantz 2004) und es ist das Design als individualisierte Anpassung, das „Tuning" und das Andocken, das die Protagonisten im Dialog

über zeitgenössische urbane Landschaften vereinigt. Weit entfernt von den hochstrebenden Megavisionen der modernistischen Bewegung halten es Designer zunehmend für notwendig, kritisch zu prüfen, was solche Epochen hinterlassen haben. Sie wollen aus dem für redundant Erklärten das herausziehen, was adaptierbar, verbesserungsfähig, verwendbar ist.

Bei Talking Cities zieht man also nicht nur Inspiration aus der Zeche Zollverein und den konzeptuellen Bezügen, die daraus entstehen, und entwickelt auf dieser Basis die Hauptthemen, sondern auch aus dem weiteren Kontext des Ruhrgebiets, das sinnbildlich für einen Zustand der Gegenwart steht: verstreute kleinere und größere Städte, dicht an dicht gereiht, deren Grenzen für den Außenstehenden nicht offensichtlich sind. Die Agglomeration und Suburbanisierung der Stadt der Gegenwart wird zum zentralen Ausgangspunkt für die aktuelle Praxis. Hierbei geht es um urbanisierte und periphere Landschaften, in denen Industriedenkmäler, Wohnsiedlungen, Kleingärten, Gewerbegebiete und Einkaufszentren miteinander verschmelzen. Die Kulturwissenschaftlerin Susanne Hauser bezeichnet solche Gebiete als „anästhetisch" (Seite 42) und meint damit, dass es uns einfach an der dafür notwendigen Sprache und den dazugehörigen Werkzeugen mangelt, um sie wahrzunehmen, d.h. die klassische Bildsprache fehlt.

Es sind die subjektiven Verläufe, die Stadterkundungen, die solche „Rand"-Landschaften verfolgen und analysieren. Die Politik des détournement, des „Umleitens" spielt auch eine Rolle als Gestaltungsmethode und Instrument, und zwar als eine Vorstufe der Intervention und der Gestaltung. Sobald man die Territorien und Landschaften, die unseren gegenwärtigen Zustand ausmachen, umfasst und definiert, werden die Möglichkeiten einer Neupositionierung der Gestaltungskultur darin zur Realität. Die italienischen Architekten IaN+ (Seite 62) und studio.eu (Seite 66) durchkämmen Grenzgebiete und städtische Umgehungsstraßen und schlagen Gestaltungsmöglichkeiten für urbane Leere vor - leere Plätze, die von Gebäuden ummauert sind. Diese Praxis erfreut sich einer radikalen Umkehr des Alltäglichen, des Ungeplanten, um eine alternative urbane Designstrategie zu manifestieren.

Die gestalterische Praxis in der kollektiven Aussage von Talking Cities repräsentiert auch einen grundlegenden Wechsel des gestalterischen Maßstabs. Die bestehenden gesellschaftlichen und wirtschaftlichen Realitäten werden in ihrem eigenen urbanen Kontext gedeutet - die ausgestorbenen Wohnsiedlungen am Rande der Stadt, die Industriebrachen und unterbewerteten öffentlichen Flächen -, die dort implementierten Interventionen und temporären Strategien sind mikropolitische Handlungen. Individualisierung und die Möglichkeit, existierende Strukturen einem kleineren Rahmen und für spezifische Nutzungen anzupassen, wird von den Protagonisten als eine Gewährleistung für die Freiheit angesehen.

[↑] Photo: Francesca Ferguson

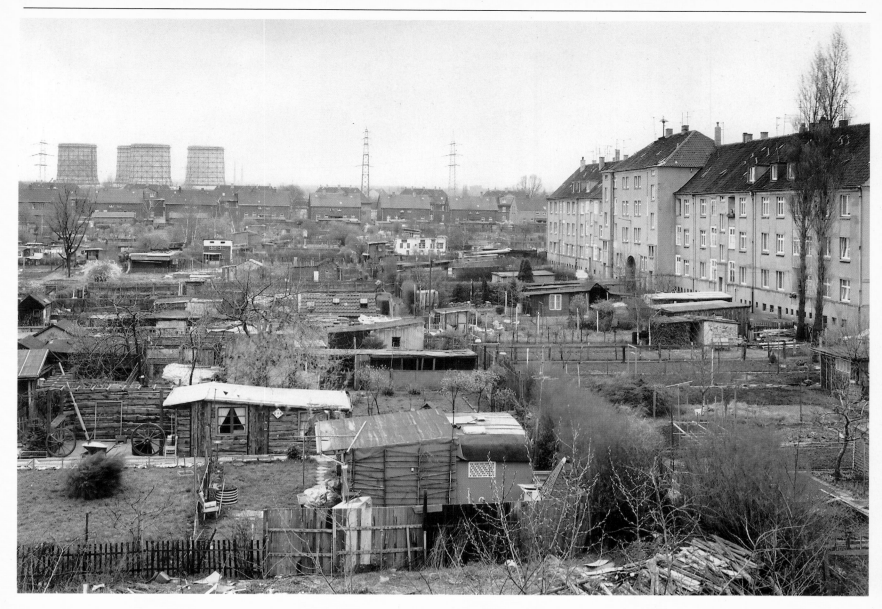

[↑] Essen-Altenessen 1977
Photo series "Cityscape and industrial landscape in the Ruhr area" / „Stadt- und Industrielandschaft im Ruhrgebiet", Photos: Joachim Schumacher

Restorative design – adaptive architecture

Restorative and adaptive planning strategies are necessary acts where the mega-visions of urban planning in the 1960s and 70s have outlived themselves. Contemporary architects often have little choice but to draw new potential from such obsolete programmes. Since a vast number of existing modernist buildings need to be fundamentally re-assessed, reprogrammed, and often saved from extinction, each micro-adaptation of the large-scale becomes, in the re-evaluation of modernism, a political statement. As a result, architects and designers are extolling the virtues of large-scale infrastructures that support individuated spatial uses: pluralities within what was originally conceived as mono-functional. It is the collective imaginary that is activated here – no wholesale dismissal of architectural eras predicated by drastic change, but instead a wry modesty in engaging with their leftovers.

Balkanisation is architecture – the informal vs. formal architecture

The breakdown of economies and political ideologies also forms the backdrop for this current pragmatism and for a wholly different reading of city spaces. Foucault's heterotopias – spaces of self-invention – are manifest within informal architecture, the self-built and the self-organised. The political fragmentation is traceable within the architecture of Eastern European cities, where Srdjan Jovanovic Weiss (page 125), an architect investigating illegal buildings and the plethora of "beautiful ugly" styles has co-opted the term "Balkanisation" for architecture. The artist Marjetica Potrč (page 124) also draws upon the positive connotations of political economies in dramatic transition by documenting informal architecture throughout Eastern Europe.

Within the "post-bubble" recession economy of Japan where space is highly contested, Atelier Bow Wow (page 130) discovered countless small-scale typologies and programmatic hybrids. Their "Pet Architecture" made in Tokyo, is a long-term documentation of da-me ("no-good") micro-architectures that – they maintain – uphold the legitimacy of individuation within the sea of generic commercial building. The ugliness, the "shamelessness" of hybridized structures has become a resource that impacts upon their own designs.

Restaurative Gestaltung – adaptive Architektur

Restaurative und adaptive Planungsstrategien sind dort als Maßnahmen erforderlich, wo die stadtplanerischen Megavisionen der 1960er und 70er Jahre ausgedient haben. Den zeitgenössischen Architekten bleibt oft nichts anderes übrig, als neues Potenzial aus solch überholten Programmen zu ziehen. Da eine enorme Anzahl existierender modernistischer Bauten grundlegend neu bewertet, neu programmiert und oft vor dem Abriss bewahrt werden muss, wird jede Mikroadaption des auf groß Angelegten in der Neubewertung des Modernismus zu einer politischen Aussage. Aus diesem Grund preisen Architekten und Designer die Vorzüge der groß angelegten Infrastruktur, die eine individuelle räumliche Nutzung unterstützt: Pluralitäten in dem, was ursprünglich als monofunktional begriffen wurde. Hier wird die kollektive Wahrnehmung angeregt - architektonische Epochen werden nicht einfach aufgrund drastischer Veränderungen aufgegeben, sondern es herrscht vielmehr eine pragmatische Bescheidenheit im Umgang mit ihren Überresten.

Balkanisierung ist Architektur – informelle vs. formelle Architektur

Der Zusammenbruch von Wirtschaftssystemen und politischen Ideologien bildet auch den Hintergrund für den aktuellen Pragmatismus und für eine gänzlich neue Deutung von städtischen Räumen. Die Heterotopien von Foucault, die Räume der Selbsterfindung waren, treten in der informellen Architektur, im Selbstgebauten und Selbstorganisierten zutage. Anhand der Architektur osteuropäischer Städte lässt sich die politische Zersplitterung nachvollziehen. Srdjan Jovanovic Weiss (Seite 125), ein Architekt, der illegale Gebäude und die Unmenge an „hässlich-schönen" Baustilen untersucht, hat hierfür den Begriff „Balkanisierung" für die Architektur neu belegt. Die Künstlerin Marjetica Potrč (Seite 124) bezieht sich auf die positiven Konnotationen in Volkswirtschaften, die einen dramatischen Wandel durchleben, indem sie die informelle Architektur von ganz Osteuropa dokumentiert.

Das Atelier Bow Wow hat im „rezessionsgeplagten Japan nach dem Zerplatzen der „bubble economy", wo Raum hart umkämpft ist (Seite 130), unzählige kleine Typologien und programmatische Hybride entdeckt. Ihre „Pet Architecture" („Haustier-Architektur") und „Made in Tokyo", sind Langzeitdokumentationen über Mikroarchitekturen des da-me (nicht guten) und hybride Strukturen, die - so ihre Behauptung - das Recht auf Individualisierung in einem Meer von gewöhnlichen kommerziellen Gebäuden be-

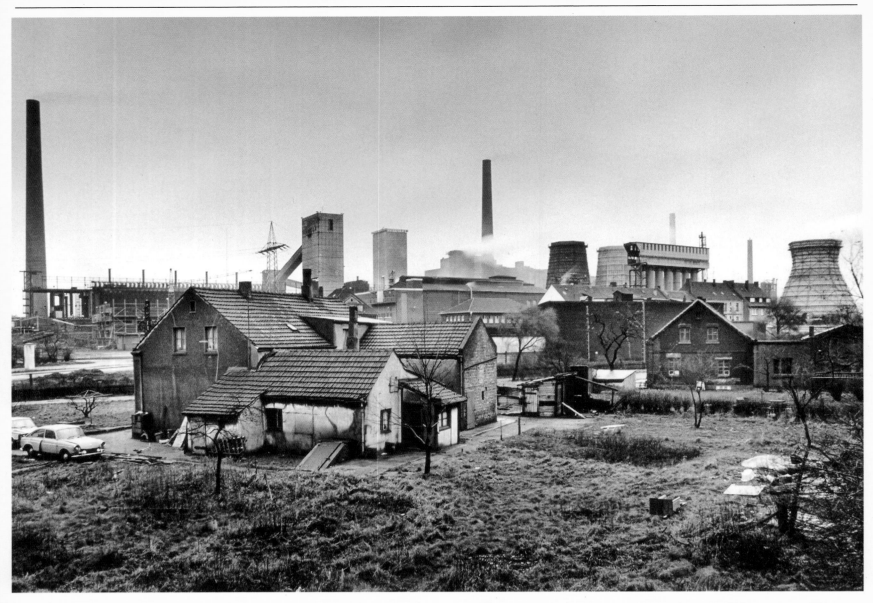

The present generation of itinerant architecture; short-term; adaptable; viral even, which resolutely resists the generic solution has therefore established a foothold in quite a different economic reality. The emphasis upon self-sufficiency, low-cost materiality and that of carving out one's own human scale utopian project is, as the architectural critic Simon Sadler notes, "the most radical sub-species of building: it is restorative, stitching together spaces torn by insensitive projects, and planting seeds of occupation in land left as waste" (page 161). This hands-on tactical design, such as the buildings nailed together from recycled material that the architect/artist partnership Folke Köbberling and Martin Kaltwasser (page 122) build up overnight on the fringes of urban housing projects, takes its cue from the survival strategies of subsistence economies. N55 (page 148) combine modular design and light-weight industrial materials with a message on pragmatic, workable utopias: "Our work is about suggesting ways to exist within as small a concentration of power as possible."

Such micro-topian actions and designs have often evolved from a frustration with the apathy that increasingly sophisticated economies of late capitalism have induced in the citizen-as-consumer. With their viral landscapes made of layer upon layer of stickers and tape that they call "tagged environments" El Ultimo Grito (page 178) appropriate and rearrange fragments of the city. Interestingly, Cedric Price's provocative "Non-Plan" of 1969 is also given expression here with minimal means in such design strategies: see too the viral wooden architecture of Interbreeding Field (page 153) from Taiwan, constructed *ad hoc* in various locations as an "interfering laboratory" re-establishes the necessity of play and the layering of space to generate dialogue and shift perceptions.

The micropolitical strategies of design and architecture proposed and realised by the Talking Cities protagonists define the need for a new politics of place. This is the architect and designer as social mediator, and agency as a design imperative. This practice of architectural planning "redirected", as Simon Sadler puts it, "to liminal spaces and materials" becomes a source for a type of knowledge. For Talking Cities this knowledge fuels a collective desire to regenerate, recycle and re-engage the contested spaces of the contemporary city.

stätigt. Die Hässlichkeit, die „Unverschämtheit" solcher Alltagsarchitektur ist zu einer Ressource geworden, die Auswirkungen auf ihre eigenen Entwürfe hat.

Die aktuelle Generation der mobilen Architekturen: befristet; adaptierbar; sogar viral, die sich gewöhnlichen Lösungen entschlossen widersetzt, hat daher in einer gänzlich anderen wirtschaftlichen Realität Fuß gefasst. Die Betonung auf Autarkie, kostengünstigen Materialien und darauf, sich im eigenen Rahmen das utopische Projekt zu schaffen, steht, wie der Architekturkritiker Simon Sadler anmerkt, für „die radikalste Untergruppe des Bauens: sie ist restaurativ, flickt Räume zusammen, die durch unsensible Projekte auseinander gerissen wurden und sät Samen des Bewohntseins auf brachliegendem Land" (Seite 161). Diese spielerische Form der taktischen Gestaltung, wie man sie bei den zusammengenagelten Gebäuden aus Recyclingmaterial der Architekten-/Künstlerpartnerschaft Folke Köbberling und Martin Kaltwasser findet (Seite 122), die sie über Nacht am Rande städtischer Wohnprojekte aufgebaut haben, erhält Impulse durch die Überlebensstrategien der Subsistenzwirtschaft. N55 (Seite 148) verbinden modulares Design und industrielle Leichtbaustoffe mit einer Botschaft über pragmatische, machbare Utopien: „Mit unserer Arbeit wollen wir Wege aufzeigen, wie

man in einer geringstmöglichen Machtkonzentration leben kann."

Solche Formen des mikrotopischen Handelns und Gestaltens entstehen oft aus der Frustration über die Apathie, die die immer weiter entwickelten Wirtschaftssysteme des Spätkapitalismus im Bürger-als-Verbraucher bewirkt haben.

Mit ihren viralen Landschaften, die aus unzähligen Schichten aus Aufklebern und Klebestreifen bestehen und von ihnen „tagged environments" genannt werden, eignen sich El Ultimo Grito (Seite 178) städtische Fragmente und Restmaterialien an und arrangieren sie neu. Interessanterweise wird durch solche Gestaltungsstrategien auch dem provokativen „Non-Plan" von Cedric Price von 1969 mit minimalen Mitteln Ausdruck verliehen: siehe hierzu auch die Holzarchitektur-Interventionen von Interbreeding Field (Seite 153) aus Taiwan. Sie wird ad hoc an verschiedenen Standorten als „interferierendes Labor" aufgebaut und begründet aufs Neue, warum das Spiel mit und die Schichtung von Raum notwendig ist, um ihn dialoghaft zu gestalten und Wahrnehmungen zu verschieben.

Die mikropolitischen Strategien in Design und Architektur, die von den Protagonisten von Talking Cities vorgeschlagen und realisiert werden, umreißen die Not-

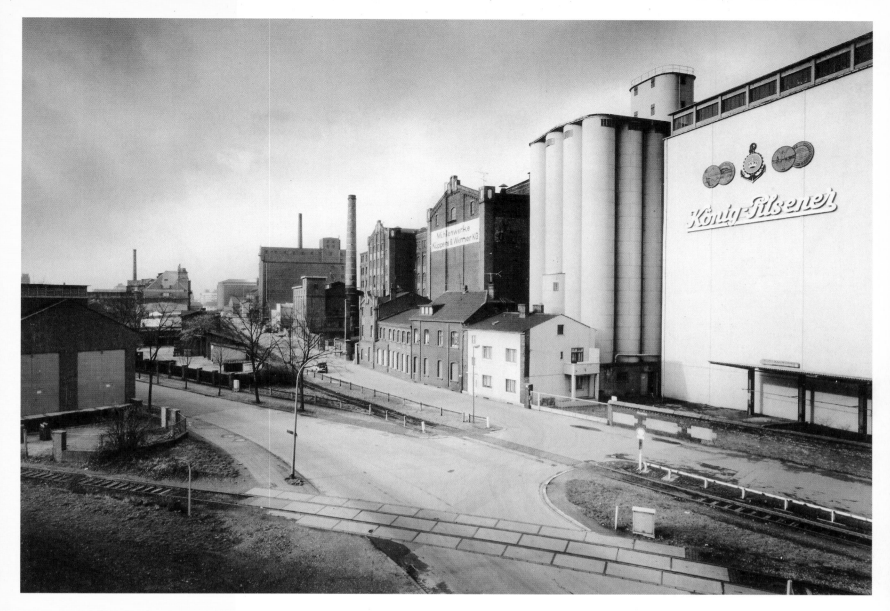

[↖] Oberhausen-Osterfeld, Zeche Osterfeld 1976
[↑] Duisburg Innenhafen 1977, photos: Joachim Schuhmacher

"Dialogue might be the only excuse for architecture ... Creating a continuous dialogue with each other is very interesting. It might be the only reason for architecture – that's the point!" Cedric Price, 2000

„Dialog könnte die einzige Rechtfertigung für die Architektur sein ... einen kontinuierlichen Dialog miteinander herzustellen ist sehr interessant. Es könnte der einzige Grund für Architektur sein – das ist der Punkt!"

wendigkeit für eine neue Politik des Ortes. Hierbei fungieren Architekten und Designer als gesellschaftliche Vermittler und Vermittlung wird zu einer gestalterischen Notwendigkeit. Diese Praxis der architektonischen Planung, die, wie Simon Sadler es ausdrückt, „neu ausgerichtet wird auf Schwellenräume und -materialien" wird zur Quelle für eine bestimmte Art des Wissens. Für Talking Cities schafft dieses Wissen den kollektiven Wunsch, die umstrittenen Räume der zeitgenössischen Stadt neu zu gestalten, wiederzuverwerten und neu zu belegen.

[↑] Duisburg-Bruckhausen 1980, photo: Joachim Schuhmacher

[↗] "Spreepark Plänterwald", derelict amusement park / *Verlassener Vergnügungspark*, Berlin-Treptow 2001, photo: Torsten Seidel

The Evacuated Field

Das evakuierte Feld Peter Lewis is Research Fellow at Leeds Metropolitan University in Curating, Art and Design, Independent Curator at Kunstverein, Bregenz, Austria and Director of Redux, Artists' Space, London. In this essay, especially commissioned for Talking Cities, he takes us on a roller-coaster ride through Cedric Price's "Fun Palace", beyond utopia, unrest and the derelict to the un-planned world of the exhibition in the ex-industrial space. Peter Lewis ist Research Fellow an der Leeds Metropolitan University im Fachbereich Curating, Art and Design, freier Kurator für den Kunstverein in Bregenz (Österreich) sowie Direktor von Redux, Artists' Space in London. Im folgenden eigens für Talking Cities verfassten Essay nimmt Peter Lewis uns mit auf eine Achterbahnfahrt durch Cedric Prices „Fun Palace", einem Ort jenseits der Utopien, der Unruhe und des Verfallenen, in die außerplanmäßige Welt der Ausstellung im ehemals industriellen Raum.

Entry

These notes propose an intersection of spatial and conceptual interventions, architectures and artworks. They are based on an idea that if "something is missing", it is also possible that "something leftover" resides in the lack. We find this paradox best exemplified in certain "unbuilt" peripheries of the city, where discreet, heterotopic spaces resist easy entry and identification. By heterotopic we mean to incite the desire of secret places, or open a new space of invention. Often small in scale, these spaces act as counter-sites to effect, enact and embed an imaginary "utopian" form in liveable, innovatory ways. They bring together a sort of mixed, joint experience in which the real sites within a culture are simulta-

Entry

In den folgenden Bemerkungen wird eine Überschneidung räumlicher und konzeptioneller Eingriffe sowie von Architekturen und Kunstwerken vorgeschlagen. Grundlegend ist dabei der Gedanke: Wenn „etwas fehlt", so kann es auch möglich sein, dass sich „etwas übrig Gebliebenes" im Fehlenden befindet. Dieses Paradox zeigt sich uns am ehesten in den „unbebauten" Peripherien einer Stadt. Denn genau dort verweigern sich die heterotopen, diskreten Räume und Flächen oft dem leichten Zugang und der eindeutigen Identifizierung. Mit dem Begriff „heterotop" soll eine Sehnsucht nach geheimen Orten geweckt oder neuer Raum für Erfindung eröffnet werden. Solche häufig kleinen Räume erzeugen als „Gegen-Orte" eine imaginäre „utopische" Form, inszenieren diese und betten sie in lebenswerte,

neously represented, contested and inverted, as in an anamorphic (distorted) lens or mirror.

The museum, in an arcane sense, had occupied such a space of invention for the *flaneur*; someone free to discover secrets and pleasures in the "entry ritual", as mythic passage through labyrinths and archives. The erotic encounter

Do the arcadia of traditional museum displays have anything more to give us?

with mysteries illuminated in tableaux, fables, and panoramas were mechanisms that enabled subjective points of view, to think an "inexistence" in the fetish as art-object. However we ask the question, do the arcadia of traditional museum displays and their contents have anything more to give us? Are they not antagonisms to radical change?

Cedric Price's "Fun Palace", as part of the movement proposing visionary "megastructural" architectures in the 1950s and 60s, was indicative of an organic re-thinking of the so-called "unity" of culture, nation, and social space, reassembled as an ingenious form of differences. Society is better seen as a "wobbly" architectural system, or a disassembly of technologies, virtualities, and spatial-temporal differences that complement yet cheekily contradict both the conditions of politics and the assumptions of what it does to antagonise subjectivity. Poetics, psychology, memory, science and love are all to be

Architecture becomes a subversion, an alert to "something missing".

assailed and realigned within a full complement of architectural and technological manifestations. As ruin, dream *and* monument, the "universal" is invoked only to be made local, regional, historical and particular, not the other way round. Price used the word "dereliction" very specifically here to indicate the "real" dimension of the derelict as both a person *and* a building sharing latent energy. He wrote:

"You were just a human being, you might be an intellectual derelict, and a social derelict ... In fact the word derelict has become more pejorative. Dereliction wasn't good or bad, it just was what it was." (*from Interview with Hans Ulrich-Obrist, Re:CP, by Cedric Price*)

Price was a destroyer of norms, stimulating the "fuzzy" logic of real, everyday life. His paper architectures characterise the resistance of an "anti-architecture" in line with its counterpart, an "anti-inhumanism", to form a new common ground founded upon the crisis of modern thought. Architecture shares the same taboos, rituals and, like it or not, wars, complicit as the rest of the "concentrate". (Price renamed

cities "concentrates". Re:CP) This is a spatial realm implied in Levi-Strauss' early, and nostalgic, anthropological observations of so-called "primitive" societies. These concentrates enable the civic subject visionary expression – Price's individual "consumers" of architecture would be able to participate in all manners of cultural transformation through the new provisional spaces of dialogue, for emerging collective and individual subjectivities. His "talking about utopia is a criminal act" of 40 years ago, seems more communicable today, in its implicit paradox of being both sincere, and a joke.

Out of late, late modernity something of Price's idea is addressed in Talking Cities, echoing the trauma of the post-war period when flowers grew literally out of the city's sites of

Price's "Non-Plan" is a subversion played amid the phantasmic ruins of knowledge.

dereliction. Unobserved in a time of optimism, the "inhuman" progression of techno-science erased social cooperation and community. Architecture becomes in parallel, a subversion, an alert to "something missing". It activates "something leftover" able to sustain and respond to these ever growing uncertain circumstances and dangers.

Price's "Non-Plan" is a subversion of the architect's "plan" played amid the phantasmic ruins of knowledge. Value

innovative Weisen ein. Sie erzeugen eine Art vermischtes, verbindendes Erlebnis: Reale Orte einer Kultur werden zugleich repräsentiert, in Frage gestellt und invertiert, wie durch eine formverzerrende Linse oder einen Zerrspiegel.

Das Museum war für den Flaneur insgeheim immer schon dieser Raum der Erfindung. Im „Eintrittsritual" - als mythische Passage durch Labyrinthe und Archive - ist der Flaneur offen für Geheimnisse und die Freuden der Entdeckung. Erotische Begegnungen mit Mysterien, festgehalten in Tableaus, Fabeln und Panoramen, waren Mechanismen, die subjektive Sichtweisen hervorriefen, um eine „Nicht-Existenz" im Fetisch als Kunstobjekt zu denken. Doch sollten wir uns fragen: Hat das Arkadien des traditionellen Museums mit seinen Präsentationen und Inhalten uns nicht mehr zu bieten? Oder widersetzen nicht gerade sie sich dem radikalen Wandel?

Cedric Prices „Fun Palace" ging es - als Teil einer in den 1950er und 60er Jahren propagierten Architektur der visionären „Megastrukturen" - um ein organisches Umdenken der so genannten „Einheit" von Kultur, Nation und sozialem Raum, die vielmehr in einem raffinierten System von Differenzen neu miteinander zu verbinden seien. Die Gesellschaft ist eher als „wackeliges" architektonisches System, als ungeordnetes System von Technologien, Virtualitäten, raum-zeitlichen Differenzen zu sehen. Diese ergänzen und widersprechen zugleich dreist den Bedingungen des Politischen und den Annahmen darüber, wie Politik Subjektivität bekämpft. Poesie, Psychologie, Gedächtnis und Erinnerung, Wissenschaft und Liebe werden angegriffen, um

sogleich wieder zusammengeführt zu werden in einem Gegenentwurf architektonischer und technologischer Manifestationen. Als Ruine, Traum und Monument wird das „Universelle" beschworen, um es im nächsten Schritt als lokal, regional, historisch und vereinzelt zu sehen - und nicht umgekehrt. Price verwendet den Begriff „dereliction" hier sehr spezifisch (das Wort „derelict" mag sich auf ein Gebäude - eine Brache, ein verfallenes Haus - beziehen, oder auf eine Person, einen Verwahrlosten), um auf die „reale" Dimension hinzuweisen, dass Person und Gebäude sich latente Energie teilen. Price schrieb:

„Du warst schlicht ein menschliches Wesen, du könntest ein intellektuelles ‚derelict' gewesen sein oder auch gesellschaftlich ‚derelict' ... Tatsächlich wurde die Bedeutung des Wortes ‚derelict' mit der Zeit immer abwertender. ‚Dereliction' war weder gut noch schlecht, sondern es war einfach das, was es war." (aus dem Interview mit Hans Ulrich-Obrist, Re:CP, von Cedric Price)

Price zerstörte Normen und folgte den Fuzzy-Logik-Prinzipien des Alltags. Seine auf Papier festgehaltenen Architekturentwürfe charakterisieren den Widerstand einer „Anti-Architektur" und ihres Pendants, dem „Anti-Inhumanismus"; sie finden eine neue Gemeinsamkeit in der Krise des modernen Denkens. Architektur benutzt Tabus, inszeniert Rituale und - ob man will oder nicht - führt die gleichen Kriege wie alle anderen Konzentrate auch. (Price nannte Städte „Konzentrate", Re:CP). Ein Raumaspekt, der in Levi-Strauss' frühen, und nostalgischen, anthropologischen Beobachtungen so genannter „primitiver Völker"

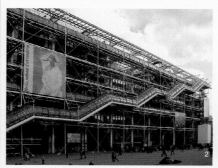

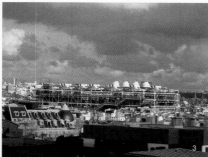

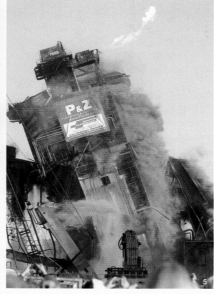

was no longer embodied in time honoured skill or craft. Globalisation was, however, not total. On the contrary, Price saw the possibilities for subversion as being increased, vitalised through a certain crisis or exhaustion, most critically via the circulation of commodities, including architectures, in order to be consumed. This exhaustion, which itself re-invigorates the imaginary, was anticipated by Price as operative on many as yet unthought-of levels, literally and metaphorically transforming redundancy into carnival, as a subversive, and collective pleasure. Price's work resided in architectures of utopia manifesting culture, as standing at a metaphysical and political crossroads.

"What do we have architecture for?" he asked. "It's a way of imposing order or establishing a belief, and that's the cause of religion to some extent. Architecture doesn't need those roles anymore; it doesn't need mental imperialism; it's too slow, it's too heavy, and, anyhow, I, as an architect don't want to be involved in creating law and order through fear and misery." (Re:CP)

The moment at which the problem of human society is posed is done so in completely new terms. However by re-inspiring the *Arche* as the unrealised dream of community, we risk an ontological leap. From the anamorphic perspective of the present, the megastructure's characteristic permissiveness and ideal "promise" of adaptability and internal transience is fizzling out at the end of the 20th Century, over-ridden by excessive ratio-science and political controls.

"The mechanism of hope is linked to that of realism. Once the proletarian social subject has greatly increased its penetration of the real, then we know that the revolution is possible. Utopia is thus accompanied by the certainty that reality is oppressive though under control. Let us call this situation 'dystopia'. This means that we have reached the threshold of victory and that the causes which inspire us are irresistible." (from *The Politics of Subversion, A Manifesto for the 21st Century* by Antonio Negri)

Negri's view coincides with Price's "Non-Plan" in that it has contempt for planned architectures. *Non-Plan: An Experiment in Freedom* published 1969, a year after the Paris protests, argued that the grand constructions of Modernism exacerbated the social problems they attempted to resolve. Planning infers failure as the co-dependency of a over-simplified architecture hiding in a field of "participations".

Index

Price's drawings both celebrate and are dismissive of a future based on the energy of science as a phantasmal perception of life. By engaging theatrical devices, rhetoric and hyperbole as material formed from the "everyday", he argues for greater freedom by ameliorating rather than over-turning existing social conditions. The cultural theorist Theodor Adorno had written: "It seems to me that what people have lost subjectively in regard to consciousness is very simply the capability to imagine

impliziert ist. Diese „Konzentrate" ermöglichen den visionären Ausdruck des bürgerlichen Subjekts: Prices individuelle „Konsumenten" der Architektur können an unterschiedlichsten kulturellen Transformationen partizipieren, nämlich durch die neuen provisorischen Räume des Dialogs, die kollektive wie individuelle Subjektivitäten hervorbringen. Prices Diktum von vor vierzig Jahren – „über Utopie zu sprechen, ist ein Verbrechen" – scheint heute einfacher kommunizierbar zu sein, da es ein Paradox impliziert und gleichzeitig ernst gemeint wie auch als Spaß zu verstehen ist.

Aus einer späten Moderne heraus klingt auch in Talking Cities etwas von Prices Idee an, wie ein Echo aus der traumatischen Nachkriegszeit, als die Blumen buchstäblich aus dem Verfallenen der Städte herauswuchsen. In Zeiten des Optimismus wird verkannt, dass der „inhumane" Fortschritt von Technik und Wissenschaft soziale Kooperation und Gemeinschaftssinn vernichtet. Parallel dazu wird die Architektur zur Subversion, zur Warnung, dass „etwas fehlt". Sie aktiviert das „übrig Gebliebene", das den stets zunehmenden Unsicherheiten und Gefahren standhalten und auf diese reagieren kann.

Prices „Non-Plan" ist eine Subversion des Architekten-„Plans", der sich in trügerischen Ruinen des Wissens entwickelt. Wert war in altbewährtem Handwerk und Geschick nicht mehr vorhanden. Die Globalisierung jedoch war nicht total. Vielmehr sah Price die vermehrten Möglichkeiten der Subversion und zwar belebt durch eine Krise oder Erschöpfung und besonders verstärkt durch den Austausch von zum Konsum bestimmten Waren, auch von Architekturen.

Price sah voraus, dass diese Erschöpfung, die dem Imaginären neue Kraft gibt, auf vielen noch unvermuteten Ebenen wirken würde, dass sie im buchstäblichen wie auch metaphorischen Sinn Redundanz in einen Karneval verwandelt, der ein ebenso subversives wie auch kollektives Vergnügen ist. Prices Arbeiten spiegelten sich in Architekturutopien wider und manifestierte Kultur, als ob sie an einem metaphysischen und politischen Scheideweg stünde.

„Warum gibt es Architektur?", fragte er. „Sie stellt eine Ordnung her oder begründet einen Glauben, und das ist ja gewissermaßen die Ursache der Religion. Doch die Architektur braucht diese Rolle nicht mehr. Sie kommt ohne geistigen Imperialismus aus. Sie ist zu langsam, zu behäbig, und außerdem habe ich als Architekt kein Interesse, ,law and order' durch Angst und Trübsal herzustellen." (Re:CP)

Stellt man nun die Frage nach der menschlichen Gesellschaft, erscheint sie in ganz neuem Licht. Doch wird der Arche als nie verwirklichter Traum von menschlicher Gemeinschaft neuer Geist eingehaucht, riskieren wir einen ontologischen Sprung. Von der verzerrten Perspektive der Gegenwart aus betrachtet, laufen sich die allzu großzügige Nachgiebigkeit und das ideale „Versprechen" von Anpassungsfähigkeit und grundlegender Vergänglichkeit, die die „Megastruktur" ausmachen, am Ende des 20. Jahrhunderts tot, werden sie doch übertrumpft von den maßlosen, rationalen Wissenschaften und politischer Überwachung.

„Der Mechanismus der Hoffnung ist mit dem des Realismus verknüpft. Sobald das proletarische soziale Subjekt die Wirklichkeit weit durchdrungen hat, wissen wir, dass die Revolution möglich ist. Utopie wird daher von der Gewissheit begleitet, dass die Wirklichkeit zwar unterdrückt, aber doch unter Kontrolle ist. Diese Situation kann man als ,Dystopie' bezeichnen. Dies bedeutet, dass wir an der Schwelle zum Sieg stehen und dass die uns inspirierenden Ursachen unwiderstehlich sind." (aus: „The Politics of Subversion, A Manifesto for the 21st Century" von Antonio Negri)

Negris Anschauung stimmt hier mit Prices „Non-Plan" in seiner Geringschätzung für geplante Architektur überein. In „Non-Plan: An Experiment in Freedom" (erschienen 1969, ein Jahr nach den Pariser Studentenunruhen) argumentiert Price, dass die modernistischen Bauten die sozialen Probleme, die sie zu lösen versuchten, nur weiter verschärften. Planung impliziert Versagen in Gestalt einer Mitabhängigkeit einer zu sehr vereinfachten Architektur, die im Diskursfeld von „Partizipationen" untertaucht.

Index

Prices Zeichnungen zelebrieren und verwerfen zugleich eine Zukunft, die auf der Energie der Wissenschaften als einer trügerischen Wahrnehmung des Lebens beruht. Durch die Anwendung von theatralischen Mitteln, Rhetorik und Übertreibung als vom „Alltag" geformte Materialien argumentierte er für mehr Freiheit, die durch Verbesserungen und nicht durch Umsturz sozialer Bedingungen herbeizuführen sei.

the totality as something that could be completely different."

It would be too easy in the over-heated climate of post modernity to dismiss his cool remarks. Seen from another anamorphic view, our time of technology has already changed our

Our time of technology has already changed our destiny permanently.

destiny permanently: in ecological terms, as atmosphere – we breathe it – and internally, as an invasive technology of the body. We need it.

Both Price's "Generator", written as a menu for the delight of "consumers" of architecture, and "Fun Palace", conceived with theatre designer Joan Littlewood, were projects where individuals were never to be fully enclosed by a technological aesthetic. The pluralities exposed in Talking Cities also denote a wariness of museographic intersections (curating architecture as a series of fixed destinations along linear routes of interpretation) that frame the polyphony of micro-cultures from single point perspectives. Art and Architecture are simultaneously object and instrument, not to be occluded as the meta-language of the museum. Price's importance therefore is in exposing a question: what is "praxis", if individuals are attentive to ambivalences buried under a "unifying" principle joining the terms "museum" and "architecture"?

In the remainders (the "suburbs"), viewed from thousands of overlooked, happy "non-places", the internalised city of signs expires. Waste culture expends enormous energy to generate tiny mass, in the milieu of pure excess and zero censure. At one time Price proposed leaving an architectural site as an empty space, rather than build anything on it, in order to occupy the "interval" of time and space in purely existing terms of its "waste".

And utopia ... nowhere to go but everywhere

The Modernist ideal (progress, freedom, rationality and revolutionary practice) intersects with a new "clean" paradigm of modernity in a state of disrepair. To put the reluctant, now old, "radical" gesture of Price to use today we work with what is "at hand". As the actors of social change, we discover in the regenerative work of participants in Talking Cities a delight in perceiving the future in terms of distorted reflections. The joke in presenting "This is Tomorrow" today (science-fiction ceases to exist since it is already well lodged in time) is redirected as the task of engineering the museum's platform on a par with the "outside" world. No easy job.

The museum, once central to the Enlightenment, constructed as a "container" or "conduit" for a totalising (European) empire, is now designed to generate disunity: multi-forms, anti-

archives, intervals, in a parody of the art historian's grammar of metonym, synecdoche and index. Nor is it to be "made up" like the story of Utopia. Rather, it is realistic, all mixed up. The Real of its architecture might be better envisaged and communicated as an "ideal" impurity, as the secondary formalisation of the advent of a hitherto formless form, an evacuated field.

A true dwelling place for thinking "art" and "architecture" can be imagined, as Price did, as an "interstitial" space. Utopian pragmatism enters consciousness as an "evacuated field" moving and locating the finite possibilities of impossible realms, at the cross roads between the Real and Ideal.

The idea of putting together artists and architects to create a space for Talking Cities brings into sensual form the playfulness of Cedric Price's paper architectures never or not to be built. A complex of surfaces and linear convolutions that, without converging on a destination, stage the new dramaturgy of the museum as a "porous" material.

The museum is now designed to generate disunity.

It becomes evident as the project develops that the models of new museum and new architecture overlap only where there is mutual individuation.

Talking Cities produces a multi-layered space in which different events and moments of aggregation, production and discussion can be developed. It places events, workshops, projects and discussions on the same plane. The arguments for a new discourse of space are questioned here. How open a system and individuated an architecture do they *really* present? Alain Badiou, from his "15 theses on Contemporary Art" can be cited in this respect:

"Thesis 13: Today art can only be made from the starting point of that which, as far as Empire is concerned, doesn't exist. Through its abstraction, art renders this in-existence visible. This is what governs the formal principle of every art: the effort to render visible to everyone that which, for Empire (and so by extension for everyone, though from a different point of view), doesn't exist."

Der Kulturtheoretiker Theodor W. Adorno schrieb dazu: „Es scheint mir, dass das, was Menschen subjektiv in Bezug zum Bewusstsein verloren haben, ganz einfach die Fähigkeit ist, die Totalität als etwas vorzustellen, das vollständig anders ist."

Diese kühlen Bemerkungen in dem aufgeladenen Klima der Postmoderne abzulehnen wäre zu einfach. Von einer weiteren verzerrten Perspektive aus betrachtet, hat sich unser Schicksal durch das technologische Zeitalter bereits dauerhaft verändert: Ökologisch formuliert, atmen wir es als Atmosphäre ein und in unseren Körpern ist es als invasive Technologie präsent. Wir können nicht mehr darauf verzichten.

Sowohl Prices „Generator", geschrieben als Gebrauchsanweisung zur Freude der „Konsumenten" von Architektur als auch sein gemeinsam mit der Bühnenbildnerin Joan Littlewood entworfener „Fun Palace" waren Projekte, die Menschen niemals vollständig in eine technologische Ästhetik einhüllen sollten. Die sich in Talking Cities offenbarenden Pluralitäten weisen auch auf eine Vorsicht gegenüber museografischen Überschneidungen hin (bei denen Architektur als eine Reihe feststehender Ziele entlang linearer Interpretationswege kuratiert wird), die die Polyphonie von Mikrokulturen innerhalb von Ein-Punkt-Perspektiven einordnen. Kunst und Architektur sind Objekt und Instrument zugleich und sollten nicht als die Meta-Sprache des Museums gelten. Prices Bedeutung ergibt sich aus folgender Frage: Was ist „Praxis", wenn Individuen auf Ambivalenzen aufmerksam werden, die von einem die Begriffe „Museum" und „Architektur" verbindenden „vereinheitlichenden" Prinzip überdeckt werden?

In den Überresten (den „Vorstädten") ist von Tausenden unbeachteten, glücklichen „Nicht-Orten" aus zu beobachten, wie die internalisierte Stadt der Zeichen verfällt. Die Wegwerfgesellschaft verbraucht – in einem Milieu des puren Exzesses und der Null-Kritik – ungeheuer viel Energie zur Erzeugung geringer Masse. Price schlug einmal vor, ein Baugrundstück leer stehen zu lassen statt es zu bebauen, um das „Intervall" von Zeit und Raum allein mit seiner „Ungenutztheit" als Brache (waste) zu besetzen.

Und Utopie ... wir können nirgendwo anders hin als überall hin

Das modernistische Ideal (Fortschritt, Freiheit, Rationalität, revolutionäre Praxis) überschneidet sich mit einem neuen „sauberen" Paradigma der Moderne im Zustand ihres Verfalls. Heutzutage wiederholen wir Cedric Prices zögerliche, nun nicht mehr neue, „radikale" Geste, indem wir mit dem arbeiten, was „zur Hand" ist. Als Akteure sozialer Veränderung entdecken wir in der regenerativen Arbeit der Talking Cities-Teilnehmer eine Freude an der Wahrnehmung der Zukunft im Spiegel verzerrter Reflektionen. Der Witz, heute bereits „Das ist die Zukunft" zu proklamieren (Science-Fiction existiert nicht mehr, da sie bereits in der Jetztzeit verwurzelt ist), wandelt sich nun in die Aufgabe, die Plattform des Museums so zu gestalten, dass sie auf einer Stufe mit der „Außenwelt" steht. Keine leichte Aufgabe.

Das Museum war im Zeitalter der Aufklärung von zentraler Bedeutung und hatte als „Behälter" oder „Leitung" eine totalisierende Aufgabe im (europäischen) Imperium; heute soll es in einer Parodie auf die Grammatik des Kunsthistorikers mit ihren Metonymien, Synekdochen und Indices vielmehr „Un-Einheit" erzeugen: Vielförmigkeit, Anti-Archive, Intervalle. Auch soll das Museum nicht frei erfunden werden wie die Geschichte der Utopie. Vielmehr ist es realistisch, alles ist durcheinander geraten. Das Reale seiner Architektur sollte besser als „ideale" Unreinheit vorgestellt und kommuniziert werden als die sekundäre Formalisierung der Ankündigung einer bisher formlosen Form, als evakuiertes Feld.

Der wahre Verweilort, von dem aus „Kunst" und „Architektur" denkbar sind, kann, wie Price es tat, als ein „Zwischenraum" vorgestellt werden. Der utopische Pragmatismus rückt als ein „evakuiertes Feld" ins Bewusstsein, das die endlichen Möglichkeiten unmöglicher Sphären – am Scheideweg zwischen dem Realen und Idealen – bewegt und verortet.

Die Idee, Künstler und Architekten zusammenzubringen, um einen Raum für Talking Cities zu schaffen, führt die spielerische Qualität Cedric Prices Architektur greifbar vor Augen, die nur zu Papier gebracht, aber nie gebaut wurde beziehungsweise nie gebaut werden sollte: Ein Komplex von Flächen und linearen Windungen, die – ohne sich in einem Zielpunkt zu treffen – die neue Dramaturgie des Museums als „poröses" Material inszenieren. Je weiter sich das Projekt entwickelt, desto klarer wird, dass das Modell des neuen Museums und das der neuen Architektur nur dort überlappen, wo beide sich wechselseitig individuieren.

Talking Cities lässt einen mehrschichtigen Raum entstehen, in dem verschiedene Ereignisse und Momente der Verdichtung, Produktion und Diskussion entwickelt werden können. Veranstaltungen, Workshops, Projekte und Diskussionen stehen ebenbürtig nebeneinander. Es werden hier die Argumente für einen neuen Raumdiskurs zur Diskussion gestellt. Wie offen und individualisiert ist die Architektur wirklich, die sie vertreten? In diesem Zusammenhang kann man aus Alain Badious „15 Thesen zur zeitgenössischen Kunst" zitieren:

„These 13: Kunst kann heute nur das als Ausgangspunkt haben, das – soweit das „Empire" betroffen ist – nicht existiert. Durch Abstraktion macht die Kunst dieses Nicht-Existente sichtbar. Dies bestimmt das formale Prinzip jeder Kunst: Das Bemühen, das sichtbar zu machen, das für das „Empire" (und im weitesten Sinne für jeden, doch immer aus unterschiedlichen Blickwinkeln) nicht existiert."

"Perhaps these areas can be hyped in some way: mansard flat in Paris; houseboat in Amsterdam; loft in New York and a little birch wood on a coal infill – perhaps even a hillside plot on the spoil heaps of the Ruhr area." Stefanie Bremmer, Land for Free

„Vielleicht lässt sich auch etwas wie ein Hype um diese Flächen entwickeln: Mansardenwohnung in Paris, Hausboot in Amsterdam, Loft in New York und Birkenwäldchen auf Kohleboden, womöglich noch Hanglage auf der Halde im Ruhrgebiet."

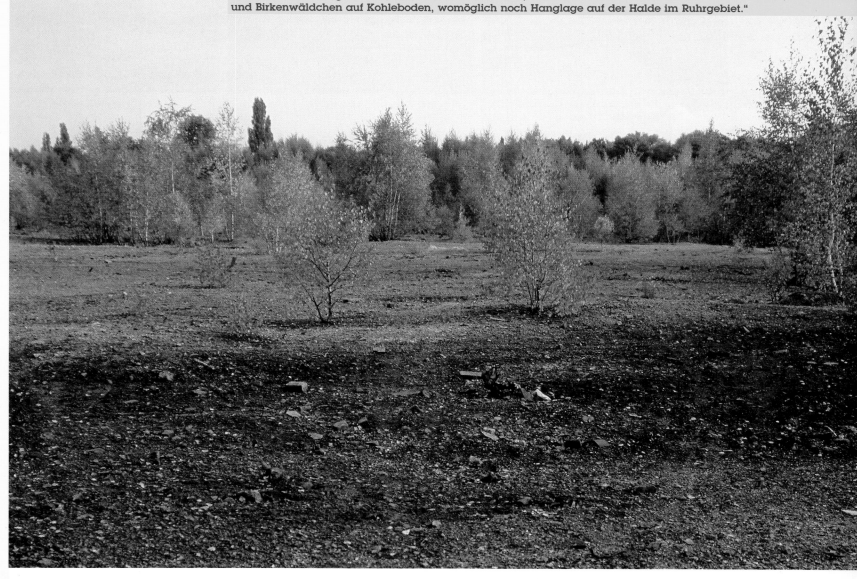

[↑] Bochum 2005, photo: Boris Sieverts

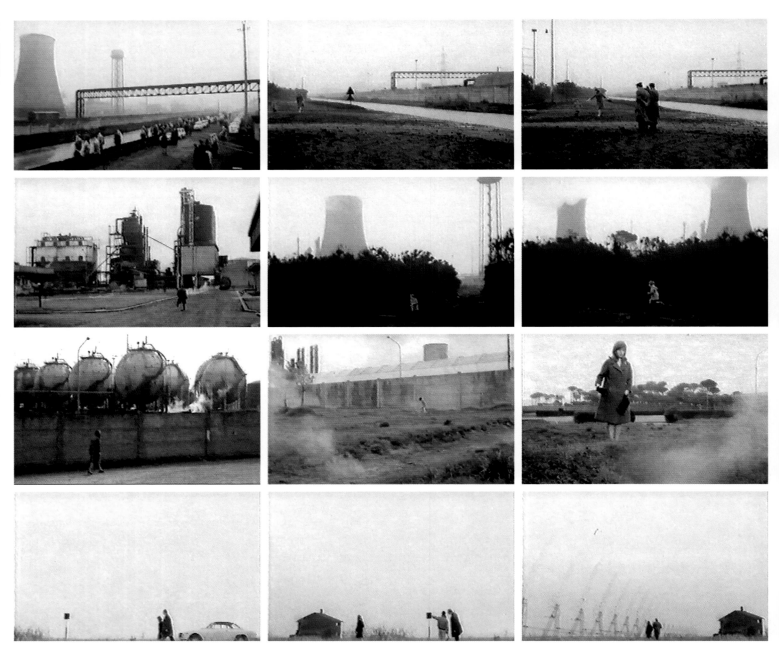

[↑] Film stills from Michelangelo Antonioni's "Il Desserto Rosso" set in Ravenna, Italy 1964 /
Filmstills aus Michelangelo Antonionis „Die Rote Wüste", gedreht in Ravenna, Italien 1964

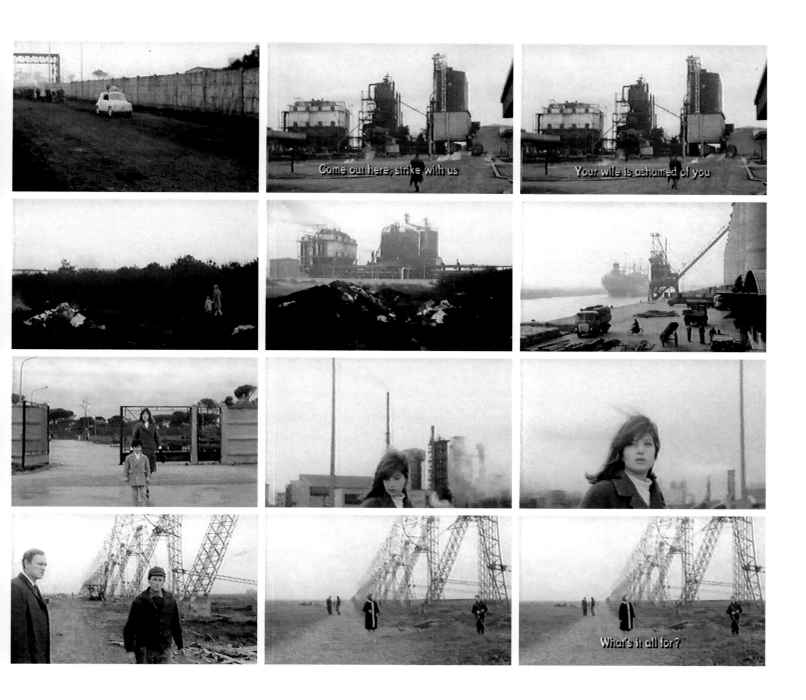

Fragmented Cityscapes

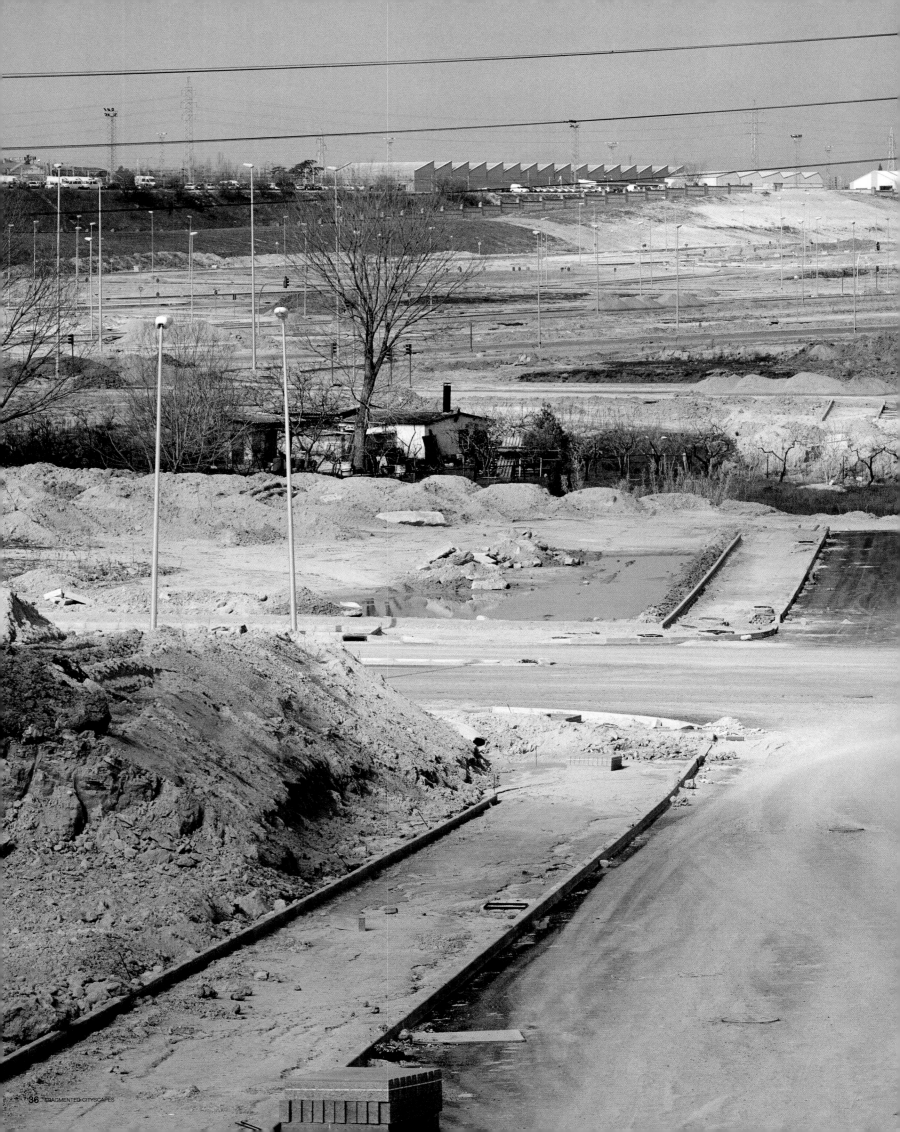

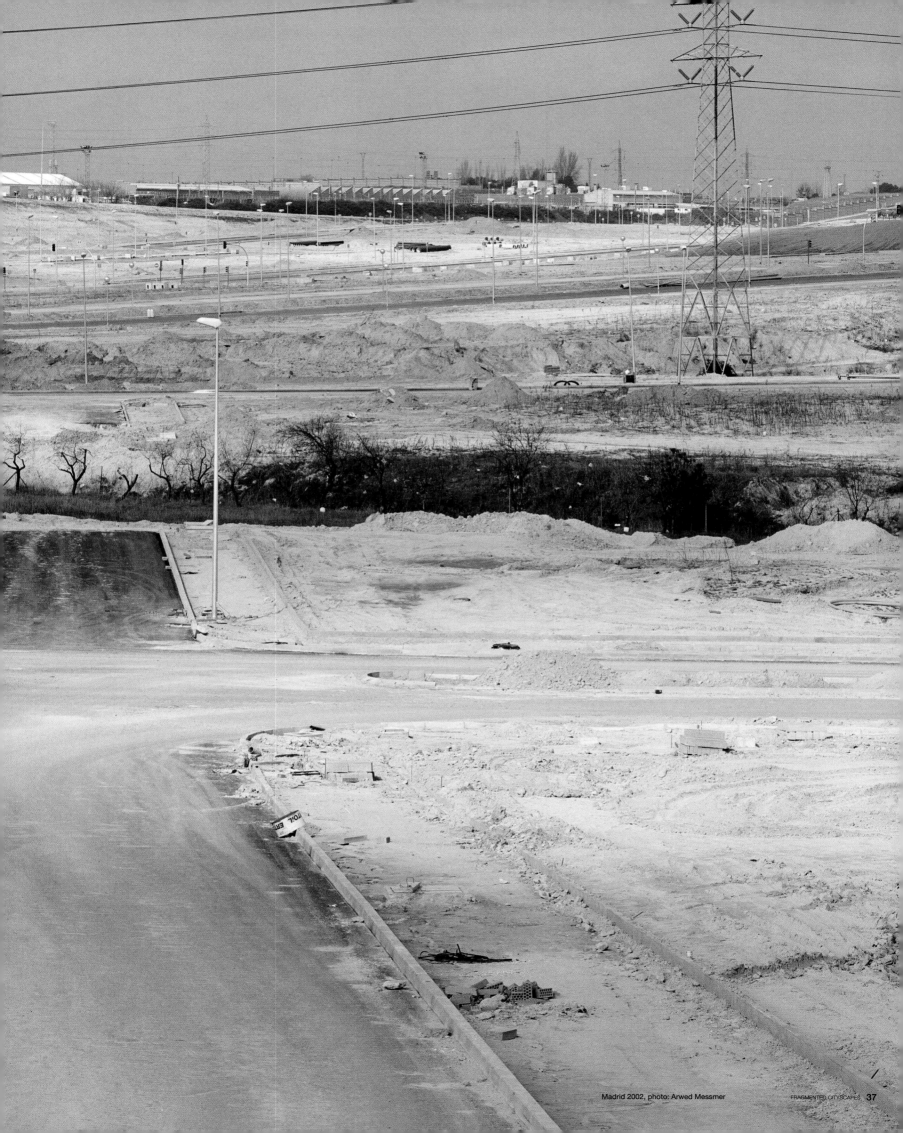

Madrid 2002, photo: Arwed Messmer

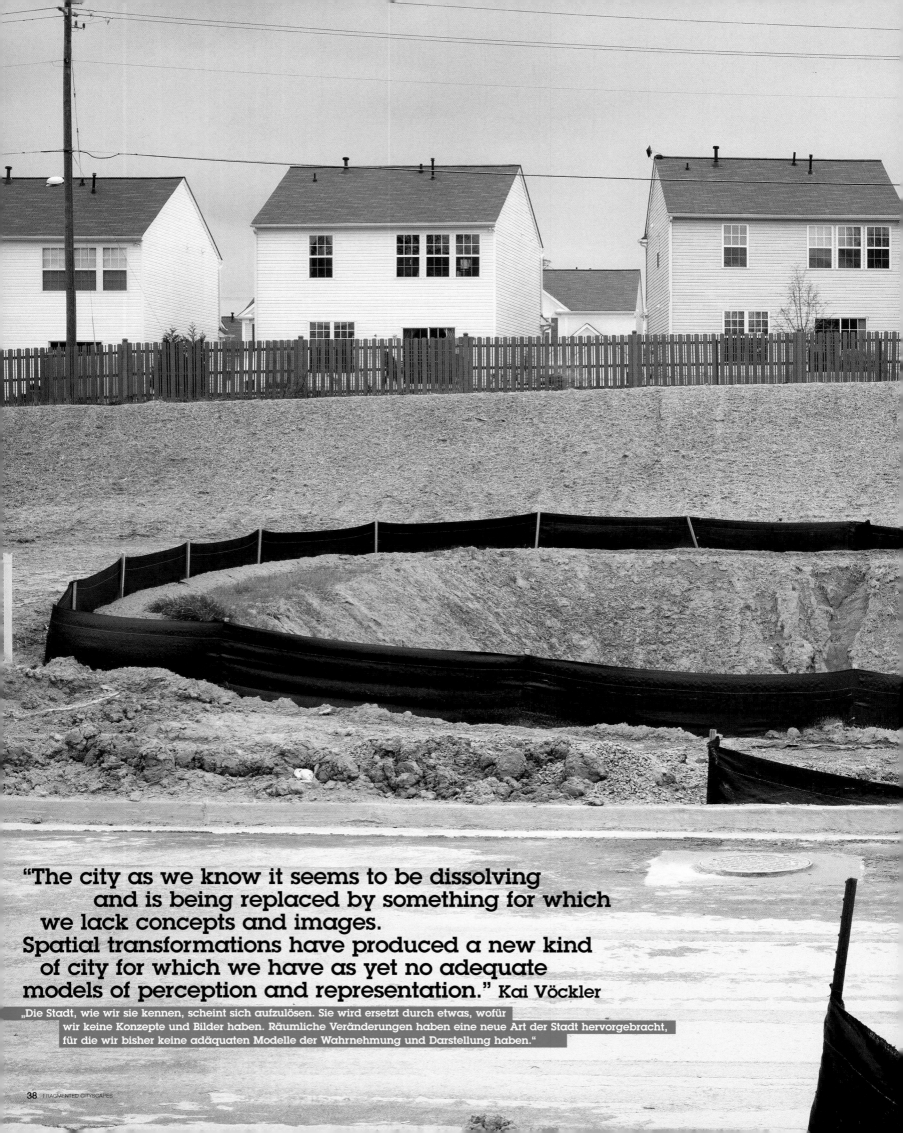

"The city as we know it seems to be dissolving
 and is being replaced by something for which
 we lack concepts and images.
Spatial transformations have produced a new kind
 of city for which we have as yet no adequate
models of perception and representation." Kai Vöckler

„Die Stadt, wie wir sie kennen, scheint sich aufzulösen. Sie wird ersetzt durch etwas, wofür
 wir keine Konzepte und Bilder haben. Räumliche Veränderungen haben eine neue Art der Stadt hervorgebracht,
 für die wir bisher keine adäquaten Modelle der Wahrnehmung und Darstellung haben."

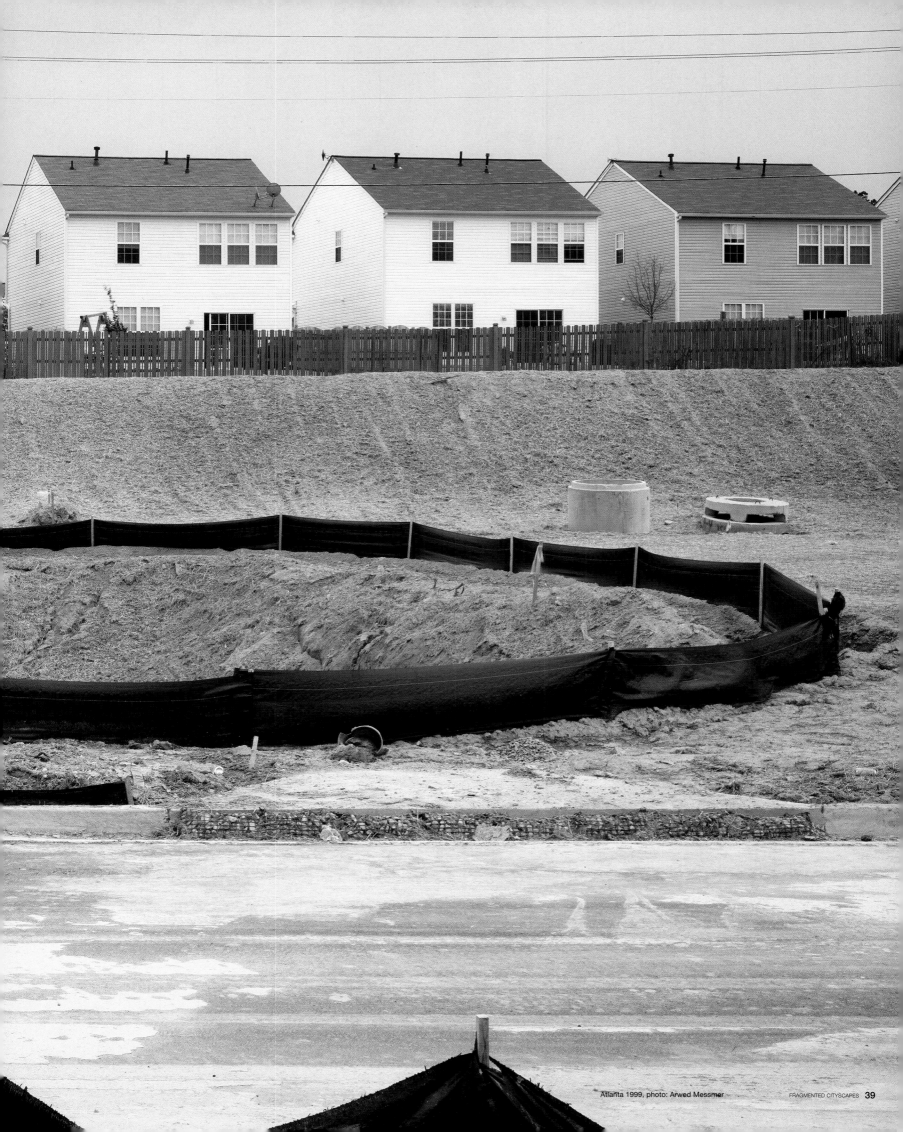

Atlanta 1999, photo: Arwed Messmer

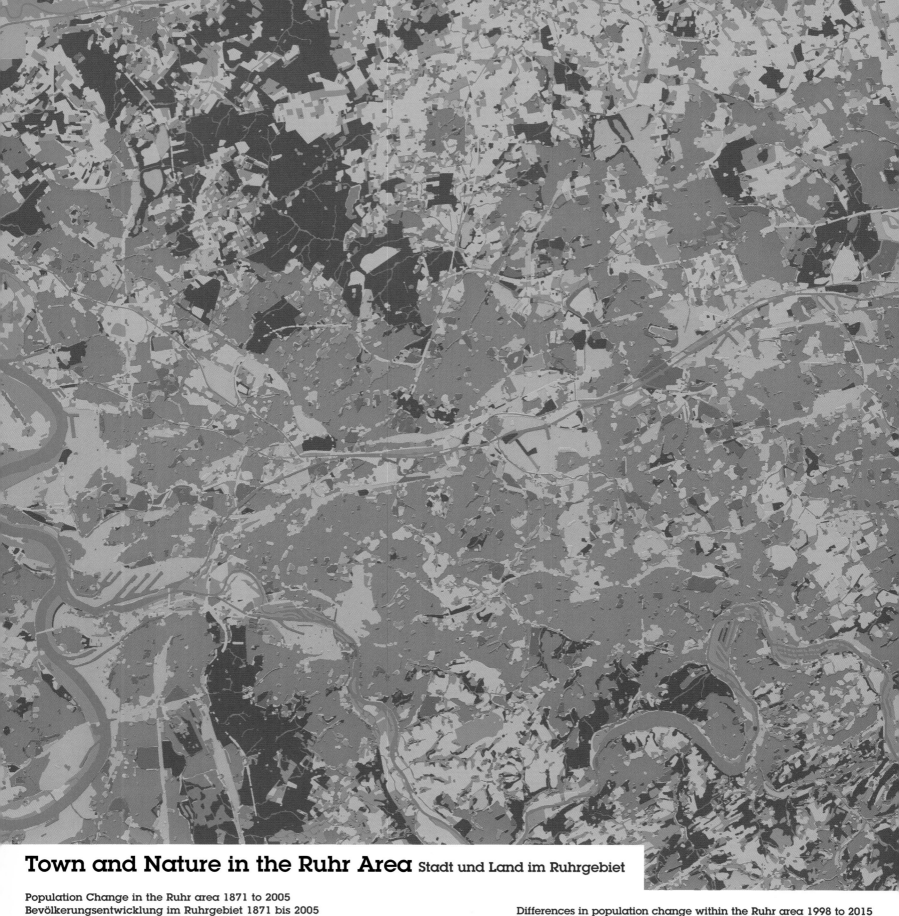

Town and Nature in the Ruhr Area Stadt und Land im Ruhrgebiet

Population Change in the Ruhr area 1871 to 2005
Bevölkerungsentwicklung im Ruhrgebiet 1871 bis 2005

5,410,081

4,231,000

3,869,496

5,031,375

891,000

-6.92%

1871 1925 1946 1980 1998 2015
(Forecast/*Prognose*)

Differences in population change within the Ruhr area 1998 to 2015
Verteilung der Bevölkerungsverluste im Ruhrgebiet 1998 bis 2015

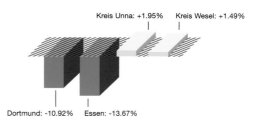

Kreis Unna: +1.95% Kreis Wesel: +1.49%

Dortmund: -10.92% Essen: -13.67%

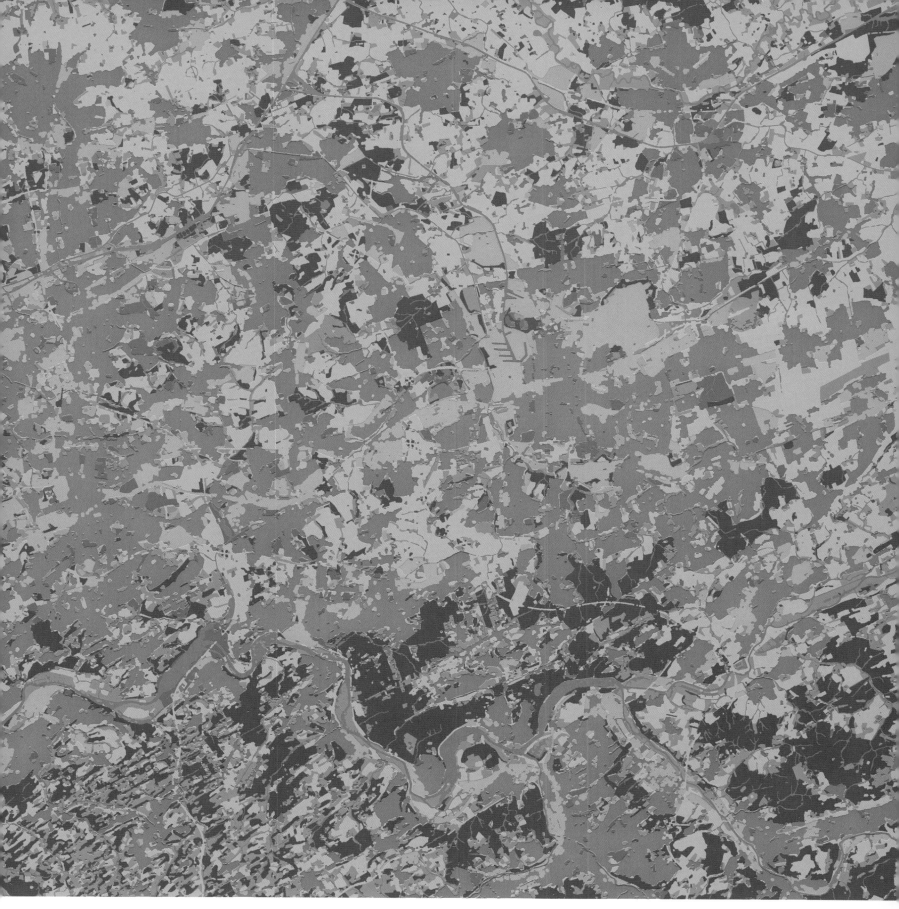

Land Use in the Ruhr Area 2003
Flächennutzung im Ruhrgebiet 2003

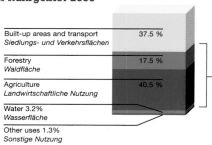

Built-up areas and transport *Siedlungs- und Verkehrsflächen*	37.5 %
Forestry *Waldfläche*	17.5 %
Agriculture *Landwirtschaftliche Nutzung*	40.5 %

Decrease of undeveloped areas
Abnahme der Freiflächen
1999–2003: -3.81%

Water 3.2%
Wasserfläche

Other uses 1.3%
Sonstige Nutzung

[↑] The distribution of "town" and "nature" areas in the Ruhr city zone indicates clearly that there is no longer any relationship between the political and structural systems of the area, rather, the whole area is simultaneously both "town" and "country". / *Die Verteilung von „Stadt" und „Natur" in der ganzen Ruhrstadt zeigt, dass keine Beziehung mehr zwischen den politischen und strukturellen Sytemen besteht, sondern dass das gesamte Gebiet gleichzeitig „Stadt" und „Land" ist.*
Map / *Karte*: Bruno Eberstadt, www.a42.org, AdbK Nürnberg

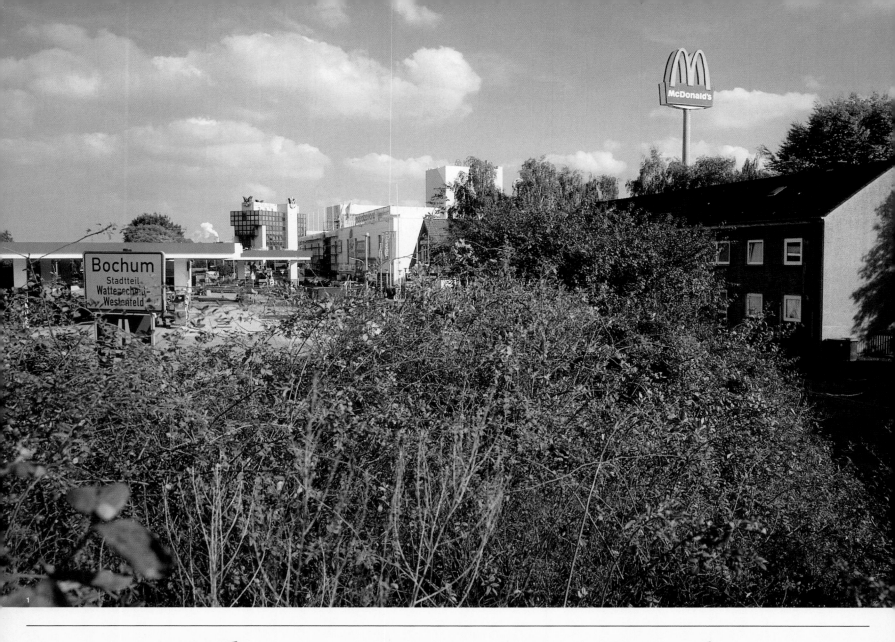

Where Density Ends

Wo Dichte endet Susanne Hauser is Professor of Cultural Sciences at the University of the Fine Arts of Berlin in Germany. Here she discusses with Francesca Ferguson the development of an urban periphery aesthetic and how our perception of these areas ultimately affects how we use them. Susanne Hauser ist Professorin der Kulturwissenschaften an der Universität der Künste in Berlin. Hier diskutiert sie mit Francesca Ferguson über die Entwicklung eines ästhetischen Empfindens für die Räume der Stadtperipherie und wie eine bewusste Wahrnehmung unsere Benutzung dieser Räume verändern könnte.

Susanne Hauser in a conversation with Francesca Ferguson *Susanne Hauser im Gespräch mit Francesca Ferguson*

Francesca Ferguson: How does our conventional picture of the city compare with reality?

Susanne Hauser: I believe that our conventional picture of the city boils down to the idea of densely built-up space in which every possible function is to be found and in which one can experience something like a feeling of density. This is exactly what we call urbanity, but the towns that we have today are something different. There are still these dense points, but very many functions have moved out. They have either gone to what was the countryside, or they have evaporated into the Internet. They are changing into something like "urbanised landscapes", in which you can't exactly say any longer what is still town and what is already countryside.

FF: It is hard to discern these areas and to even to find terms for this sort of urbanised landscape. Why do architects and planners have such difficulties in approaching these areas and in comprehending them?

SH: One problem is that there is no classical picture for urbanised landscapes. They disappoint us both in relation to

Francesca Ferguson: Wie sieht unser konventionelles Bild der Stadt aus verglichen mit der realen Stadt?

Susanne Hauser: Ich glaube, das herkömmliche Bild von Stadt läuft darauf hinaus, dass es so etwas gibt wie einen dicht bebauten Raum, in dem alle möglichen Funktionen sind und in dem man so etwas erleben kann wie ein Gefühl von Dichte. Das ist genau das, was wir Urbanität nennen. Aber die Städte, die es heute gibt, sind etwas anderes. Da gibt es zwar noch diese dichten Punkte, aber viele Funktionen sind ausgewandert. Sie sind entweder aufs ehemalige Land gegangen oder sie haben sich ins Internet verflüchtigt. Die Städte, in denen wir heute leben, gehen über in so etwas wie urbanisierte Landschaften, in denen man gar nicht mehr so genau sagen kann, was jetzt noch Stadt ist oder schon Land.

FF: Diese Gebiete sind schwer wahrzunehmen und es ist ja sogar schwer, Begriffe für diese Art verstädterte Landschaft zu finden. Warum haben Architekten und Planer solche Schwierigkeiten, sich diesen Gebieten zu nähern beziehungsweise sie zu erfassen?

SH: Ein Problem ist: Für die verstädterten Landschaften gibt es keine klassischen Bilder. Sie enttäuschen sowohl unsere Idealbil-

[1, 2] Photos: Boris Sieverts

our ideal pictures of landscape and our ideal pictures of the city. That's why they are hard to see; we simply have no paradigms for them. The arrangement of functions is not self-explanatory: there's a supermarket standing next to a filling station, next to a housing estate, next to a wood – and after that a disco perhaps. The reasons for this are many, but one of them is that all these functions came from the city at one time or another and then settled in an almost random form around it.

FF: You were speaking about there being no symbolic pictures and terms for any of these fragmented areas …

SH: This lack of visual ability has something to do with the fact that we demand a certain unity from our pictures. If we think of an idyllic village or a lovely meadow we immediately have a picture in our heads. We are satisfied with these pictures, because we have known many of them for a long time. It is exactly this sort of picture, in my opinion, that that does not yet exist for the urbanised landscape. There are neither paradigms, nor is there this passion.

FF: Why is that?

SH: On the one hand, we have no nostalgic relationship to it of any kind yet we live in them and they are as normal to us as a car, or a piece of clothing. We do have a nostalgic relationship to old towns and landscapes, but nowadays they are actually just alternative situations that we seek out on our holidays. It isn't always possible, however, to get back to the concentrated town, or to recreate good old small-scale farming by a concerted act of will. We have to develop images and terms for our everyday surroundings in the urbanised landscape.

FF: In respect to these areas, you speak of an "an-aesthetic", which I find to be a fairly hard term …

SH: Yes, I often talk of an "an-aesthetic", but that doesn't mean that the ur-

banised landscape is unaesthetic, or ugly. An-aesthetic means that all too often we simply don't perceive these areas at all. A certain amount of boredom can arise, because one sees too many heterogeneous things one after another that are not made to be looked at; they don't present themselves.

FF: Could it be that for too long, architects and town planners have exercised no particular influence on the peripheries of cities? Is that perhaps the reason why they have such an ambivalent attitude, such uneasiness, about approaching these areas?

SH: The role of architecture and urban design in these areas has been relatively weak until now. Naturally town and regional planning is carried out on larger scales, but essentially, it only describes the functional order. There is practically nothing with pretensions towards design in these areas.

FF:. What will be the shape of things in future? Where will the urban areas be, when urbanity is moving out into the country and dissolving completely as a result of fragmentation?

SH: Our feeling of urbanity begins in places where there is something happening. Today, we find this life at airports, or in the shopping centre; usually somewhere outside the old town centres. There you can experience this energy, which used to only be found in the towns. That doesn't necessarily mean that urbanity is leaving the towns completely, but life in town centres is comparatively quiet today – for smaller towns in particular.

FF: What does that mean for the way in which we live in these urbanised landscapes?

SH: It is very difficult to say how we in Germany live in urbanised landscapes. We can assume that the dependency on privately owned cars and public transport is very great. What doesn't develop in these landscapes is something like

der der Landschaft, als auch unsere Idealbilder von Stadt. Und deshalb sind sie so schwer zu sehen, wir haben einfach keine Vorbilder für sie. Die Zusammenstellung der Funktionen erklärt sich nicht von selbst: Dort steht ein Supermarkt neben einer Tankstelle, neben einer Siedlung, neben einem Wald, und dann kommt vielleicht eine Diskothek. Die Gründe dafür sind vielfältig, aber einer ist, dass diese ganzen Funktionen irgendwann einmal aus der Stadt herausgekommen sind und sich dann in einer fast beliebigen Form um die Stadt angesiedelt haben.

FF: Sie hatten einmal über eine mangelnde Bildfähigkeit gesprochen: dass es in diesen fragmentierten Gebieten einfach keine repräsentativen Bilder und Begriffe mehr gibt.

SH: Diese mangelnde Bildfähigkeit hat etwas damit zu tun, dass wir von Bildern eine gewisse Geschlossenheit verlangen. Wenn wir jetzt an eine idyllische kleine Stadt denken oder an ein schönes Wiesenstück, dann haben wir sofort ein Bild im Kopf. Wir sind zufrieden mit diesen Bildern, weil wir viele davon lange kennen. Und genau solche Bilder gibt es meiner Meinung nach von der urbanisierten Landschaft noch nicht. Es gibt keine Vorbilder, es gibt auch diese Leidenschaft nicht.

FF: Warum ist das so?

SH: Einerseits haben wir noch keine nostalgische Beziehung dazu, obwohl wir in diesen urbanisierten Landschaften leben - sie sind für uns so normal wie ein Auto oder ein Kleidungsstück. Zu den alten Städten und Landschaften haben wir das. Aber das sind für uns eigentlich nur noch Ausweichsituationen, die wir in den Ferien aufsuchen. Wir können aber nicht immer unbedingt zurück zu einer konzentrierten Stadt oder zur guten alten kleinteiligen Landwirtschaft. Wir müssen für die alltägliche Umgebung unserer urbanisierten Landschaft Bilder und Begriffe entwickeln.

FF: Sie sprechen in Bezug auf diese Gebiete von „An-Ästhetik", was, wie ich finde, ein ziemlich harter Begriff ist …

SH: Ja, ich rede öfter von einer „An-Ästhetik", aber das heißt nicht, das die urbanisierte Landschaft unästhetisch oder hässlich ist. An-Ästhetik heißt, dass wir diese Gebiete einfach zu oft gar nicht wahrnehmen. Eine gewisse Langeweile kann dabei auftreten, weil man zu viele heterogene Dinge hintereinander sieht, die sich uns nicht präsentieren, weil sie nicht zum Ansehen gemacht sind.

FF: Könnte es sein, dass der Architekt und Städteplaner viel zu lange keinen besonderen Einfluss auf diese Peripherie der Städte genommen hat? Ist das vielleicht auch der Grund, warum er jetzt so eine ambivalente Haltung, so ein Unbehagen hat, sich diesen Gebieten zu nähern?

SH: Die Rolle von Architektur und Städtebau in diesen Gebieten ist bis heute relativ schwach. Natürlich gibt es Stadt- und

Raumplanung in größeren Maßstäben, aber sie beschreibt im Wesentlichen nur die funktionale Ordnung. Es gibt praktisch nichts mit Anspruch Gestaltetes in diesen Gebieten.

FF: Wie werden diese Gebiete in der Zukunft aussehen? Wo werden die „urbanen Gebiete" der Stadtlandschaft sein, wenn die „Urbanität" hinaus aufs Land wandert und sich in dieser Fragmentierung auflöst?

SH: Unser Gefühl der Urbanität bezieht sich auf Orte, an denen einfach etwas los ist. Heute finden wir dieses Leben auf Flughäfen oder im Shoppingcenter; also meistens irgendwo außerhalb der alten Stadtkerne. Da lässt sich jetzt diese Energie erleben, die früher eigentlich nur in den Städten erlebbar war. Das heißt nicht unbedingt, dass Urbanität vollständig aus den Städten wandert, aber das Leben in den Innenstädten ist heute vergleichsweise ruhig, insbesondere in kleineren Städten.

FF: Was bedeutet das für die Art, wie wir in diesen urbanisierten Landschaften leben?

SH: Es ist allgemein sehr schwer zu sagen, wie wir in Deutschland in urbanisierten Landschaften leben. Man kann davon ausgehen, dass die Abhängigkeit vom eigenen Auto und von öffentlichen Verkehrsmitteln sehr, sehr hoch ist. Was in diesen Landschaften eben nicht entsteht, ist so etwas wie ein urbanes Leben: dass man beispielsweise einfach vor die Haustür tritt und etwas einkaufen kann, seine Amtsgeschäfte erledigt, zur Arbeit geht. Fußläufigkeit ist in solchen Gegenden eine Utopie. Ich glaube, dass das manchen Leuten fehlt. Dieser enge städtische Umkreis ist die klassische europäische Wohnsituation in Städten oder Stadtteilen vor 1950. Das findet sich heute auch in den Kernen von Städten immer weniger, weil die Läden fehlen, weil die übrigen Funktionen von dort auswandern und sich im Raum zerstreuen. Es ist eben ein umfassend neues Gefüge des Lebens entstanden: ein Leben, in dem wir mit dieser Zerstreuung fertig werden müssen und viel Zeit brauchen, um uns darin zu organisieren.

FF: Eigentlich bedient man sich nur noch bei den Versorgungseinrichtungen. Aber wo ist dann das gesellschaftliche Gefüge außerhalb der Landschaften des Konsums, außerhalb der Shoppingmalls und Gewerbeparks?

SH: Die meisten Teile dieser urbanisierten Landschaften dienen genau einer Zweckbestimmung. Viele dienen der infrastrukturellen Versorgung; sie sind Straßenland oder Konsumland oder sie sind Wohnland. Das heißt, sie sind fast immer monofunktional und sehr präzise aufgeteilt. Es gibt eigentlich keinen Grund, dort irgendwo zu verweilen. Sobald etwas erledigt ist, kann man wegfahren. Alles ist sehr genau bestimmt in diesen organisierten Landschaften, bis auf ein paar Zwischenräume wie Lärmschutzwälle oder eine zufällig noch freiliegende Brache, die zwischen zwei Straßen vergessen wurde. Das sind die einzigen Gebiete, wo etwas Unvorhergesehenes geschehen kann.

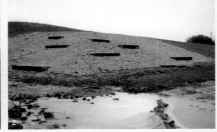

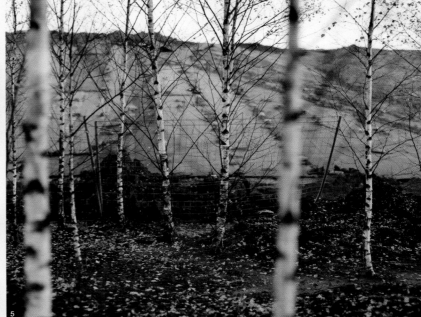

an urban lifestyle: for example, that you can simply walk out of the front door and buy something, do your official business, or go to work. Reaching places on foot is utopian in such districts. I believe that some people miss it. This close, urban neighbourhood is the classic European living situation in towns or districts from before 1950. Today, it is to be found less and less, even in the hearts of towns, because the shops are missing, because the remaining functions move out from there and disperse geographically. A comprehensively new structure of life has emerged: a life in which we have to cope with this dispersal and need a lot of time to organise ourselves within it.

FF: We only go to retail outlets to get what we need, so where is the social structure outside the landscapes of consumption, outside the shopping malls and business parks?

SH: Most parts of these urbanised landscapes serve just one functional requirement. Many supply infrastructure; they are for highways, or shops, or for housing. This leads to a situation in which there is no actual reason to linger there. As soon as a task has been completed, you can drive away. Everything is precisely determined in these organised landscapes, apart from a couple of intermediate spaces such as noise-reduction berms or plots of disused land waiting to be built upon, lying forgotten between two streets. Those are the only areas where something unforeseen can happen.

FF: If the planners were to attend to the "micropolitics of space" – that is, were to turn their backs on the failed, large scale approach – and took measures at a much smaller and more stabilising level, would that be the key to a solution?

SH: Well, in one way I like "micropolitics of space" a lot and in another I don't like it at all. Certainly, there are many situations in which the state of things can be improved – or, shall we say, enriched – by relatively small measures. On the other hand, the results of the construction activity of the last fifty years, which we are now discussing as urbanised landscape, would actually need a very much greater intervention and very much more theoretical consideration. For that this sudden new modesty in town planning, with small measures, simply does not suffice.

FF: I have the feeling that in the Ruhr conurbation there are few places where you sense both density and society – there is no strong public space. Once the major vision that directed society – in this case big industry – has gone, then any kind of momentum or cohesion is missing. This is now shifting into the private sphere: into the small world of the allotment and the newspaper kiosk, as virtually the last social meeting place. There is almost no occupation of public space any longer. Here, small measures could surely be effective as a systematic strategy.

SH: Naturally, micro-interventions can certainly be social events and thus also change the spaces in which they take place. And that can be very important. I am in favour of the idea that all these new landscapes with their large, mono-functional blocks must become more permeable and that more functions should develop, so that it is quite simply fun to be there. I find this forgetting of the possible demands on landscapes beyond their mono-functional organisation is the true poverty of urbanised landscapes. It is precisely here that public opinion should demand and make use of its right to have public spaces designed.

FF: Wenn sich die Planer um die „micropolitics of space" kümmern, sich also von dem gescheiterten, großen Maßstab verabschieden würden, und die Eingriffe auf einer viel kleineren und eher stabilisierenden Ebene geschehen würden - wäre das ein Lösungsansatz?

SH: Naja, „micropolitics of space" gefällt mir einerseits sehr gut und andererseits überhaupt nicht. Sicher gibt es viele Situationen, in denen sich die Lage verbessern oder anreichern lässt durch relativ kleine Eingriffe. Auf der anderen Seite gefällt mir das deshalb nicht, weil das Ergebnis der Bautätigkeit der letzen 50 Jahre, das wir jetzt als urbanisierte Landschaft diskutieren, eigentlich einen sehr viel größeren Eingriff und ein sehr viel prinzipielleres Nachdenken bräuchte. Und da reicht diese plötzliche neue Bescheidenheit in der Stadtplanung mit kleinen Eingriffen nicht aus.

FF: Ich habe zum Beispiel im Ruhrgebiet das Gefühl, dass es dort wenig Orte gibt, an denen man eine Dichte spürt und wo die Gesellschaft zu spüren ist. Nachdem die große Vision, die einmal die Gesellschaft gesteuert hat - im Falle des Ruhrgebiets die Großindustrie -, wenn das einmal weg ist, dann fehlt jede Art von Dynamik oder Zusammenhalt. Das verlagert sich jetzt ins Private: in die kleine Welt des eigenen Schrebergartens oder an den Kiosk, als quasi letztem Treffpunkt der Gesellschaft. Eine Inbesitznahme des öffentlichen Raums gibt es fast gar nicht mehr. Hier könnten doch Kleineingriffe als systematische Strategie wirken.

SH: Natürlich können Mikroeingriffe soziale Ereignisse sein und damit auch die Räume, in denen sie stattfinden, verändern. Und das kann sehr wichtig sein. Ich bin dafür, dass diese ganzen neuen Landschaften mit ihren großen monofunktionalen Blöcken durchlässiger werden müssen, damit mehr Funktionen entstehen und es einfach Spaß macht, dort zu sein. Dieses Vergessen der möglichen Ansprüche an Landschaften hinter ihrer monofunktionalen Ausgestaltung ist die wahre Armut der urbanisierten Landschaften. Genau hier sollte die Öffentlichkeit ihr Recht auf Gestaltung der öffentlichen Räume wieder einfordern und nutzen.

7

8

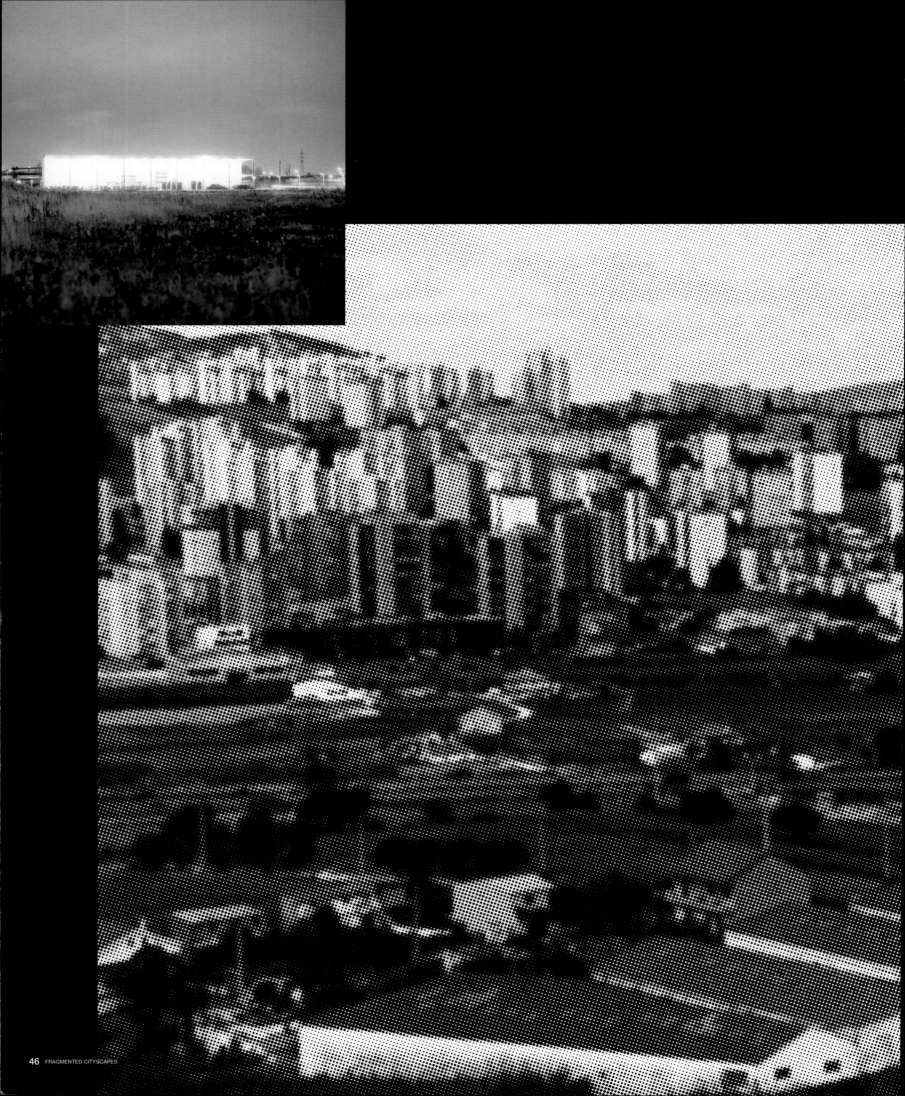

"Home. Home was BAMA, the Sprawl, the Boston-Atlanta Metropolitan Axis. Program a map to display frequency of data exchange, every thousand megabytes a single pixel on a very large screen. Manhattan and Atlanta burn solid white. Then they start to pulse, the rate of traffic threatening to overload your simulation. Your map is about to go nova. Cool it down. Up your scale. Each pixel a million megabytes. At a hundred million megabytes per second, you begin to make out certain blocks in midtown Manhattan, outlines of hundred-year-old industrial parks ringing the old core of Atlanta ..."
William Gibson, Neuromancer, 1984

„Zu Hause. Zu Hause, das war BAMA, das ausufernde Stadtgebiet, die Boston-Atlanta Metropolitan Achse. Programmiere eine Karte, die die Häufigkeit des Datenaustauschs anzeigt, alle tausend Megabytes ein einzelner Pixel auf einem sehr großen Bildschirm. Manhattan und Atlanta erstrahlen als eine kompakte weiße Fläche. Dann beginnen sie zu pulsieren. Die Geschwindigkeit des Datenverkehrs droht deine Simulation zu überlasten. Deine Karte ist kurz davor zu explodieren. Kühl sie ab. Vergrößere den Maßstab. Jedes Pixel eine Million Megabytes. Bei einhundert Megabytes pro Sekunde kannst du allmählich bestimmte Blocks im Zentrum von Manhattan ausmachen, die Umrisse von hundert Jahre alten Industriegebieten, die einen Ring um den alten Stadtkern von Atlanta bilden ..."

[↖] Photo: Christoph Buckstegen, © Rhein. Industriemuseum Oberhausen

[←] Cimêncio 2003, photo: Nuno Cera

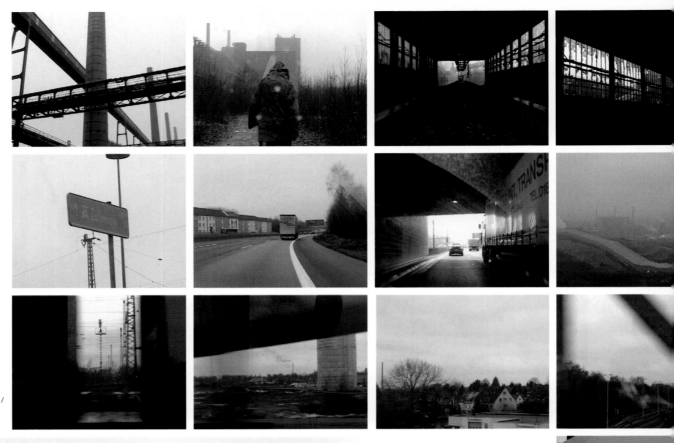

[↑] Film stills from Nuno Cera's "Ultra Ruhr", 2006 /
Filmstills von Nuno Ceras „Ultra Ruhr", 2006

[↓] Photo: Christian Hiller

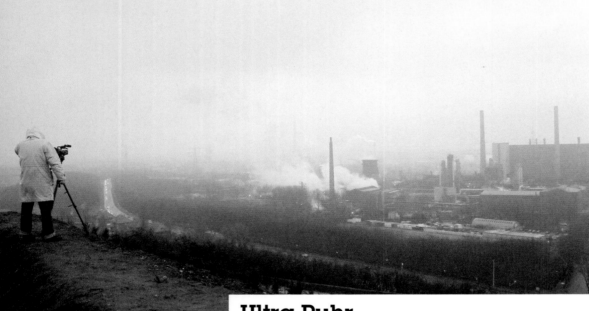

Ultra Ruhr

The Portuguese artist Nuno Cera is based in Berlin. He uses film and photography to communicate his insightful and often poetic impressions of cityscapes and fallow urban spaces. His video installation "Ultra Ruhr", filmed in the Ruhr area, was created specifically for the Talking Cities exhibition. It is, he says, about: "agglomeration, fragments, excess, reality, autistic landscapes, nature, industry, architecture, memory, movement, traffic, highways, connections, science-fiction locations, non-places, searching and being lost."

Der portugiesische Künstler Nuno Cera lebt in Berlin. Er nutzt Film und Fotografie, um seine einfühlsamen und oft poetischen Eindrücke von Stadtlandschaften und urbanen Brachflächen zu vermitteln. Seine Videoinstallation „Ultra Ruhr", die im Ruhrgebiet aufgenommen wurde, wurde speziell für die Ausstellung Talking Cities geschaffen. Darin geht es, wie er selbst sagt, um „Agglomeration, Fragmente, Überfluss, Realität, autistische Landschaften, Natur, Industrie, Architektur, Erinnerung, Bewegung, Verkehr, Autobahnen, Verbindungen, Science-Fiction-Orte, Unorte, Suchen und Verlorensein."

"All I need is a brief glimpse, an opening in the midst of an incongruous landscape, a glint of light in the fog, the dialogue of two passers-by meeting in a crowd, and I think that, setting out from there, I will put together, piece by piece, the perfect city, made of fragments mixed with the rest, of instants separated by intervals … discontinuous in time and space, now scattered, now more condensed." Italo Calvino, *Invisible Cities*, 1972

„Alles, was ich brauche, ist ein flüchtiger Blick, eine Lücke inmitten einer inkongruenten Landschaft, einen Lichtschein im Nebel, den Dialog zweier Passanten, die sich in einer Menschenmenge begegnen, und ich denke, dass ich, dort beginnend, Stück für Stück die perfekte Stadt zusammensetzen werde aus Fragmenten vermischt mit dem Rest, aus Augenblicken getrennt durch Intervalle … diskontinuierlich in Zeit und Raum, mal verstreut, mal stärker zusammengedrängt."

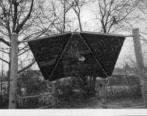

The Cartography of Everyday Life

Kartographie des Alltags The freelance architect and town planner Bernd Kniess and urban researcher Leonhard Lagos Kahlhoff are concerned with what they call "everyday cartography" where they examine the movements of migrants, children or teenagers in the Ruhr district in an attempt to gather relevant and useful data about the reality of suburban life. Here they elucidate the reasoning behind their work. Der Architekt und Stadtplaner Bernd Kniess arbeitet zusammen mit dem Stadtwissenschaftler Leonhard Lagos an dem, was sie selbst eine „Kartographie des Alltags" nennen. Sie beobachten und analysieren die Bewegung von Migranten, Kindern oder Jugendlichen im Ruhrgebiet, um neue Einsichten in die Realitäten des suburbanen Lebens zu gewinnen. Hier sprechen beide über die Hintergründe ihrer Forschung.

Behind this series of studies entitled "The Cartography of Everyday Life" is the observation that people are somewhat lost for words when it comes to describing the contemporary town. We all have a picture in our minds when we hear the word "town"; it certainly stems from our own experience and yet

> **Every "user" of towns carries with them an image that is characterised by collective memory and his or her own experience.**

it is highly likely to be based primarily on memories of other times (childhood, for example), or of other places (perhaps from our last memorable holiday). Every "user" of towns carries with them an image of towns that is characterised simultaneously by collective memory and by his or her own experience. This mental construct is consequently likely to have very little to do with the reality that we experience every day.

Even experts are divided when it comes to abstract concepts for the space in which over 70 percent of the population in central Europe currently live. They talk of the intermediate city (*zwischenstadt*), or of suburbia, and describe it as fragmented and diffuse.

Imprisoned by our own expertise, by the terms and images that we have learned, we search for a way of overcoming this bias for a moment at least. We look at things through other people's eyes to get an idea of "other" realities.

We try to do this by immersing ourselves in specific patterns of spatial use and the associated perception of space

Hintergrund unserer Untersuchungsreihe „Kartographie des Alltags" ist die Feststellung einer gewissen Sprachlosigkeit, wenn es darum geht, die zeitgenössische Stadt zu beschreiben. Jeder von uns hat zwar ein Bild vor Augen, wenn von „Stadt" die Rede ist; es entstammt auch sicher der eigenen Erfahrung, jedoch beruht es mit größter Wahrscheinlichkeit vornehmlich auf der Erinnerung an eine andere Zeit (wie etwa der Kindheit) oder einen anderen Ort (etwa der letzten Urlaubsidylle). Jeder Stadtnutzer trägt so ein gleichzeitig von kollektiver Erinnerung und eigener Erfahrung geprägtes Bild der Stadt in sich. Mit der Wirklichkeit, wie wir sie alltäglich leben, dürfte diese Vorstellung folglich wenig zu tun haben.

Selbst die Fachwelt ist sich uneins über eine Begrifflichkeit für den Raum, in dem derzeit über 70 Prozent der Menschen in Mitteleuropa leben. Sie spricht von „Zwischenstadt" oder „Suburbia" und beschreibt ihn als fragmentiert und diffus.

Gefangen im eigenen Expertentum, den erlernten Begriffen und Bildern, suchen wir nach einem Weg, diese Befangenheit zumindest für einen Augenblick zu überwinden. Wir nutzen den „fremden Blick", um uns den „anderen" Realitäten anzunähern.

Wir versuchen es, indem wir uns in spezifische Raumnutzungsmuster und die damit einhergehende Wahrnehmung des Raums von Personen entführen lassen, die sich weniger um die Zusammenhänge kümmern, sondern vielmehr intuitiv und routiniert städtische Strukturen nutzen. Mit intuitiv meinen wir die Begabung, auf Anhieb eine meist „richtige" Entscheidung zu treffen, ohne die zugrunde liegenden Zusammenhänge explizit verstehen zu müssen.

Unsere Überlegung ist, dass beispielsweise Kinder in ihrem Forschungs- und Entdeckungsdrang viel aktiver, experimenteller und unbefangener mit ihrer Umgebung umgehen. Sie haben noch keine genauen Vorstellungen, wie die Stadt zu sein hat.

Besonders deutlich wird dies am Ruhrgebiet. Hier haben geogene und anthropogene Faktoren ein Gebilde hervorgebracht, das sich nicht auf Anhieb mit unserem vertrauten Bild der Stadt zur Deckung bringen lässt: Hier findet man scheinbar unbegründet direkt nebeneinander liegend die verschiedensten Funktionen, die sich zu einem diffusen Gefüge addieren.

Dennoch ist das Ruhrgebiet ein durch und durch urbaner Raum. Es ist voller Orte der Zusammenkunft, den Orten die Lefebvre als Kennzeichen von Zentralität und Urbanität ausmacht. Wesentliches Kriterium ist die städtische Heterogenität, die sich aus der Differenz des Zusammenkommenden ergibt.

Insofern ist das Ruhrgebiet ein idealer Raum, um zu untersuchen, wie eigentlich dieses Zusammenbringen und Kombinieren von zumindest scheinbar Unzusammenhängendem funktioniert. Trotz oder viel-

leicht wegen der undefinierten Gesamtsituation des Ruhrgebiets, das immer noch den Wandel zu verarbeiten hat, der unsere Gesellschaft in den vergangenen Jahrzehnten verändert hat.

Hier zeigt sich in den vielfältigen Zusammenhängen, die selbstverständlich Auswirkungen auf Nutzung und Wahrnehmung von Raum haben und einen fundamentalen Wandel im Verhältnis zu homogenen Gemeinschaften wie etwa Dörfern darstellen.

Wir suchen nach neuen Wegen, das zu verstehen, was sich unseren bewährten Beschreibungsmustern zu entziehen scheint, gerade weil Architekten und Stadtplaner ein herausgehobenes Interesse an Stadt und Gesellschaft haben müssen. Schließlich ist dies das Feld, in dem sie agieren.

Nachdem wir uns in den bisherigen Untersuchungen bereits dem Blick von Kindern und Migranten gewidmet haben, sind es jetzt die Jugendlichen, die uns interessieren.

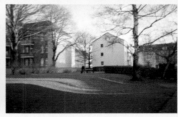
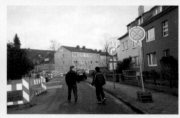

by people who are less concerned with interrelationships, and use urban structures intuitively and routinely. By intuitively, we mean having the gift of making a mostly "right" decision on the spur of the moment, without having to understand the underlying context explicitly.

We contend that children, for instance, with their urge to explore and discover, interact with their surround-

We look at things through other people's eyes to get an idea of "other" realities.

ings more actively, experimentally and uninhibitedly. They do not yet have any precise ideas of what a town should be like.

This is particularly clear in the Ruhr area conurbation. Here, geogenic and

anthropogenic factors have produced an entity that initially cannot be made to fit with our own familiar image of the town. Here one finds a diffuse structure that has accumulated from a wide variety of functions, which lie next to each other without any apparent reason.

The Ruhr conurbation is nonetheless a thoroughly urban space. It is full of meeting places, the places that Lefebvre identifies as signs of centrality and urbanity. The essential criterion is urban heterogeneity, which results from the differences between everything that comes together.

To this extent, the Ruhr conurbation is an ideal space in which to study how this bringing together and combination of at least seemingly unconnected things really works. This is true in spite of – or perhaps because of – the undefined overall situation in the Ruhr conurbation, which still has

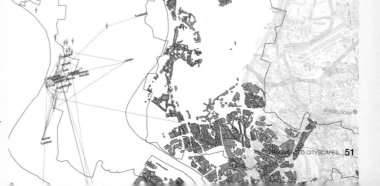

[→] "Explore" – space relationship patterns of children in the Ruhr area. / „Explore" – Räumliche Beziehungsmuster von Kindern im Ruhrgebiet, map / Karte: Martina Pusch

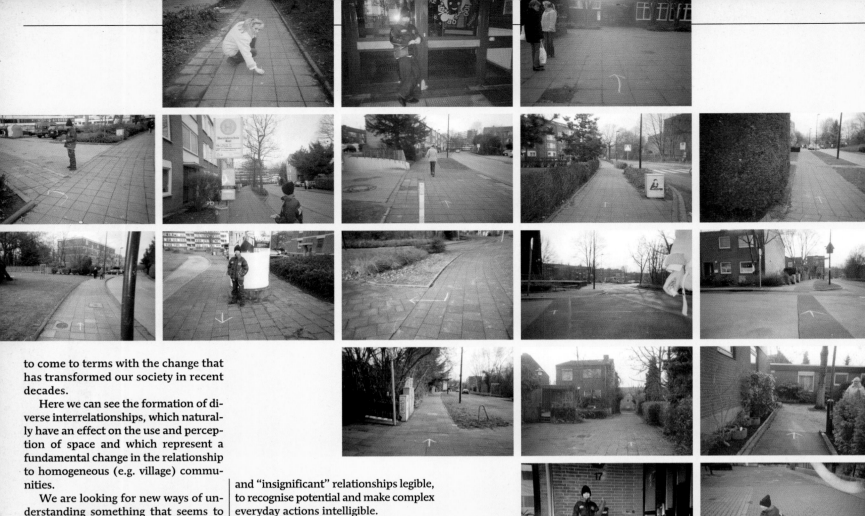

[↑] Snapshots by children from the "Explore: Playground" project, Ruhr area 2005 / *Schnappschüsse der Kinder des „Explore: Playground"-Projektes, Ruhrgebiet 2005*

to come to terms with the change that has transformed our society in recent decades.

Here we can see the formation of diverse interrelationships, which naturally have an effect on the use and perception of space and which represent a fundamental change in the relationship to homogeneous (e.g. village) communities.

We are looking for new ways of understanding something that seems to evade our tried and tested patterns of description, precisely because architects

We are looking for new ways of understanding something that seems to evade tried and tested patterns of description.

and town planners need to take a heightened interest in towns and society. After all, it is the area in which they are active.

After having concentrated on the viewpoints of children and migrants in our previous studies, we are now interested in those of adolescents. In "Explore", the focus is on the perspective of a specific age group entering a new phase of life, on the way to defining a personal identity. In young people, we can observe the process of orientation; they are searching for something and they have developed strategies of their own for organising their daily routine. They have internalised the available technology. For them, modern telecommunications, which today play an essential role in communicating with others and organising daily life, are generally commonplace things that they use without preconceptions and (to the distress of many adults) without inhibitions. This makes them not only users, but also the vanguard of a new spatial organisation.

For us, the aim is only to train our way of seeing, to make seemingly mundane

and "insignificant" relationships legible, to recognise potential and make complex everyday actions intelligible.

What is ultimately important here are precisely those relationships that we have lost. It is necessary to reflect upon this, because the less we manage to grasp this interpretation of "town" conceptually, the less efficient the tools that we use in analysing, designing and managing urban processes will become in future.

Lastly, the study provides an insight into structures that would normally be overlooked. Although, in a structure as we see it in the Ruhr conurbation, these spaces may well be what actually links things. It is, one could assume, held together by the disconnected … Thus it is

The aim is only to train our way of seeing, to make mundane and "insignificant" relationships legible.

instructive to experience how these spaces actually work, how they are used and which criteria young people, for example, apply when seeking such spaces.

From all these different viewpoints, a new concept of spatial quality emerges. The aim is to achieve a new understanding of public space by observing people closely: the search for the forms of production of public space. The point is not to reinvent the town; it is rather an attempt to reacquire the language of the urban, so as to be able to involve oneself again as a designer.

Bei „Explore" geht es um die Perspektive einer spezifischen Altersklasse im Aufbruch, auf dem Weg zur Definition des eigenen Selbst. Bei den Jugendlichen können wir den Prozess der Orientierung beobachten, sie sind auf der Suche und haben dazu eigene Strategien entwickelt, ihren Alltag zu organisieren. Sie haben die zur Verfügung stehende Technik verinnerlicht. Für sie ist moderne Telekommunikation, die heute wesentlichen Anteil am Austausch und der Organisation des Alltags hat, in der Regel eine Selbstverständlichkeit, die sie gänzlich unbefangen und (zum Leidwesen vieler Erwachsener) auch ungehemmt nutzen. Sie sind damit nicht einfach nur Nutzer, sondern Vorreiter neuer räumlicher Organisation.

Uns geht es nur darum, das eigene Sehen zu schulen, alltägliche und „unbedeutende" Zusammenhänge lesbar zu machen, die Potenziale zu erkennen und komplexe Alltagshandlungen intelligibel zu machen.

Wichtig sind dabei schließlich eben jene Zusammenhänge, die uns verloren gegangen sind. Es ist notwendig darüber nachzudenken, denn so wenig wir diese Interpretation der Stadt begrifflich zu fassen bekommen, werden unsere Werkzeuge der Analyse, des Entwurfs und der Steuerung von urbanen

Prozessen zukünftig zunehmend uneffizienter.

Letztlich gewährt die Untersuchung Einblick in Strukturen, die normalerweise übersehen werden. Obwohl diese Räume in einem Gefüge wie es das Ruhrgebiet darstellt vielleicht das eigentlich Verbindende sind. Es ist, könnte man annehmen, durch das Unverbundene zusammenhängend …

Es ist daher aufschlussreich zu erfahren, wie diese Räume eigentlich funktionieren, wie sie genutzt werden und nach welchen Kriterien beispielsweise Jugendliche diese Räume suchen: nach welchen Kriterien gehen derart spezielle Gruppen vor.

Aus den unterschiedlichen Sichtweisen ergibt sich dann aber auch ein neuer Begriff von Raumqualität. Ziel ist ein neues Verständnis des öffentlichen Raumes durch genauere Beobachtung: die Suche nach den Formen der Produktion des Öffentlichen.

Es geht also nicht darum, die Stadt neu zu erfinden, sondern es ist der Versuch, sich die Sprache des Städtischen neu anzueignen, um sich damit wieder gestaltend einbringen zu können.

Photo: Boris Sieverts

THERE'S BARE EARTH RIGHT UP TO MY BORDERS.
A PATH LEADS DOWN TO THE WATER.
I STOP FOR A REST IN THE BIRCH WOOD.
GOOD WOOD FOR BUILDING.
EVERYTHING'S QUIET.
I CAN HEAR THE ROAR OF TRAFFIC FROM THE MOTORWAY. AND THE SONOROUS
DRONE OF THE POWER STATION BEYOND THE RIVERBANK.
THE AIR IS COLD. YOU CAN SEE A LONG WAY TODAY. MY LAND.
FOR FREE!

Der kahle Boden reicht bis an meine Grenze. Ein Pfad führt hinunter zum Wasser. Im Birkenwald mache ich Rast. Gutes Bauholz.
Es ist still. Ich höre das Rauschen der Autobahn. Und das sonore Brummen des Kraftwerks auf dem Festland. Es ist kalt. Man kann heute weit blicken. Mein Land. Geschenkt!

"To perceive all the interstitial spaces
of the Ruhr area as a city,
as *the other city* is a vision that,
for everyone involved with the
complicated network of the Ruhr area, is both
liberating and sexy." Dirk Haas

„Die Summe aller Zwischenräume des Ruhrgebiets als eine Stadt,
als ‚die andere Stadt' zu begreifen, diese Vorstellung wirkt für jeden, der mit den
komplizierten Geflechten des Ruhrgebiets zu tun hat, befreiend und sexy."

[↑] Galaxy of possible spaces: the relationship between city and wasteland in the Ruhr area (abstracted).
/ Galaxie der Möglichkeitsräume: Beziehung zwischen Stadt und Brachland im Ruhrgebiet (abstrahiert).
Map / Karte: Land for Free

**Apply now and register
in advance for free at
entry@landforfree.eu
Space for good ideas!
Places for pioneers!
The Ruhr area is giving land away.
On Emscher Island. For free.**

*Jetzt anmelden und kostenlos vorregistrieren unter
entry@landforfree.eu
Raum für gute Ideen! Platz für Pioniere!
Das Ruhrgebiet vergibt Land.
Auf der Emscherinsel. Gratis.*

For an information pack write to:

Infomaterial anfordern von:

*Bewerbungsbüro „Essen für das Ruhrgebiet.
Kulturhauptstadt Europas 2010"
Stichwort: Land for Free*

*c/o Regionalverband Ruhr
Kronprinzenstraße 35
45128 Essen*

Land for Free

Boris Sieverts, Henrik Sander, Dirk Haas and Stefanie Bremer's "Land for Free" project is a vision of a new city growing in and between the cities of the Ruhr area. It is not to be a conventional city with street plans, sewage networks and building authorities, but one that comprises the realisation of individual dreams facilitated by the acquisition of derelict Ruhr land. The protagonists aim to attract settlers from all over Europe for their project as part of Essen for the Ruhr – European Capital of Culture 2010. „Land For Free" von Boris Sieverts, Henrik Sander, Dirk Haas und Stefanie Bremer ist die Utopie einer neuen Stadt in und zwischen den Städten des Ruhrgebietes. Keine Stadt im herkömmlichen Sinne (mit Planstraßen, Kanalnetzen, Baubehörden), sondern eine Stadt, entstanden aus der Verwirklichung individueller Lebensträume, ermöglicht durch die Aneignung von brachliegendem Ruhrland. Die Protagonisten des Projekts werben im Rahmen der Kulturhauptstadt Essen für das Ruhrgebiet bis 2010 Siedler aus ganz Europa an.

"It is the 'bricolage' character of the contemporary city that interests us. Here we are not far removed from the 'Non-Plan' of the 1960s when Cedric Price and Reyner Banham combined their criticism of paternalistic town planning with the understanding that one needs to make disparity productive." Henrik Sander

„Der ‚bricolage'-Charakter der zeitgenössischen Stadt ist es, der uns interessiert. Da sind wir nicht weit weg vom ‚Non-Plan' der 1960er Jahre: Cedric Price und Reyner Banham haben damals ihre Kritik an paternalistischer Stadtplanung ja auch mit der Einsicht verbunden, dass man Ungleichheit produktiv machen muss." Henrik Sander

Artificial Arcadia

The Dutch architect and photographer Bas Princen's photographs show snippets of "edge condition" landscapes, not as illustrations of reality but as images of a potential reality of this landscape. Die Fotografien des niederländischen Architekten und Fotografen Bas Princen zeigen Schnipsel von Landschaften unter „Randbedingungen", nicht als Abbildung der Realität, sondern als Bilder einer potenziellen Realität dieser Landschaft.

[←] Garbage Dump – a mountain bike track winds across an old refuse dump. The hill is covered in plastic bristles left over from an artificial ski slope that went bankrupt after a new skiing dome opened nearby, 2002 / *Müllkippe – eine Mountainbike-Piste schlängelt sich über eine ehemalige Müllhalde. Der Hügel ist mit Kunststoffresten von einem künstlichen Skihang bedeckt, der Konkurs anmelden musste, als in der Nähe eine Skihalle eröffnet wurde. 2002.*
Photo: Bas Princen

[←] End of the Highway, Peugeot 205 burn out meeting, 2001 /
Ende der Autobahn, Peugeot 205 Burn-out-Meeting, 2001.
Photo: Bas Princen

[↑] Artificial Sea Wall, land reclaimed from the sea, intended for a future
 industrial zone, 2000 / *Künstlicher Deich, dem Meer abgerungenes Land,
 als zukünftiges Gewerbegebiet geplant, 2000.* Photo: Bas Princen

[↗] Future Suburb, 2003 / *Zukünftiger Vorort, 2003.* Photo: Bas Princen

"More completely than anywhere else, the Dutch landscape is planned, programmed and designed. Modernist ideas about outdoor leisure resulted in a flood of newly created 'landscape types': safari parks, motocross circuits, rowing canals. But now, if people's outdoor activities depend on products, there is no need to programme the landscape itself. Any piece of bare or undeveloped land will do; the people define the landscape by the gear they bring with them. The gear makes you aware of landscape features and conditions you wouldn't even notice otherwise."

"In a world in which the leisure industry can strike, or has struck, anywhere and anytime, it's a miracle that people can still discover non-programmed adventure. By choosing other forms of use, people alone can turn an unnatural area into nature or wilderness." Bas Princen

„Die niederländische Landschaft ist gründlicher als irgendwo anders durchgeplant, programmiert und gestaltet. Modernistische Vorstellungen von Outdoor-Freizeitaktivitäten führten dazu, dass eine Flut von neuen ‚Landschaftstypen' geschaffen wurde: Safariparks, Motocross-Rennstrecken, Ruderkanäle. Jetzt, wo die Outdoor-Aktivitäten der Menschen von Produkten bestimmt werden, ist es aber nicht mehr nötig, die Landschaft selbst zu programmieren. Eine beliebige leere oder unerschlossene Fläche genügt völlig. Die Menschen definieren die Landschaft durch die Ausrüstung, die sie mitbringen. Diese rückt Merkmale und Bedingungen der Landschaft ins Bewusstsein, die man sonst nicht einmal bemerken würde."

„In einer Welt, in der die Freizeitindustrie zu jeder Zeit und an jedem Ort zuschlagen kann und auch zugeschlagen hat, grenzt es an ein Wunder, dass der Mensch noch das nicht-programmierte Abenteuer entdecken kann. Durch die Wahl der Nutzungsform kann nur der Mensch allein ein unnatürliches Gebiet in Natur oder unberührte Landschaft verwandeln." Bas Princen

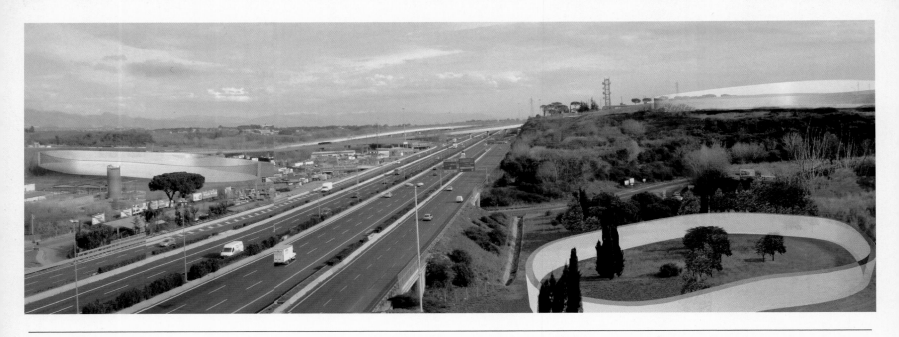

Emptiness

Leere IaN+ examine the tensions in peripheral urban spaces arising from dialectical areas of density and void. Reclaiming the voids around the city ring road is for them a route to understanding the urban identity of Rome. IaN+ untersuchen die Spannungsverhältnisse zwischen dichter Bebauung und leeren Flächen in städtischen Randgebieten. Die leeren Räume entlang des Autobahnrings aufs Neue zu besetzen ist für sie der Weg zum Verständnis der urbanen Identität von Rom.

"We need to develop our inner capacity to resettle our city, starting from a completely different approach. This requires civil actions destroying, somehow demolishing certain firmly held assumptions and replacing them with radically new ones." Stefania Manna, IaN+

The city of today is distinguished by the the fullness of its dimensions. It is an artificial territory, where urban politics and architecture have always spoken the language of power, made evident and actualized through built form and the multiplication of functional areas. One can read this fullness by examining its interwoven form, characterized by distributed mega-infrastructures, zones of pure consumption, and the prevalent singularity of multiple internalized voids. Today's metropolises live and grow in an auto-destructive process, ignoring the cultural forms and environmental characteristics of their local geographic locations. The resource of territory is considered to be unlimited, so metropolises effectively alienate themselves from their own genius loci , ultimately destroying the capacity of the environment to reproduce itself.

Rome is a special case, somehow perched between times: between ancient and modern. Here, one can easily decipher the cycle of destruction/construction/excavation in its "unedited" landscapes, providing an unexpected unifying presence in diverse areas of the city from a myriad of historical times.

Forming a ring around this historical center is the GRA (*Grande Raccordo Anulare*) highway. Constructed in the 1950s, the highway was intended as a kind of wall, a line of confinement and not as a developing system. It was hoped that it would somehow act like a "sacred ring" protecting the inner city from the difficult (and ambiguous) urbanity outside. The GRA was not made to grow rapidly since the city was not expected to expand so quickly, yet today the Rome metropolis has pushed towards, and even overtaken, the highway. This has provoked a transformation of the very notion of "centre" with the GRA itself now forming a new centrality, a trace on which the body of the eternal city continually to intensifies its density.

The GRA is a space of passage or transit, full of signs of the present. It is a contemporary fullness characterized by advertising on billboards that sym-

The built and the void confront one another, pushing back and forth until a total confusion is achieved.

bolize this present. Contrasting this fullness are closely connected spaces of emptiness or voids, often separated in most cases from the full spaces by time

„Wir müssen unsere innere Fähigkeit zur Neubesiedlung unserer Stadt entwickeln und dabei von einem völlig anderen Ansatz ausgehen. Das erfordert zivile Initiativen, die gewisse feststehende Annahmen irgendwie zerstören und sie durch radikal neue ersetzen." Stefania Manna, IaN+

Die zeitgenössische Stadt zeichnet sich durch die Fülle ihrer Dimensionen aus. Sie ist ein künstliches Territorium, auf dem Stadtpolitiker und Architekten seit jeher die Sprache der Macht sprechen – manifestiert und aktualisiert in gebauter Form und durch die Vervielfältigung von funktionalen Gebieten. Man kann diese Fülle analysieren, indem man ihre ineinander verwobenen Formen untersucht, die charakterisiert sind durch verteilte Mega-Infrastrukturen, reine Kommerz- und Konsumzonen und die Individualität multipler Innenräume. Die Metropolen von heute existieren und wachsen in einem selbstzerstörerischen Prozess, der die kulturellen Formen und ökologischen Besonderheiten ihrer geografischen Lage ignoriert. Die Ressource des Territoriums gilt als unbegrenzt ausdehnbar, weshalb sich Metropolen gewissermaßen von ihrem eigenen Genius loci entfremden und letztlich die Fähigkeit der Umwelt, sich selbst zu reproduzieren, zerstören.

Rom ist dabei ein Sonderfall und ist in der Schwebe zwischen Antike und Moderne. Hier lässt sich der Kreislauf von Zerstörung/Aufbau/Ausgrabung mühelos an „unredigierten" Stadtlandschaften ablesen und dadurch entsteht in unterschiedlichen Teilen der Stadt eine ungeahnte verbinden-

de Präsenz aus einer Unzahl historischer Epochen. Die 1950 gebaute Autobahn GRA (Grande Raccordo Anulare) führt um das historische Stadtzentrum herum und war als eine Art Stadtmauer gedacht, als Eingrenzungslinie und nicht als Stadtentwicklungssystem. Man hoffte, sie würde als eine Art „heiliger Ring" die Innenstadt vor der sie umgebenden schwierigen (und mehrdeutigen) Urbanität schützen. Der Bau der GRA war nicht auf großes Wachstum hin konzipiert, da man nicht davon ausging, dass die Stadt so schnell wachsen würde. Heute jedoch hat sich Rom sogar über die Ringautobahn hinaus weiter ausgedehnt. Dies löste eine Transformation des eigentlichen Begriffs „Zentrum" aus, denn die GRA schuf eine neue Art Zentralität: eine Spur, entlang der sich die Ewige Stadt in ihrer Dichte beständig intensiviert.

Die GRA ist ein Ort des Durchgangs und Übergangs gefüllt mit Gegenwartszeichen. Es ist eine zeitgenössische Fülle, die sich sich an den großen Werbewänden, Symbolen unserer Zeit, ablesen lässt. Kontrast zu dieser Fülle sind eng verbundene Räume der Leere oder Lücken, die sich von den Räumen der Fülle eher durch die Zeit als durch den Raum unterscheiden, wie Marc Augé bemerkt hat. Tendenziell sind es diese Leeren, die unsere Wahrnehmung der zeitgenössischen Stadt prägen und, ähnlich wie früher die alten Stadtmauern, unsere Stadtwahrnehmung lenken. So stehen sich Bebauung und leere Fläche gegenüber und arbeiten gegeneinander, bis die totale Konfusion erreicht ist.

[↖] "To isolate entire areas; to void them; eliminate the superfluous; demolish buildings; close access. These spaces will be forgotten and rediscovered at the end of the millennium, they will then be the city of the future." / „Gebiete in Gänze zu isolieren; sie zu leeren; das Überflüssige zu entfernen; Gebäude zu zerstören; den Zugang zu versiegeln. Diese Gebiete werden vergessen werden und am Ende des Jahrhunderts wiederentdeckt, diese Räume werden die Städte der Zukunft sein." Photomontage: IaN+

[↑] "Urban voids" along the GRA ringroad / „Urbane Leere" entlang der GRA-Ringstraße, photos: IaN+

'The GRA, as with many other infrastructural ring roads which are common in European cities, should be considered an obligatory passage, a compulsory transit-border, a filter between different urban densities. In reality it is a gateway to the city that doesn't so much divide inside from outside as represent a change of perception when you cross it. Being inside is a physical feeling and a psychological condition. Today the GRA traces the foundation of the city to come."
Stefania Manna, IaN+

„Wie viele andere Ringstraßen und Stadtringautobahnen in Europa sollte die GRA als obligatorische Passage, Transitbereich und Grenze gesehen werden, als Filter zwischen unterschiedlich dicht bebauten Stadtarealen. Tatsächlich bildet sie das ‚Tor' zur Stadt und trennt innen von außen nicht wesentlich voneinander, sondern repräsentiert vielmehr eine veränderte Wahrnehmung, wenn man sie überquert. ‚Innerhalb der Stadt zu sein' ist ein physisches Gefühl und ein psychologischer Zustand. Heute bildet die GRA das Fundament der zukünftigen Stadt Rom."

[←] "The GRA forms a kind of new wall, a trace on which the body of the eternal city continually intensifies its density, alternating landscapes of dense areas and empty ones."/ „Der GRA ist eine Art neue Stadtmauer, an deren Trasse die ewige Stadt kontinuierlich ihre Dichte intensiviert, sich abwechselnde Landschaften aus verdichteten und leeren Gebieten." Map / Karte: IaN+

[↙] "The voids are the property of the future city, their incompleteness contains promise." / „Die Leerstellen sind das Vermögen der Stadt der Zukunft, ihre Unvollständigkeit beinhaltet ein Versprechen." Map / Karte: IaN+

rather than by space, as Marc Augè suggested. These spaces of emptiness tend to represent our perception of the contemporary city, functioning as ancient city walls once did to define and focus our urban attentions. Thus, the built and the void confront one another, pushing back and forth until a total confusion is achieved.

We protest against this contemporary city form, stuck in an eternal present of consumption, where buildings and space are always replaceable. We propose installing walls for a period of one hundred years, a relatively small interval in the life of a city. This would permit the survival of uncultivated fields and demolished districts. They

We do not want to kill time by freezing it in an infinite present, we desire to void the enclosure so that it begins to play with time.

will become specialized spaces of waiting, enabling nature to wake within us, a portal for the temptations of both past and future.

We do not intend to conserve the emptiness as one would with historical buildings. Instead, we seek to initiate an action with results as intense as those of catastrophes and create voids that are capable of reactivating the fundamental nature of places. We do not want to kill time by freezing it in an in-

finite present, rather, we desire to void the enclosure so that it begins to play with time. At some point in the undefined future, we would forget these spaces, only to rediscover them at a later date. It is only at this moment, at this moment precisely, that we would be able to have a clear idea about the city of the future.

The Berlin Wall was a violent action that marked the city. A no man's land

Specialized spaces of waiting, portals for the temptations of both past and future.

ripped Berlin apart, but, at the same time, it made its people more sensitive and aware about the image of their wounded, but living, city. The wall ultimately created historical leaks, which made it possible to see time itself at work. Today, the Berlin Wall has fallen and its memory has given way to a blazingly fast and intimate unification. The wound was filled in too rapidly, allowing the city to erase a precious well of memories. The void could have become the new face of the city. When the wall we build up is removed, the voids will not be filled up again.

Wir protestieren gegen diese zeitgenössische Form der Stadt, die dem steten Konsum unterworfen ist und in der Bauten und Räume stets austauschbar sind. Wir schlagen vor, für einen Zeitraum von hundert Jahren – in der Lebensdauer einer Stadt eine relativ kurze Zeitspanne – Mauern zu errichten, die den brach liegenden Feldern und Abrissvierteln ihr Überleben sichern würden. Daraus würden spezielle Wartezonen entstehen, in denen die Natur erwachen kann – ein Portal für die Verheißungen der Vergangenheit und der Zukunft.

Wir haben nicht die Absicht, die Leere zu konservieren, wie dies mit historischen Bauten gemacht wird. Stattdessen wollen wir eine Aktion initiieren, deren Resultat den Reaktionen, die auf eine Naturkatastrophe folgen, gleichen sollte: Wir wollen Lücken schaffen, die es ermöglichen sollen, die elementare Natur eines Ortes zu reaktivieren. Wir wollen die Zeit nicht aufhalten, indem wir sie in einer unendlichen Gegenwart einfrieren. Es ist unser Wunsch, den Inhalt mit Leere zu füllen, so dass das Spiel mit der Zeit beginnt. Irgendwann hat man dann diese Orte vergessen, um sie viel später wieder zu entdecken. Erst dann wird man sich klare Vorstellungen von der Stadt der Zukunft machen können.

Der Bau der Berliner Mauer war ein Gewaltakt, der die Stadt mit dem Niemandsland des Mauerstreifens in zwei Teile riss, die Bevölkerung zugleich aber auch feinfühliger machte und sie das Bild ihrer verwundeten, aber lebendigen Stadt bewusster sehen ließ. Die Mauer schuf letztlich historische „Lecks", die es ermöglichten, die Zeit selbst am Werke zu sehen. Heute gibt es die Berliner Mauer nicht mehr und die Erinnerung daran hat die Wiedervereinigung rasant beschleunigt. Die Wunde wurde viel zu schnell geschlossen und der Stadt wurde eine kostbare Quelle der Erinnerung genommen. Die Lücken hätten zum neuen Gesicht der Stadt werden können. Wenn die Mauer, die wir bauen wollen, abgerissen wird, soll die Leere, die sie hinterlässt, nicht wieder gefüllt werden.

"The big topic of today, and of the next 20 years, will be peripheries. How you can transform peripheries into a town. The peripheries are the city that will be. Or not. Or will never be." Renzo Piano

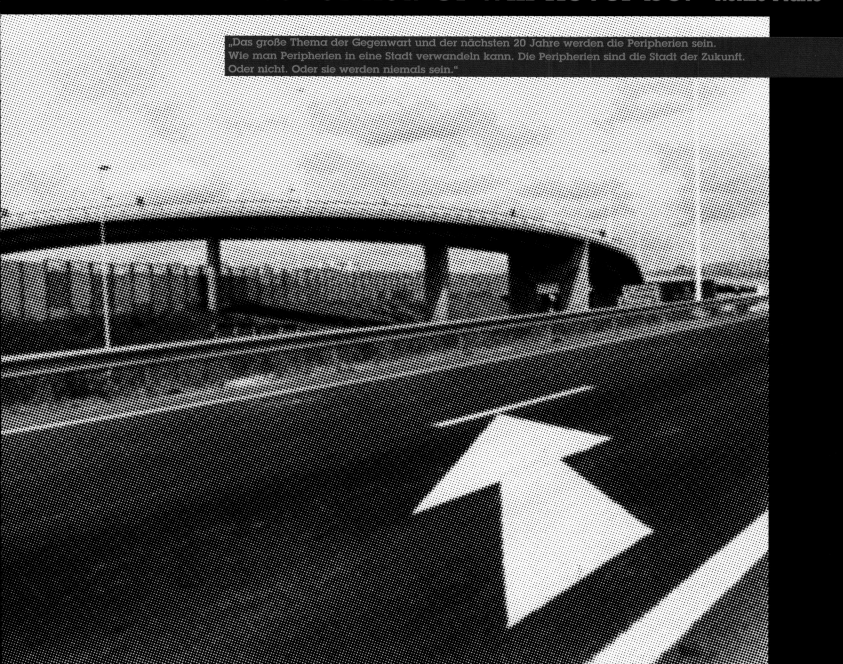

„Das große Thema der Gegenwart und der nächsten 20 Jahre werden die Peripherien sein. Wie man Peripherien in eine Stadt verwandeln kann. Die Peripherien sind die Stadt der Zukunft. Oder nicht. Oder sie werden niemals sein."

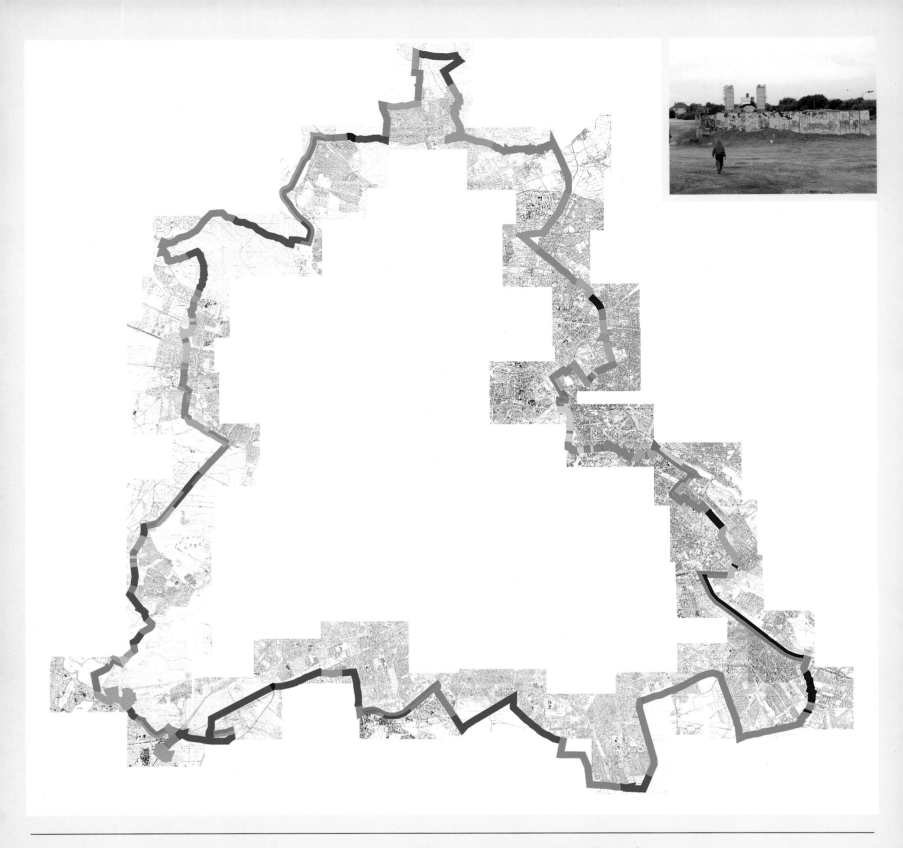

Berlin Wall(k)

Berliner Mauer(spaziergang) The following is a text collage, based on a series of conversations with and between the members of Studio E.U. (Paola Cannavò, Maria Ippolita Nicotera, Francesca Venier) based in Berlin, and the Italian group Stalker (Iacopo Gallico Romolo Ottaviani). They comment on their general approach to urbanism, the city, and architecture, and their recent joint project in Berlin: Wall(k). Der folgende Text ist eine Zusammenstellung von Ausschnitten aus Gesprächen mit und zwischen Mitgliedern des Berliner Büros studio.eu (Paola Cannavò, Maria Ippolita Nicotera, Francesca Venier) und der italienischen Gruppe Stalker (Iacopo Gallico Romolo Ottaviani). Sie äußern sich über ihre generelle Herangehensweise zum Städtebau, der Stadt an sich, Architektur und ihr jüngstes Gemeinschaftswerk in Berlin: Wall(k).

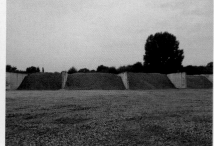

[←] Analysis and cartography of the former "Wall area" / *Analyse und Kartographie des ehemaligen Mauergebiets*, Berlin and Brandenburg, 2005, map / *Karte:* studio.eu

[↑] Photo series of the project "wall(k)", taken along the former "Wall strip" / *Photoserie des Projekts „wall(k)",* *aufgenommen entlang des Mauerstreifens*, Berlin and Brandenburg, 2005, photos: studio.eu

Many contemporary cities are divided into two different perspectives or zones: The first, which we consider to be the positive one, is where we all live and act as a society at large. It is the normal urban developmental pattern. The second, the negative one, contains abandoned areas or spaces that are not useful for the positive pattern, but nonetheless exist in an osmotic relationship with it. In this sense, we see the city as a living organism, and we are interested in the active processes of transformation, shrinking and development one finds in the city today.

Cities are under constant transformation. These changes are now happening very fast, which means one needs to provide a flexible framework, which can incorporate a process capable of accommodating, at any moment, the most unlikely adaptations into its development. Thus our work and research efforts are preoccupied not just with space, but also with the agents that contribute to its sustenance and modification. Our projects seek to become instruments for assessing, mediating, and re-arranging a set of conditions and situations, which should never become obstacles, rather constitute an enriching opportunity instead.

Our lives take place between Berlin and various places in Italy, and our work is greatly influenced by the strongly contrasting daily realities of these two places. Adapting between these two cultures, their affinities and differences, exposes the many rifts as well as similarities from which our particular way of looking at urban issues arises.

The Wall left a clear incision in the urban structure of Berlin. When this space began to be reclaimed all the phenomena which constitute urban development and decline crystallized within it – much more quickly and drastically than anywhere else. We see it as a concentrated manifestation of many of the sources of urban conflict that are prevalent everywhere – a near-perfect paradigm from which to develop a more general understanding of the processes of urban transformation which interest us.

Wall(k) is a research project which seeks to provoke public discussion and debate. It explores these incredibly fast transformation processes that have occurred here, with an eye towards linking them to the greater urban and socio-political concerns of contemporary urban development in other contexts. Many of the things that have happened here in Berlin over the last 15 years generally take much longer – say 50 years or more – elsewhere.

We have found that talking about empty urban spaces means talking directly about a process of transformation and identity. We don't think that politics and political decisions are enough to transform these empty spaces alone. We wondered how to start a process for interested people or planners to help change the space, to develop it, to give it a new face and a new meaning. Ultimately, mapping and sharing the immediate experience of such a space and its multiple components provides a means of comprehending, in all their complexity, all the transformations that have taken place there. It is also an inverted approach to understanding other, analogous situations. The challenge is to learn how to discern characteristics and dynamics of new urban landscapes in other contexts.

Viele Städte sind heute in zwei verschiedene Perspektiven oder Zonen aufgeteilt. Bei der ersten, die wir für die positive halten, handelt es sich um den Raum, in dem wir alle als Gesellschaft leben und handeln. Er stellt das normale Stadtentwicklungsmuster dar. Die zweite, negative Zone umfasst verlassene Flächen oder Räume, die nicht auf das positive Muster übertragen werden können, aber dennoch in einer osmotischen Beziehung dazu stehen. In diesem Sinne sehen wir die Stadt als lebenden Organismus und interessieren uns für die aktiven Prozesse der Transformation, Schrumpfung und Entwicklung in der Stadt von heute.

Städte verändern sich eigentlich ständig. Heute tun sie das sehr schnell, so dass man einen flexiblen Rahmen schaffen muss, in dem sich ein Prozess vollziehen kann, der jederzeit Anpassungen – selbst die undenkbarsten – an laufende Entwicklungen zulässt. Deshalb befassen wir uns in unserer Arbeit und bei unseren Forschungen nicht nur mit dem Raum, sondern auch mit den in ihm wirksamen Kräften, die zu seiner Erhaltung und Veränderung beitragen. Unsere Projekte wollen Instrumente zur Bewertung, Vermittlung und Umgestaltung verschiedener Zustände und Situationen sein, die niemals Hindernisse bilden dürfen, sondern vielmehr bereichernde Möglichkeiten darstellen.

Unser Leben findet statt zwischen Berlin und unterschiedlichen Orten in Italien und dadurch ist unsere Arbeit in hohem Maß von den gegensätzlichen Alltagsrealitäten Deutschlands und Italiens beeinflusst. Die Anpassung an diese beiden Kulturkreise mit ihren Affinitäten und Unterschiedlichkeiten deckt nicht nur die vielen Unterschiede auf, die uns trennen, sondern auch die Ähnlichkeiten, aus denen wir unsere besondere Sicht auf urbane Fragen beziehen.

Die Mauer hinterließ einen deutlichen Einschnitt im Stadtgefüge von Berlin. Als der Mauerstreifen aufs Neue beansprucht wurde, kristallisierten sich dort all die Phänomene von Stadtentwicklung und Stadt-

verfall heraus – aber viel schneller und drastischer als irgendwo sonst. Wir sehen dies als konzentrierte Manifestation des Ursprungs von zahlreichen städtischen Konflikten, die es überall gibt – ein fast vollkommenes Paradigma, aus dem man ein breiteres Verständnis der urbanen Transformationsprozesse, für die wir uns interessieren, entwickeln kann.

Wall(k) ist ein Forschungsprojekt, das eine öffentliche Diskussion auslösen soll. Hierbei werden die unglaublich schnellen Transformationsprozesse, die in dieser Stadt stattgefunden haben, untersucht, jedoch mit Blick auf ihre Verbindungen mit den übergreifenden städtischen und sozio-politischen Inhalten der zeitgenössischen Stadtentwicklung in anderen Zusammenhängen. Viele der Veränderungen, die in Berlin in den letzten fünfzehn Jahren stattgefunden haben, dauern in der Regel anderswo viel länger: vielleicht fünfzig Jahre oder mehr.

Wir haben festgestellt, dass man, wenn man über urbane Leerstellen spricht, unweigerlich einen Prozess der Transformation und Identitätsfindung meint. Wir glauben nicht, dass Politik und politische Entscheidungen allein genügen, um diese leeren Flächen zu verändern. Wir stellten uns die Frage, wie wir einen Prozess in Gang bringen konnten, um interessierte Menschen oder auch Planer dafür zu gewinnen, bei der Umgestaltung aktiv zu werden, sich an der Entwicklung zu beteiligen und den leeren Flächen ein neues Gesicht, eine neue Bedeutung zu geben. Durch das Kartographieren und das unmittelbare gemeinsame Erleben eines solchen Raums und seiner vielfachen Komponenten erhält man letztendlich ein tieferes Verständnis für seine Komplexität, für jegliche Transformationen, die dort stattgefunden haben. Umgekehrt führt dieser Ansatz dazu, andere, analoge Situationen zu begreifen und die Herausforderung besteht darin, die Merkmale und die Dynamik neuer Stadtlandschaften in anderen Zusammenhängen zu begreifen.

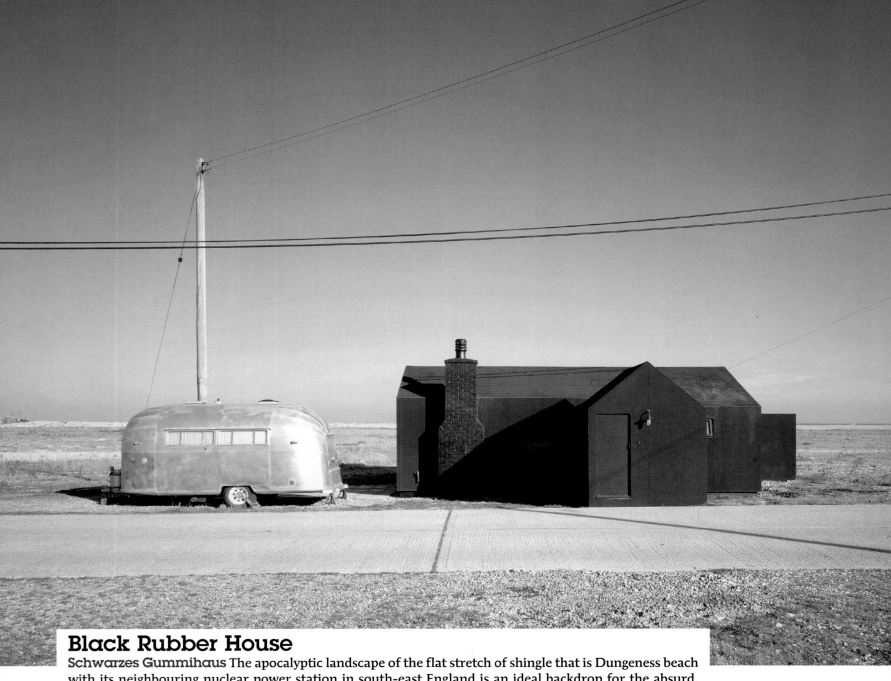

Black Rubber House

Schwarzes Gummihaus The apocalyptic landscape of the flat stretch of shingle that is Dungeness beach with its neighbouring nuclear power station in south-east England is an ideal backdrop for the absurd, the surreal and the unexpected: A place where architectural anachronisms, like architect Simon Conder's black rubber house, feel right at home. Der apokalyptisch anmutende, flache Kiesstrand von Dungeness und das benachbarte Atomkraftwerk an der Südküste Englands bilden die ideale Kulisse für das Absurde, Surreale und Überraschende: ein Ort, an dem architektonische Anachronismen wie das schwarze Gummihaus des Architekten Simon Conder sich wie zu Hause fühlen.

Our black rubber house on Dungeness beach in Kent is a very personal response to an extraordinary place.

The ultimate "edge" community, Dungeness is literally and emotionally at the end of the road, situated as it is at the tip of a peninsular projecting into the English Channel. It is a place of strange alienation and rough beauty, blasted by both the wind and the sea, and dominated by a massive 1950s nuclear power station. At 31 square kilometres it is the largest area of shingle beach in Europe, and over the last hundred years this essentially unstable and moving site has become home to a very unusual squatter settlement, a classic example of "Non-Plan" and a place of architectural lawlessness.

The community that developed here were essentially outsiders – an unusual combination of fisherman and exiles from the city – and the individual homes often started life as redundant railway carriages. Over time this core module would

Unser Haus aus schwarzem Gummi am Strand von Dungeness in Kent ist eine sehr persönliche Reaktion auf diesen ungewöhnlichen Ort.

Dungeness, diese ultimative Randsiedlung, liegt tatsächlich am Ende einer Sackgasse; weit weg von jeder Stadt, auf der Spitze einer Halbinsel im Ärmelkanal. Es ist ein entlegener, befremdlich anmutender Ort, vom Wind und von Brandungswellen gepeitscht und von einem massiven Atomkraftwerk der 1950er Jahre beherrscht. Mit seinen 31 km² ist der Kiesstrand von Dungeness der größte Europas und in den letzten hundert Jahren ein im Wesentlichen unsteter Ort gewesen, der ständig seine Form ändert. Hier hat sich eine ungewöhnliche Landbesetzerszene angesiedelt und ein klassisches Beispiel des „Non-Plan", also des Ungeplanten und der architektonischen Gesetzlosigkeit geschaffen.

Die Leute, die hier eine neue Art von Dorfgemeinschaft geschaffen haben, waren überwiegend Aussteiger, aber auch Fischer und Stadtflüchtlinge. Viele lebten zunächst in alten Eisenbahnwaggons,

"Because the rubber is all over it,
comes all the way down to the ground,
people have been coming up to the house and
stroking it, touching and feeling it.
In a way it has a slightly kinky appeal."
Chris Neve, Simon Conder Associates

„Weil es komplett mit Gummi überzogen ist,
kommen die Leute bis zum Haus und streicheln
es, berühren und befühlen die Oberfläche. Irgend-
wie hat es einen etwas schrulligen Charakter."

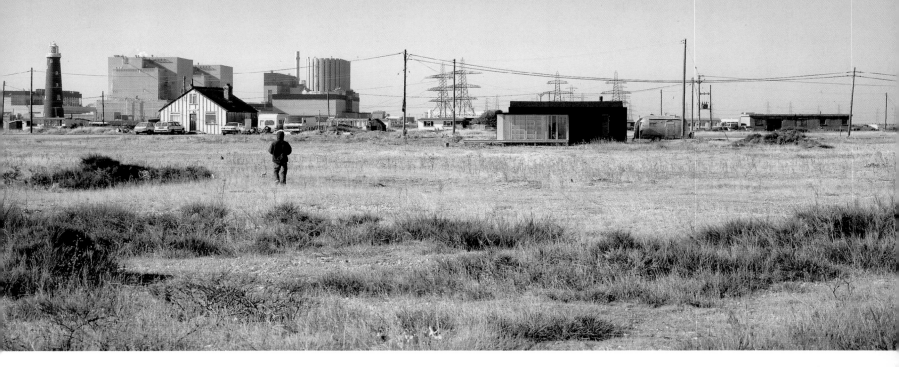

[↖] "Black Rubber Beach House", west-facing elevation, Dungeness / *Schwarzes Gummistrandhaus", Ansicht West, Dungeness*, Simon Conder Associates 2003, photo: Chris Gascoigne

[↑] "Black Rubber Beach House", east-facing elevation with Dungeness nuclear power station beyond / *"Schwarzes Gummistrandhaus", Ansicht Ost, im Hintergrund das Atomkraftwerk von Dungeness*, Simon Conder Associates 2003, photo: Chris Gascoigne

be extended, normally in a series of small stages, to form bigger homes. The result is an architecture of improvisation and bodge.

Our challenge, as contemporary architects, was to devise a means of intervention that would sit comfortably with its neighbours and not destabilize this unique but essentially fragile infrastructure.

Like the film-maker Derek Jarman's famous house and garden only six hundred metres away, our completed house has taken on its own afterlife, attracting large numbers of visitors, as well as its own fan mail.

In a recent interview on Channel 4 television, our client recounted how in one letter, addressed simply to "The Black Rubber Beach House, Dungeness, Kent", the writer said he wanted to buy the house, should the owners ever leave. Our client's response was that she had no plans to sell because she intended to die there.

den „Kernmodulen", aus denen in kleinen Schritten immer größere Wohneinheiten wurden. Das Ergebnis ist eine Architektur der Improvisation und des Selbstgemachten.

Als zeitgenössische Architekten standen wir vor der Herausforderung, etwas zu entwerfen, das einerseits zu den Nachbarhäusern passen würde, andererseits deren einzigartiges und im Grunde zerbrechliches Gefüge nicht stören sollte.

Wie beim berühmten Haus und Garten des Filmemachers Derek Jarman, das nur 600 m entfernt steht, hat auch unser fertiges Haus sein Eigenleben entwickelt: Es lockt nicht nur viele Besucher an, sondern bekommt inzwischen sogar eigene Fanpost.

Vor kurzem hat unsere Bauherrin in einem Fernsehinterview erzählt, dass jemand in einem nur an „Das schwarze Gummistrandhaus, Dungeness, Kent" adressierten Brief schrieb, er wolle das Haus kaufen, sollten die jetzigen Besitzer es jemals verlassen. Unsere Bauherrin schrieb zurück, dass sie keinerlei Absicht habe, es zu verkaufen, denn sie beabsichtige, darin zu sterben.

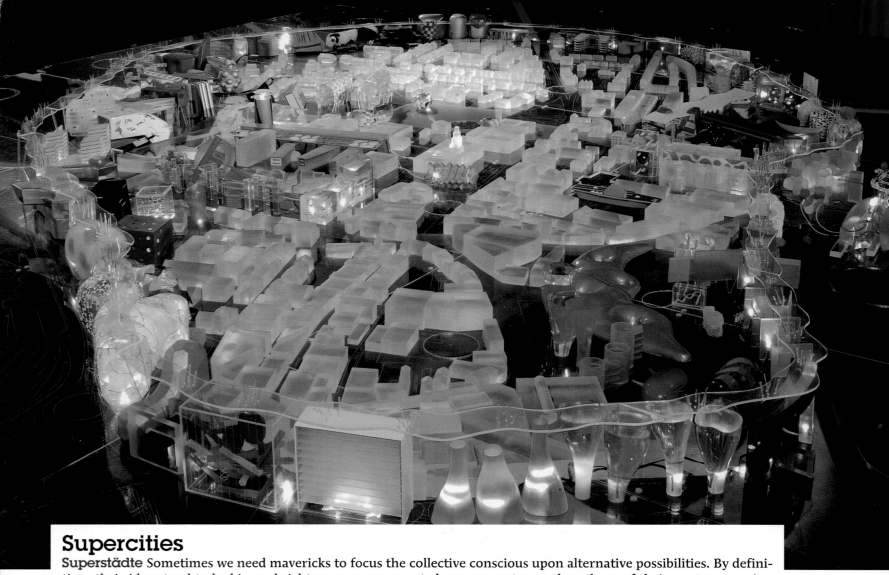

Supercities

Superstädte Sometimes we need mavericks to focus the collective conscious upon alternative possibilities. By defini-
tion, their ideas tend to be bigger, brighter, more exaggerated or more extreme than those of their contemporaries.
They also have to shout louder to get their point across and expect to take a lot of flak when they do so. City planning
is one of the most loaded issues of our age – and one heavily burdened with the negative feedback of the recent past.
Manchmal braucht es Außenseiter, um das kollektive Bewusstsein auf alternative Möglichkeiten zu lenken. Per Defi-
nition sind ihre Ideen tendenziell größer, strahlender, übertriebener oder extremer als die ihrer Zeitgenossen. Sie müssen
sich auch offensiver bemerkbar machen, um ihren Standpunkt zu vertreten und sind darauf eingestellt, unter Beschuss
zu geraten, sobald sie dies tun. Die Stadtplanung ist eines der aufgeladensten Themen unserer Zeit – und eines, auf
dem das negative Feedback der jüngeren Vergangenheit schwer lastet.

The British architect Will Alsop is known for his large-scale designs,
penchant for colour and outlandish approach. He has produced mas-
terplans for a number of northern English industrial cities such as
Bradford, Barnsley and Manchester. With his "Supercity" project of
2005 he proposed a development plan for the coast to coast conur-
bation that follows the M62 motorway stretching from Liverpool to
Hull; an area 20 miles wide, 130 miles long and with a population
of some 15.5 million that has distinct parallels with the Ruhr area
in Germany.

Like with the Ruhr district, industry and commerce has moved
on for many of the traditional cities in this area taking, as Alsop says,
their *raison d'être* and therefore their sense of identity with it. He
believes that this sense of identity can be regained by abandoning
territorial rivalry and creating a feeling of collective belonging to the
entire area via increased mobility, specialisation and new settlement
areas of "high energy". Thus the "Supercity" would contain: "a pop-
ulation that considers the entire region to be their local neigh-
bourhood, living in Liverpool, shopping in Leeds and clubbing in
Manchester."

The advantages of this "Supercity" concept over traditional ways
of looking at urbanism begin for Alsop with this sense of belonging:
"What I realized is that the people who live in this multitude of
towns and cities actually use everyone else's city to do everything
they want – and so, it is in fact one city. And yet, there's enormous
civic pride attached to each of the little towns there. For the local

*Der britische Architekt Will Alsop ist bekannt für seine im großen Maß-
stab angelegten Entwürfe und seinen Hang zu Farbigkeit und außergewöhn-
lichen Ansätzen. Er hat Bebauungspläne für eine Reihe von nordenglischen
Industriestädten wie Bradford, Barnsley und Manchester erstellt. Mit sei-
nem Projekt Supercity („Superstadt") von 2005 hat er einen gewaltigen, zu-
sammenhängenden Bebauungsplan für das Ballungsgebiet vorgelegt, das sich
von Küste zu Küste entlang der Autobahn M62 von Liverpool bis Hull er-
streckt. Das ist ein Gebiet mit einer Breite von rund 30 km, einer Länge von
ca. 200 km und einer Bevölkerung von ungefähr 15,5 Millionen Einwoh-
nern; es weist deutliche Parallelen zum Ruhrgebiet in Deutschland auf.*

*Wie im Ruhrgebiet sind auch hier Industrie und Handel weitergezogen
und haben vielen der traditionellen Städte in diesem Gebiet ihren Daseins-
zweck und ihre Identität genommen, wie Alsop es formuliert. Er glaubt, dass
diese Identität wiedergewonnen werden kann, wenn man territoriale Riva-
litäten aufgibt und in der gesamten Region durch eine höhere Mobilität,
durch Spezialisierung und neue, dicht konzentrierte Siedlungsgebiete ein kol-
lektives Zugehörigkeitsgefühl schafft. Somit sähe die „Superstadt" folgender-
maßen aus: „Einwohner, die die gesamte Region als ihre unmittelbare Nach-
barschaft betrachten - Leben in Liverpool, Einkaufen in Leeds und Ausge-
hen in Manchester."*

*Der Vorteil dieses „Superstadt"-Konzepts gegenüber traditionellen stadt-
planerischen Ansätzen beginnt für Alsop beim Zugehörigkeitsgefühl: „Ich
stellte fest, dass die Menschen, die in dieser Vielzahl von kleineren und grö-
ßeren Städten leben, eigentlich jeweils die Städte der anderen nutzen, um al-
les zu tun, was sie möchten – und somit handelt es sich in Wirklichkeit um*

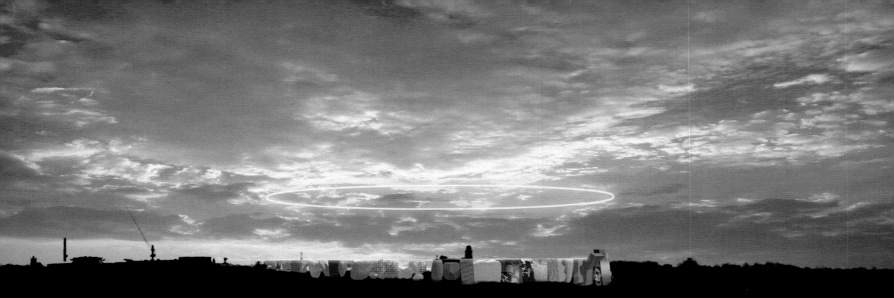

"If you do a project on the scale of a city, it would be almost sinister if part of your intentions were not utopian, if utopian means to be connected to an ambition to realise some measure of an ideal condition" Rem Koolhaas

„Wenn man ein Projekt von der Größenordnung einer Stadt umsetzt, dann wäre es beinahe unheimlich, wenn ein Teil der eigenen Pläne nicht auch utopisch wäre, sofern utopisch bedeutet, dass man die Ambition hat, in gewissem Maß einen Idealzustand herzustellen."

"Perhaps an architect has an obligation to have an utopian vision and at the same time an equal obligation to be realistic about the futility of these utopian ambitions." Rem Koolhaas

„Vielleicht hat ein Architekt die Pflicht zur utopischen Vision und gleichzeitig dieselbe Pflicht, die Aussichtslosigkeit dieser utopischen Ambitionen realistisch zu betrachten."

[↖] "New Barnsley" from above: new development around the town centre would form a "living wall" with public space above it. Eventually the wall would join up so that people could walk around the town centre on top of the buildings. / „Neu-Barnsley" von oben: die Neuentwicklung um das Stadtzentrum herum formt eine Art „lebende Mauer", auf der öffentlicher Raum entsteht. Nach und nach würde die Mauer sich schließen, so dass die Menschen auf den Dächern um das Stadtzentrum herumspazieren könnten. Photo: Alsop Architects

[↑] Will Alsop's masterplan of how Barnsley could look in 30 years: the colourful wall and illuminated halo above would make the town visible for miles. Alsop likens his redesign of this northern English industrial town to a 21st century "Tuscan hill village". / Will Alsops Masterplan, wie Barnsley in 30 Jahren aussehen könnte: Die farbenprächtige Wand und der leuchtende Kreis machen die Stadt über große Entfernungen sichtbar. Alsop vergleicht seine Neugestaltung dieses nördlichen Industrieortes mit einem „toskanischen Hügeldorf" des 21. Jahrhunderts. Photomontage: Alsop Architects

people, each place has a particular individuality, which is important to them."

For the Supercity, as with other large-scale urban projects, transport is key but Alsop does not dwell much on details in his proposal except to say that existing transport links – i.e. the motorway – combined with "where possible, high speed rail" would form the core around which the Supercity should be built. The M62 should function like a river along which the new polycentric settlements with giant buildings containing up to 5,000 inhabitants would take hold: "These would and should be extraordinary structures that litter the landscape as objects of curiosity and wonder in the manner of the castles of the Welsh Marches."

It will be travellers, rather than transports, who will define Alsop's future vision: Through his studies of the area he has found that there are many weekly "hostellers" who tend to stay in peripheral and isolated motels for days at a time. He proposes pulling these working-week nomads into the centres of the new communities by placing hotels at key central points. They would then enrich the fabric of local identity by bringing their experiences with them in a Chaucerian tableau of tales in taverns: "Our future travellers become the people who establish the identities for the new towns – a network of stories beautifully told." SL

eine einzige Stadt. Und dennoch hat jede dieser kleinen Städte einen ungeheuren Stolz. Für die lokale Bevölkerung hat jeder Ort seine besondere Individualität, die ihnen wichtig ist."

Bei der Superstadt ist, wie bei anderen städtischen Großprojekten, der Verkehr entscheidend, aber Alsop geht in seinem Vorschlag nicht näher auf Einzelheiten ein. Er sagt lediglich, dass bestehende Verkehrsverbindungen - etwa die Autobahn - in Kombination mit „Hochgeschwindigkeitszügen, wo möglich" den Kern bilden würden, um den herum die Superstadt entstehen soll. Die M62 soll wie eine Art Fluss fungieren, an dessen Ufern sich die neuen polyzentrischen Siedlungen mit gigantischen Gebäuden für bis zu 5.000 Bewohner ansiedeln würden: „Das könnten und sollten außergewöhnliche Bauten sein, die über die Landschaft verstreut sind als Objekte der Neugier und des Staunens im Stil der Burgen des Waliser Grenzlandes."

Es werden wohl eher die Reisenden als der Verkehr sein, die die zukünftige Vision Alsops definieren: Als er das Gebiet untersuchte, stellte er fest, dass es dort während der Woche viele Pendler gibt, die für mehrere Tage hintereinander in den isoliert gelegenen Motels der Peripherie übernachten. Er schlägt vor, diese Arbeitswochen-Nomaden durch den Bau von Hotels an zentralen Schlüsselpunkten in die Zentren der neuen Gemeinschaften zu integrieren. Diese Menschen würden dann das lokale Identitätsgefüge bereichern, indem sie ihre Erfahrungen wie die Reisenden in den Tavernen aus Chaucers Erzählungen mitbringen: „Unsere Reisenden der Zukunft würden diejenigen sein, die die Identität der neuen Städte schaffen - ein Netzwerk an Geschichten, wunderbar erzählt." SL

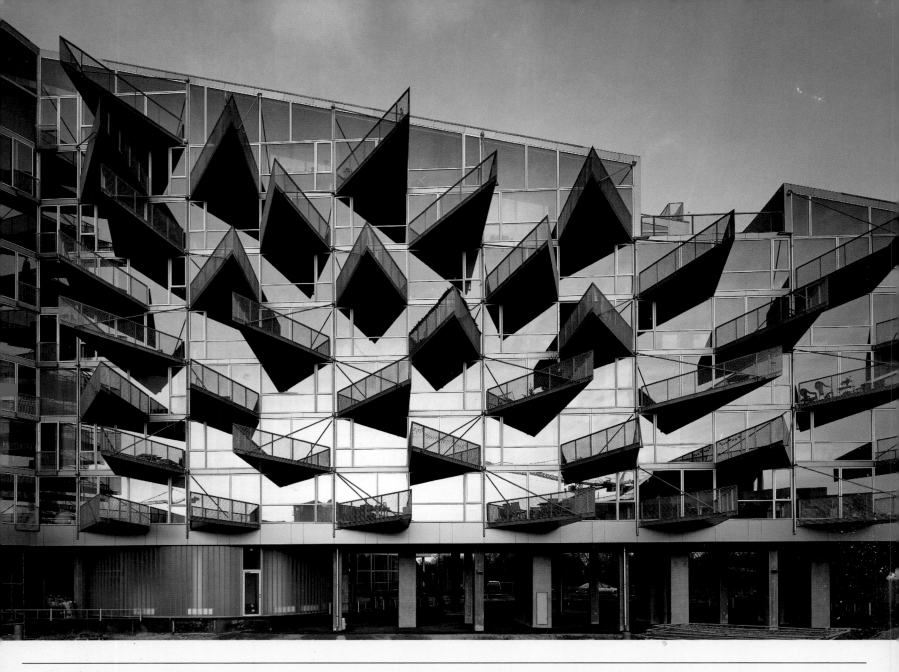

Pragmatic Utopias:
The CPH Experiments

Pragmatische Utopien: die CPH-Experimente As co-founder of the Danish architectural firm PLOT and founder of B.I.G., Bjarke Ingels dares to ressurect the utopian question, tempers it with contemporary pragmatism and proposes a new generation of *Unité* living in peripheral environments. Als Mitbegründer des dänischen Architekturbüros PLOT und Gründer von B.I.G. wagt es Bjarke Ingels, die Frage nach der Utopie neu zu stellen, indem er sie mit zeitgenössischem Pragmatismus „abmildert" und eine neue Generation von *Unité*-Wohnungen in städtischen Randgebieten entwirft.

u·to·pi·a: An ideally perfect place, especially in its social, political, and moral aspects.
prag·mat·ic: Dealing or concerned with facts or actual occurrences; practical.

Historically, the field of architecture has been dominated by two opposing extremes: an avant-garde full of wild ideas (that are often so detached from reality that they fail to become anything other than eccentric curiosities) and well-organised corporate consultants that design and build good quality but predictable and boring boxes. Architecture seems to be entrenched in two equally infertile fronts: Either naively utopian or petrifyingly pragmatic.

U·to·pie: ein idealerweise perfekter Ort, besonders im Hinblick auf seinen gesellschaftlichen, politischen und ethischen Aspekt.
Prag·ma·tisch: *die Auseinandersetzung oder die Beschäftigung mit Fakten oder tatsächlichen Vorkommnissen; zweckmäßig.*

Historisch gesehen war und ist das Betätigungsfeld der Architektur von zwei entgegengesetzten Extremen geprägt: einerseits einer Avantgarde von „wilden" Ideen (die vielfach so fern jeder Realität sind, dass sie nichts anderes als exzentrische Kuriositäten bleiben) und andererseits gut durchorganisierten Architekturbüros, die zwar gute Qualität liefern, aber doch nur in der vorhersagbaren Form langweiliger Kastenbauten. Die Architektur scheint in zwei glei-

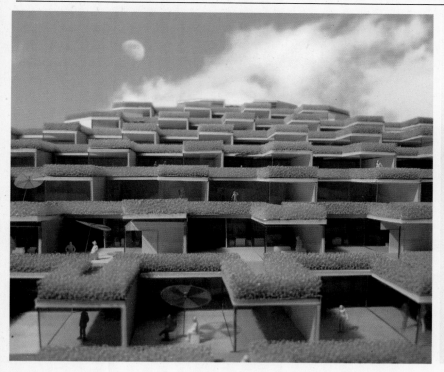

We believe that there is a third way wedged in the no man's land between diametrical opposites – or in the small but very fertile overlap between the two. A pragmatic utopian architecture that takes on the creation of socially, economically and environmentally perfect

By hitting this fertile overlap zone we architects have a chance at changing the surface of our planet, not through revolution, but pragmatic utopian evolution.

places as a practical objective. Not in terms of universal solutions to generic problems, but rather as the creation of specific interventions in restricted areas of operation. By hitting this fertile overlap zone we architects have a chance at changing the surface of our planet, to better fit the way we want to live: not through universal revolution, but rather through pragmatic utopian evolution.

The problem with the modernist utopia was the idea that a solution was only credible if it was universally applicable. The result was vast areas governed by very few ideas and universal repetition of those areas eliminating surprise and exploration from the urban experience. The big idea ended up eliminating the small event. As a consequence Danish architecture has been paralysed by an agoraphobic fear of the "big". Big projects and big ideas have been dismissed from the repertoire of Danish architecture. Danish architects have lost the interest or the courage to deal with big problems, and have spent the last 50 years perfecting smaller and smaller details of the same small scale urban typologies – until now.

Over the last five years we [B.I.G.] have been involved in projects of increasing size and complexity. Due to a radical rise in real estate value, decreasing interest rates and explosive housing demand, Copenhagen seem to have turned into our own little laboratory for new urban life forms. In a series of projects we have tested the effects of scale and the balance of programmatic mixtures on the social, economical and ecological outcome. Like a form of alchemy we have tried to create architecture by mixing conventional ingredients such as living, leisure, working, parking and shopping. Each of our building sites is a test bed for its own pragmatic utopian project.

The paradox of being an architect is that you want to live and work in the city, but the available building slots are always on the peripheries. Here there is actually no historical context. On one side you have got a big open field of green and on the other side you have a flat landscape of single-family homes. There are no historical limitations, there is no existing identity in terms of

Danish architects have lost the interest or the courage to deal with big problems.

architectural culture that you need to respect. So it seems to be a laboratory for evolving new urban life forms – things that are completely impossible in more preserved historical areas: Where there is nothing, everything is possible.

We are currently working on a project for a private developer, which is a combination of two thirds of parking and one third of housing in a total area of 25,000m². Since Copenhagen has absolutely no topography and is com-

chermaßen „unfruchtbaren Fronten" fest verwurzelt zu sein: entweder naiv utopisch oder streng pragmatisch.

Wir glauben, dass es einen dritten Weg gibt, der durch das Niemandsland zwischen weit auseinanderklaffenden Gegensätzen führt – oder aber durch den schmalen, jedoch sehr fruchtbaren Landstrich, auf dem sich die Gegensätze überlagern. Dieser dritte Weg ist eine pragmatisch-utopische Architektur mit dem praktisch-konkreten Ziel, gesellschaftlich, wirtschaftlich und ökologisch makellose Orte zu schaffen – nicht im Sinne universeller Lösungen für allgemeine Probleme, sondern im Sinne maßgeschneiderter Eingriffe auf begrenzten Aktionsfeldern. Wenn wir auf diese fruchtbare Überschneidungszone treffen, haben wir Architekten die Chance, die Oberfläche unseres Planeten so zu verändern, dass sie sich besser für die von uns gewünschte Lebensweise eignet, und zwar nicht durch universale Revolution, sondern durch eine pragmatisch-utopische Evolution.

Das Problem mit den modernen Utopisten war ihre Vorstellung, nur eine universell anwendbare Lösung wäre auch eine glaubwürdige. Das führte zu ausgedehnten, nur von wenigen gestalterischen Ideen geprägten Bebauungen und die universelle Wiederholung solcher Bebauungen beraubte das Stadterlebnis aller Überraschungen und Entdeckerfreuden. Der große Gedanke vernichtete schließlich das kleine Ereignis. Infolgedessen ist die dänische Architektur wie gelähmt von einer Art Agoraphobie vor dem „Großen". Großprojekte und großartige Ideen sind aus dem Repertoire der dänischen Architektur verbannt worden. Dänische Architekten haben kein Interesse mehr daran – oder trauen sich nicht mehr –, große Aufgaben zu lösen. Sie haben die letzten fünfzig Jahre damit verbracht, immer kleinere Details der immer gleichen kleinteiligen städtischen Bautypen zu perfektionieren – und tun es heute noch.

In den vergangenen fünf Jahren haben wir [B.I.G.] an zunehmend größeren und komplexeren Bauvorhaben gearbeitet. Aufgrund von drastisch gestiegenen Grundstücks- und Immobilienpreisen, sinkenden Zinsen und explodierender Nachfrage hat sich Kopenhagen offenbar zu unserem eigenen kleinen Labor für neue städtische Wohnformen entwickelt. Mit einer Reihe von Entwürfen haben wir die sozialen, ökonomischen und ökologischen Auswirkungen von Maßstäblichkeit und ausgewogen gemischtem Raumprogramm auf die Ergebnisse getestet. In einer Art alchemistischem Prozess haben wir uns bemüht, Gebäude mit einer Mischung konventioneller Nutzungen (Wohnen, Freizeit, Arbeit, Parken, Einkaufen) zu schaffen. Jedes unserer Baugrundstücke ist ein Testgebiet für sein ureigenes pragmatisch-utopisches Projekt.

Für uns besteht das Paradoxe eines Architekten darin, dass er meist mitten in der Stadt leben und arbeiten möchte, die Baugrundstücke aber fast immer an der Peripherie liegen, in der keine historisch gewachsene, gebaute Umwelt existiert. Auf der einen Seite hat man die große grüne Wiese, auf der anderen die mit Einfamilienhäusern bebaute Flachlandsiedlung. Es gibt keine historischen Grenzen, keine baukulturelle Identität des Ortes, die man respektieren müsste. Deshalb erscheint der Ort wie ein Labor, in dem man neue städtische Wohnformen entwickeln kann, die in historischen Beständen völlig undenkbar wären. Wo nichts ist, ist alles möglich.

Derzeit arbeiten wir an einem Bauvorhaben für einen privaten Investor, an einer Kombination aus zwei Dritteln Parkhaus und einem Drittel Wohneinheiten mit einer Gesamtfläche von 25.000 m². Da Kopenhagen keinerlei Topographie besitzt, beschlossen wir, das Parkhaus wie eine Art Berghang anzulegen und die Wohnungen nicht wie große Gebäuderiegel zu gestalten, sondern die Einfamilienhäuser Schicht für

[↑] "Clover Block", B.I.G. – Bjarke Ingels Group

pletely flat, we decided to use the parking as a way of building up a sort of mountainside. Instead of making a slab of housing, we could smear the houses as a thin layer of single-family homes up this sloping site. So instead of apartments, we create 80 homes each with 100m² gardens, facing south and under them a spiral of parking moving up beneath. It looks like a piece of suburban neighbourhood floating above the city.

By combining parking that just needs deep space and road access with housing that wants sun and a view, we have basically given each of these elements what they want. It is as though the invisible hand of Adam Smith has

Where nothing is, everything is possible.

organised everything to fit the needs of all the participants.

In the 1960s and 70s, which was the last time people dared to talk about utopia, the idea of the collective was more of a social obligation or a moral issue. Whereas the way *we* deal with collective effort is by combining different interest groups or users or programmes, that help each other in a very practical way. By using other programmes or activities as the soil upon

which you build, you start considering the building programme as a sort of artificial landscape. The multi-storey car park is no longer just a building, it is the earth upon which homes are built. Sensually it has all the qualities of a suburban single-family neighbourhood, but placed in high-density urban context.

The utopians actually dared to dream of new ways of doing things, but they always had to prove that this applied to everything. The way we work is in the same way, we try to show new ways of living and especially new programmes of living together, but we always start from a specific situation. It is about looking at each situation on its own and then trying to develop a plot that turns this particular situation into an interesting story. Each project has its own ingredients; has it own characters; its own spaces. The plot is the one thing that is capable of tying it all together, so it becomes something other and more than just the sum of its parts. In architecture, it is the plot that makes a building more than just an accumulation of bedrooms and toilets and storage.

Schicht den Hang hinauf zu bauen. Anstelle von Wohnungen schufen wir achtzig Terrassenhäuser mit jeweils 100 m² Garten zum Süden hin ausgerichtet und unter ihnen die sich nach oben windende Spirale aus Parkflächen. Es sieht aus wie eine über der Stadt schwebende Vorstadtsiedlung. Indem wir ein Parkhaus, das nur die Tiefe und Zu- und Ausfahrten benötigt, mit Wohnhäusern kombinierten, die Sonnenlicht und eine schöne Aussicht haben sollten, haben wir beiden Element gegeben, was sie wollten. Es ist so, als hätte die unsichtbare Hand von Adam Smith die Bedürfnisse aller Beteiligten berücksichtigt.

In den 1960er und 70er Jahren - als man zum letzten Mal über Utopien zu diskutieren wagte - galt das Kollektiv eher als gesellschaftliche Verpflichtung oder moralische Frage. Unsere Bemühungen um das Kollektive dagegen richten sich darauf, verschiedene Interessengemeinschaften, Nutzergruppen oder Programme so zu verbinden, dass sie sich ganz praktisch gegenseitig unterstützen. Indem man Programme oder Aktivitäten nutzt, wie z.B. die Erde, auf der man baut, fängt man an, Bauprogramm als eine Art künstliche Landschaft zu betrachten. Das mehrstöckige Parkhaus ist dann nicht mehr einfach nur ein Gebäude, sondern es wird zum Grundstück, auf dem die Häuser gebaut werden. Das Ganze besitzt dann alle sinnlich erfahrbaren Merkmale eines Vorortviertels mit Einfamilienhäusern - aber

in einem dicht bebauten städtischen Umfeld.

Die Utopisten wagten davon zu träumen, neue Lösungsansätze zu finden, mussten aber stets beweisen, dass diese allgemein gültig und anwendbar waren. Wir arbeiten ähnlich und versuchen auch, neue Formen des Wohnens und speziell neue gemeinschaftliche Wohnformen aufzuzeigen, wobei wir aber immer von einer tatsächlich vorhandenen Situation ausgehen. Es geht darum, jede Gegebenheit für sich zu betrachten und dann daraus einen Entwurf zu entwickeln, der diese spezifische Situation in eine interessante Geschichte verwandelt. Jedes Projekt hat seine eigenen Inhalte, Merkmale, Räume, die nur die eigentliche architektonische Handlung so zusammenführen kann, dass etwas anderes daraus wird - etwas, das mehr ist als die Summe seiner Teile. In der Architektur ist es der plot an sich, der aus einem Gebäude mehr macht als eine Ansammlung von Schlafzimmern, Toiletten und Stauräumen.

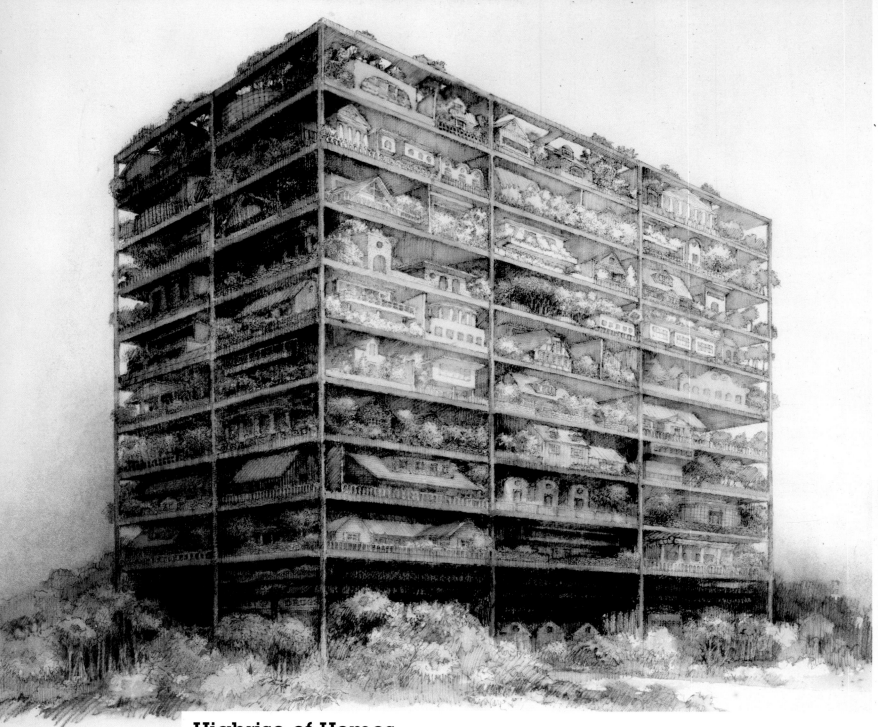

Highrise of Homes

The Manhattan-based architecture and environmental arts studio SITE believe in an expanded concept of "environmental thinking" and the fusion of art, technology and nature. Their experimental multiple dwelling concept of 1981 "Highrise of Homes" docks on to Bjarke Ingels' pragmatic utopias in concept. This project is based on the premise that people everywhere, especially those living in large megacities, need an identity in density. Rather than continue the tradition of empowering architects to be the dictators of people's living space and its architectural imagery, designers would only be asked to provide a skeletal matrix, which would then accommodate an invasion of the inhabitants' far more interesting decisions. The "Highrise of Homes" was also conceived to take advantage of abandoned buildings in large metropolitan centres which are frequently left as steel frames with no walls, but with floor planes intact.

Das Architektur- und Umweltkunststudio SITE aus Manhattan geht von einem erweiterten Konzept von „Umweltdenken" und der Verschmelzung von Kunst, Technik und Natur aus. Ihr experimentelles Wohnungsbaukonzept „Highrise of Homes" aus dem Jahr 1981 knüpft an die pragmatischen Utopien von Bjarke Ingels an. Das Projekt beruht auf der Prämisse, dass Menschen überall und insbesondere diejenigen, die in Megastädten leben, eine Identität in dieser Dichte brauchen. Anstatt die Tradition fortzusetzen, sich als Architekten die Macht zuzusprechen, zu Diktatoren des menschlichen Lebensraums und seiner architektonischen Bildersprache zu werden, würden Designer lediglich um eine skelettartige Matrix gebeten werden, die dann einer Invasion der viel interessanteren Entscheidungen der Bewohner selbst Raum bietet. „Highrise of Homes" wurde unter anderem entwickelt, um sich verlassene Gebäude in den Zentren großer Metropolen zunutze zu machen, die oft als Stahlrahmen ohne Wände, jedoch mit intakten Bodenflächen zurückbleiben.

[↑] "Highrise of Homes", urban city, 1981, © SITE

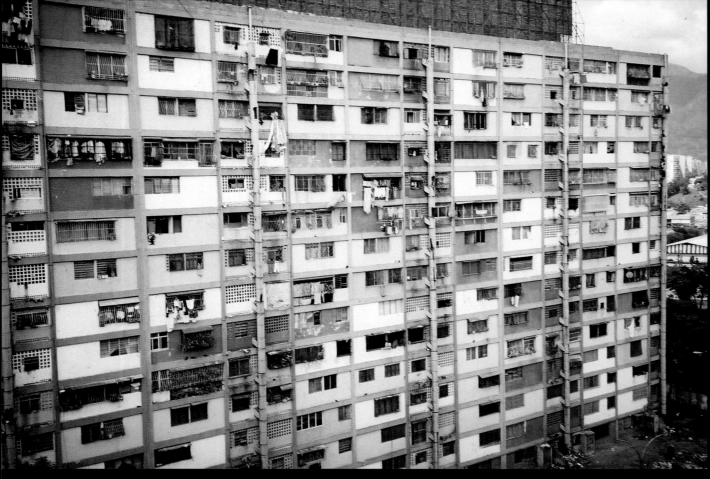

[↑] Photo: Marjetica Potrč

"I believe that moderni
... **there is** no money an
anymore about the big
future. People **try to co**
now by themselves ... t
old and new in the city
particular qualities, ev

m is on the way out
l there is no vision
beautiful, progressive
solidate their territories
day it is the layering of
hat determines its
n beauty." Marjetica Potrč

„Ich glaube, dass die Moderne ein Auslaufmodell ist … es gibt kein Geld und keine Visionen mehr
für die große, schöne, progressive Zukunft. Die Menschen versuchen nun selbst, ihr Territorium
abzustecken … Heute bestimmt die Überlagerung von Alt und Neu in einer Stadt ihre besonderen
Eigenschaften, ja sogar ihre Schönheit."

Rethinking Modernism's Megavisions

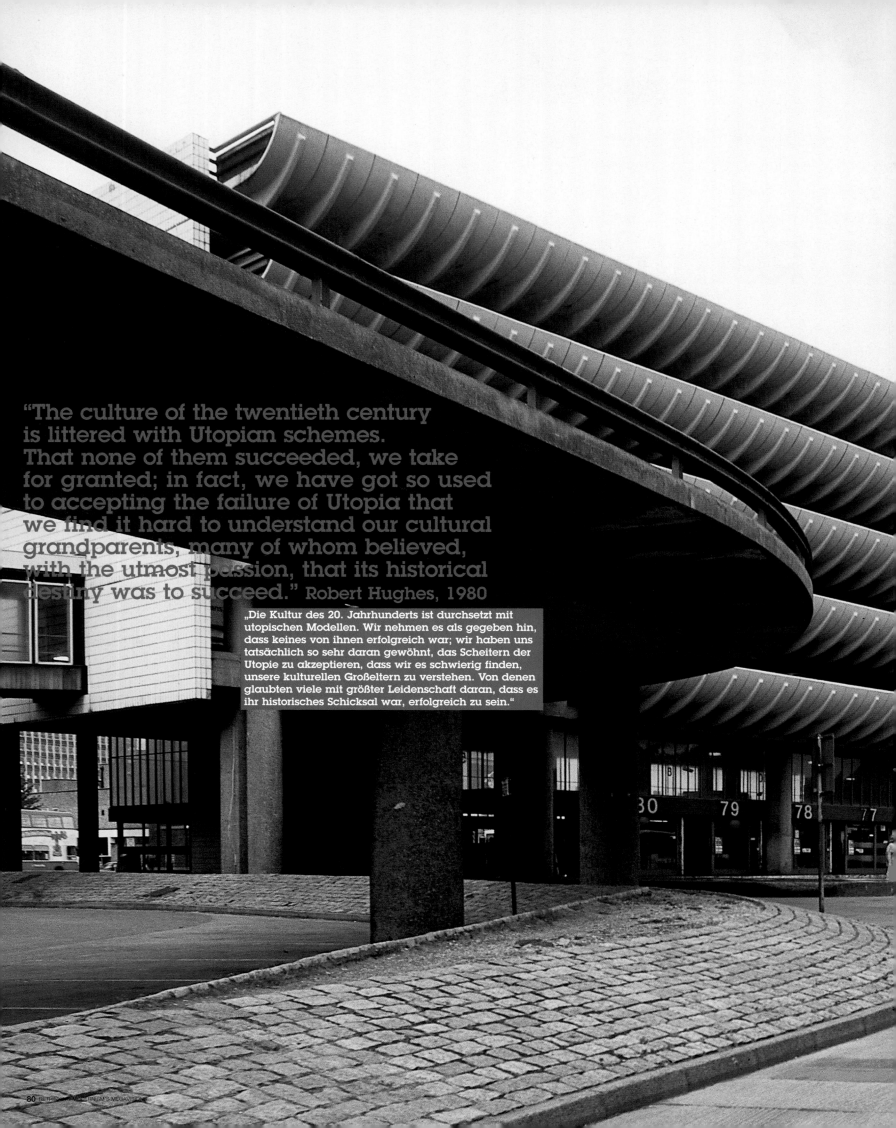

"The culture of the twentieth century is littered with Utopian schemes. That none of them succeeded, we take for granted; in fact, we have got so used to accepting the failure of Utopia that we find it hard to understand our cultural grandparents, many of whom believed, with the utmost passion, that its historical destiny was to succeed." Robert Hughes, 1980

„Die Kultur des 20. Jahrhunderts ist durchsetzt mit utopischen Modellen. Wir nehmen es als gegeben hin, dass keines von ihnen erfolgreich war; wir haben uns tatsächlich so sehr daran gewöhnt, das Scheitern der Utopie zu akzeptieren, dass wir es schwierig finden, unsere kulturellen Großeltern zu verstehen. Von denen glaubten viele mit größter Leidenschaft daran, dass es ihr historisches Schicksal war, erfolgreich zu sein."

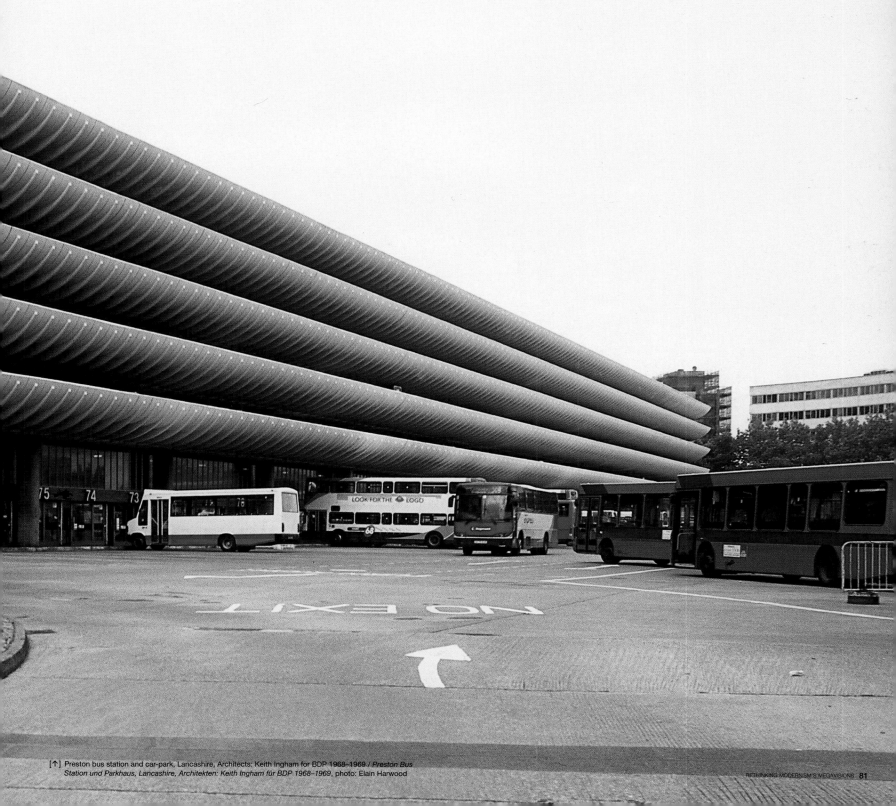

"When it appears that we do not need, or possibly even cannot bring about new utopias, it is about time to (re)consider the social and urban utopias of the past. The continuation, reinterpretation and 're-inhabitation' of the utopian projects of the past could re-ignite a defunct 'social machine' that has run out of 'useful ideology'. The analysis must be proposed not through ideal forms but within the past formalized spatiality of our environment, building thus on the built." Ines Weizman, 2005

„Wenn es so scheint, als bräuchten wir keine neuen Utopien oder als könnten wir sie möglicherweise nicht einmal erfinden, ist es an der Zeit, über die gesellschaftlichen und städtischen Utopien der Vergangenheit (neu) nachzudenken.
Die Fortsetzung, Umdeutung und ‚Wiederbelebung' der utopischen Projekte der Vergangenheit könnte eine stillgelegte ‚gesellschaftliche Maschine', der die ‚brauchbare Ideologie' ausgegangen ist, wieder zum Laufen bringen. Die Analyse sollte dabei nicht über ideale Formen erfolgen, sondern innerhalb der vergangenen formalisierten Räumlichkeit unserer Umwelt und somit auf dem Bestehenden aufbauen."

[↑] Preston bus station and car-park, Lancashire, Architects: Keith Ingham for BDP 1968–1969 / *Preston Bus Station und Parkhaus, Lancashire, Architekten: Keith Ingham für BDP 1968–1969*, photo: Elain Harwood

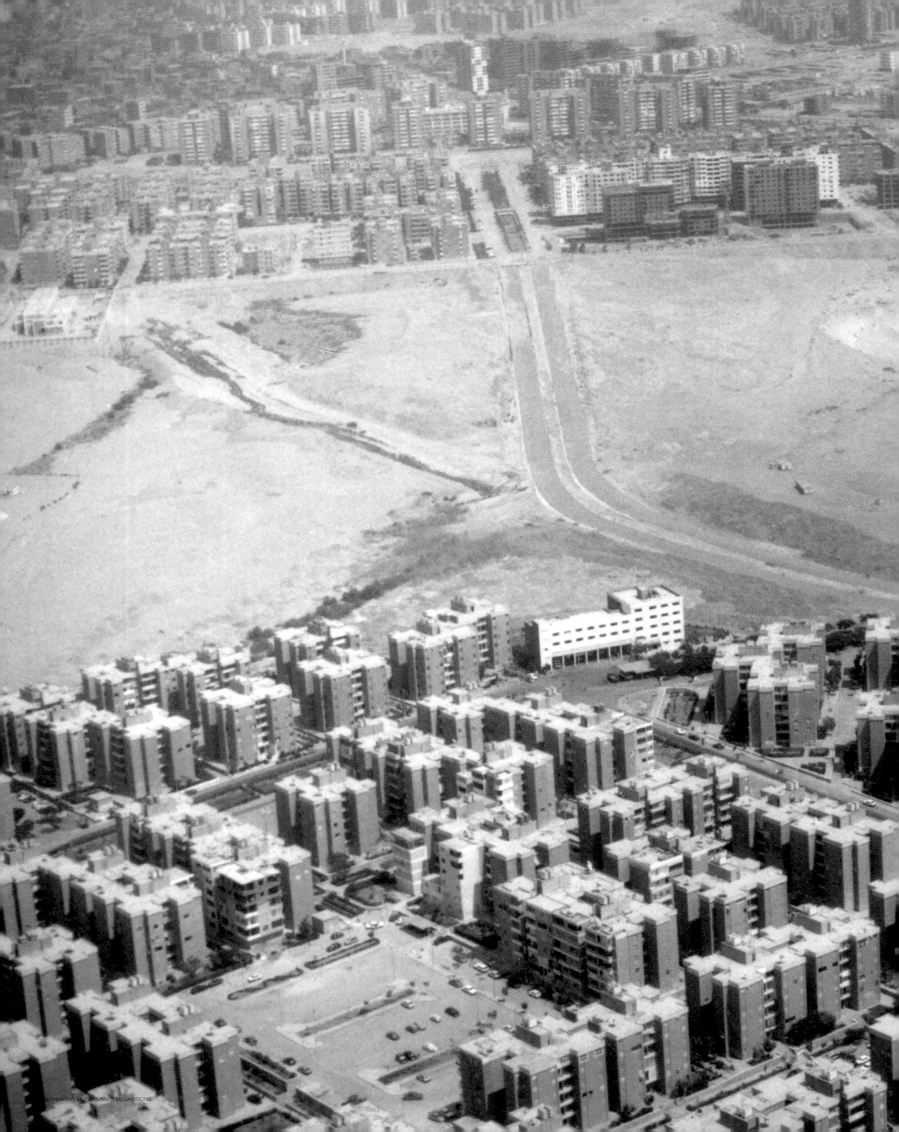

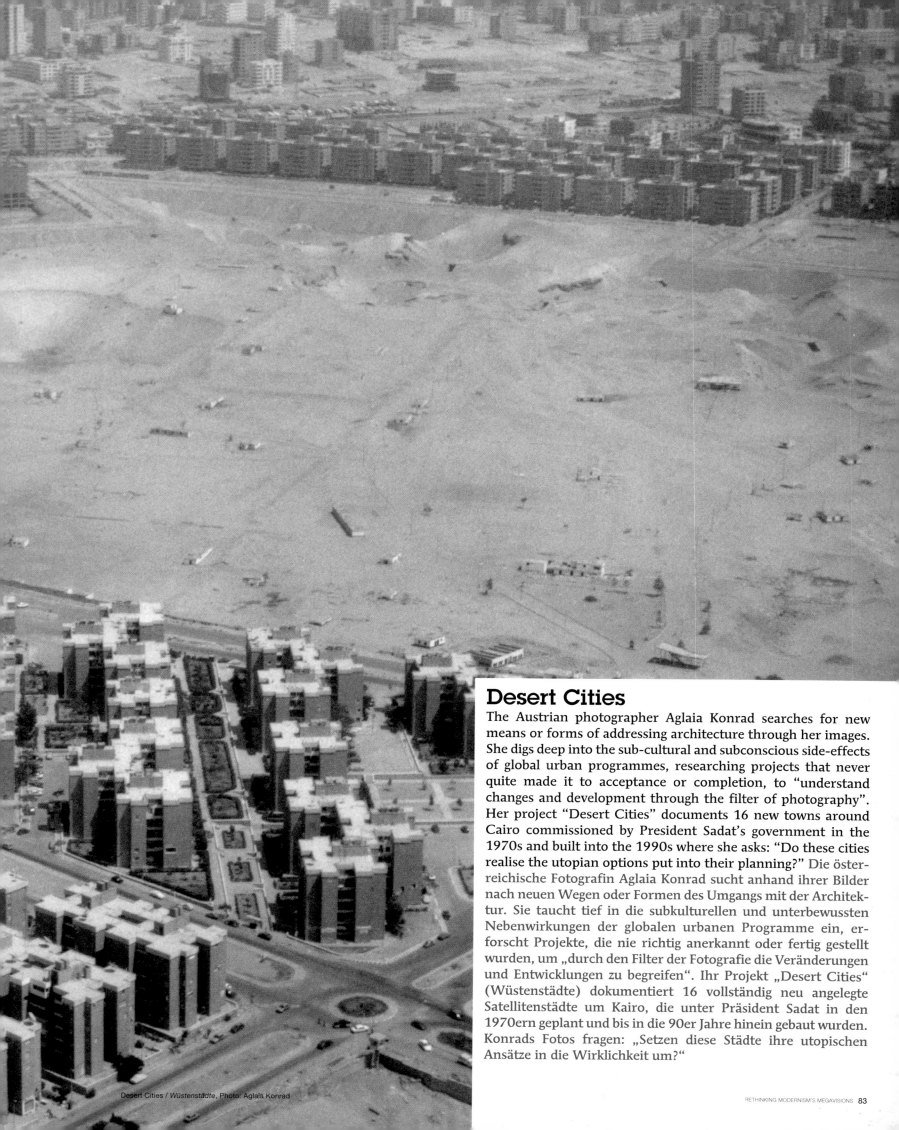

Desert Cities

The Austrian photographer Aglaia Konrad searches for new means or forms of addressing architecture through her images. She digs deep into the sub-cultural and subconscious side-effects of global urban programmes, researching projects that never quite made it to acceptance or completion, to "understand changes and development through the filter of photography". Her project "Desert Cities" documents 16 new towns around Cairo commissioned by President Sadat's government in the 1970s and built into the 1990s where she asks: "Do these cities realise the utopian options put into their planning?" Die österreichische Fotografin Aglaia Konrad sucht anhand ihrer Bilder nach neuen Wegen oder Formen des Umgangs mit der Architektur. Sie taucht tief in die subkulturellen und unterbewussten Nebenwirkungen der globalen urbanen Programme ein, erforscht Projekte, die nie richtig anerkannt oder fertig gestellt wurden, um „durch den Filter der Fotografie die Veränderungen und Entwicklungen zu begreifen". Ihr Projekt „Desert Cities" (Wüstenstädte) dokumentiert 16 vollständig neu angelegte Satellitenstädte um Kairo, die unter Präsident Sadat in den 1970ern geplant und bis in die 90er Jahre hinein gebaut wurden. Konrads Fotos fragen: „Setzen diese Städte ihre utopischen Ansätze in die Wirklichkeit um?"

Desert Cities / *Wüstenstädte*, Photo: Aglaia Konrad

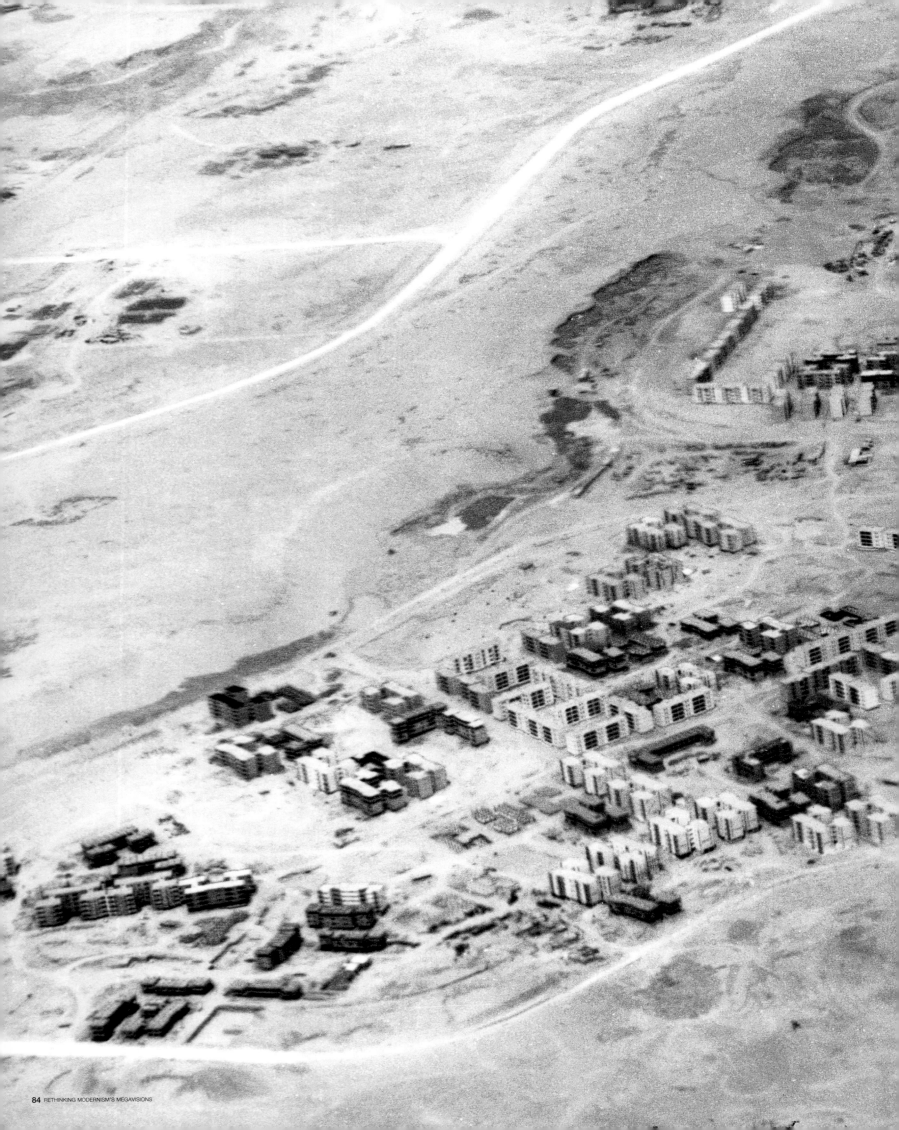

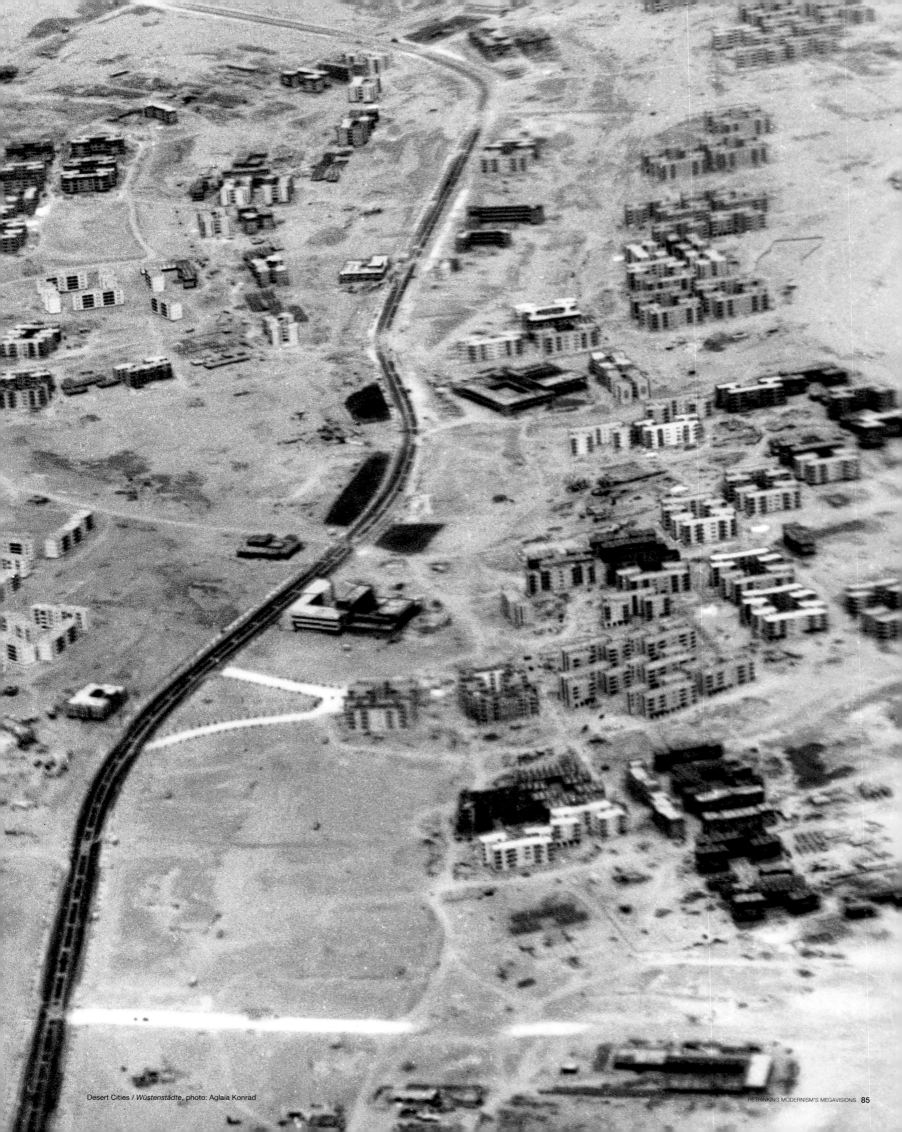

Desert Cities / *Wüstenstädte*, photo: Aglaia Konrad

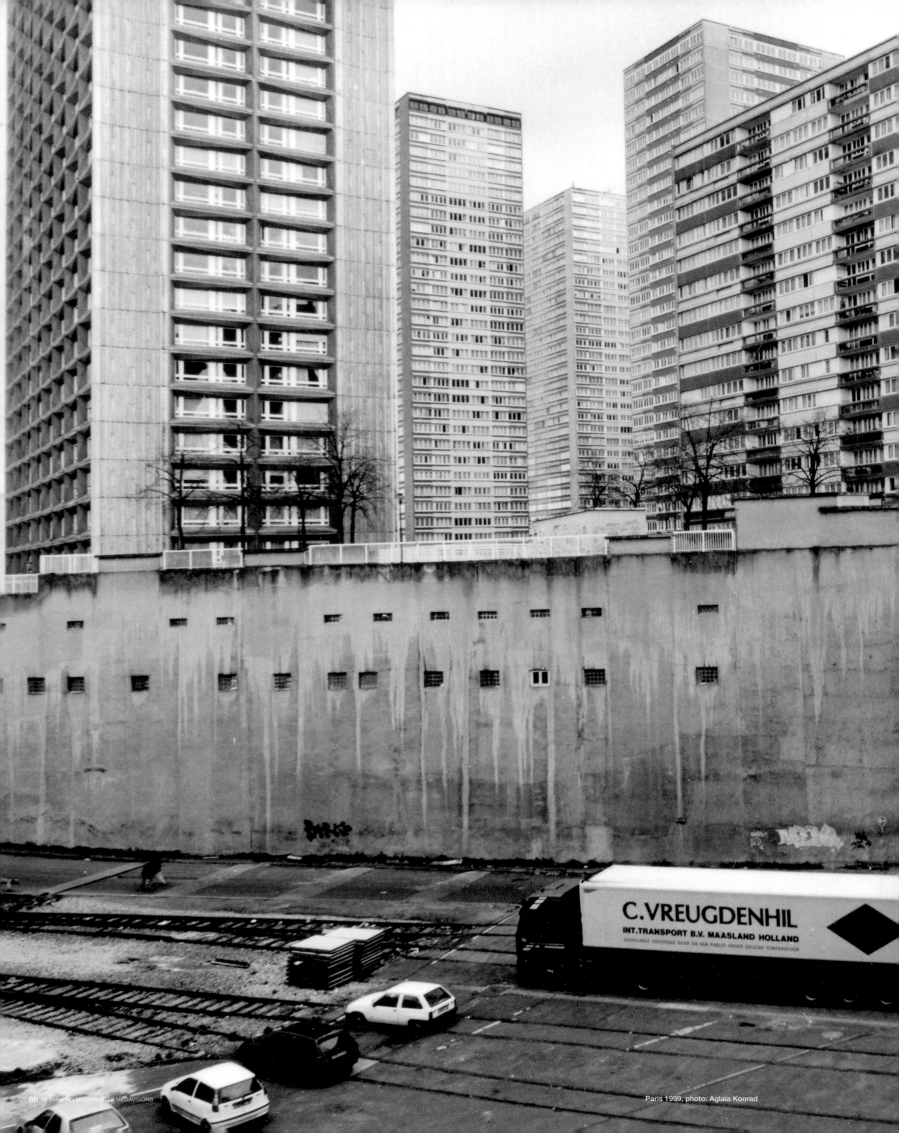

Paris 1999, photo: Aglaia Konrad

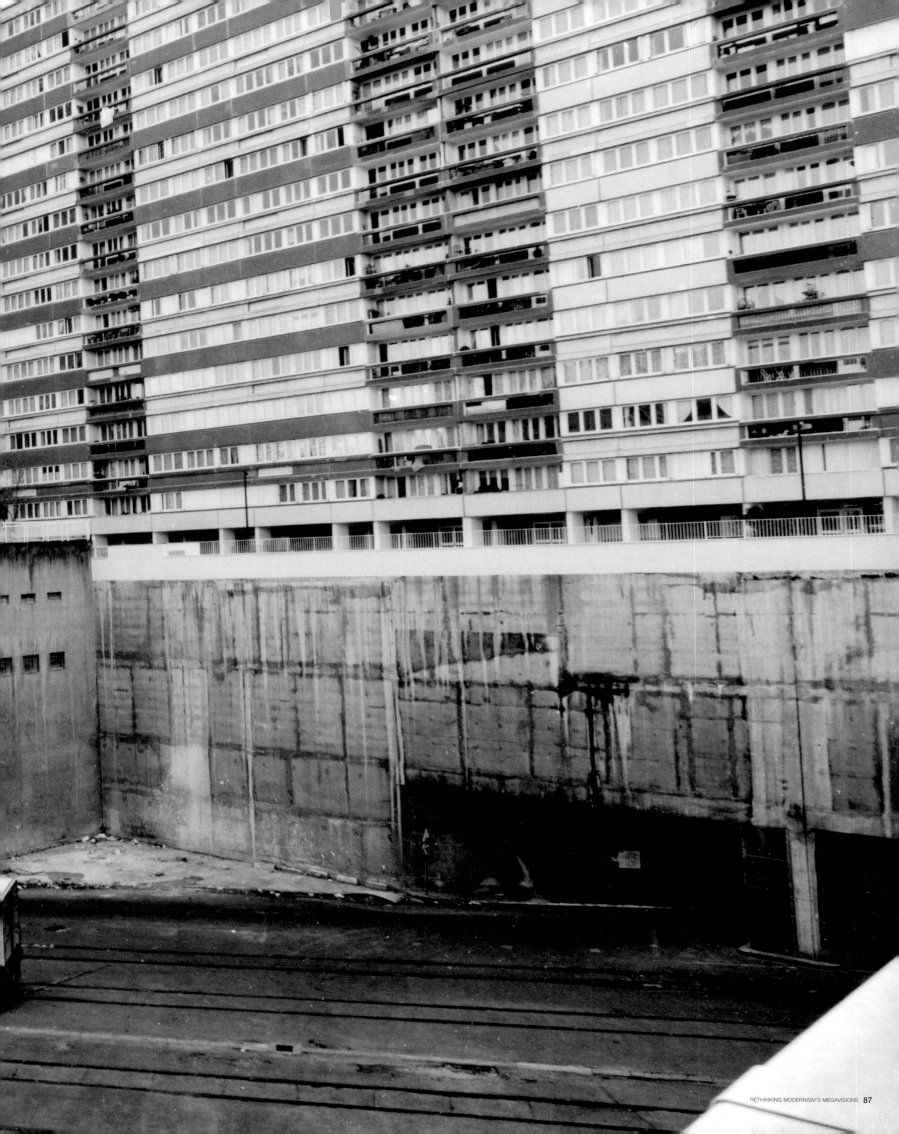

[↑] Marne la Vallée 1999, photo: Aglaia Konrad

[↗] Paris 1999, photo: Aglaia Konrad

"I do think we live in a very exiting, pivotal and intensive time. The 21st century, in which developments take place that cannot yet be judged, amidst existing utopian phases of modernity. We live in it and yet how many of all the consequences do we actually realise or experience? … What kind of newly created notions of spaces do we implement in reality and what are the implications of this? How do we keep a critical position?" Aglaia Konrad

„Ich denke, dass wir in einer sehr aufregenden, entscheidenden und intensiven Zeit leben. Im 21. Jahrhundert, in dem Entwicklungen stattfinden, über die inmitten von existierenden utopischen Phasen der Moderne jetzt noch nicht geurteilt werden kann. Wir leben darin, aber wie viele der Konsequenzen realisieren oder erleben wir eigentlich? … Welche Art von neu entwickelten Vorstellungen von Räumen setzen wir in die Realität um und was sind deren Auswirkungen? Wie bewahren wir eine kritische Haltung?"

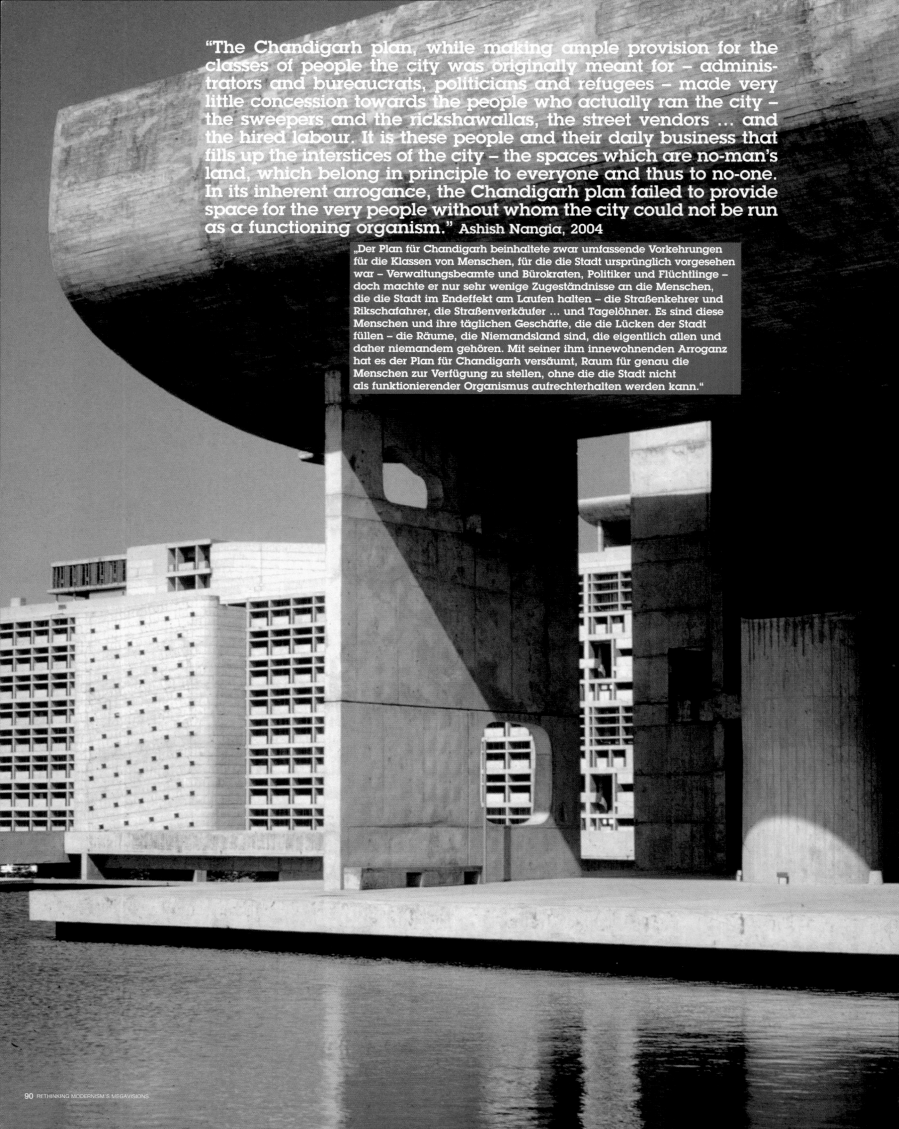

"The Chandigarh plan, while making ample provision for the classes of people the city was originally meant for – administrators and bureaucrats, politicians and refugees – made very little concession towards the people who actually ran the city – the sweepers and the rickshawallas, the street vendors … and the hired labour. It is these people and their daily business that fills up the interstices of the city – the spaces which are no-man's land, which belong in principle to everyone and thus to no-one. In its inherent arrogance, the Chandigarh plan failed to provide space for the very people without whom the city could not be run as a functioning organism." Ashish Nangia, 2004

„Der Plan für Chandigarh beinhaltete zwar umfassende Vorkehrungen für die Klassen von Menschen, für die die Stadt ursprünglich vorgesehen war – Verwaltungsbeamte und Bürokraten, Politiker und Flüchtlinge – doch machte er nur sehr wenige Zugeständnisse an die Menschen, die die Stadt im Endeffekt am Laufen halten – die Straßenkehrer und Rikschafahrer, die Straßenverkäufer … und Tagelöhner. Es sind diese Menschen und ihre täglichen Geschäfte, die die Lücken der Stadt füllen – die Räume, die Niemandsland sind, die eigentlich allen und daher niemandem gehören. Mit seiner ihm innewohnenden Arroganz hat es der Plan für Chandigarh versäumt, Raum für genau die Menschen zur Verfügung zu stellen, ohne die die Stadt nicht als funktionierender Organismus aufrechterhalten werden kann."

Chandigarh: Plan in the Punjab

Planwerk Punjab When Le Corbusier was offered the commission to design a new capital city for the Punjab province in India in 1950, he had the chance at last to put his long-treasured theories of *Urbanisme* into practice. Als Le Corbusier 1950 der Auftrag angeboten wurde, eine neue Hauptstadt für die Provinz Punjab in Indien zu entwerfen, hatte er endlich Gelegenheit, seine lang gehegten Theorien des *Urbanisme* in die Praxis umzusetzen.

India had recently gained independence but been riven by partition. Prime Minister Jawaharial Nehru, wanted a new architecture for this regional capital, Chandigarh, one that was "unfettered by the traditions of the past, a symbol of the nation's faith in the future". Le Corbusier was given free rein. He and his team from CIAM (Congrès International d'Architecture Moderne) set out to design a city that fulfilled the aims of the Athens Charter: an egalitarian place where work, living, leisure and movement were strictly segregated from one another; where a new moral/social order would herald the birth of the second machine age. That this model had been designed for western European criteria rather than those specific to India did not seem to be an issue for either client or architect. Chandigarh was to be a "radio-concentric city of exchanges", a place of "concentration and diffusion; a place of exchange, a place of distribution." (Le Corbusier, 1953).

A rigid road grid was laid down enclosing 800 x 1,200 metre neighbourhood areas known as "sectors", there was a pedestrianised "centre" containing only public buildings (residential strictly separate); an industrialised zone to the east and a university and cultural buildings along the western edge. Large green areas stretched from north to south through the sectors to accomodate schools and hospitals. The city's structure was planned as a framework that should fill itself and increase in density over time: The "bones" were supplied for the initial 150,000 inhabitants and the "flesh" should grow itself later. In order to encourage density and prevent unregulated growth on the periphery, a 16km wide green belt zone was envisaged by the Punjab government to prevent the creation of "bad semi-urban conditions", to protect the rural community from degeneration by contact with urban life and to safeguard agricultural land for fresh supplies to the city. Le Corbusier was in accord:

"To build on open ground, of easy topography, filled with natural beauty, Chandigarh, thanks to its urban and architectural layout, will be sheltered from base speculation and its disastrous corollaries: the suburbs. No suburb is possible at Chandigarh." (Le Corbusier, 1951)

Today, although still one of the cleaner and wealthier cities in India with less traffic chaos than most, Chandigarh has not remained immune to the vagaries of city growth. Despite egalitarian principles, there is a more privileged and wealthier zone in the north of the city. Despite the green belt there is heavy dependency on the city by neighbouring residential towns such as Panchkula and Mohali that seem likely to end up merging with Chandigarh as a metropolis. Density has come to the wide, originally over-proportioned empty spaces of Chandigarh but not along the guidelines and regulations expected by its creators. Natural growth does not always occur according to plan. SL

Indien hatte gerade erst seine Unabhängigkeit erlangt, war aber durch die Teilung zerrissen. Premierminister Jawaharlal Nehru strebte eine neuartige Architektur für diese Provinzhauptstadt Chandigarh an,,,auf dass diese Stadt eine neue Stadt werde, Symbol der Freiheit Indiens, ohne Fesseln durch Tradition aus der Vergangenheit, ein Ausdruck des Glaubens der Nation an die Zukunft …" Le Corbusier wurde freie Hand gegeben; er und sein Team von CIAM (Congrès International d'Architecture Moderne) machten sich an den Entwurf einer Stadt, die den Zielen der Charta von Athen entsprechen sollte: Ein egalitärer Ort, an dem die Bereiche Arbeit, Wohnen, Erholung und Bewegung streng voneinander getrennt sein sollten und an dem eine neue Moral und Sozialordnung den Beginn des zweiten Maschinenzeitalters einleiten sollte. Dass dieses Modell eher nach westeuropäischen als nach spezifisch indischen Kriterien entwickelt worden war, schien weder für den Auftraggeber noch für den Architekten ein Problem zu sein. Chandigarh sollte eine „radial-konzentrische Stadt des Austausches" sein, ein Ort der „Konzentration und Diffusion, ein Ort des Austausches, ein Ort der Verteilung." (Le Corbusier, 1953)

Die Straßen wurden in einem strengen, rechtwinkligen Raster angelegt und umfassten Wohngebiete mit einer Fläche von jeweils 800 m x 1.200 m, die als „Sektoren" bezeichnet wurden. Das Zentrum bestand ausschließlich aus öffentlichen Gebäuden (Wohngebäude lagen streng getrennt davon) und war lediglich Fußgängern zugänglich. Im Osten befand sich ein Industriegebiet und entlang des westlichen Stadtrands eine Universität und kulturell genutzte Gebäude. Große Grünflächen erstreckten sich vom Norden nach Süden, durch die Sektoren, die als Standorte für Schulen und Krankenhäuser angedacht waren. Die Struktur der Stadt glich einem Rahmenwerk, das sich nach und nach von selbst mit Inhalt füllen sollte: Dieses „Skelett" war für die ersten 150.000 Einwohner angelegt, das „Fleisch" sollte später nachwachsen. Um die Bevölkerungsdichte zu fördern und der unkontrollierten Ausweitung an den Rändern der Stadt vorzubeugen, wurde von der Provinzregierung ein 16 km breiter Grüngürtel vorgesehen. Mit ihm sollte einerseits das Aufkommen „schlechter, vorstädtischer Gegebenheiten" verhindert, andererseits die ländliche Bevölkerung vor den degenerierenden Einflüssen durch den Kontakt mit dem städtischen Leben geschützt werden. Zusätzlich sicherte der Grüngürtel den Erhalt von Ackerland für die Versorgung der Stadt mit frischen Lebensmitteln. Le Corbusier war einverstanden:

„Gebaut auf freiem Grund, von einfacher Topografie, mit natürlichem Charme, wird Chandigarh dank seiner städtebaulichen und architektonischen Gestaltung geschützt sein vor Bodenspekulationen und ihren desaströsen Begleiterscheinungen: den Vorstädten. In Chandigarh sind Vorstädte nicht möglich." (Le Corbusier, 1951)

Auch wenn Chandigarh heute im Vergleich zu anderen indischen Städten noch immer eine der saubersten und wohlhabendsten mit geringem Verkehrschaos ist, blieb sie jedoch nicht immun gegenüber den Launen der Stadterweiterung. Trotz egalitärer Prinzipien existiert im Norden der Stadt eine privilegierte, wohlhabendere Region. Trotz des Grüngürtels sind benachbarte Satellitensiedlungen wie Panchkula und Mohali in hohem Grad von der Stadt abhängig und werden voraussichtlich mit Chandigarh zu einer Metropole verschmelzen. Die weiten, ursprünglich überproportionierten Freiräume von Chandigarh weisen inzwischen eine hohe Dichte auf, jedoch nicht den von ihren Schöpfern vorgesehenen Richtlinien und Vorschriften entsprechend. Natürliches Wachstum entwickelt sich nicht immer nach den Planvorgaben. SL

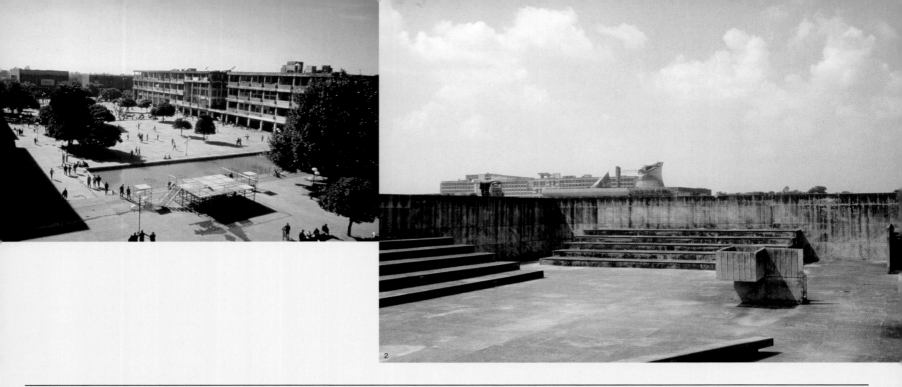

Chandigarh Revisited

Eine Neubewertung In the 1960s, the Belgian architect Luc Deleu began to reject the building excesses of his generation. He was attracted by the idea of architecture as a mental model and a spiritual prototype and his inspiration was Le Corbusier. In den 1960er Jahren begann der belgische Architekt Luc Deleu die baulichen Exzesse seiner Generation abzulehnen. Er begeisterte sich stattdessen für die Idee, Architektur als mentales Modell und spirituellen Prototyp zu verstehen. Deleus Inspiration war dabei Le Corbusier.

Through a careful study of Le Corbusier's theory and buildings I discovered a reading of his urbanistic work completely different from the usual cliché. I clearly understood his intuitive search for an order that could integrate ad hoc life and human chaos. I became interested in his pursuit of priorities in urbanistic concepts. I was also overwhelmed by the formal concept and his

> **Only man and mankind, can appreciate the art of building cities; institutions cannot, and neither can the market.**

design technology and knowledge as demonstrated in, for example, *Ville Radieuse* and in his project for the left bank in Antwerp.

It is clear to me that what has so often been described as Le Corbusier's failure to provide a "pragmatic" solution for Chandigarh was in fact his biggest achievement. Only man and mankind, can appreciate architecture and the art of building cities; institutions cannot, and neither can the market. For this reason, the art of building should only be focused on the human being and humanity, to make a better or at least a more beautiful and pleasant environment.

The work of Le Corbusier represents a unique design attitude focused directly on the human being. His strictly formal, urban prototype, *une ville contemporaine pour 3.000.000 habitants* (a contemporary city for 3,000,000 inhabitants) evolved via "Plan Obus" into Chandigarh, creating an infrastructure where each family can organise its dwelling and environment in almost complete freedom within a positive and stimulating larger order.

I see Chandigarh as the 20th century's outstanding example of the "right" priorities for urban design. It might well be the last example of modernist planning and the first example of applied contemporary urban theory. Here, Le Corbusier looked centuries

> **I see Chandigarh as the 20th century's outstanding example of the "right" priorities for urban design.**

ahead, seeing his project at Chandigarh in historic terms right from the start. Looking at it today, one can tell that he had a collage city in mind. For this, the most striking characteristic of Chandigarh is the integrated attention it gives both to large-scale infra-

Während des sorgfältigen Studiums der Theorien und Gebäude von Le Corbusier entdeckte ich die Möglichkeit, sein urbanes Werk vollkommen anders zu interpretieren als durch die gängigen Klischees vorgegeben. Ich verstand seine intuitive Suche nach einer Ordnung, die in der Lage sein sollte, sowohl menschliches Chaos als auch Alltagsleben zu integrieren. Mich interessierte sein Bemühen, Prioritäten in urbanen Konzepten zu setzen. Ich war überwältigt von Le Corbusiers formalem Konzept, seinen Designtechniken und Kenntnissen, demonstriert in „La Ville Radieuse" und seinem Projekt am linken Flussufer von Antwerpen.

Das, was so oft als Le Corbusiers Scheitern bei der Entwicklung einer „pragmatischen Lösung" für Chandigarh bezeichnet wird, ist eigentlich seine größte Errungenschaft. Nur der Mensch und die Menschheit können Architektur und die Kunst, Städte zu bauen, schätzen – Institutionen und auch der Markt können das nicht. Aus diesem Grund sollte die Baukunst auch ausschließlich auf den Menschen und die Menschheit ausgerichtet sein, um eine bessere oder wenigstens eine schönere und angenehmere Umgebung zu schaffen.

Le Corbusiers Werk verkörpert ein einzigartiges Gestaltungskonzept, das unmittelbar auf den Menschen ausgerichtet ist. Sein streng formaler Prototyp einer Stadt, „une ville contemporaine pour 3.000.000 habitants" (eine zeitgenössische Stadt für 3.000.000 Einwohner), entwickelte sich

über den „Plan Obus" bis hin zu Chandigarh. Hier schuf er eine Infrastruktur, in der jede Familie ihren Wohnraum und ihre Umgebung in nahezu vollkommener Freiheit selbst gestalten kann und dies innerhalb einer größeren Ordnung, die positiv und stimulierend wirkt.

Meiner Meinung nach ist Chandigarh das für das 20. Jahrhundert herausragende Beispiel für die Wahl der „richtigen" Prioritäten in der Stadtplanung. Man könnte es auch als das letzte Beispiel modernistischer Planung und das erste Beispiel angewandter städtebaulicher Theorie der Gegenwart beschreiben. Hier hat Le Corbusier Jahrhunderte vorausgedacht, wobei er sein Projekt in Chandigarh von Beginn an in einem historischen Kontext sah. Aus heutiger Sicht erkennt man, dass er beim Entwerfen der Stadt eine Collage im Sinn hatte. Darauf bezogen ist das charakteristischste Merkmal von Chandigarh sowohl die großzügig angelegte Infrastruktur als auch die Freiheit in der Organisation der Wohnobjekte.

Um eine rein wirtschaftliche Vermarktung von „Ad-hoc-Stadtentwicklung" zu vermeiden, halte ich es für unerlässlich, Kunst und Theorie in eine nachvollziehbare Städteplanung miteinzubeziehen. Gesellschaften, die aus freien Menschen bestehen, leben zwangsläufig in einem räumlichen Chaos, welches viel Toleranz erfordert. Aus der Sicht eines Architekten hat Le Corbusiers Strategie, im großen Maßstab zu

[1–3] Chandigarh 1995, photo: Luc Deleu

[→] "Unadapted City: One nautical mile of amenities for 9,500 inhabitants" / *"Eine Seemeile von An-nehmlichkeiten für 9.500 Einwohner"*. Model: Luc Deleu / T.O.P. office 2004

> "Developing the large scale from the small scale ensures a differentiated result because it takes into account peculiarities, exceptions and individuality: it is an essential guarantee for the conservation of individual freedom." Luc Deleu

> "Die Entwicklung des großen Maßstabs im Kleinen zu beginnen, sichert ein differenzierteres Resultat, denn das lässt Ungewöhnliches, Ausnahmen und Individualität zu: Es ist eine essenzielle Garantie für die Bewahrung individueller Freiheit."

structure and the liberty of its housing organisation.

I believe that to avoid mere economic *ad hoc* urbanism and city-branding, the art and theory of conceiving urbanism is indispensable. Societies of free people inevitably live in a spatial chaos that requires a great amount of tolerance. From an archi-

Architecture is a spiritual and cultural reality.

tect's point of view, Le Corbusier's strategy of developing the large scale with the small scale in mind ensured a differentiated result because he took into account the peculiarities and exceptions of individuality, an essential guarantee for the conservation of individual freedom.

When the modernists began to include everyday programmes in architecture, a persistent ongoing confusion arose between the terms "architecture" and "building". Until today, these two completely different notions have been seen and understood as one. Because the modernists in Europe strongly emphasised housing as the basis of city structure and city development, we are still facing overly strin-

A newer and more contemporary urban policy should shift its attention to public space, infrastructure and equipment.

gent urban regulations as the standard for housing. However, architecture is a spiritual and cultural reality and by no means a valid pretext for building. Also, after the last century's construction explosion it will be necessary to

manage material resources, space and volumes much more sparingly.

Yet, as Chandigarh shows, a newer and more contemporary urban policy should shift its attention to public space, infrastructure and equipment, so as to structure the urban conglomerate on multiple scales in parallel.

With my agency T.O.P. Office I wanted to create a prototype city in which one single exciting structure would embody the city forum, cars and mono-rail for public transport and otherwise only urban equipment. The result was "The Unadapted City" – a research by design project that took a period of ten years.

"The Unadapted City" resulted in a totally new typology, the street turned inside out, in other words, in this model all traffic, public space and most of the urban equipment fitted into an architectural hill crest as opposed to the classical urban pattern in which public space and traffic are situated in a constructed canyon between the buildings.

We called this study "The Unadapted City" because the concept was to create an unadapted spatial score for an unadapted equipment. With the word score I explicitly refer to the flexibility of a musical score, which allows countless arrangements but at the same time conducts them in a positive and non-repressive way. Compare this with actual, merely restrictive and narrow-minded urbanistic regulations that are very rarely inspiring.

The model on scale 1:100 shows a kind of structural work, a possible structure to be filled in freely – and with a minimal footprint for an environment- and people-friendly spatial and urban planning.

Here, private organisations are meant to participate in building the public space, the transport and the public amenities while the public authorities are meant to participate in building the equipment for the commercial market.

planen, ohne dabei die kleinen Elemente aus den Augen zu verlieren, zu einem differenzierten Ergebnis geführt; es lässt Raum für die Berücksichtigung der Eigenheiten und Besonderheiten von Individuen und garantiert damit die Beibehaltung von individuellen Freiräumen.

Als die Modernisten begannen, Alltagsprogramme in der Architektur zu berücksichtigen, entstand eine beharrlich andauernde Konfusion in Bezug auf die Begrifflichkeiten „Architektur" und „Bebauung". Bis heute werden diese zwei vollkommen unterschiedlichen Begriffe als dasselbe betrachtet und verstanden. Da die Modernisten in Europa großen Wert auf den Wohnungsbau als Grundlage der Stadtstruktur und Stadtentwicklung legten, stehen die Anforderungen an den Wohnungsbau immer noch viel zu strengen städtebaulichen Vorschriften gegenüber. Doch Architektur ist eine geistige und kulturelle Realität und keinesfalls ein ausreichender Vorwand für Bebauung. Hinzu kommt, dass es nach dem Bauboom des letzten Jahrhunderts notwendig sein wird, sowohl mit den Material-Ressourcen als auch mit Raum und Volumen viel sparsamer umzugehen.

Dennoch sollte, wie Chandigarh zeigt, eine neue, zeitgenössischere Stadtentwicklungspolitik ihre Aufmerksamkeit dem öffentlichen Raum, der Infrastruktur und den Ausstattungen widmen, um städtische Ballungspunkte in verschiedenen Maßstäben parallel zu strukturieren.

Mit meinem Büro T.O.P. Office wollte ich den Prototyp einer Stadt erschaffen, in der eine einzige, anregende Struktur das Forum der Stadt, Autos, den Monorail als öffentliches Verkehrsmittel und sonst ausschließlich städtische Ausstattung enthält. Das Ergebnis war „The Unadapted City" („Die unangepasste Stadt") - ein designorientiertes Studienprojekt, das sich über einen Zeitraum von zehn Jahren erstreckt.

Mit „The Unadapted City" entstand eine vollkommen neue Typologie, die Straßen von innen nach außen gekehrt, d.h. in diesem Modell sind jeglicher Verkehr, alle öffentlichen Räume und der größte Teil der

urbanen Anlagen als ein architektonischer „Berggipfel" angelegt, ganz im Gegenteil zum klassischen Stadtmodell, in dem sich Verkehr und öffentlicher Raum in einer zwischen den Gebäuden konstruierten Schlucht befinden.

Wir nannten diese Studie „The Unadapted City", weil das Konzept darin bestand, eine unangepasste räumliche Partitur für eine unangepasste Ausstattung zu schaffen. Mit dem Wort Partitur möchte ich ausdrücklich auf die Flexibilität einer Partitur in der Musik Bezug nehmen, die zahllose Arrangements zulässt, diese aber gleichzeitig positiv und nicht-repressiv dirigiert. Im Vergleich dazu stehen die gegenwärtigen rein restriktiven und engstirnigen städtebaulichen Vorschriften, die in den seltensten Fällen inspirierend wirken.

Unser Studienmodell im Maßstab 1:100 zeigt eine Art von baulicher Struktur, eine mögliche Struktur, die ungehindert ausgefüllt werden kann - mit minimalen Vorgaben zugunsten einer umwelt- und menschenfreundlichen Stadt- und Raumplanung.

Die Idee ist, private Organisationen an der Erschaffung des öffentlichen Raums, des Transportwesens und der öffentlichen Anlagen zu beteiligen, während die Behörden zur entsprechenden Ausstattung für den kommerziellen Markt beitragen sollen.

Demolition

In late 2005 the British TV station Channel 4 ran a series called "Demolition", in which they asked viewers to nominate "Britain's worst buildings". Highlight of the series, co-presented by former president of the Royal Institute of British Architects, George Ferguson, was to be the public airing of the demolition of the most "hated" building in the final episode. The winner turned out to be the shopping centre in the Scottish town of Cumbernauld – whose equally hated town centre, like Costa and Niemeyer's Brasilia, was designed in the 1960s *specifically* for the automobile. Unfortunately, when it came to the crunch it turned out that there were not enough funds to actually knock down the building at the end of the series after all, and suggestions for change of use and redevelopment were called for instead … Ende des Jahres 2005 lief auf dem britischen Fernsehkanal Channel 4 eine Serie mit dem Titel „Demolition"(Abriss), in der die Zuschauer gebeten wurden, „Großbritanniens schlechteste Gebäude" zu benennen. Höhepunkt dieser Serie, deren Ko-Moderator George Ferguson, der frühere Präsident des Royal Institute of British Architects war, sollte in der letzten Folge die öffentliche Übertragung des Abrisses des „meistgehassten" Gebäudes sein. „Gewonnen" hat das Einkaufszentrum in der schottischen Stadt Cumbernauld, deren ungeliebtes Zentrum ähnlich wie die Planungen für Brasilia von Costa und Niemeyer in den 1960er Jahren *eigens* für das Automobil gebaut wurde. Als der große Moment des Abrisses jedoch gekommen war, stellte sich heraus, dass nicht genügend finanzielle Mittel zur Verfügung standen, um das Gebäude am Ende der Serie auch tatsächlich abzureißen, und so wurden stattdessen Vorschläge für eine Umnutzung und Neugestaltung erbeten …

[↑] Cumbernauld shopping centre, Scotland / *Cumbernauld Einkaufszentrum, Schottland.*
Photo: 2006 © Oxford Film & TV Ltd.

[↑] "Palast der Republik" (1976-2006) – "Palace of Doubt" / „Palast des Zweifels", Berlin 2005, photo: Lars Ramberg

[←] "WK8P2ABBAU": From the exhibition "Superconversion" in Hoyerswerda-Neustadt, Germany, 2003. Artist group "Stadt im Regal" comment on the removal of a block of flats with a poster declaring "coming soon: a field" / „WK8P2ABBAU": Aus der Ausstellung „Superumbau" in Hoyerswerda-Neustadt, 2003. Die Künstlergruppe „Stadt im Regal" begleitet den Abriss einer Hochhausanlage. Photo © Stadt im Regal

[↗] "Love your City", panorama pavilion, Cologne, Germany / „Liebe deine Stadt", Panorama Pavillion, Köln, 2005, www.liebedeinestadt.de, photo: Albrecht Fuchs

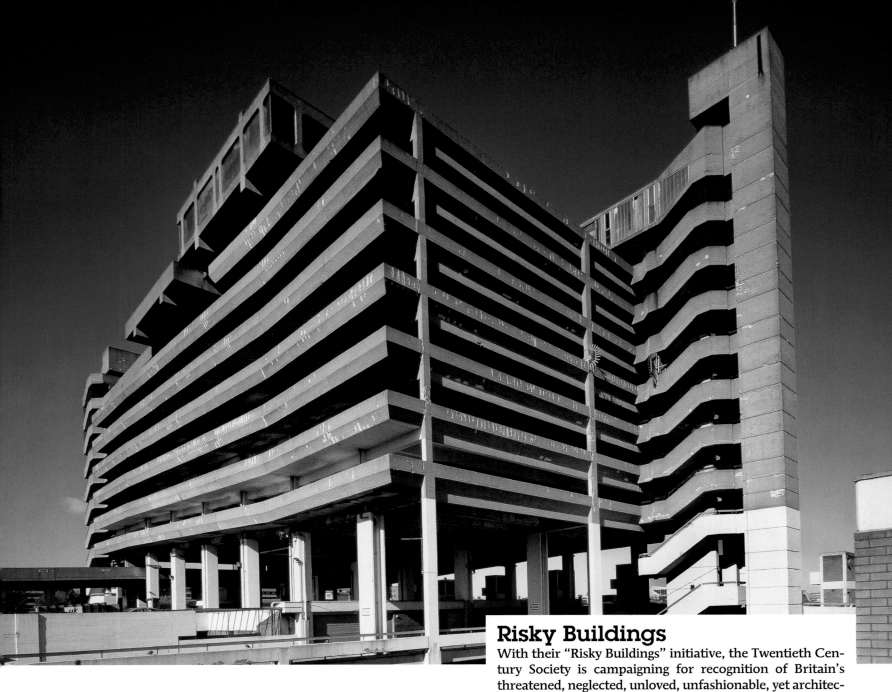

Risky Buildings

With their "Risky Buildings" initiative, the Twentieth Century Society is campaigning for recognition of Britain's threatened, neglected, unloved, unfashionable, yet architecturally significant 20th century buildings for posterity – or until we learn to appreciate their value. Caseworker Cordula Zeidler explains their motivation. Mit ihrer Initiative „Risky Buildings" („riskante Gebäude") setzt sich die Twentieth Century Society für Großbritanniens bedrohte, vernachlässigte, ungeliebte, aus der Mode gekommene, architektonisch bedeutende Bauten des 20. Jahrhunderts ein. Sie sollen für die Nachwelt erhalten bleiben – oder bis zu dem Zeitpunkt, an dem wir ihren Wert schätzen lernen. Mitarbeiterin Cordula Zeidler erklärt hier die Beweggründe der Initiative.

[↑ ↗] Gateshead car park, UK. Architects: Owen Luder Partnership 1964–9 / Gateshead Parkhaus, Großbritannien. Architekten: Owen Luder Partnership 1964–9, photo: Sarah Duncan

[←] Film stills from Mike Hodges' "Get Carter" scene set in Gateshead Car Park, 1971 / Filmstills aus Mike Hodges' „Get Carter"-Szene im Gateshead-Parkhaus, 1971

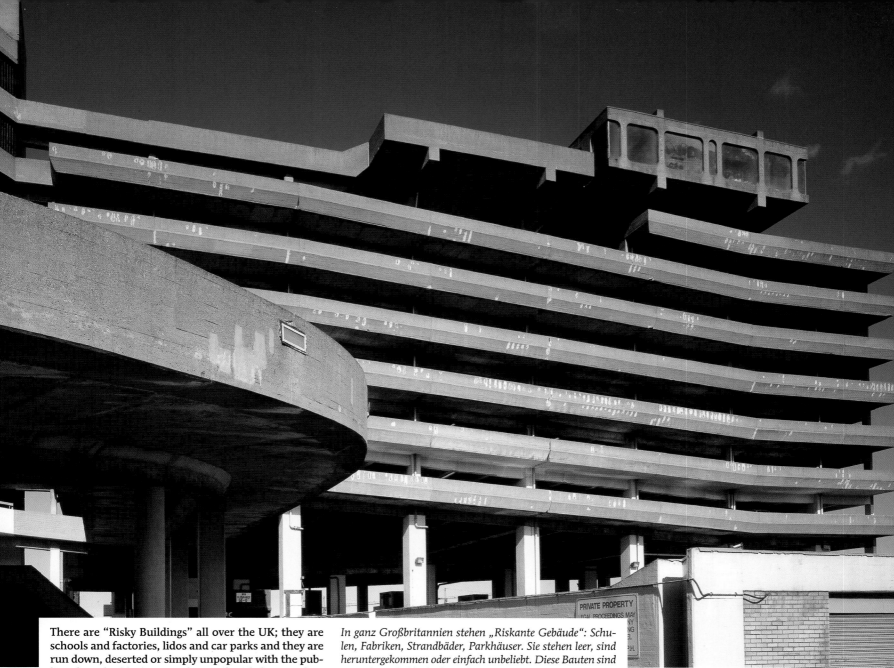

There are "Risky Buildings" all over the UK; they are schools and factories, lidos and car parks and they are run down, deserted or simply unpopular with the public. These buildings were designed with heroic ideas and utopian enthusiasm – but today they are confronted with changed attitudes and different tastes. And with harsh realities that work against them. The National Sports Centre in South London's famous Crystal Palace Park was the first of its kind – a place for the public to practice and watch sports in a dramatic and beautiful building. Today its owners, after letting it decay, do not want to pay for its future. But does that have to mean demolition? Or can an imaginative re-use scheme give it a new lease of life?

Other buildings are great manifestations of a past industrial era. The Farnborough wind tunnels were used to test aeroplanes. Can they be updated and continue to work as testing facilities? While their fate is still undecided, the former Guinness brewery in London's Brent, designed by the best early 20th Century architect of industrial buildings, Giles Gilbert Scott, is being demolished and replaced with a dull retail park – an unnecessary and wasteful loss of an impressive design.

Many of the "Risky Buildings" on our list have much to offer; they have guts and character. Most of the building are structurally sound and can be adapted for today's requirements – if we show as much enthusiasm and creativity as their designers!

In ganz Großbritannien stehen „Riskante Gebäude": Schulen, Fabriken, Strandbäder, Parkhäuser. Sie stehen leer, sind heruntergekommen oder einfach unbeliebt. Diese Bauten sind einmal mit heldenhaften Ideen und utopischem Enthusiasmus gebaut worden, werden aber heute mit völlig veränderten Auffassungen und Geschmäckern konfrontiert. Und mit harten Realitäten, die gegen sie arbeiten. Das National Sports Centre im berühmten Crystal Palace Park im Süden Londons war einmal das erste Bauwerk seiner Art - ein eindrucksvoller und wunderschöner Sportpalast, in dem jeder selbst Sport treiben oder als Zuschauer an Sportveranstaltungen teilhaben konnte. Nachdem seine Besitzer es verfallen ließen, wollen sie heute nichts mehr in seine Zukunft investieren. Muss das zwangsläufig Abriss bedeuten? Oder könnte ein fantasievoller Umnutzungsplan das Leben des Sports Centre verlängern? Andere Bauten sind großartige Zeugen der Industrialisierung im 20. Jahrhundert. In den Windkanälen in Farnborough wurden früher Flugzeuge getestet. Könnte man sie modernisieren und weiter für Testzwecke nutzen? Während ihr Schicksal noch unentschieden ist, wird die ehemalige Guinness-Brauerei in London Brent - erbaut von Giles Gilbert Scott, dem besten Industriearchitekten des 20. Jahrhunderts - derzeit abgerissen und soll durch ein langweiliges Einkaufszentrum ersetzt werden. Das ist ein unnötiger und unwirtschaftlicher Verlust eines architektonisch eindrucksvollen Gebäudes. Die „Riskanten Gebäude" auf unserer Liste haben einiges zu bieten: Sie stellen mutige Entwürfe dar und haben Charakter. Die meisten haben eine intakte, stabile Bausubstanz und lassen sich heutigen Nutzungen anpassen - unter der Bedingung, dass wir ebenso viel Begeisterung und Kreativität aufbringen wie ihre Erbauer!

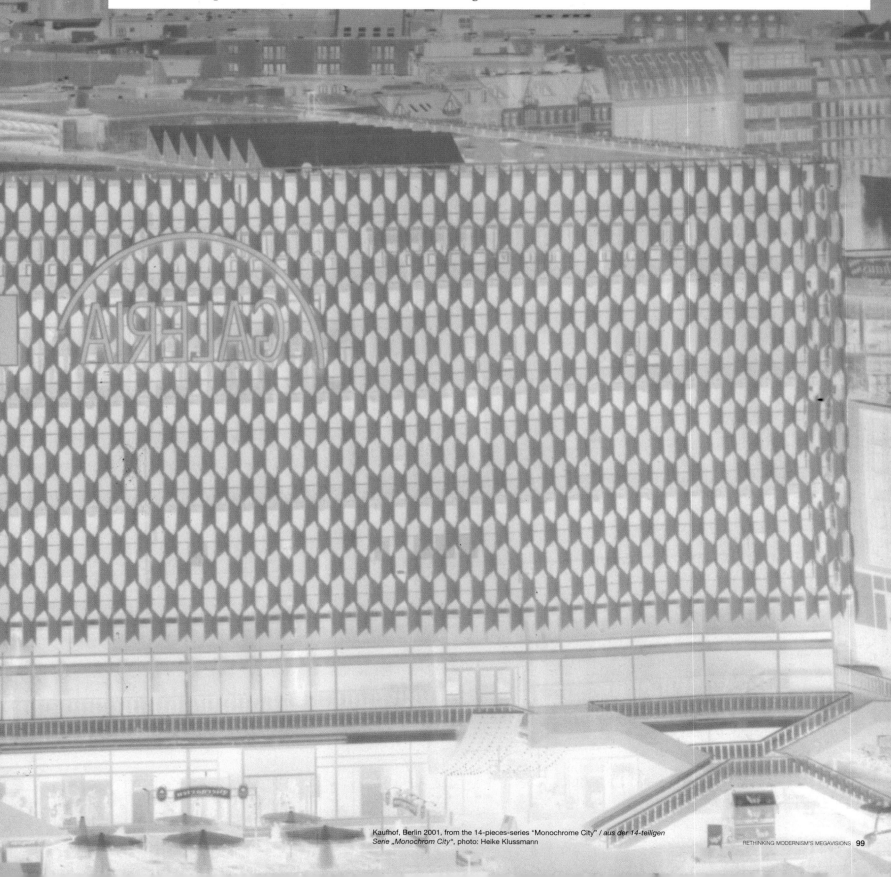

Architecture Erased

When the German department store chain Kaufhof refitted their store on Berlin's Alexanderplatz in 2005, the removal of the original façade, designed by Josef Kaiser's collective in 1967, erased the key features and proportions of a GDR international style landmark. With "Monochrome City", the artist Heike Klussmann documented the old Kaufhof from her studio in a building opposite. To create the images, she converted her entire studio into a black box – a *camera obscura* – and produced a series of exposures over several days. Thus, she created imprints that convey the memory of a building that was once a major feature of the Berlin cityscape. Als sich die Warenhauskette Kaufhof 2005 entschloss, ihr Gebäude am Berliner Alexanderplatz zu renovieren, bedeutete die vollständige Entfernung der Fassade aus Aluminiumteilen (entworfen 1967 vom Kollektiv Josef Kaiser) die Vernichtung eines Schlüsselelements des internationalen Stils der DDR. In ihrer Arbeit „Monochrom City" hat die Künstlerin Heike Klussmann den „alten" Kaufhof von einem gegenüber liegenden Gebäude aus dokumentiert. Für die Aufnahmen hat sie ihren gesamten Atelierraum in eine Black Box – eine *Camera Obscura* – umgewandelt und dort Belichtungen über mehrere Tage durchgeführt. So entstanden Erinnerungsabdrücke eines Gebäudes, das einmal ein Hauptbestandteil der Berliner Stadtlandschaft gewesen ist.

Kaufhof, Berlin 2001, from the 14-pieces-series "Monochrome City" / *aus der 14-teiligen Serie „Monochrom City",* photo: Heike Klussmann

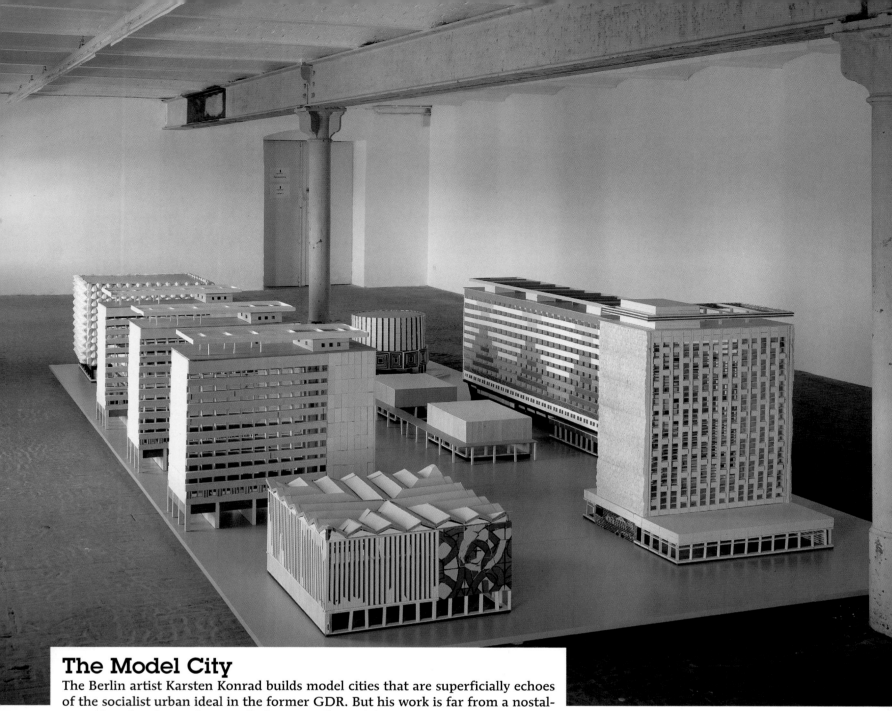

The Model City

The Berlin artist Karsten Konrad builds model cities that are superficially echoes of the socialist urban ideal in the former GDR. But his work is far from a nostalgic nod to dated city planner ideals. Konrad's models are created from the refuse of domestic dreams: the discarded materials of 20th century dwellings such as cheap pulpwood cupboard panels, kitchen cabinet remnants and found chipboard. His resulting structures parody the clean, expensive, idealised scale vehicles of modernism's visions; concepts and projections of architects egos and clients' demands. Konrad's use of oversized scale with his model architecture invites the viewer to participate, to stroll through and to interact. Closer inspection reveals that the brave forms and grand gestures of yesterday are never far from the rubbish heap of obsolescence today – bulldozed by the next generation. Der Berliner Künstler Karsten Konrad baut Modellstädte: Oberflächlich betrachtet sind sie ein Widerhall des urbanen sozialistischen Ideals der ehemaligen DDR. Konrads Modelle entstehen aus dem Abfall häuslicher Träume, den ausrangierten Materialien aus den Wohnungen des 20. Jahrhunderts, aus billigen Holzfaser-Schrankplatten, Überresten von Küchenschränken oder gefundenen Spanplatten. Die daraus entstehenden Gebilde sind eine Parodie auf die sauberen, teuren Vehikel modernistischer Visionen im Idealmaßstab; Konzepte und Projektionen der Selbstgefälligkeit von Architekten und der Forderungen von Bauherren. Konrad verwendet einen überdimensionalen Maßstab für seine Modellarchitektur und lädt so den Betrachter zur Partizipation, zum Flanieren und zur Interaktion ein. Bei näherer Betrachtung wird deutlich, dass die gewagten Formen und großen Gesten von einst heute nicht weit entfernt vom Müllhaufen der Überalterung sind – den die kommende Generation dem Erdboden gleich machen wird.

[↑] "Stadtplaner's workshop", Berlin, 2003,
photo: Martin Eberle © loop-raum für aktuelle kunst

Memory Game

baukasten.berlin (comprising seven German labels: ethicdesign, faltplatte, karhard, lucks+vonrauch, superclub, Sankt Oberholz and s.wert design) have developed a broad range of products that all deal with the subject of memory and architecture. Their "Plattenbauquartett" card game, for example, features sets of images of details from GDR prefab blocks. Their playful approach reveals the aesthetic value of the buildings, alters their context and draws the focus towards detail in objects that we otherwise tend to assimilate on a macroscopic level. baukasten.berlin (bestehend aus den sieben Labeln: ethicdesign, faltplatte, karhard, lucks+vonrauch, superclub, Sankt Oberholz und s.wert design) haben inzwischen eine breite Palette von Produkten entwickelt, die sich mit den Themen Architektur und Erinnerung beschäftigen. Beispielsweise dokumentiert das „Plattenbauquartett" in Bild und Text den Zustand Ostberliner Plattenbauten vor ihrem Abriss bzw. ihrer Sanierung. Mit meist spielerischem Ansatz, aber auch mit wissenschaftlichem Anspruch dokumentieren baukasten-Produkte städtebauliche Phänomene, indem sie sie aus ihrem Kontext lösen und den Fokus des Betrachters auf Details lenken, denen wir ansonsten im großen Maßstab keine Aufmerksamkeit schenken.

"As a rule, buildings erected before the twentieth century are considered to be 'historical' and those put up later are considered 'modern', i.e. not 'historical'. Even though they can be up to a century old, it still takes a lot to explain exactly why they are worth preserving – especially in Berlin. The eastern part of the city was once the capital of the communist-ruled GDR and the modern buildings that stand in the city centre today are a part of that legacy. Preserving them reminds people of an only just recently closed chapter of German history. The members of baukasten.berlin believe that these relics of the past are important for the future. Baukasten doesn't just concern itself with the architecture of the GDR era in Berlin's centre; it also examines other city districts, towns and peripheries for particles of memory that are in danger of disappearing." Cornelius Mangold, baukasten.berlin

„In der Regel werden zu ,historischen Bauwerken' solche Bauten gerechnet, die vor dem Beginn des 20. Jahrhunderts gebaut wurden. Später entstandene Bauten gelten als ,modern', also nicht ,historisch'. Obwohl auch sie inzwischen ein halbes Jahrhundert alt sein können, bedarf es eines hohen Erklärungsbedarfs, was an ihnen schützenswert sei. Besonders in Berlin. In Berlins Mitte sind solche modernen Gebäude auch immer Bauwerke der DDR, denn sie wurden auf dem Territorium der sozialistischen Hauptstadt gebaut. Mit ihrem Erhalt wird gleichzeitig an eine jüngst abgeschlossene Periode der deutschen Geschichte erinnert. baukasten.berlin glaubt daran, dass diese Relikte der Vergangenheit für die Zukunft bedeutsam sind. Dabei schenkt baukasten nicht nur der DDR-Architektur in Berlins Zentrum seine Aufmerksamkeit, sondern spürt auch in anderen Bezirken, Städten und Stadträndern Erinnerungspartikeln nach, die bedroht sind, aus dem Stadtbild zu verschwinden."
Cornelius Mangold, baukasten.berlin

[↑] 14 cards from the "Prefab happy families set" / 14 Spielkarten aus dem „Plattenbauquartett", photos: baukasten.berlin

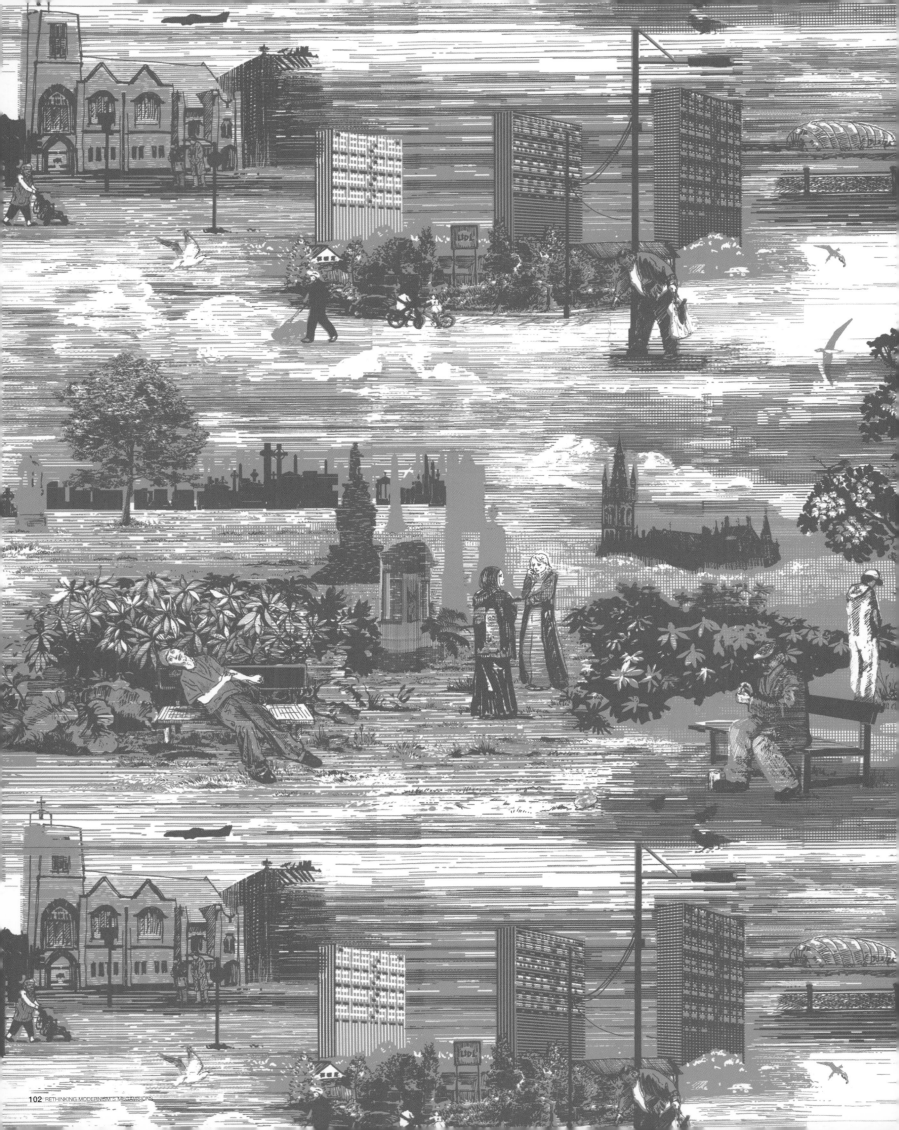

Dystopian Idyll

By depicting uncompromisingly urban and dystopian contemporary images on traditional textiles and wallpapers, Timorous Beasties (alias Alistair McAuley and Paul Simmons, Glasgow, UK) have defined an iconoclastic style of design once described as "William Morris on acid". They print fabrics, such as their "Glasgow Toile", which explore social and political issues in a pastiche context of the romantic 19th century rural idyll. *Durch die Abbildung von kompromisslos-urbanen und dystopischen Bildern der Gegenwart auf traditionellen Stoffen und Tapeten haben Timorous Beasties (alias Alistair McAuley und Paul Simmons, Glasgow) einen ikonoklastischen Designstil definiert, der einmal als „William Morris auf LSD" beschrieben wurde. Sie stellen Stoffe wie den „Glasgow Toile" her, die politische und gesellschaftliche Themen im Pastiche-Kontext der romantischen ländlichen Idylle des 19. Jahrhunderts bearbeiten.*

"The 'Glasgow Toile' [came from] the old *Toile de Jouey* that were produced in pre-revolutionary France, in the small town of Jouey in the 1770s.

The imagery in the original French 18th century toiles was quite sinister. They depicted scenes that were then contemporary, but we now see as traditional. Some scenes showed the factory at Jouey, and others rural scenes of workers relaxing, drinking, dancing, and womanising. So we did not actually change much in the Glasgow Toile; a glass of wine became a can of super lager, a pipe became a rollie, and an old man sitting on a stool in a rural scene became a tramp on a park bench. All this is happening as the Glasgow University Tower looms above like a fairy tale castle. Other landmarks are the Charles Rennie Mackintosh Church situated in Maryhill, a poor area of Glasgow where we used to have a studio, while Norman Foster's Armadillo building represents the changes along the Clyde, a once booming industrial port. The urban landscape in many UK cities seems to change all the time. Modern buildings have become icons that give us a strong sense of identity, therefore the Glasgow Toile seemed a perfect expression of where we were coming from." Interview extract: www.designmuseum.org

„Der ‚Glasgow Toile' ist vom alten Toile de Jouey inspiriert, der in den siebziger Jahren des 18. Jahrhunderts im vorrevolutionären, postindustriellen Frankreich in der Kleinstadt Jouey hergestellt wurde.

Die Darstellungen auf den französischen Originaltoiles aus dem 18. Jahrhundert waren ziemlich düster. Sie zeigten Szenen, die damals zeitgenössisch waren, die wir aber heute als traditionell empfinden. In einigen Szenen war die Fabrik in Jouey zu sehen, andere stellten ländliche Szenen mit Arbeitern dar, die sich ausruhten, tranken, tanzten und mit den Frauen flirteten. Wir haben also nicht wirklich viel für den Glasgow Toile geändert; aus einem Glas Wein wurde eine Dose Bier, aus einer Pfeife eine Selbstgedrehte, und ein alter Mann, der in einer ländlichen Szene auf einem Schemel saß, wurde zu einem Landstreicher auf einer Parkbank. All das spielt sich ab, während der Turm der Universität von Glasgow wie ein Märchenschloss darüber ragt. Weitere verwendete Wahrzeichen von Glasgow sind die Charles-Rennie-Mackintosh-Kirche in Maryhill, einer armen Gegend, in der wir früher ein Atelier hatten; während das Clyde-Auditorium des Armadillo Building (Gürteltiergebäude) von Norman Foster für den Wandel am Ufer des Clyde, einem ehemals boomenden Industriehafen, steht. Die urbane Landschaft in vielen britischen Städten scheint sich ständig zu verändern. Moderne Gebäude sind zu Ikonen geworden, die uns ein starkes Identitätsgefühl geben, daher erschien uns der Glasgow Toile als perfekter Ausdruck unserer Herkunft." Interviewauszug: www.designmuseum.org

[↖] "Glasgow Toile", photo: Timorous Beasties

Negative Space

Negativraum Based in Hong Kong, Map Office (conceived by French architects Laurent Gutierrez and Valérie Portefaix) is an open platform concerned with rethinking the socio-political agenda of architecture. In 2004 they initiated a project examining the transformed spaces underneath the elevated ring road of Guangzhou in China. Running counter to the local architectural circle fixated on master structures to meet the market's demand, the mission of Map Office is to bring forward a set of fresh alternatives to a region preoccupied with "just in time" industrial production and efficiency. Most of Map's projects involve critical analysis of spatial and temporal anomalies and documentation of the ways in which human beings subvert and appropriate spaces for their own uses. Map Office in Hongkong (gegründet von den französischen Architekten Laurent Gutierrez und Valérie Portefaix) bildet ein offenes Forum für die Neukonzeption der sozio-politischen Aufgaben der Architektur. 2004 initiierten sie ein Studienprojekt, das die transformierten Räume unterhalb des erhöhten Stadtautobahnrings von Guangzhou, China, dokumentiert. Den Interessen der chinesischen Architektenschaft zuwiderlaufend, die, um die Nachfrage des Marktes zu befriedigen, hauptsächlich auf die Entwicklung von Großstrukturen fixiert sind, hat sich Map Office zum Ziel gesetzt, in einer Region der industriellen „Just-in-Time"-Produktion und Effizienz neue architektonische Alternativen anzubieten. Ein Großteil der Map-Projekte umfasst kritische Analysen räumlicher und zeitlicher Anomalien und die Dokumentation der Methoden, mit denen sich Menschen Räume aneignen und diese auf verschiedenste Weise subversiv umgestalten und nutzbar machen.

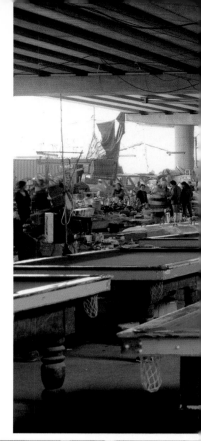

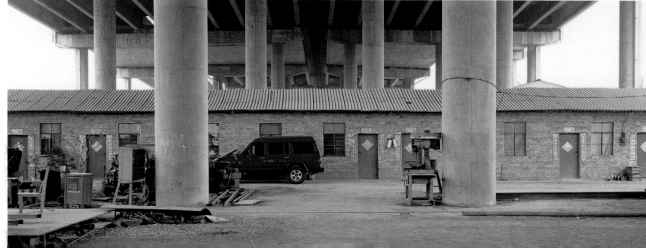

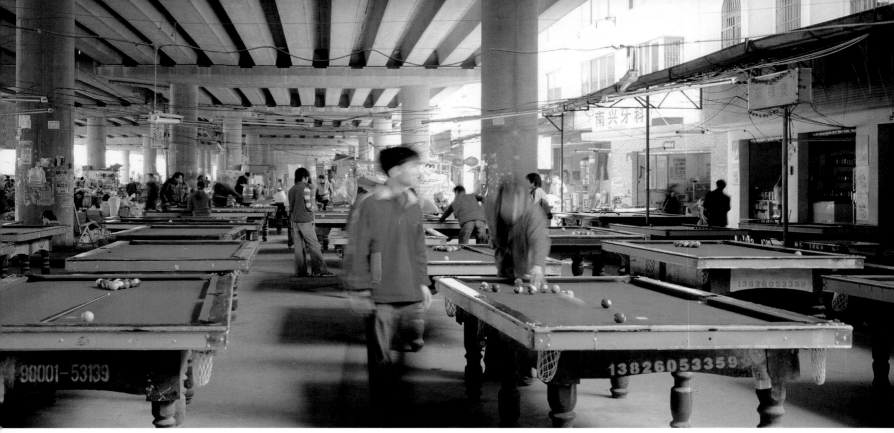

"Underneath" is 63 kilometres of superhighway owned by Hong Kong developer Hopewell Holding and its CEO Sir Gordon Wu, a private empire that controls the economy, the geography and ultimately the culture of the region.

"Underneath" questions zones of contact and zones of conflict. It is China at its best.

Environment and landscape are transformed under a multitude of pressures: the simultaneous presence of farms, plastic factories, traditional villages, new villas, stadiums and shopping malls. This transformation presents a contrast that extends far beyond conventional urban and rural dichotomies.

"Underneath" is now a linear platform for migrants to invent a new geography of living. Along this artificial geographic line, the superhighway introduces a striking perspective of potential scenarios.

"Underneath" works in the very same way as a lift in a tower, with congestion and acceleration. Here, time and occasion are more important than the places traversed.

"Underneath" is a powerful planning instrument, with no particular concern for spatial sequence or articulation, its extended line constitutes an effective strategy for colonisation, transforming the environment in a series of polynuclear construction systems. In this unstable context, its physical and temporal scale is measured by the superhighway itself.

"Underneath", through its images and text, ultimately challenges our sense of place as it is pressured by constant transformation and destabilisation. Map Office

„Underneath" (Unterhalb) befasst sich mit der 63 km langen Fläche unterhalb der Ringautobahn, deren Besitzer die Hongkonger Bauentwicklungsfirma Hopewell Holding und ihr Generaldirektor Sir Gordon Wu sind. Dieses private Firmenimperium beherrscht die Wirtschaft, die Landschaft und letztlich auch die Kultur dieser Region.

„Underneath" untersucht die Kontakt- und Konfliktbereiche im Bereich des Autobahnrings und führt uns markant vor Augen, was das heutige China ausmacht.

Umwelt und Landschaft verändern sich unter dem Druck zahlreicher Faktoren: Kunststofffabriken schießen neben alten Bauernhöfen aus dem Boden; neue Villen, Stadien und Einkaufszentren entstehen in unmittelbarer Nähe zu traditionellen Dörfern. Diese Veränderungen bilden Kontraste, die weit über die herkömmliche Dichotomie von Stadt und Land hinausgehen.

„Underneath" ist eine linear angelegte Bühne: Nicht auf, sondern unter ihr erfinden „Landflüchtlinge" ihre Lebensräume neu. Entlang dieser künstlichen geografischen Linie bieten die „Superhighways" überraschend neue Szenarien und Konstellationen.

Die Grundfunktionen von „Underneath" sind solche, die man auch von Aufzügen in Hochhäusern kennt: Überfüllung und Beschleunigung. Zeit und Gelegenheit sind hier wichtiger als die Orte, die man durchquert oder an denen man vorüberzieht.

„Underneath" ist ein kraftvolles Planungsinstrument, das sein Augenmerk nicht auf die besondere Raumfolge oder andere Betonungen legt, denn unter der fortlaufenden Linie dieser Trasse ergeben sich die unterschiedlichsten Strategien für eine Kolonialisierung. Es verwandelt seine Umgebung in eine Abfolge von polynukleären Konstruktionssystemen. In diesem instabilen Kontext ist es der „Superhighway", der die physischen und zeitlichen Maßstäbe setzt.

„Underneath" hinterfragt durch seine Bilder und Texte unser Gefühl für einen Raum, der permanent zu radikaler Veränderung und Destabilisierung gezwungen ist. Map Office

[↑] Photo series "Underneath", spatial programmes beneath highway, Guangzhou, China / *Umnutzung unterhalb der Stadtautobahn in Guangzhou, China*, photos: Gutierrez+Portefaix, Map Office, 2005

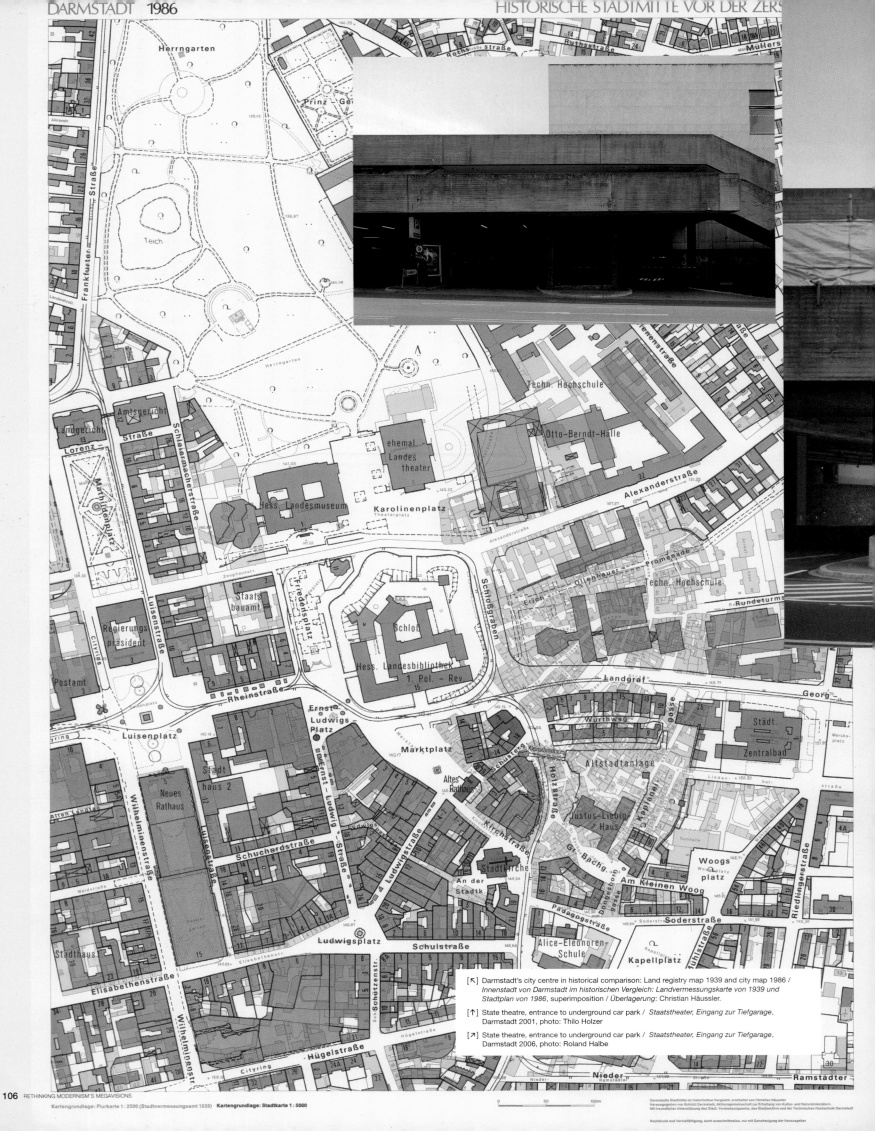

[↖] Darmstadt's city centre in historical comparison: Land registry map 1939 and city map 1986 / *Innenstadt von Darmstadt im historischen Vergleich: Landvermessungskarte von 1939 und Stadtplan von 1986*, superimposition / *Überlagerung*: Christian Häussler.

[↑] State theatre, entrance to underground car park / *Staatstheater, Eingang zur Tiefgarage*, Darmstadt 2001, photo: Thilo Holzer

[↗] State theatre, entrance to underground car park / *Staatstheater, Eingang zur Tiefgarage*, Darmstadt 2006, photo: Roland Halbe

Kartengrundlage: Flurkarte 1 : 2500 (Stadtvermessungsamt 1939) Kartengrundlage: Stadtkarte 1 : 5000

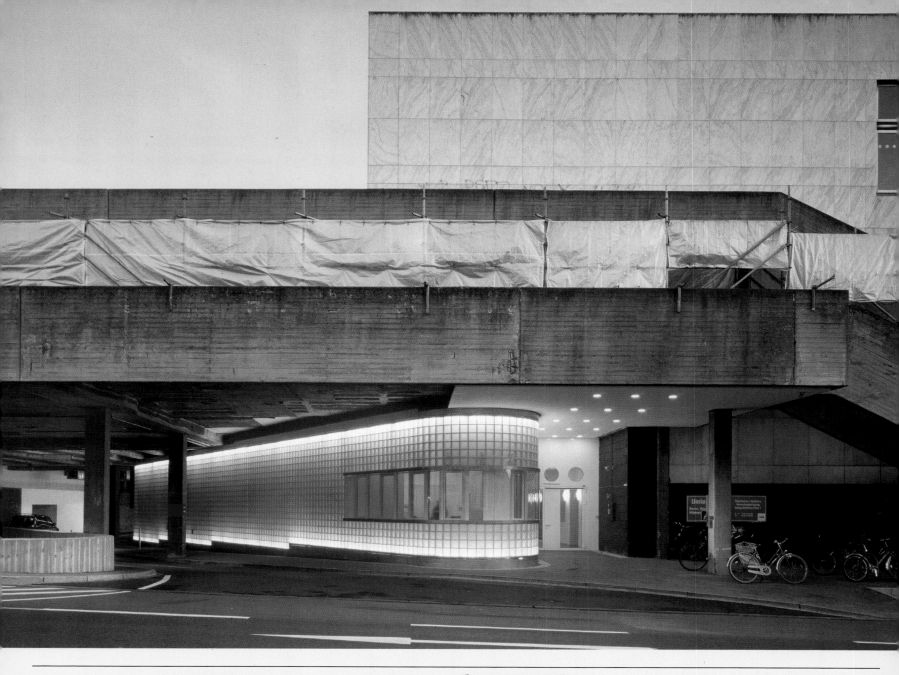

Darmstadt Plug-In

Das autogerechte Theater The Hessian State Theatre in Darmstadt is a theatre for the mobile citizen: The 1970s planning set the entrance to the foyer in the car park in order to make the route from vehicle to cultural enjoyment as comfortable and short as possible. Stuttgart architects Lederer+Ragnarsdóttir+Oei have now converted this modern concrete cruise liner into a performance venue that at last opens itself out to the city. Partner and professor Arno Lederer explains the transformation. *Das Staatstheater in Darmstadt ist ein Theater für den mobilen Bürger: Die Planungen der 1970er Jahre legten den Zugang zum Foyer in das Parkhaus, um den Weg vom Auto zum kulturellen Genuss so kurz und angenehm wie möglich zu gestalten. Die Stuttgarter Architekten Lederer+Ragnarsdóttir+Oei verwandeln dieses moderne Schlachtschiff aus Beton in eine Spielstätte, die sich endlich der Stadt und dem Fußgänger öffnet. Büropartner und Professor Arno Lederer erklärt diese Transformation.*

One day in the late 1960s, as we were putting reinforcement into some big formwork units, we heard the reports on the moon landing. It was self-evident for us then to plan a "drive-in"-theatre along American lines. Why should anyone walk anywhere in an age of unshaken faith in technology, at a time of change? The future that we envisaged back then

returns today as an old lady, unsteady on her feet. If you look at her for long enough, you believe you can recognise the strength that she once had. Loss only becomes visible where things have actually disappeared … that which remains standing tells of the courage that we once had.

The State Theatre in Darmstadt is an excursion to the then firmly believed

Ende der 1960er Jahre hörten wir beim Armieren von Großschalungen die Reportage über die Mondlandung. Dass man in dieser Zeit „Drive-in-Theater" nach amerikanischem Muster plante, empfanden wir als selbstverständlich. Wer sollte in einer Zeit immenser Technikgläubigkeit, in dieser Zeit des Aufbruchs, noch zu Fuß laufen? Die Zukunft von damals kehrt heute als wacklige

alte Dame zurück. Wer sie lange anschaut, glaubt die ursprüngliche Kraft wiederzuerkennen. Verlust wird nur sichtbar, wo die Dinge abhanden gekommen sind … die Stehengebliebenen erzählen zwischen der modernen Vergangenheit von dem Mut, den wir einmal hatten.

Das Staatstheater in Darmstadt ist ein Ausflug in die damals sicher geglaubte – in-

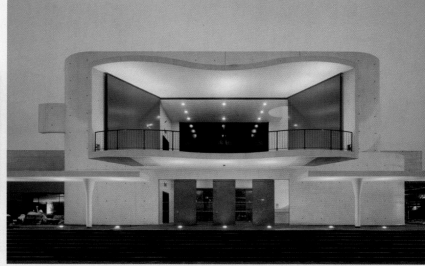

[↖] State theatre, entrance from car park roof / *Staatstheater, Eingang vom Dach des Parkhauses*, Darmstadt 2001, photo: Johannes Marburg

[↑] State theatre, entrance from car park roof / *Staatstheater, Eingang vom Dach des Parkhauses*, Darmstadt 2006, photo: Roland Halbe

in – but now faded – future of the past. It's a successful example of the arrival of the Charter of Athens on the daily scene for post-war West Germany: smack in the middle of the city, with no relation-

A leap into a new era that then failed to appear.

ship to the urban space, paying no consideration to what is already there. It was a leap into a new era that then failed to appear.

The theatre, completed in 1972, was planned by Rudolf Prange at a time when the inner city area of Darmstadt was due to be redesigned for the benefit of the car. It is a large building that, although perfect for the routing of future traffic, stands helplessly admist its surroundings: a completely oversized box with multi-lane drive-in access at street level. A main entrance for pedestrians with a portal would have been unthinkable in those days – who should, (or would want to) go through the town on foot to the theatre when there is direct access from the parking area in the basement to the foyer above? This is typical of how the form of the entire building is subordinated (not without a certain 1960s charm) to perfect functionalism. On top of the underground car park there is, instead of an urban square connecting the theatre to the city around it, a landscaped area that seems ashamed to reach out to the organic structure of the city.

This building, of exposed concrete, marble cladding and corrugated sheet metal, has always worn the mantle of modernity. In this form it endured unnoticed through postmodernism and the 1990s, until all at once failure to carry out maintenance, inadequate fire precautions and unsafe stage machinery made the whole thing look old. People suddenly began to find the theatre ugly, because it now so easily fitted the cliché of sad, grey, inhuman concrete architecture.

What, then, was to be done with this great concrete ship?

If it had simply been an old, worn out coat, there would have been three possible ways of dealing with it: a) throw the coat away, b) darn the torn bits, which isn't pretty, but it works (the engineering solution), or c) use scraps of cloth as patches to sew on top of the torn bits. Now we have a coat that is both old and new at the same time (the architectural and engineering solution).

Solution c is not merely a strategy that is suitable for our building, it is a general principle to be applied when it comes to dealing with buildings from the 1960s.

Our approach turns the "car-friendly theatre" into a "city-friendly" one: a building that is present as part of the urban space and helps to give it character. This makes it possible to dispense with the opulent driveway that spreads out in multiple lanes under the building. The extra space gained is large

The cliché of sad, grey, inhuman concrete architecture.

enough to comfortably accommodate all of the organisational functions needed to run a theatre. Where cars once entered, is a studio theatre, a canteen and all of the storage rooms.

The new structure that we inserted into the former entrance to the underground car park, together with staircase and lifts, provides the theatre with an impressive entrance that relates it in one go to its urban context. On the planted area above the underground car park, an open-air stage is to be built to enliven the square in front of it. This striking structure makes reference to the buildings beyond the landscaping. One can only hope that the opportunity is recognised as such and that the city authorities will remodel the planted area as an urban square. This would help the theatre to become a visible component of the city and give it the urban status that it is once again possible to expect from an institution of this sort.

zwischen verblichene – Zukunft der Vergangenheit. Ein gelungenes Beispiel über die Ankunft der Charta von Athen im bundesdeutschen Alltag der Nachkriegszeit: mitten in der Stadt, ohne Bezug zum Stadtraum, ohne Rücksicht auf Bestehendes. Ein Aufbruch in eine neue Zeit, die dann nicht stattgefunden hat.

Das Gebäude, 1972 fertig gestellt, wurde von Rudolf Prange in einer Zeit geplant, die eine autogerechte Umgestaltung der Darmstädter Innenstadt zum Ziel hatte. Perfekt in der Verflechtung zukünftiger Verkehrsströme, steht das große Haus ohne räumliche Beziehung hilflos in seiner Umgebung: Ein vollkommen überdimensionierter Kasten mit mehrspuriger Zufahrt auf Straßenebene. Ein Haupteingang für Fußgänger mit Portal wäre damals undenkbar gewesen – wer sollte und wollte denn noch zu Fuß durch die Stadt ins Theater gehen, wenn es doch einen direkten Zugang aus den Parkdecks im Untergeschoss nach oben ins Foyer gibt? Wie in diesem Bereich beherrscht – nicht ohne den Charme der 1960er Jahre – die perfekte Funktion die Formgebung des gesamten Gebäudes. Über der Tiefgarage liegt nicht etwa ein urbaner Platz, der das Theater in den Stadtraum einbindet, vielmehr findet man dort eine Grünanlage die sich geniert, der gewachsenen Struktur die Hand zu geben.

Immer trug das Haus – aus Sichtbeton, Marmorverkleidung und Wellblech – den Mantel der Moderne. So dümpelte es unbeachtet durch die Postmoderne und die 1990er Jahre, bis mit einem Schlag unterlassener Bauunterhalt, mangelhafter Brandschutz und eine menschengefährdende Bühnentechnik das Ganze alt aussehen ließen. Da empfand man das Theater mit einem Male als hässlich, denn es passt heute nahtlos in das Klischee einer tristen, grauen, menschenverachtenden Betonarchitektur.

Was tun mit diesem Schlachtschiff aus Beton?

Hätten wir es mit einer Jacke zu tun, gäbe es drei Möglichkeiten des Umgangs mit dem beschädigten Bestand: a) wir werfen die Jacke weg, b) wir flicken die Risse, was nicht schön ist, aber funktioniert (die ingenieurstechnische Lösung) oder c) wir benutzen Stoffreste, mit denen wir die kaputten Stellen zusammennähen. Nun haben wir eine alte und neue Jacke zugleich (architektonische und ingenieurstechnische Lösung).

Die Lösung c) ist nicht nur eine Strategie, die zu diesem Haus in Darmstadt passt, sondern eine prinzipielle für den Umgang mit Gebäuden der 1960er Jahre.

Unser Ansatz wird aus dem „autogerechten Theater" ein stadtgerechtes Theater machen, also ein Haus, das im Stadtraum präsent ist und diesen prägt. So kann auf die opulente Zufahrt, die in mehreren Spuren unter dem Haus hindurchführt, verzichtet werden. Der so gewonnene Raum ist groß genug, alle organisatorischen Bedürfnisse des Theaterbetriebs bequem unterzubringen: Wo früher die Autos parkten gibt es eine Studiobühne, eine Kantine und alle Lagerräume.

Der neue Baukörper, den wir in die Auffahrt der Tiefgarage gesetzt haben, ergibt mit Treppenanlage und Aufzug ein repräsentatives Portal, welches das Staatstheater plötzlich in den städtebaulichen Kontext einbindet. Auf der begrünten Ebene über der Parkgarage entsteht eine Freilichtbühne, die den davor liegenden Platz bedient. Dieses markante Bauteil nimmt mit den Gebäuden jenseits der Grünanlage Bezug auf. Man kann nur hoffen, dass die Chance erkannt wird und die erwähnte Anlage der Stadt in einen urbanen Platz umgebaut wird. Dann wird die Theater sichtbarer Teil der Stadt werden und jenen städtebaulichen Stellenwert haben, den man heute wieder von einer solchen Einrichtung erwarten kann.

"I am fascinated by the kiosk as a real downtown condition.
I am even trying to incorporate the kiosk into a piece of urban structure
which I'm working on in Spain where a sort of high-powered building
stands on legs above the territory that is left for the kiosk. I don't know
if we can convince the client to do it! To say that the ticky-tacky can
exist with the organised is like the filling in a sandwich. The car park
below, then a gap, then the building above, then another gap and then
the roof where you allow things to grow. So you have two areas of
sandwich; three areas of bread, as it were, two areas of filling,
then a topping which can be much more ad-hoc." Peter Cook, 2004

„Ich bin fasziniert vom Kiosk als tatsächlichem innerstädtischen Zustand.
Ich versuche sogar, den Kiosk in ein städtisches Bauwerk in Spanien zu integrieren, an dem ich gerade arbeite:
eine Art Hochleistungsgebäude, das auf Stelen über dem Bereich steht,
der für einen Kiosk ausgespart wurde. Ich weiß nicht, ob wir den Auftraggeber überzeugen können,
sich darauf einzulassen. Wenn man sagt, dass das Kitschige, Billige gemeinsam mit dem Organisierten existieren kann,
so verhält es sich wie bei dem Belag auf einem Sandwich.
Der Parkplatz unten, dann eine Lücke, dann das Gebäude darüber, dann eine weitere Lücke und dann das Dach,
auf dem etwas wachsen kann. Somit hat man zwei Sandwichschichten, gewissermaßen drei Brotschichten und
zwei Belagschichten, darauf eine Garnierung, die sehr viel spontaner sein darf."

"Urbane Anarchisten", photos: Christoph Buckstegen

Corviale: The Urban Imaginary

Eingebildete Urbanität The Corviale is a 958-metre-long building planned by Mario Fiorentino in 1974 and completed in 1982. A multi-disciplinary group of Italian artists and architects, called Osservatorio Nomade, worked in the building between 2004 and 2005 on their project "Immaginare Corviale", examining how public space and architecture is lived, transformed, remembered and imagined. *Corviale ist ein 958 m langer Wohnblock, der 1974 von Mario Fiorentino entworfen und 1982 fertig gestellt wurde. Ein interdisziplinäres Team italienischer Künstler und Architekten, das Osservatorio Nomade, arbeitete dort von 2004 bis 2005 an dem Projekt „Immaginare Corviale", bei dem untersucht wurde, wie öffentliche Räume und Gebäude bewohnt, transformiert, erinnert und neu erfunden werden.*

Text: Flaminia Gennari Santori

When it was conceived, the Corviale, situated on top of a hill in the southwestern periphery of Rome surrounded on three sides by intact countryside, was considered innovative because alongside the 1,200 apartments, it contained many services and public and commercial spaces. Commissioned by the Public Housing Agency of Rome as an antidote to the disordered and often illegal development of the city and as a frontier for urban planning and public housing, Corviale was developed not just a building but as a self contained part of the city. It took ten years to erect, but by the time it was completed, it was already obsolete: The legendary public services arrived stillborn because the public administration was never able to manage them. Ironically, Corviale was never in-

Als es konzipiert wurde galt Corviale – auf dem Gipfel eines Hügels am südwestlichen Stadtrand von Rom gelegen und auf drei Seiten von einer ökologisch intakten Landschaft umgeben – als innovativ, weil der Wohnblock außer 1.200 Wohnungen auch viele Dienstleistungen, Läden und öffentliche Einrichtungen enthielt. Auftraggeber war die römische Behörde für sozialen Wohnungsbau, die dem planlosen und häufig illegalen Wachstum der Stadt einen Riegel vorschieben und neue stadtplanerische Möglichkeiten im Bereich des öffentlichen Wohnungsbaus aufzeigen wollte. Corviale war nicht nur als einfacher Wohnblock gedacht, sondern als autarker Stadtteil. Die Bauzeit betrug zehn Jahre und als Corviale fertig gestellt war, war es bereits obsolet. Die angepriesenen öffentlichen Dienstleistungen wurden nicht umgesetzt,

[↑] Corviale and surrounding meadows / *Corviale und umliegende Wiesen*, photo: Armin Linke

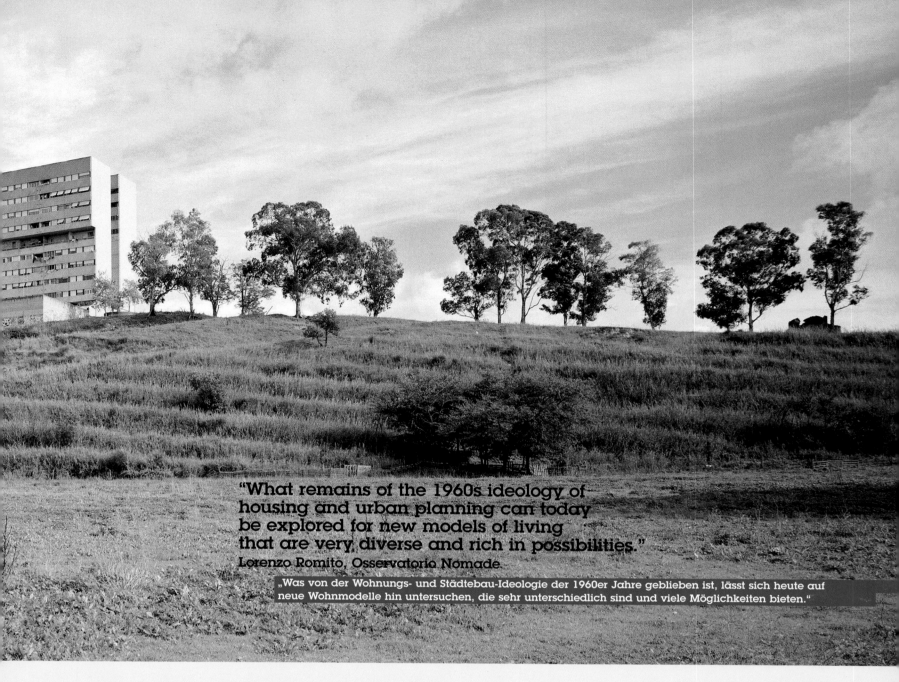

"What remains of the 1960s ideology of housing and urban planning can today be explored for new models of living that are very diverse and rich in possibilities."
Lorenzo Romito, Osservatorio Nomade.

„Was von der Wohnungs- und Städtebau-Ideologie der 1960er Jahre geblieben ist, lässt sich heute auf neue Wohnmodelle hin untersuchen, die sehr unterschiedlich sind und viele Möglichkeiten bieten."

novative: the building itself was decayed from the start, perceived in the public domain as an obsolete, unmanageable relic from another time zone. Corviale is one of the last monuments to modernist public housing policy in Italy. It is highly symbolic of a period and a notion of society that no longer exists, yet it is also a negative inner city stereotype. Since the 1980s many people, architects included, have been calling for its demolition, but to relocate more than 6,000 people is not that easy and no one has

Corviale is highly symbolic of a period and a notion of society that no longer exists.

yet dared to demolish it. Today Corviale has assumed the status of a paradigm, both positive and negative, of public housing. Public debate about it has begun to resurface after years of oblivion in the light of the current housing shortfall in Rome.

Created by Stalker in 2001, Osservatorio Nomade has developed an alternative procedure of intervention in public contexts such as a multicultural enclave in the centre of Rome, an area in the south of Italy of recent and ancient immigration and a thousand year old road of migration, the Egnatia that stretches from Istanbul to Rome. They move to these contexts together as a large group of people and "live them" for a prolonged period of time. Their approach implies thorough explorations of the site that consciously avoid any predetermined disciplinary approach. The establishment of relationships with the people that live in and use the sites results in their involvement in "games" that trigger a novel view, perception and criticism of the place itself. In the case of Corviale, Osservatorio Nomade had to face Architecture with a capital "A", for the first time, responding to it with "an architecture of behaviour, uses and interpretations of space". The collective worked for a year on the reality that is the build-

weil es den Behörden nicht gelang, diese zu organisieren. Ironischerweise war Corviale zu keinem Zeitpunkt innovativ: Das Gebäude war von Anfang an marode und im öffentlichen Sektor hielt man das Projekt für ein überholtes, unkontrollierbares Relikt aus einer anderen Zeit.

Corviale ist eines der letzten Denkmäler der modernen sozialen Wohnungsbaupolitik in Italien. Es ist höchst symbolisch für eine vergangene Zeit und eine Gesellschaftsphilosophie, die so heute nicht mehr existiert, und repräsentiert dabei auch einen negativen Innenstadt-Stereotypen. Seit den 1980er Jahren haben viele Leute – Architekten eingeschlossen – den Abriss der Anlage gefordert, jedoch ist die Umsiedelung von über 6.000 Menschen nicht einfach zu realisieren und niemand hat deshalb gewagt, Corviale tatsächlich abreißen zu lassen. Inzwischen hat der Bau, im positiven wie im negativen Sinne, den Status eines Paradigmas für den sozialen Wohnungsbau eingenommen. Die in Vergessenheit geratene öffentliche Diskussion über Corviale ist nun nach Jahren angesichts der gegenwärtigen Wohnraumknappheit in Rom wieder neu entflammt.

Die von Stalker 2001 gegründete Gruppe Osservatorio Nomade hatte bereits zuvor eine alternative Prozedur der Vermittlung in öffentlichen Situationen entwickelt, unter anderem in einer der multikulturellen Enklaven im Zentrum von Rom, einem Gebiet in Süditalien mit einer Bevölkerung, die sich aus früheren Einwanderern und neuen Immigranten zusammensetzt und außerdem im Gebiet entlang einer Jahrtausende alten Straße der Ein- und Auswanderer – der Egnatia – von Istanbul nach Rom. Im Rahmen dieses Projektes sind größere Gruppen der Mitarbeiter von Osservatorio Nomade in diese Gebiete gezogen, um dort über einen längeren Zeitraum zu leben und diese Orte zu „erfahren". Ihr Ansatz beinhaltet eine sorgfältige Erforschung des Gebietes, dabei bewusst jede vorgefasste fachliche Herangehensweise vermeidend. Sie bauen Beziehungen zu den Menschen auf, die dort leben und das Areal nutzen und werden dadurch in eine Art von Rollenspiel verwickelt – dies ermöglicht ihnen eine andere Wahrnehmung des Ortes und schließlich eine kritische Neubewertung der eigenen Umgebung. Im Fall von Corviale musste sich

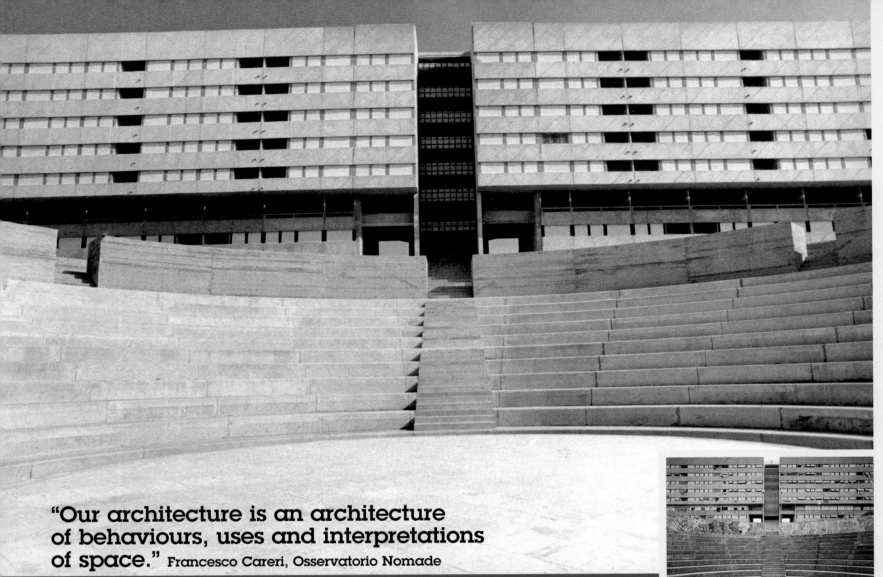

"Our architecture is an architecture
of behaviours, uses and interpretations
of space." Francesco Careri, Osservatorio Nomade

„Unsere Architektur ist eine Architektur des Umgangs mit,
der Nutzung und Interpretation von Räumen."

ing and on the imaginary that is the response to it amongst residents, the media and in the architectural debate, seeking to bring both aspects together on the same level. In their own words: "Osservatorio Nomade was a participant observer of the reality of Corviale, a territory that is not ours and for which we don't think we have the formula to summon the residents to participate. What we asked them for was a more emotional involvement ... we proposed visions that could stimulate the people to transcend the banality and the everyday nature of their surrounding spaces".

The establishment of relationships with the people that live there triggers a novel perception and criticism of the place itself.

With the collaboration of a group of residents, Osservatorio Nomade transformed Corviale into an urban laboratory on public space, public housing, access to representation, collective memory and the reorganisation of the building itself.

"Working at Corviale, we started from the overlapping of art, architecture and politics that informed the original project for the building. We tried to individuate the instruments that could revitalise a deteriorated relationship between public administrators, architects and residents, instruments and attitudes that could converge into a strategy of intervention in urban reality." (Lorenzo Romito, Osservatorio Nomade)

To trace a site-specific history of the place that went beyond mainstream architectural history or sociological vernacular was a core aspect of the Osservatorio Nomade approach. They brought back many people that had been involved in the design and construction of Corviale and invited them to lunch at the apartment of a resident who collaborated with the project, thus establishing a dialogue, at last, between "designers" and "users" that had never taken place when it should have.

Other traces of the history of the building were found in the ways the residents adapted the building to their needs. This analysis evolved on the one hand into a sort of atlas of transformation of a very fixed environment, and on the other, into suggestions and proposals for improvements for the building that took account of the residents'

das Team von Osservatorio Nomade zum ersten Mal mit einer baulichen Großform auseinandersetzen und darauf mit einer „Architektur des menschlichen Verhaltens, des Gebrauchs und der Interpretation von Raum" reagieren. Das Kollektiv arbeitete ein Jahr lang sowohl an der Realität des Gebäudes als auch an deren Projektion in den Reaktionen von Bewohnern, Medien und der Architekturdebatte; die Realität und die projizierten Vorstellungen aller Beteiligten sollten auf einer Ebene zusammenfinden. Nach eigener Aussage war Osservatorio „ein Anteil nehmender Beobachter der Realität von Corviale, eines Territoriums, das nicht unseres ist und für das wir keine Patentformel hatten, um die Bewohner zum Mitmachen aufzufordern. Wir baten sie um eine engagierte, emotionale Beteiligung und schlugen ihnen „Visionen" vor, die sie dazu anregen könnten, die Banalität und Alltäglichkeit der sie umgebenden Räume zu überwinden"

Durch die Zusammenarbeit mit einer Gruppe von Bewohnern transformierte Osservatorio Nomade Corviale in ein urbanes Labor zur Untersuchung von öffentlichem Raum und Sozialbauwohnungen, und gewann Einsichten in die Repräsentation, kollektive Erinnerung und Umstrukturierung des Gebäudes selbst.

„Bei unserer Arbeit in Corviale gingen wir von den Überschneidungen zwi-

schen Kunst, Architektur und Politik aus, die den ursprünglichen Entwurf bestimmt hatten. Wir versuchten, die Instrumente zu individualisieren, die die zerstörte Beziehung zwischen Behördenvertretern, Architekten und Bewohnern wiederbeleben konnte; Instrumente und Einstellungen, um gemeinsam eine Strategie für den Umbau der urbanen Realität zu entwickeln." (Lorenzo Romito, Osservatorio Nomade)

Ein grundlegendes Ziel von Osservatorio Nomade war es, die ortsspezifische Geschichte des Bauwerks nachzuzeichnen, die über die allgemeine Architekturgeschichte oder soziologische Analysen hinausging. Die Gruppe lud viele der Leute, die am Entwurf und Bau von Corviale beteiligt gewesen waren, zu einem Besuch der Anlage und zu einem Mittagessen in der Wohnung eines an ihrem Projekt beteiligten Bewohners ein und stellte dadurch - endlich - den vorher nie stattgefundenen Dialog zwischen Architekten und Benutzern her.

Die Um- und Einbauten, mit denen die Bewohner das Gebäude ihren Bedürfnissen angepasst hatten, offenbarten andere Aspekte der Geschichte von Corviale. Die Bestandsaufnahme dieser Adaptionen entwickelte sich einerseits zu einer Art Atlas der Transformationen an einem bestehenden Gebäude, andererseits führte sie zu Vor-

[↑] Corviale amphitheatre at the rear of the building / *Corviale-Amphitheater
an der Rückseite des Gebäudes*, 1981-2, photo © Archivio Fiorentino

[↑] Corviale amphitheatre at the rear of the building / *Corviale-Amphitheater
an der Rückseite des Gebäudes*, 2005, photo: Alessandro Coco

[1] Corviale internal balcony on the 9th floor / *Corviale Innenbalkon in der neunten Etage*, photo: Armin Linke

[3] Corviale 4th floor with spaces for shops and services / *Corviale vierte Etage mit Platz für Geschäfte und Dienstleistungen*, 1981-2, photo © Archivio Fiorentino

[2] Corviale internal light well from the 5th floor / *Corviale Lichtschacht fünfte Etage*, photo: Laurent Malone

[4] Corviale internal light well and space above elevator volume with an opening created by the residents / *Corviale Lichtschacht und Raum über dem Aufzugsschacht mit einem von den Bewohnern gestalteten Eingang*, photo: Laurent Malone

detailed knowledge of it. Central to this approach was the work done on the 4th floor. This so-called "free floor" was originally conceived by Mario Fiorenti-

To trace a site-specific history that went beyond mainstream architectural history or sociological vernacular.

no as an internal road with shops and services – but it never arrived. In the early 1990s, about 10 years after the completion of Corviale, the 4th floor began to be squatted by people who were often related to the legal residents. Now the 4th floor is almost entirely occupied by self-built apartments organised around complex nets of proximity that maintain communal spaces shared by various apartments. The mapping of the fourth floor developed into a renewal project drawn up together with the residents that was accepted by the public administration who are now legalising the squatters.

Since the focus of the project was a stereotyped image of the building and its reception by the city of Rome and the media, it was necessary to find means that could work as a positive instrument of exchange and information both within and outside the Corviale. A new public space, a flexible instrument that can be modulated according to the different needs of its shareholders as and how they feel necessary. So

This analysis evolved into an atlas of transformation of a very fixed environment.

Osservatorio Nomade came up with an experimental TV station, the "Corviale Network". The station was accepted more easily than other aspects of the project by the residents as a social game because it mocked and democratised the dynamics of mainstream TV while providing a local, self-produced media channel that involved the residents, and yet was transmitted throughout the city.

schlägen für konkrete Verbesserungen des Gebäudes unter Berücksichtigung der genauen Ortskenntnisse der Bewohner. Die Arbeiten im vierten Stock waren dabei von zentraler Bedeutung. Diese so genannte „leere Etage" hatte Mario Fiorentino ursprünglich als interne Ladenstraße konzipiert, die jedoch nie realisiert wurde. Anfang der 1990er Jahre - rund zehn Jahre nach Fertigstellung von Corviale - wurde der vierte Stock von Leuten besetzt, die meistens mit den legalen Mietern verwandt waren. Heute ist die leere Etage fast vollständig von selbst gebauten Wohnungen eingenommen und diese sind organisiert wie ein komplexes Netz aus Nachbarschaften mit kommunalen Flächen, die jeweils von mehreren Wohnungen geteilt werden. Die Kartographierung des vierten Stocks entwickelte sich schließlich zu einem Sanierungsprojekt, das zusammen mit den Bewohnern entwickelt und dann auch von den Behörden akzeptiert wurde - die inzwischen die Hausbesetzer als legale Bewohner anerkannt haben.

Ein weiterer Fokus des Projekts war das zu einem Klischee erstarrte Image der ganzen Anlage und deren Rezeption bei der Stadtverwaltung von Rom und das von den

Medien transportierte Bild. Es war notwendig, Mittel und Wege zu finden, die als positives Instrument dazu dienen konnten, den Austausch von Gedanken und Informationen sowohl innerhalb wie außerhalb von Corviale zu fördern. Ein flexibles Instrument war nötig, ein neuer öffentlicher Raum, der sich nach den Bedürfnissen der Beteiligten verändern ließ. Osservatorio Nomade kam auf die Idee, einen experimentellen Fernsehsender, das „Corviale Network" einzurichten. Die Bewohner akzeptierten es sehr viel bereitwilliger als die meisten anderen Projektmaßnahmen; es wurde ein Gesellschaftsspiel, weil es die Dynamik des italienischen Mainstream-Fernsehens durch die Ausstrahlung eines lokalen, selbstproduzierten Fernsehsenders, der die Bewohner involvierte, der aber auch im gesamten Stadtgebiet empfangen werden konnte, verspottete und demokratisierte.

[↑] Housing block at La Courneuve, cleared for demolition / *Wohnblock in La Courneuve, zum Abriss freigegeben*, Paris 2004

[↑] After Demolition, June 2004 / *Nach dem Abriss, Juni 2004*

Transformation

Anne Lacaton and Jean Philippe Vassal are an architectural team based in Bordeaux. Their projects, such as the Centre of Contemporary Creation in the Palais de Tokyo in Paris, are based on a rational and intelligent use of new and often cheap industrial materials, which enable them to offer optimal and ingenious solutions to their clients' requirements without renouncing their avant-garde architectural stance. Here they renounce the policy of demolition in favour of the transformation of faded modernist housing projects. *Anne Lacaton und Jean Philippe Vassal sind ein Architektenteam mit Sitz in Bordeaux. Ihre Projekte, wie das Zentrum für zeitgenössische Kunst im Palais de Tokyo in Paris, zeichnen sich durch rationellen und intelligenten Einsatz von neuen und oft billigen industriellen Werkstoffen aus. So können sie ihren Auftraggebern optimale und raffinierte Lösungen anbieten, ohne dabei ihren avantgardistischen Ansatz aufzugeben. Sie ziehen es vor, verfallende modernistische Wohnbauten umzugestalten anstatt sie abzureißen.*

Given France's serious housing crisis, which is typified by a growing number of people living in inadequate housing and a housing shortage, how can one justify a city's demolition policy? This weighty and destructive initiative, launched under the guise of improving living conditions, is anything but inevitable.

According to the current national urban renovation programme in France, demolishing an apartment costs €15,000 (technical costs + social support), and constructing a new apartment costs €152,000 (construction + fees). In all, €167,000 is spent on demolishing an apartment and constructing a new one – yet renovating an apartment would costs 8 to 10 times less.

These sums would be better spent on mounting a strategy of transformation and re-use of existing residential buildings, creating even more housing while promoting social diversity, noticeably improving quality, legitimising acquired practices, providing recourse to sustainable materials, optimising energy inputs, and integrating services and lightweight equipment. The inconsistent history of housing project design (from luxury complexes to more modest, yet spacious, complexes) leads us to an unequivocal conclusion: the value of housing is linked to the amount of thought – not the amount of funds – invested in its design.

Considering renovation as proactive and as only an emergency solution leads us to question this heritage, not in terms of its historical and aesthetic aspect, but primarily in its contemporary value and ability to provide a service, to be put to use. We must maintain a link to what already exists and view it as a store of values. The modernist plan behind the construction of housing projects in the 1960s has not been continued in the same worthy spirit. It is a legacy that all architects must *recover* and transform without contradicting its structure, without seeking to introduce unsuitable elements à la Haussmann.

Housing projects already contain the seeds for their own transformation, such as glass surfaces, visual disengagement, height,

Frankreich erlebt gegenwärtig eine tiefe Krise des Wohnungsbaus: Die Zahl der in prekären Wohnverhältnissen lebenden Menschen nimmt zu und es herrscht großer Wohnungsmangel. Wie kann man angesichts dieser Situation eine städtische Politik des Abrisses rechtfertigen? Diese folgenschwere und verhängnisvolle Herangehensweise bedient sich des umstrittenen Arguments der Verbesserung von Wohnverhältnissen und ist dabei alles andere als zwangsläufig.

Frankreichs nationalem Stadterneuerungsprogramm zufolge kostet der Abriss einer Wohneinheit 15.000 Euro (Kosten für Technik und soziale Begleitmaßnahmen). Für einen Neubau werden 152.000 Euro (Bau- und Honorarkosten) veranschlagt. Insgesamt betragen die Ausgaben für Abriss und Neubau also 167.000 Euro, während entsprechende Sanierungsmaßnahmen acht bis zehn Mal weniger kosten würden.

In Anbetracht dieser Differenz sollte man besser eine Strategie des Umbaus und der Umnutzung vorhandener Wohngebäude entwickeln, die mehr Wohnraum mit einer höheren sozialen Diversifikation schafft, die Wohnqualität deutlich verbessert, die in der Praxis bewährten Verfahren durchsetzt, nachhaltige Baustoffe einsetzt, die Energieversorgung optimiert und Dienstleistungen und Leichtbauweise integriert. Die widersprüchliche Geschichte der Wohnungsbauplanung (von luxuriösen bis hin zu den bescheideneren, jedoch großzügig konzipierten Wohnblöcken) lässt eine eindeutige Schlussfolgerung zu: Der Wert des Wohnungsbaus richtet sich nach der Menge der Gedanken, die in sein Design fließen – nicht nach den verbrauchten Geldmitteln.

Wenn Sanierung eine proaktive Alternative und auch einzige Lösung dieser Krise ist, führt das dazu, dass das Erbe der alten Bausubstanz nicht in seiner historisch-ästhetischen Dimension hinterfragt wird, sondern vielmehr in Hinblick auf seine zeitgemäße Entsprechung, Nützlichkeit und Nutzbarkeit. Wir müssen die Verbindung zum Bestehenden aufrecht erhalten und das Vorhandene als ein Reservoir wichtiger Werte betrachten.

Das modernistische Projekt, das dem Bau der in den 1960er Jahren entstandenen Neubauviertel zu Grunde lag, wurde in seinen durchaus achtbaren Ansätzen nicht weiter geführt. Wir haben es nunmehr mit einem

[↑ ↗] Transformation: alternative project for La Courneuve / *Transformation: Alternatives Projekt für La Courneuve*

Photos: La Courneuve – high-rise estate in an eastern suburb of Paris / *Hochhaus-Siedlung in einem östlichen Vorort von Paris*, photo collage: Frédèric Druot, from the study / *aus der Studie:* "PLUS-Les grands ensembles – Territories d'exception" (Frédèric Druot – Anne Lacaton and Jean Philippe Vassal)

green areas and available land – dormant qualities that must be uncovered, developed, transcended. There can be only one initial premise: to consider housing projects from the inside, not from the outside, at close range instead of at a distance.

Projects should never demolish, remove or replace but always add, transform and utilise. They should do more by taking what already exists and transforming it efficiently to lend housing universally appreciated features such as space, balconies and transparency. Building on what already exists accomplishes more and serves a better purpose than demolishing housing and rebuilding based on today's standards.

This analysis has its roots in several classic housing projects, where the day-to-day activities of their inhabitants – marked by their emotional side, by pleasure, frustration and obligation – gradually come to be reflected in the exterior.

Housing and housing alone will retell history. The existing structure – both in terms of society and construction – will serve as the foundation for superficial yet critical reorganisation strategies, which stem from the assembly and piecing together of distinct yet shared factual situations. These attitudes based on eclecticism seem typical of current concerns in the world of creation and its economy; they are characteristic of a realistic and positive manner of acting, both within and with, what already exists. They aim to construct new relationships, new presences and *reassemble* the architectural patchwork as an overt and graceful approach to the most ambitious of contemporary urban creations: the housing project.

Erbe zu tun, das sich alle Architekten zu Eigen machen und umgestalten sollten, ohne seiner Struktur zu widersprechen oder unangemessene Haussmann'sche Elemente integrieren zu wollen.

Wohnungsbauprojekte tragen den Keim ihrer Umgestaltung schon in sich und zwar in Form von Glasflächen, optischer Ablenkung, dem Spiel mit Höhe, Grünflächen und verfügbarer Fläche – verborgene Potenziale, die es freizulegen, zu entwickeln und zu transzendieren gilt. Es kann nur eine grundlegende Forderung geben: Wohnungsbauprojekte nicht von außen, sondern von innen, nicht aus der Ferne, sondern aus der Nähe zu betrachten und zu konzipieren.

Niemals abreißen, abtragen oder durch einen anderen Bau ersetzen, sondern immer ergänzen, umgestalten und einer Nutzung zuführen - das ist das Gebot. Es geht darum, das Vorhandene zu nutzen und es wirksam so zu verändern, so dass offensichtliche Verbesserungen erzielt werden wie zum Beispiel mehr Raum, neue Balkone, mehr Transparenz. Durch die Nutzung der vorhandenen Bausubstanz kann mehr erreicht werden als durch Abriss und Neubau nach gegenwärtig geltenden Normen.

Die Analyse bezieht sich dabei auf mehrere klassische Wohnungsbautypen, bei denen die alltäglichen Aktivitäten seiner Bewohner nach und nach - mit all ihren Emotionen wie Freude, Frustration und Engagement - im Äußeren reflektiert sind.

Wohnungsbau - und dieser allein - wird Geschichte wiedererzählen. Die vorhandene soziale und bauliche Struktur bildet das Fundament für Reorganisationsstrategien, die oberflächlich angelegt und doch von entscheidender Bedeutung sind. Sie beruhen auf der Kombination und der Zusammenfügung unterschiedlicher und doch gemeinsamer faktischer Situationen. Diese eklektizistischen Haltungen scheinen typisch zu sein für die gegenwärtigen Sorgen in der Welt des Schaffens und seiner Ökonomie. Sie sind charakteristisch für ein realistisches und positives Spiel im und mit dem Vorhandenen. Das Ziel ist der Aufbau neuer Verbindungen, neuer Gegebenheiten und die Neugestaltung des architektonischen „Patchworks" als offene und elegante Herangehensweise an eines der ambitioniertesten städtebaulichen Schöpfungen der heutigen Zeit: den Wohnungsbau.

Superscapes

Alexa Kreissl and Daniel Kerber deal with the perception of the contemporary cityscape. They create collages of city-superscapes, places that do not exist, but deliver highly associative impressions of a place that *might be*. They say they are mostly inspired by places, where the rules of control got out of hand in one way or the other. Alexa Kreissl und Daniel Kerber beschäftigen sich mit der Wahrnehmung der zeitgenössischen Stadtlandschaft. Sie erschaffen in ihren Computerzeichnungen Collagen von Superstädten; Orte, die nicht existieren, die aber Assoziationen hervorrufen von Orten, die *sein könnten*. Sie suchen bewusst die Orte einer Stadt, die sich auf die eine oder andere Art den Regeln von Kontrolle und Ordnung entziehen.

"the points at which a town's system of order breaks down, where the town makes itself redundant, are areas in which it is overwritten by a second system. where a different level of reality mingles with the commonplace. this includes primarily building sites, complex urban situations, accumulations, vacant lots, temporary changes of use, chronological and spatial, vertical and horizontal layers and a large and small scale. [here] the undreamt-of becomes a possibility, the town becomes a system of building blocks." Kreissl Kerber

„die orte, an denen das ordungssystem einer stadt zusammenbricht, gebiete, wo sie von einem zweiten system ueberlagert wird, wo die stadt sich selbst ueberholt. wo eine andere realitaetsebene sich mit dem gewohnten vermischt, hierzu zaehlen vor allem baustellen, komplexe bauliche situationen, akkumulationen, brachflächen, temporaere umnutzungen, zeitliche und raeumliche, vertikale + horizontale schichtungen im grossen wie im kleinen. das ungeahnte wird zur moeglichkeit, die stadt ein baukastensystem." Kreissl Kerber

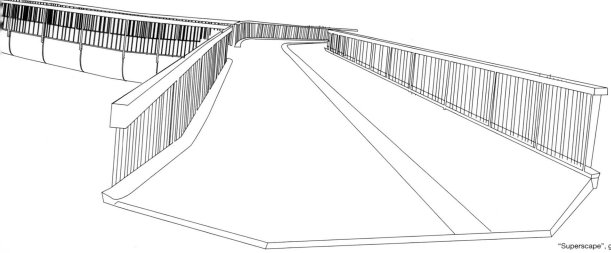

"Superscape", graphic: Kreissl Kerber

Re-engaging Contested Spaces

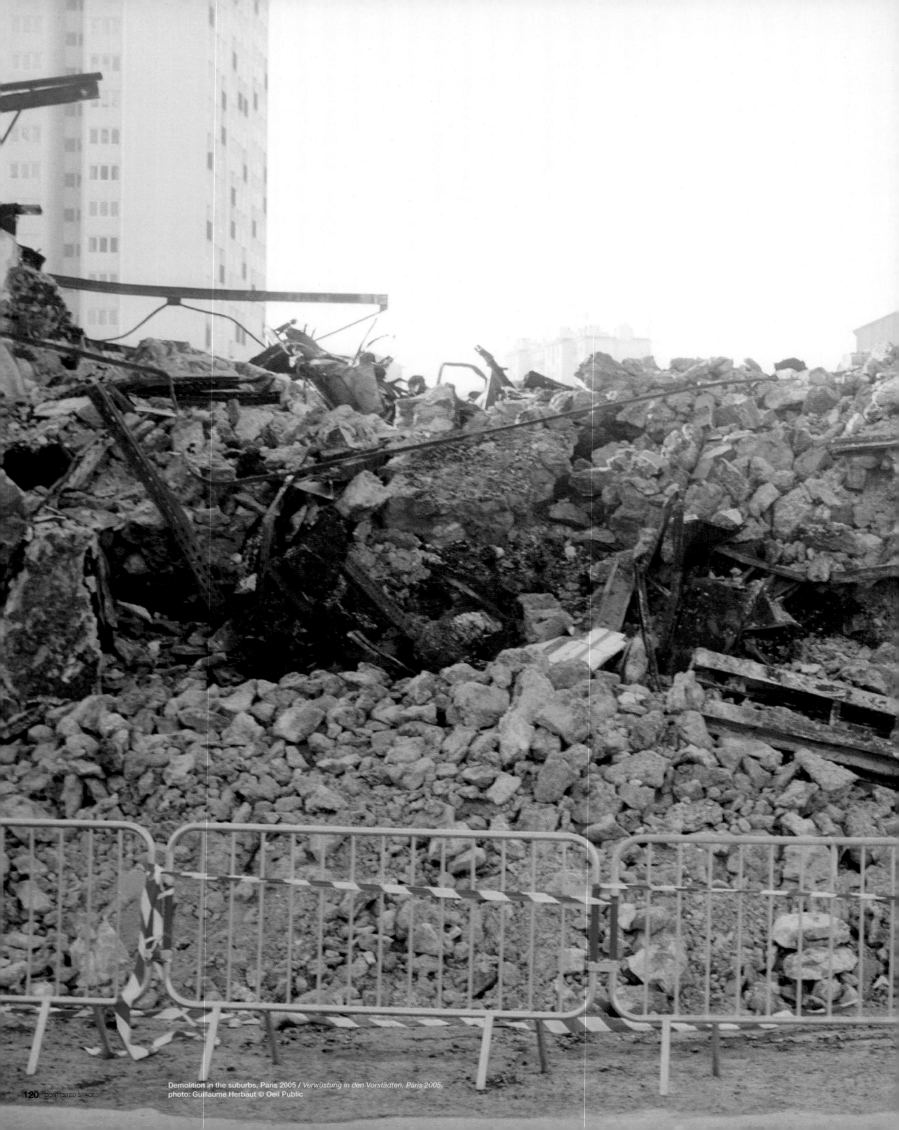

Demolition in the suburbs, Paris 2005 / *Verwüstung in den Vorstädten, Paris 2005*,
photo: Guillaume Herbaut © Oeil Public

"So that is another rule for the whole nature of architecture; it must actually create new appetites, new hungers – not solve problems, architecture is too slow to solve problems." Cedric Price, 2000

„Dies ist also eine weitere Regel für die Architektur an sich; sie muss neues Verlangen, neue Begierden wecken – nicht Probleme lösen; Architektur ist zu langsam, um Probleme zu lösen."

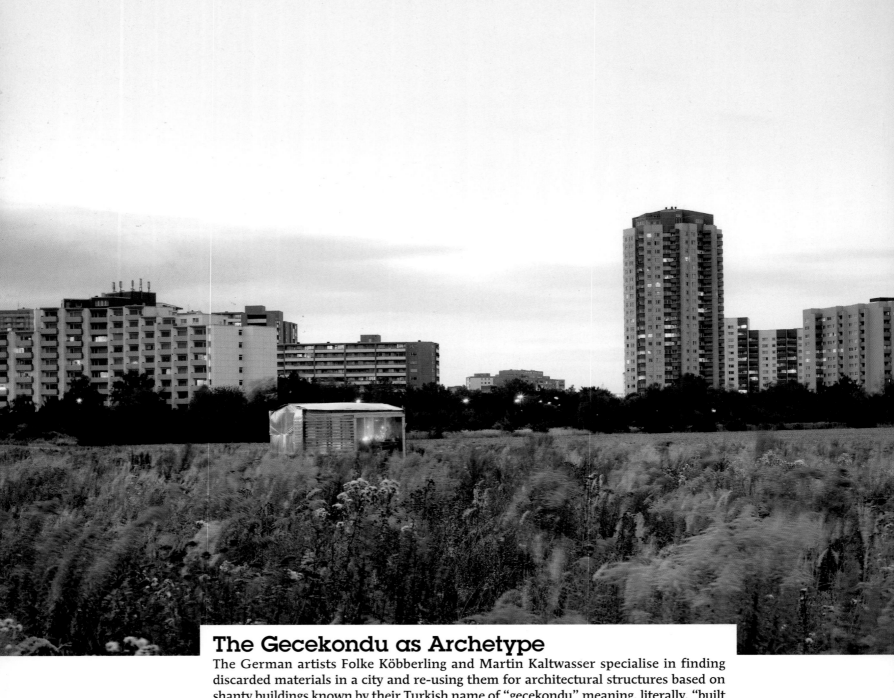

The Gecekondu as Archetype

The German artists Folke Köbberling and Martin Kaltwasser specialise in finding discarded materials in a city and re-using them for architectural structures based on shanty buildings known by their Turkish name of "gecekondu" meaning, literally, "built overnight". Millions across the globe live in concentrations of these, often illegal, structures and shanty towns are now one of the most significant and fastest-growing urban built forms worldwide. Die Künstler Folke Köbberling und Martin Kaltwasser thematisieren in ihren Arbeiten die Wiederverwendung von Restmaterialien für architektonische Strukturen. Ihr Prozess stützt sich auf die Analyse der Entstehung von so genannten „gecekondu"-Siedlungen in der Türkei, im Wortsinne: „über Nacht gebaut". Millionen Menschen auf der Welt leben in solchen Siedlungen, die meisten davon illegal – noch immer sind Slums die weltweit am weitesten verbreitete und am schnellsten wachsende urbane Siedlungsform.

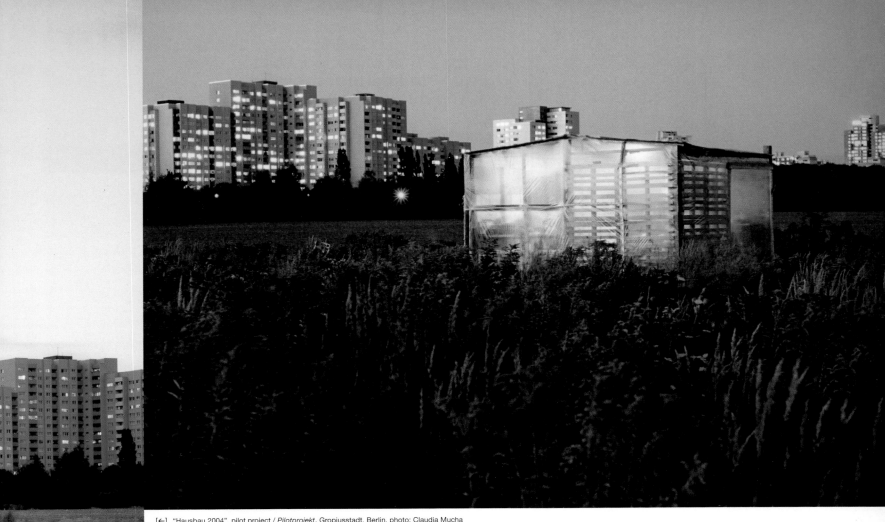

[←] "Hausbau 2004", pilot project / *Pilotprojekt*, Gropiusstadt, Berlin, photo: Claudia Mucha
[↑] "Hausbau 2004", pilot project / *Pilotprojekt*, Gropiusstadt, Berlin, photo: Folke Köbberling und Martin Kaltwasser

"We took the idea of informal building, which is widespread around the world and characterises some of the more recent parts of Istanbul, and we transported it straight into the city of Berlin. The house is a visible contradiction of Berlin's monoculture of building enclosed blocks and of the rigid planning policy for the inner city."

"We are concerned with the town as a resource – by working, for example, with found materials, to make certain interventions in public space."

"Personally, perfection has always inhibited me – as a child I much preferred drawing on newspaper then on the Pelikan drawing pad. To me, the unfinished state is actually the perfect one." Köbberling/Kaltwasser

„Wir haben die Idee des weltweit verbreiteten informellen Bauens, das auch Teile der jüngeren Stadtentwicklung Istanbuls geprägt hat, einfach auf Berlin übertragen. Das Haus steht im Widerspruch zur Berliner Monokultur der Blockrandbebauung und zum rigiden Konzept des Planwerks Innenstadt."

„Wir beschäftigen uns mit der Stadt als Ressource - zum Beispiel, indem wir mit gefundenen Materialien arbeiten, um Interventionen im öffentlichen Raum vorzunehmen."

„Persönlich hat mich das Perfekte immer gehemmt - als Kind wollte ich viel lieber auf Zeitungen malen als auf dem Pelikan-Malblock. Für mich ist das Unfertige eigentlich der perfekte Zustand." Köbberling/Kaltwasser

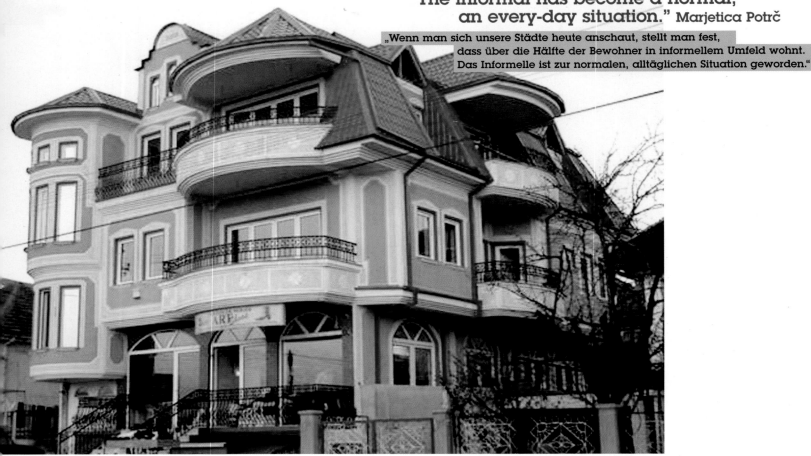

"When you look at our cities today, more than half of the population lives in informal settlements. The informal has become a normal, an every-day situation." Marjetica Potrč

„Wenn man sich unsere Städte heute anschaut, stellt man fest, dass über die Hälfte der Bewohner in informellem Umfeld wohnt. Das Informelle ist zur normalen, alltäglichen Situation geworden."

The Beauty of Informality

The Ljubljana-based artist and architect Marjetica Potrč rejects urban planning as being too limited and prefers to concentrate her interests towards individual initiatives. She focuses on and documents the tensions and fractures between the formal and informal city.
Die Künstlerin und Architektin Marjetica Potrč aus Ljubljana lehnt die Stadtplanung als zu begrenzt ab und bevorzugt individuelle Initiativen. Sie konzentriert sich auf die Spannungen und Brüche zwischen der formellen und informellen Stadt und dokumentiert sie.

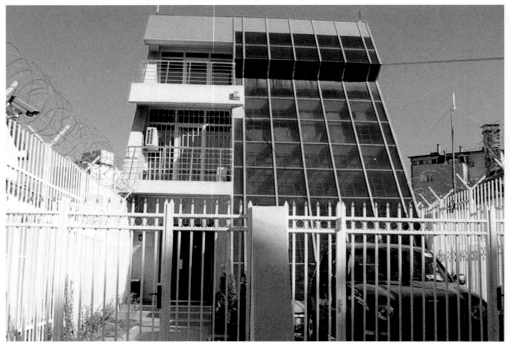

"This architecture actually tells you about the values in society: about what inspires the people, about their basic needs and what they see as beauty."

"Infrastructure will be the thing of the future; the way in which people use and adapt a basic infrastructure and utilities. Small-scale systems that can be shared."
Marjetica Potrč

„Diese Architektur sagt prinzipiell etwas über die Werte der Gesellschaft aus: etwas darüber, was die Menschen inspiriert, über ihre Grundbedürfnisse und darüber, was sie als schön empfinden."

„Die Infrastruktur wird das Thema der Zukunft sein; die Art und Weise, wie Menschen eine Grundinfrastruktur und Versorgungseinrichtungen für sich nutzen und anpassen. Mikrosysteme, die sie gemeinsam nutzen können."
Marjetica Potrč

[↖] Photo: Kyong Park

[↑] "Hybrid façades: first orientalism, last modernism, no architects" / „Fassadenhybride: erst orientalisch, dann modernistisch, keine Architekten", Priština, Kosovo 2005, photo: Marjetica Potrč

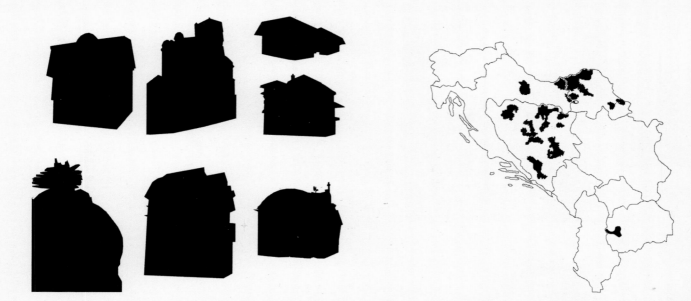

Balkanisation is Architecture

Balkanisierung ist Architektur Srdjan Jovanovic Weiss, architect, founder of NAO (Normal+Architecture+ Office) and lecturer at the University of Pennsylvania argues for turning a negatively-loaded contemporary term into a new and positive urban architectural strategy and tool to encourage variety. Srdjan Jovanovic Weiss ist Architekt, Gründer von NAO (Normal+Architecture+Office) und Dozent an der University of Pennsylvania. Er setzt sich dafür ein, den negativ besetzten Begriff „Balkanisierung" in eine neue, positive Richtung als Strategie für urbane Architektur umzudeuten – als Instrument zur Förderung von architektonischer Vielfalt.

If you lose yourself in Europe where fragmentation is a source of fear, then find yourself in the experience of the Balkans, where fragmentation is normal. Balkanisation used to be seen as a negative process, but recent usages of the term show the potential of Balkanisation vis-à-vis democracy. The original negative meaning emerged in response

Balkanisation is a source of difference: Difference is the source of city fragments.

to small-scale independence movements in the Balkans; the breaking of unity and forceful fragmentation. The term has also expanded to connote a varied tableau of scenarios involving fragmentation, such as "the Balkanisation of the Internet": privatised public knowledge, and as the racist: "the Balkanisation of America" accusing non-white immigrants of splintering the unity of the US.

Balkanisation is a source of difference: Difference is the source of city fragments.

It fragments cities into pixels, blurs their borders, makes city islands and makes them grow at parallel speeds. The result is a city of difference against sameness, a city of dynamism against staleness, a field of growth against shrinking. Balkanisation's main product: difference, is what defines its po-

tential as a strategy. We can use it to depict positive effects like the polycentric difference of territory, most notably in the expanding European Union. There are also attempts to use Balkanisation in a positive way by equating it with the need for sustenance of a group or society. It is an ocean of small acts all together in swarming opposition to grand schemes that earned bad reputations and are proven to fail.

It is Balkanisation that we should thank for all the small, inventive and funny building additions, hilarious new villas of random styles, march of dream-come-true houses, cities in fragments and innovations born in the Balkans: As the republics in former Yugoslavia split from each other, many displaced people marched in desperation from enclaves towards homeland states. There, life had to be started anew. Many were prompted to built their own homes and businesses rather than wait for the nation-

An ocean of small acts in swarming opposition to grand schemes with bad reputations and proven to fail.

alist systems to help out. Buildings grew on top of roofs, in the middle of parks, floating in rivers and in the middle of streets, capturing street lamps and signs. Rooms popped up over alleys, enormous terraces took over spaces,

In Europa wird die urbane Fragmentierung als beängstigend empfunden – im Balkan hingegen fühlt man sich damit wohl, dort ist Fragmentierung der Normalzustand. Lange wurde Balkanisierung als negativer Prozess verstanden, doch in jüngster Zeit wird das in ihr steckende Potenzial gegenüber der Demokratie zunehmend entdeckt. Die ursprünglich abwertende Konnotation resultierte aus den verschiedenen „kleinen Unabhängigkeitsbewegungen" im Balkan und der durch Zerfall und Gewalt forcierten Zersplitterung der Einheit. Später wurde der Terminus auch auf andere „Spaltungsprozesse" übertragen; er findet sich zum Beispiel in Formulierungen wie „die Balkanisierung des Internets": privatisiertes, allgemeines Wissen oder „die Balkanisierung Amerikas" – ein Vorwurf der Rassisten, dass nicht-weiße Einwanderer die Einheit der USA zerstören würden.

Balkanisierung ist eine Quelle der Unterschiedlichkeit: Und Unterschiedlichkeit ist die Quelle für städtische Fragmentierung. Sie zerteilt die Stadt in Pixel, verwischt ihre Grenzen, schafft städtische Inseln und lässt diese in parallelen Geschwindigkeiten wachsen. Das Ergebnis ist eine Stadt der Vielfalt und nicht der Gleichheit, ein Ort der Dynamik und nicht der Stagnation, ein Feld des Wachstums und nicht der Schrumpfung. Balkanisierung produziert hauptsächlich Unterschiede – und genau das ist ihr strategisches Potenzial. Wir können es benutzen, um die positiven Effekte wie die polyzentrische Differenzierung von Territorien zu veranschaulichen – in der sich ausdehnenden Europäischen

Union lässt sich dies eindrucksvoll beobachten. Und es gibt Ansätze, Balkanisierung als Mittel zur notwendigen Erhaltung einer Gruppe oder Gesellschaft positiv zu nutzen. Balkanisierung ist die wimmelnde Summe vieler kleiner Handlungen, die in Opposition stehen zu den großen Entwürfen, die sich ihre schlechte Reputation verdient und ihr Scheitern bereits bewiesen haben.

Der Balkanisierung verdanken wir die kleinen, einfallsreichen und skurrilen Anbauten, die neuen Villen in ungewöhnlichen Stilmischungen, die Massen an Traumhäusern – innovative Städte in Fragmenten, ihr Ursprung liegt in den Balkanländern. Als das ehemalige Jugoslawien in einzelne Nationalstaaten zerfiel, marschierten viele vertriebene Menschen verzweifelt aus ihren Enklaven zurück in die Staaten, in denen ihr Volk die Mehrheit bildet. Dort mussten sie sich ihr Leben neu aufbauen. Viele bauten ihre Häuser, Firmen- und Geschäftsgebäude aus eigener Kraft auf, da die staatlichen Hilfen auf sich warten ließen. Behausungen entstanden auf Dächern, in Parks, auf Flüssen schwimmend und mitten auf der Straße – selbst Straßenlaternen und -schilder wurden vereinnahmt. Zimmer entstanden in schmalen Gassen, riesige Terrassen nahmen enorm viel Platz ein und die Dächer wurden höher als zulässig gebaut. Ihre

[↖] Diversity of building shapes in the Balkans / *Vielfalt der Gebäudeformen im Balkan.* Graphic: Balkanisation Studio, Srdjan Weiss and School of Missing Studies

[↑] Fragmented territories of no ethnic majority, former Yugoslavia 1991 / *Fragmentierte Territorien ohne ethnische Mehrheit, ehemaliges Jugoslawien 1991.* Graphic: Balkanisation Studio, Srdjan Weiss and School of Missing Studies

[1] "This new Christian Orthodox Church being erected on the outskirts of Belgrade is a copy of a medieval Serbian monastery modified by the technology of concrete and masonry." / „Diese neue orthodoxe Kirche in einem Außenbezirk von Belgrad entsteht als Kopie einer mittelalterlichen serbischen Klosterkirche, aufgrund der Bauweise aus Beton und Mauerwerk nur leicht verändert." Photo: Srdjan Weiss

[2] "This high-rise is a beautiful example of vertical Balkanisation purified by white modernist paint. Each floor is customised and later 'glued' together to look united. There must be some antagonism, and also mutual envy between the carpet of additions in the foreground and the towering condominium." / „Dieses Hochhaus ist das beste Beispiel einer mit weißer Farbe modernistisch bereinigten vertikalen Balkanisierung. Jede Etage wurde nach den Wünschen der Bewohner individuell gestaltet und alle wurden ‚zusammengeklebt', damit sie einheitlich aussehen. Sicher gibt es einigen Antagonismus und wechselseitigen Neid zwischen dem Anbautenteppich im Vordergrund und dem Wohnhochhaus". Photo: Srdjan Weiss

[3] "An amazing process of 'radical preservation' is taking place in the former Belgrade workers' district of Karaburma, stalled in a corrupt process of urban reconstruction, residents happily sign over their rights to a private developer to renovate their homes and add four to six new floors to rent out. A new concrete structure is built around the existing residence to support the new floors. Finally the entire complex is painted in bright colours to attract new customers." / „Ein erstaunlicher Prozess der „radikalen Denkmalpflege" vollzieht sich derzeit in Karaburma (früheres Arbeiterviertel von Belgrad): Die Einwohner sind gefangen in einem korrupten Stadterneuerungsprozess und überschreiben ihre Eigentumsrechte bereitwillig einem privaten Investor, wenn dieser ihre Häuser renoviert und um vier bis sechs vermietbare Etagen aufstockt. Dafür wird das alte Haus mit Betonmauern umbaut, die dann die neuen Stockwerke tragen. Schließlich wird das Ganze in hellen Farben gestrichen, um neue Kunden zu werben. Text: Srdjan Weiss, photo: Dubravka Sekulic

roofs were raised well above the permissible limits. Their architecture appeared random and free, unexpected, often unfinished and decorated. Buildings started to speak about where they were coming from, but many, illegal ones, just tried to conceal an apparent and sudden desire for more space. Some buildings would say: "Here I am", while others would whisper: "Please don't look".

After the fall of Yugoslavia, all the separated cities in the Western Balkans felt free to chose their own path and their own look. For example, Zagreb has allowed extensive proliferation of the "urban villa", mixed-style houses for the upwardly mobile ex-village class in the city. Priština tripled in size and named its main street decorated with a miniature of the Statue of Liberty after William Jefferson Clinton in thanks for his military support against Milošević. Belgrade grew extensive roof-top additions, split-level cute mushroom houses that are a mix of high-tech and neo-Byzantine styles: part new Orthodox shrine and part glitzy turbo architecture. In contrast, Sarajevo, renovated by Europeans and Americans, has become a forgotten town, sinking into apathy. But Mostar has renovated its famous bridge and erected a sculpture of Bruce Lee. Novi Sad doubled its population and has its new Valley of Thieves on the privatised coastline along the river Danube. Skopje's new fluorescent cross on the hilltop overlooking the city adds to the vibrant mix of Roman, Byzantine, Ottoman and Communist and New Orthodox Christian monuments. In Tirana the artist mayor Edi Rama paints both illegal and legal buildings in bright colours and abstract patterns. In Ljubljana, leading architecture firms have copied Tirana's mix of colours for new façade designs.

Whereas the only true nomads in the Balkans, the Gypsies, keep building poor shanties out of the cardboard they find which they sell or recycle for miserable rates.

Now why do we cherish these examples? We love them because they are ugly-beautiful, self-made, optimistic and full of energy. We also respect them because they are not against the system, they are not alternative to the system, they are the system taken seriously by legalisation processes.

Balkanisation can be seen to apply both to the architecture of politics and the architecture of cities. We can learn with Balkanisation by mapping emerging differences, borders, islands and pixels. We can turn Balkanisation into an architectural strategy as a tool for difference by learning the parameters of adaptation and translating them into scripting and software. We can then balkanise monotonous and ugly corporate architecture and design better working spaces. We can balkanise European suburbia by highlighting cracks and building creative borders and islands of exciting lifestyle. We can lower European standards of boredom to make better results and small and beautiful adaptations. Balkanisation can give the majority a feeling of being the ruling minority. That can abolish the failed concept of the local in exchange for the balkanised, which is more dynamic, more optimistic, and more in charge.

Balkanisation is optimal because it is an architecture of conflict that shifts the results of conflict and war to city building. As such, we can turn Balkanisation into a tool for catalysing difference. Europe needs difference and looks for it. Why look far away when a source of exciting difference is in Europe's own yard? Balkanisation is the real architecture of Europe.

Architektur wirkte zufallsbedingt und ohne jegliche Norm, unerwartet, oft unfertig und verziert. Die Gebäude verrieten, wie sie ursprünglich zustande kamen und viele, die meisten davon illegal gebaut, versuchten einfach einen offensichtlichen Wunsch nach mehr Platz zu kaschieren: Einige Bauten schienen zu sagen: „Seht her, hier bin ich!", andere dagegen flüsterten: „Bitte seht mich nicht an!"

Nach dem Zerfall Jugoslawiens verspürten alle Städte in den westlichen Balkanländern die Freiheit, sich ihren eigenen Weg und ihr eigenes Erscheinungsbild auszusuchen. Zagreb zum Beispiel hat übermäßige Wucherungen der „Stadtvilla" zugelassen - Häuser mit den unterschiedlichsten Stilmischungen für die aufstrebende Schicht der mobilen Ex-Dorfbewohner. Priština ist heute dreimal so groß wie früher und hat seine Hauptstraße (die eine Miniaturausgabe der Freiheitsstatue ziert) nach William Jefferson Clinton benannt - zum Dank für dessen militärische Hilfe im Kampf gegen Milošević. Belgrad ließ zahlreiche Penthäuser auf Dächern wachsen, niedliche pilzköpfige Häuschen in einer Mischung aus High-Tech und neo-byzantinischem Stil - einerseits orthodoxer Heiligenschrein, andererseits glitzernde Turbo-Architektur. Im Gegensatz dazu ist das von Europäern und Amerikanern renovierte Sarajewo zu einer vergessenen, in Apathie versinkenden Geisterstadt geworden. Mostar hat seine berühmte Brücke rekonstruiert und eine Skulptur von Bruce Lee aufgestellt. Novi Sad verdoppelte seine Bevölkerungszahl und besitzt ein neues „Tal der Diebe" - auf einer privatisierten Küstenstraße entlang des Donauufers. Skopjes neues Neonkreuz thront auf dem Gipfel eines Hügels über der Stadt und fügt damit der lebendigen Mischung aus römischen, byzantinischen, osmanischen, kommunistischen und neo-orthodoxen christlichen Baudenkmälern eine neue Facette hinzu. In Tirana lässt der Künstler und Bürgermeister Edi Rama sowohl legale als auch illegale Gebäude mit abstrakten Mustern in leuchtenden Farben anstreichen. In Ljubljana haben führende Architekturbüros Tiranas bunte Fassaden imitiert. Die einzigen echten Nomaden des Balkans dagegen - die Zigeuner - bauen immer noch ihre ärmlichen Hütten aus Brettern und Pappe, die sie sammeln und für einen Hungerlohn verkaufen oder recyclen.

Was schätzen wir an diesen Beispielen eigentlich? Wir finden sie gut, weil sie hässlich-schön, selbst gebaut, optimistisch und voller Energie sind. Wir respektieren sie, weil sie nicht gegen das System sind, keine Alternative zum System darstellen, sondern weil sie das System sind, ernst genommen in einem Prozess der Legalisierung.

Balkanisierung ist sowohl auf die politische Architektur als auch auf die Architektur der Stadt anwendbar. Wir können durch Balkanisierung lernen, indem wir entstehende Unterschiede, Grenzen, Inseln und Pixel kartographieren. Wir können Balkanisierung als architektonische Strategie zur Erzeugung von Vielfalt einsetzen: Wir können aus ihren Parametern der Anpassung lernen und diese in Planungswerkzeuge und -software übersetzen. Wir können dann monotone, hässliche Firmen- und Fabrikgebäude balkanisieren und bessere Arbeitsräume daraus entstehen lassen. Wir können europäische Vorstädte balkanisieren, indem wir Brüche hervorheben und kreative Grenzen und Inseln voll spannender Lebensstile schaffen. Wir können die langweiligen Maßstäbe europäischer Normen einschränken, um bessere Ergebnisse und kleine und schöne architektonische Adaptationen zu erzielen. Balkanisierung kann der Mehrheit das Gefühl vermitteln, die herrschende Minderheit zu sein. So könnten wir die gescheiterten örtlichen Konzepte gegen „Balkanisiertes" eintauschen; dies wäre viel dynamischer, optimistischer und verantwortungsvoller.

Balkanisierte Architektur ist die optimale Lösung, weil sie aus Konflikten entsteht und die Folgen von Konflikten und Krieg in Städtebau umwandelt. Also können wir Balkanisierung als Katalysator zur Erzeugung von Differenzen einsetzen. Europa braucht und sucht nach Differenz. Warum in die Ferne schweifen, wenn die Quelle für spannende Vielfalt in Europas eigenem Vorgarten zu finden ist? Balkanisierung ist die wahre Architektur Europas.

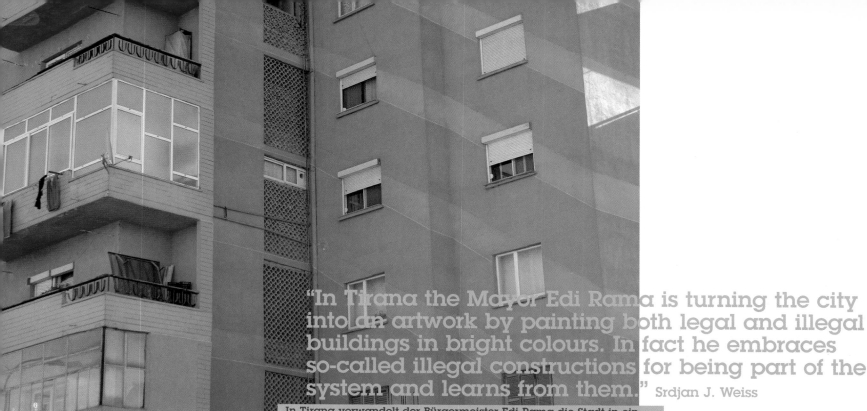

"In Tirana the Mayor Edi Rama is turning the city into an artwork by painting both legal and illegal buildings in bright colours. In fact he embraces so-called illegal constructions for being part of the system and learns from them." Srdjan J. Weiss

„In Tirana verwandelt der Bürgermeister Edi Rama die Stadt in ein Kunstwerk, indem er legale und illegale Gebäude in leuchtenden Farben anstreichen lässt. Faktisch bezieht er die so genannten illegalen Bauten als Teil des Systems mit ein und lernt von ihnen."

[4] "An unfinished 'wedding castle' on the outskirts of Tuzla in Bosnia. Profane buildings for public events such as weddings incorporate elements from a mix of both Islamic and Christian sacral architecture." / *Ein unfertiger 'Hochzeitspalast' am Stadtrand von Tuzla in Bosnien. Saalgebäude für öffentliche Veranstaltungen wie Hochzeiten werden in einer Mischung aus islamischer und christlicher Sakralarchitektur errichtet.*" Photo: Azra Aksamija

[5] "The three buildings in this picture from Belgrade were all built at the same time. On the left is a contemporary interpretation of Byzantine heritage clad in aluminium erected for a highly popular TV station. The unfinished building in the centre is a private villa built in a neutral rural style. On the right is an apartment building built by a private developer in a neo-modernist style to attract the new wealthy class of professional migrants in Belgrade." / *Die hier gezeigten drei Bauten in Belgrad entstanden alle zur selben Zeit. Links die zeitgenössische, mit Aluminium verkleidete Version eines byzantinischen Baudenkmals für einen beliebten Fernsehsender. Die Bauruine in der Mitte soll eine Privatvilla im Landhausstil werden. Das Gebäude rechts im Bild ist das von einem privaten Investor gebaute Mietshaus im neo-modernen Stil, gedacht für wohlhabende Neubürger, die aus beruflichen Gründen nach Belgrad gezogen sind.*" Text: Srdjan Weiss, Photo: Dubravka Sekulic

[6, 7] "Project Europe Lost and Found", 2005, photo: Kyong Park

"The informal city loves to plug in. To reuse the situation which preexists there. Such as buildings built on top of buildings in today's Belgrade or in Tirana." Marjetica Potrč

„Die informelle Stadt will sich einklinken, eine Situation, die bereits existiert, wiederverwenden. So, wie die Gebäude im heutigen Belgrad oder Tirana, die auf bereits existierende Gebäude gebaut wurden."

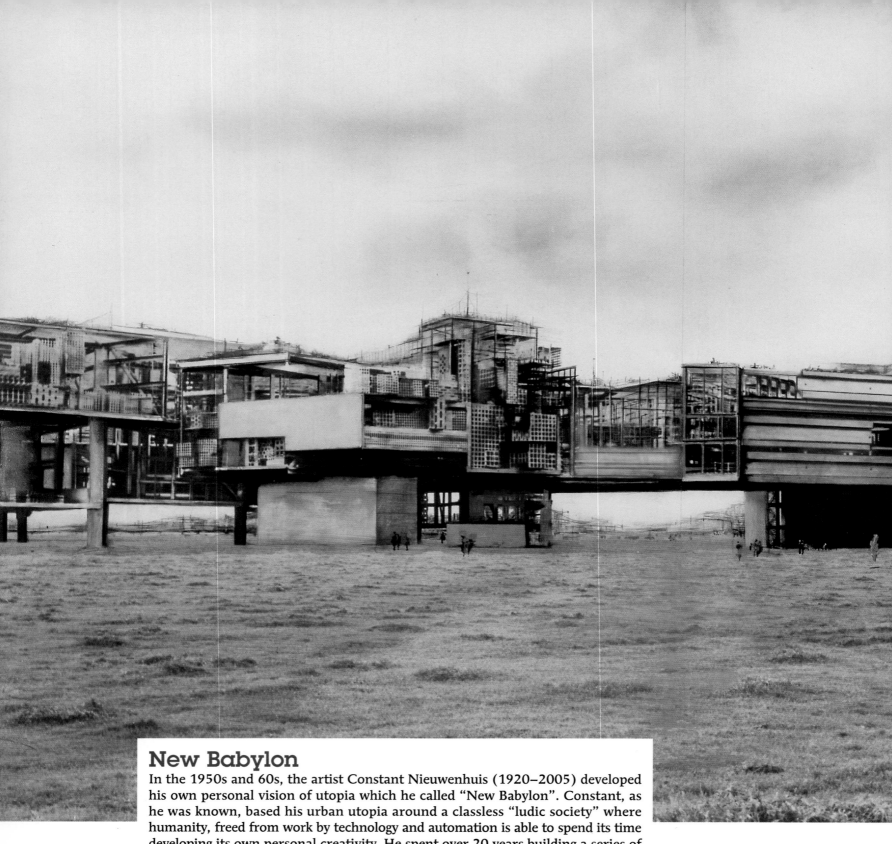

New Babylon

In the 1950s and 60s, the artist Constant Nieuwenhuis (1920–2005) developed his own personal vision of utopia which he called "New Babylon". Constant, as he was known, based his urban utopia around a classless "ludic society" where humanity, freed from work by technology and automation is able to spend its time developing its own personal creativity. He spent over 20 years building a series of models, collages and other projects related to his theories of urban development and social interaction. In den 1950er und 60er Jahren entwickelte der Künstler Constant Nieuwenhuis (1920–2005) seine ganz persönliche utopische Vision, die er „New Babylon" nannte. Constant, wie er sich nannte, gründete seine städtische Utopie auf eine klassenlose spielerische Gesellschaft , in der die Menschheit, durch Technologie und Automatisierung von der Arbeit befreit, ihre Zeit damit verbringen kann, die eigene persönliche Kreativität zu entfalten. Er verbrachte über 20 Jahre damit, eine Reihe von Modellen, Collagen und anderen Projekten im Zusammenhang mit seinen Theorien zur städtischen Entwicklung und gesellschaftlichen Interaktion zu entwickeln.

"New Babylon ends nowhere (since the earth is round);
it knows no frontiers (since there are no more national economies)
or collectivities (since humanity is fluctuating).
Every place is accessible to one and all.
The whole earth becomes home to its owners." Constant Nieuwenhuis

„New Babylon endet nirgendwo (da die Erde rund ist); es kennt keine Grenzen
(da es keine nationalen Wirtschaftssysteme mehr gibt) oder Gemeinschaften
(da die Menschheit sich ständig verändert). Jeder Ort ist für alle und jeden Einzelnen
zugänglich. Die gesamte Erde wird zur Heimat derer, denen sie gehört."

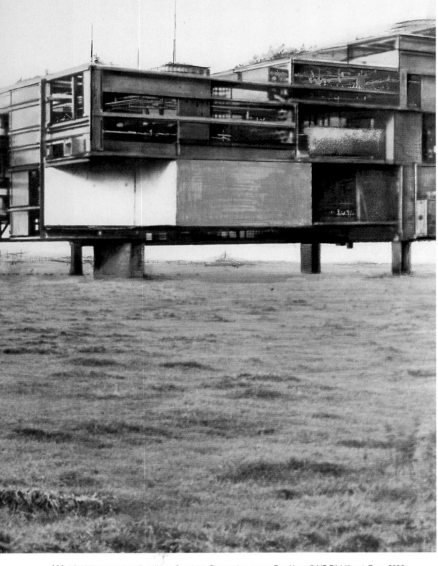

[↑] "Gezicht op sectoren", collage: Constant, Gemeentemuseum Den Haag © VG Bild-Kunst, Bonn 2006

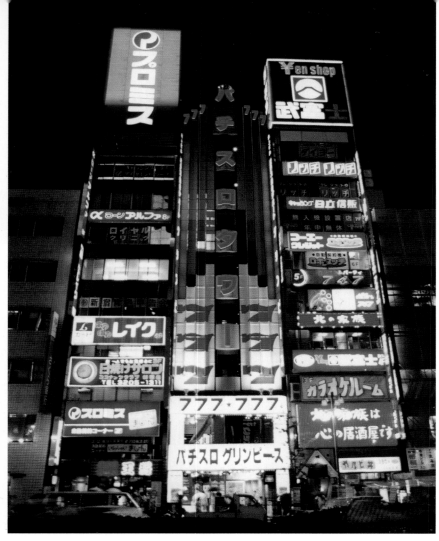

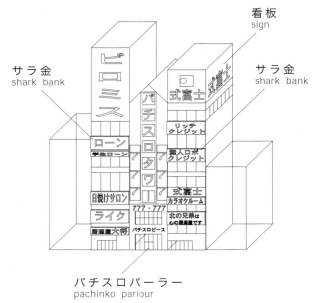

看板
sign

サラ金
shark bank

サラ金
shark bank

パチスロパーラー
pachinko parlour

Tokyo Pet Hybrids

Atelier Bow Wow – Yoshiharu Tsukamoto and Momoyo Kaijima – have been scouring the city of Tokyo for some years, discovering and documenting *da-me* ("no-good") architecture and extraordinary hybrid buildings. Pet Architecture is a compendium of the small-scale, customised and individuated buildings, constructed to fit the extremely limited spaces of the city. Made in Tokyo delights in the symbiotic – often parasitical – relationships and new forms engendered by stacked programs that make for contemporary hybridity. Both investigations draw upon the commonplace as a source of inspiration for new architectural typologies and constitute an entirely different way of seeing one of the world's greatest consumer capitals in its current post-bubble recession incarnation. Yoshiharu Tsukamoto und Momoyo Kaijima vom Atelier Bow Wow dokumentieren schon seit mehreren Jahren ihre Streifzüge durch Tokyo. Ihre Studien widmen sich vor allem der Architektur des *da-me* („nicht-guten") und den außerordentlich hybriden Gebäuden dieser Stadt. Die Publikation „Pet Architecture" präsentiert eine Sammlung von Kleinst-Häusern, die höchst individuell und unkonventionell konstruiert und genutzt werden und sich dabei in eine Stadt einpassen, die in extremer Raumnot ist. „Made in Tokyo" beleuchtet die symbiotischen, oft auch parasitären Beziehungen, Kombinationen und neuen Formen, die durch programmatische Überlagerungen und hybride Nutzungen entstehen. Beide Studien lassen sich von Bildern des Alltags inspirieren und machen den Blick frei für neue architektonische Typologien. Zugleich eröffnen sie einen höchst ungewöhnlichen Zugang zu einer Stadt, die eines der bedeutendsten Wirtschaftszentren der Welt ist und wie keine andere die Rezessionsära der Post-Bubble-Economy verkörpert.

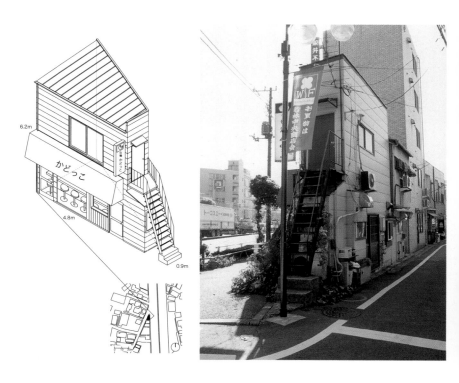

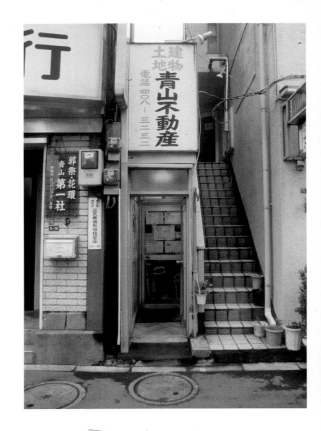

[↑] Banraiken, a Chofu speciality ("Pet Architecture"): "A noodle shop at a train crossing painted in striking yellow. The low eaves, street level entrance and good smell of soup invite you to enter. Rooftop billboards cover half of the façade. Wax models of the menu in the window and the red flags (Noren) in front of both entrances are common to noodle shops." / "Ein knallgelb gestrichener Nudel-Imbiss an einer Eisenbahnkreuzung. Ein niedriges Dachgesims und der Eingang auf Straßenhöhe sowie der Duft nach schmackhafter Suppe laden ein, das Lokal zu betreten. Auf dem Dach angebrachte Reklametafeln nehmen die Hälfte der Fassade ein. Wachsmuster der Speisen im Fenster und rote Vorhänge (Noren) vor beiden Eingängen sind übliche Kennzeichen von Noodle Shops." Photo: Atelier Bow Wow

[↗] Aoyama estate agent ("Pet Architecture"): "An estate agent's office sandwiched between two buildings. It is only 0.8 m wide but 10 m deep. It bends in the middle following the shape of external stairs of the next building. The minimum frontage to the street is carefully used as combined entrance and signage." / "Büro eines Immobilienmaklers, das zwischen zwei Gebäude eingefügt wurde. Es ist nur 0,8 m breit, jedoch 10 m tief. In der Mitte gekrümmt folgt es der Form der Außentreppen des nächsten Gebäudes. Jeder Zentimeter der äußerst schmalen Vorderfront zur Straße hin wird wohl überlegt als Eingang kombiniert mit einem Schild darüber benutzt." Photo: Atelier Bow Wow

[→] Drawing / Zeichnung: Atelier Bow Wow

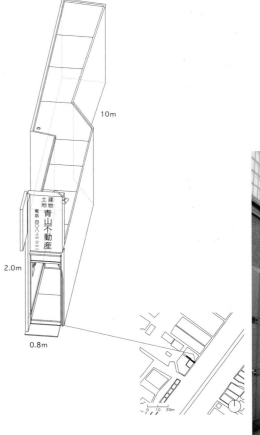

"Our interest is in ... the unexpected adjacency of function created by cross-categorical hybrids, the co-existence of unrelated functions in a single structure, the joint utilisation of several differing and adjacent buildings and structures, or the packaging of an unusual urban ecology in a single building."

"Everyday life is made up of traversing various buildings. Living space is constituted by connections between various adjacent environmental conditions, rather than by any single building. Can't we draw out the potential of this situation and project that into the future?" Tsukamoto/Kaijima

„Wir interessieren uns für ... die unerwartete Nachbarschaft von Funktionen durch kategorienübergreifende Hybriden, für die Koexistenz von nicht zueinander in Beziehung stehenden Funktionen in einem Gefüge, die gemeinsame Nutzung mehrerer unterschiedlicher und nebeneinander liegender Gebäude und Strukturen oder die Bündelung einer ungewöhnlichen Stadtökologie in einem einzigen Gebäude."

„Der Alltag besteht aus der Durchquerung verschiedener Gebäude. Den Lebensraum bildet nicht so sehr ein einzelnes Gebäude, vielmehr besteht er in den Verbindungen zwischen unterschiedlichen angrenzenden Umweltbedingungen. Können wir das Potenzial dieser Situation nicht ausschöpfen und es in die Zukunft projizieren?" Tsukamoto/Kaijima

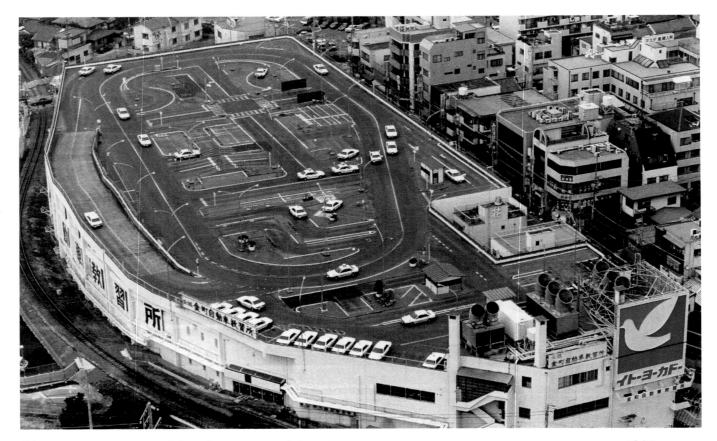

[↑] Super driving school ("Made in Tokyo"): "On top of a two-storey supermarket is an extra layer occupied by a driving school. The site includes small parcels of other people's property, which could not be purchased. The site itself is framed by the curve of the railroad, which is reflected directly in the curve of the building. The entry ramp is highlighted above by the practice slope for handbrake starts." / „Super-Fahrschule: Auf dem Dach des zweistöckigen Supermarkts befindet sich eine weitere Ebene mit einer Fahrschule. Zum Gelände gehören auch kleine Parzellen, die Dritten gehören und nicht aufgekauft werden konnten. Das Gelände wird von der Kurve der Eisenbahnstrecke eingerahmt, was sich direkt in der nach außen gewölbten Form des Gebäudes widerspiegelt. Die Auffahrt wird oben von der Übungsrampe für das Anfahren mit Handbremse gesäumt." Photo: Atelier Bow Wow

[→] Drawing / Zeichnung: Atelier Bow Wow

看板
billboard

ナイター照明
street lights

自動車教習所
driving school

教習車
learner cars

坂道発進練習用
practice slope for
hand brake starts

スーパーマーケット
supermarket

[←] House in Sendagaya ("Pet Architecture"): "An old wooden corner house in a distinguished residential area. The roof is extended as long and low as possible, at the front it reaches down to the height of the sliding door. The long façade has exposed plumbing, an electricity junction box, poles for drying clothes, a boiler, a gas meter and kitchen and bathroom ventilation grills. A folding fence abuts the corner with foot mat, and heating oil container made of concrete blocks. The air conditioning set on the front rooftop echoes the colour of the roofs." / „Ein altes Eckhaus aus Holz in einer angesehenen Wohngegend. Das Dach wurde so lang und tief wie möglich ausgebaut, an der Vorderseite reicht es bis auf die Höhe der Schiebetür herunter. Entlang der Außenwand sind Rohre, ein Stromverteiler, Stangen für das Trocknen von Kleidung, ein Wasserboiler, ein Gaszähler sowie Lüftungsgitter für Küche und Bad untergebracht. Die Hausecke wird durch einen faltbaren Zaun mit Fußmatte sowie durch einen Heizölcontainer aus Beton abgeschlossen. Das Klimagerät auf dem Vorderdach imitiert die Farbe der Dächer." Photo: Atelier Bow Wow

"If we can't try to turn *disgusting* buildings into resources, then there is no particular reason to stay in Tokyo. Surely we can start to think about how to take advantage of them, rather than trying to run away? Shamelessness can become useful."

"I am interested in the forward-looking quality, the throw-away feeling, the really-living-right-now-sense of these buildings."
Tsukamoto/Kaijima

„Wenn wir nicht versuchen können, hässliche Gebäude in inspirierende Ressourcen zu verwandeln, dann gibt es keinen besonderen Grund, in Tokio zu bleiben. Wir können doch anfangen, darüber nachzudenken, wie wir sie uns zunutze machen können, anstatt wegzulaufen. Schamlosigkeit kann manchmal sehr nützlich sein."

„Ich interessiere mich für die zukunftsorientierte Eigenschaft, das Gefühl der Leichtfertigkeit und das Gefühl, im Hier und Jetzt zu leben, das diese Gebäude vermitteln."
Tsukamoto/Kaijima

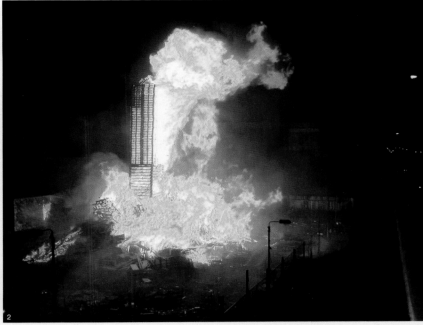

Bonfires of Urbanity

Fegefeuer der Planbarkeiten Building Inititative is a project by a group of architects from Berlin and Belfast, who investigate developments in Belfast since the initiation of the peace process. They draw their inspiration from everyday culture – in this case street bonfires in Belfast, Northern Ireland. Their principal objective is to support a political development that creates diverse, accessible and integrated spaces. Building Inititative ist ein Projekt einer Gruppe von Architekten aus Berlin und Belfast. Sie untersuchen die stadträumliche Entwicklung in Belfast seit dem Beginn des Friedensprozesses. Ihre Inspiration entsteht aus der Alltagskultur – in diesem Fall den „Freudenfeuern" in Belfast, Nordirland. Ihr Hauptanliegen ist eine politische Entwicklung zu unterstützen, die allgemein zugängliche und integrative Räume schafft.

Large-scale fire based public events are a common feature of the cultural life of Northern Ireland. These range from benign New Year's and Halloween celebrations to the openly sectarian Bonfire Night celebrated by the unionist community on the evening before the 12th of July, the anniversary of the victory of the Protestant army of William of Orange over the Catholic army of James at the Battle of the Boyne. This is interpreted as a triumphalist celebration, which agitates sectarian tensions between communities resulting in a large proportion of the population leaving the city for this period.

Contrary to the seasonal exodus from Belfast in the lead-up to the 12th

These bonfires resemble apocalyptic landscapes, whilst the commercial city appears artificial and absurd in contrast.

of July, we had just arrived in the city. Being new to both Belfast and Northern Ireland, we were relatively unversed in the symbolism of the events. This afforded us a naïve curiosity when observing the phenomenon of Belfast's large urban fires.

The organisational and community aspects of bonfire construction became apparent from our observations of a particular bonfire site. The detritus of the modern city including tyres, mattresses, furniture, and timber palettes had been collected over the preceding months, stacked on the site and sorted according to their flammability and constructional properties, before the

Unlike the other built forms of the city, the bonfires are both structure and event, an uncanny combination of architecture and theatre.

carefully staged building process commenced. The result was a slender, tiered tower rising to a height of approximately 20 metres, with obvious aspirations of power and dominance, competing with the chimneystacks, church spires and office blocks of the Belfast skyline. The sites of these bonfires, with their surreal collection of urban debris, resemble apocalyptic landscapes, whilst the commercial city, as backdrop, appears artificial and absurd in contrast.

Große öffentliche Veranstaltungen, bei denen Feuer eine Rolle spielt, sind typisch für das kulturelle Leben in Nordirland. Dazu gehören die Neujahrs- und Halloween-Feiern ebenso wie die offen separatistischen „Bonfire Nights", die von den Unionisten mit einem großen Feuer am Vorabend des 12. Juli gefeiert werden – traditionsgemäß die elfte Nacht des Jahrestags der Schlacht von Boyne am 1. Juli 1690, als die Protestanten-Armee unter Wilhelm von Oranien über die katholische Streitmacht König Jakobs II. von England siegte. Diese Feierlichkeiten verstärken die sektiererische Provokation zwischen den Bevölkerungsgruppen und führen dazu, dass große Teile der Bevölkerung von Belfast in dieser Zeit die Stadt verlassen.

Kurz vor dem alljährlichen Exodus im Vorfeld des 12. Juli kamen wir in Belfast an. Da wir das erste Mal sowohl Belfast als auch Nordirland besuchten, waren wir uns der Symbolkraft des Jahrestages nicht bewusst und konnten so dem Phänomen der riesigen Feuer in Belfast mit naiver Neugierde begegnen.

Wir beobachteten die Vorbereitungsarbeiten für ein solches Feuer und stellten fest, dass es Organisationstalent erforderte und gemeinschaftsfördernd wirkte. Die Hinterlassenschaften der modernen Stadt – Autoreifen, Matratzen, Möbel, Europaletten – wurden über Monate gesammelt, gelagert

und nach Brennbarkeit und baulichen Eigenschaften sortiert, bevor der sorgfältig geplante Aufbau begann. Das Ergebnis war ein etwa 20 m hoher, schlanker, treppenartig aufgestapelter Turm, der ganz offensichtlich den Anspruch auf Dominanz und Vorherrschaft ausstrahlen sollte und mit den benachbarten Schornsteinen, Kirchturmspitzen und Bürohochhäusern der Skyline von Belfast wetteiferte. Die Orte für diese Siegesfeuer mit ihren surrealen Anhäufungen von brennbarem, urbanem Sperrmüll wirken wie apokalyptische Landschaften, vor deren Hintergrund die eigentliche Stadt einen künstlichen und absurden Kontrast bildet.

Im Gegensatz zu den übrigen gebauten Formen der Stadt sind die Freudenfeuer sowohl als Konstruktion wie auch als Event geplant – eine makabre Kombination aus Architektur und Bühneninszenierung. In Größe und Design sind diese Freudenfeuer in den letzten Jahren immer ehrgeiziger geworden. Wir sahen einen Glockenturm, einen Khmer-Tempel und eine Nachempfindung des bekannten Londoner Hochhauses „The Gherkin" von Lord Norman Foster. Sie

[1] Bonfire site close to Belfast's commercial centre at Sandy Row / Freudenfeuer in der Nähe von Belfasts Zentrum, Sandy Row, photo: Dougal Sheridan / Building Initiative

[2] Tates Avenue bonfire / Tates-Avenue-Freudenfeuer, photo: Dougal Sheridan / Building Initiative

"Contested meanings, uses and ownerships are in the nature of urban space and urbanisation in general. Architects can no longer propose solutions to these, as there can be no spatial solutions to social problems, but can learn to cope and live with them, as there can be social solutions to spatial problems."

Jürgen Patzak-Poor, Building Initiative

„Die Infragestellung von Bedeutungen, Verwendungen und Eigentum liegen im Wesen des städtischen Raums und der Urbanisierung im Allgemeinen. Die Architekten können hierfür keine Lösungen mehr anbieten, denn es kann keine räumlichen Lösungen für gesellschaftliche Probleme geben, aber sie können lernen damit zurechtzukommen und zu leben, denn es kann gesellschaftliche Lösungen für räumliche Probleme geben."

 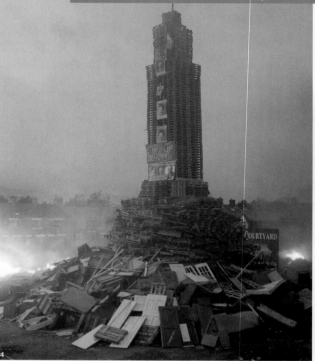

Unlike the other built forms of the city, the bonfires are designed both as structure and event, an uncanny combination of architecture and theatre. The scale and ambition of these bonfires has increased in recent years resulting in a wider variety of built forms: We saw a campanile, a Khmer temple, and an interpretation of Sir Norman Fosters "Gherkin" in London. They already seem to be suggesting another agenda, apart from the sectarian divisions of the city.

The appropriation of empty building sites for bonfires suggests community protest against the encroaching development and in some cases highlights the poverty of public space in these areas.

The physical location of these fires reveals something about their position in the hegemonic structure of the city. The bonfire sites we observed occurred most often within gaps in the urban fabric. These were usually devoid of the characteristics of park, public square, or other defined urban space. The term *terrain vague* was coined to label these apparently abandoned, disused, indeterminate areas of cities. Their vague

status allows the appropriation of these spaces in ways not defined or determined by the state apparatus.

Returning through the deserted streets of the central city to the bonfire site on the evening of the 11th, we found the inhabitants of the area had gathered at the bonfire site where a kiosk selling food, a DJ playing music,

When ablaze the bonfire seemed to shed these attached meanings becoming pure mesmerising spectacle.

and mixture of age groups gave the impression of a festive community event. But meanwhile, the bonfire had changed in appearance, it now carried an Irish flag on its summit and was embellished with the election posters of Sinn Féin (republican) politicians, transforming it from an abstract expressive structure to a symbol of aggression. However these add-ons looked like afterthoughts, un-integrated in the design and construction of the bonfire.

scheinen bereits andere Vorstellungen abseits jeglicher konfessionsgebundener Spaltung der Bevölkerung anzudeuten.

Die Inbesitznahme unbebauter Grundstücke für die Freudenfeuer erscheint auch wie ein Protest der Bevölkerung gegen die dort stattfindende Entwicklung und offenbart manchmal den heruntergekommenen Zustand der öffentlichen Räume in diesen Gebieten.

Der physische Standort dieser Feuer offenbart etwas über die hegemonialen Strukturen der Stadt. Die Plätze der Freudenfeuer, die wir beobachteten, lagen meist in Lücken im Stadtgefüge. Dabei handelte es sich weder um Parks oder öffentliche Plätze noch um andere klar definierte urbane Räume. Für diese scheinbar verlassenen, ungenutzten, undefinierten Stadtflächen wurde der Begriff „terrain vague" geprägt. Ihr unklarer Status ermöglicht eine Inbesitznahme dieser Orte auf eine Art und Weise, die nicht durch den Staatsapparat definiert oder bestimmt werden kann.

Als wir am Abend des 11. Juli in die menschenleeren Straßen der Innenstadt zum Freudenfeuerplatz zurückkehrten, hatten sich die Anwohner dort bereits versammelt. Es gab einen Imbissstand, ein DJ

[3] Bonfire site next to the motorway at Belvoir Estate / *Freudenfeuer neben der Autobahn bei Belvoir Estate*, photo: Dougal Sheridan / Building Initiative

[4] Tates Avenue bonfire adorned with sectarian messages / *Sektiererische Plakate schmücken das Freudenfeuer an der Tates Avenue*, photo: Dougal Sheridan / Building Initiative

[5] Tates Avenue bonfire against backdrop of Belfast illuminated by bonfires / *Feuer an der Tates Avenue, die Kulisse von Belfast ist von den Freudenfeuern erleuchtet*, photo: Dougal Sheridan / Building Initiative

legte auf und Menschen unterschiedlicher Altersgruppen erweckten den Eindruck einer fröhlichen Gemeindezusammenkunft. Jedoch hatte sich der Anblick des Freudenfeuers inzwischen verändert: Es war jetzt mit einer irischen Fahne gekrönt und mit Wahlplakaten von Sinn-Féin-Politikern (die Partei der anti-britischen Republikaner) ausgeschmückt worden – so wurde die abstrakte, expressive Form in ein Symbol der Aggression transformiert. Die Zusätze wirkten jedoch wie nachträgliche Einfälle, nicht wie integrale Bestandteile in der Konstruktion des Freudenfeuers. Als das Freudenfeuer dann schließlich lichterloh brannte, löste die sich ihm angeheftete Bedeutung in einem schier hypnotisierenden Spektakel auf.

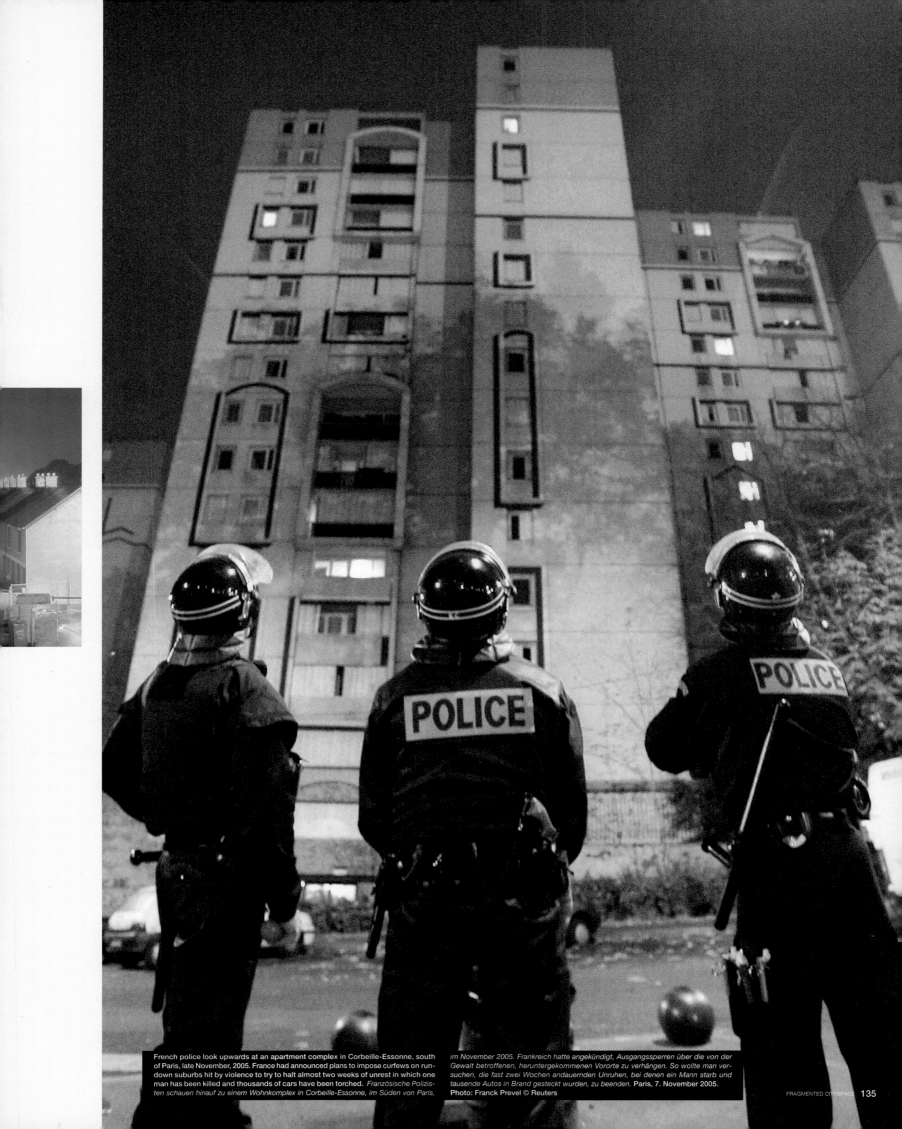

French police look upwards at an apartment complex in Corbeille-Essonne, south of Paris, late November, 2005. France had announced plans to impose curfews on run-down suburbs hit by violence to try to halt almost two weeks of unrest in which one man has been killed and thousands of cars have been torched. *Französische Polizisten schauen hinauf zu einem Wohnkomplex in Corbeille-Essonne, im Süden von Paris,* *im November 2005. Frankreich hatte angekündigt, Ausgangssperren über die von der Gewalt betroffenen, heruntergekommenen Vororte zu verhängen. So wollte man versuchen, die fast zwei Wochen andauernden Unruhen, bei denen ein Mann starb und tausende Autos in Brand gesteckt wurden, zu beenden. Paris, 7. November 2005.* **Photo: Franck Prevel © Reuters**

The Banlieue Condition

Zustand: Banlieue With their "Micro-équipements mobiles" (plug-in-and-play urban units) such as Suitcase House and Video-K, the French architects Claire Petetin and Philippe Grégoire install prototypes in public spaces to encourage the re-activation of underused and sensitive urban areas by those living in them and to challenge stereotyping and judgemental attitudes. Mit ihren „Micro-équipements mobiles" (urbane Plug'n'play-Einheiten) installieren die französischen Architekten Claire Petetin and Philippe Grégoire Prototypen im öffentlichen Raum, die eine Wiederbelebung besonders empfindlicher und ungenutzter städtischer Gebiete durch deren Bewohner ermöglichen sollen, genauso wie die Überwindung der stereotypen und reflexartigen Ablehnung solcher Gebiete.

We must urgently contemplate the future of the mass social housing projects built in the aftermath of World War II, which many public authorities now consider to be a form of urban gangrene that must be eradicated.

These familiar urban landscapes have been banalised and stigmatised as *dangerous* (a favourite theme of the media). They are seen as a blight, full of over-crowded apartments, unsanitary buildings with dingy paint, ancient stairways, deserted and dangerous public spaces, neglected gardens and dead grass; fetid dens inhabited by squatters, burning cars and wasted lives. Social housing projects are currently the target of a political *tabula rasa* campaign that encourages cities, with the prom-

ise of significant financial subsidies, to destroy entire neighbourhoods of low-income housing built in the sixties. Meanwhile, paradoxically, France is currently suffering a major shortage of social housing.

The recent phenomenon of burning ghettos is not a manifestation of some new social malaise. The suburbs of all major French cities have, since the eighties, experienced sporadic explosions of urban violence in numerous urban enclaves where poor living conditions, chronic unemployment and poverty hold sway. What the authorities are confronting today is the birth of a new form of demonstration of resistance: the eruption of a social virus that has assumed a new magnitude.

Wir müssen dringend über die Zukunft der Großsiedlungen des sozialen Wohnungsbaus nachdenken, die nach dem Zweiten Weltkrieg gebaut wurden, die von der öffentlichen Hand nur mehr als urbane Geschwüre betrachtet werden, die entfernt werden müssen.

Diese vertraut wirkenden urbanen Landschaften werden von Seiten der Medien als gefährlich banalisiert und stigmatisiert. Sie werden als eine Verschandelung der Landschaft bezeichnet, voller überfüllter Wohnungen, heruntergekommene, schäbige Gebäude mit verfallenen Treppenhäusern, mit menschenleeren und gefährlichen öffentlichen Plätzen, vernachlässigten Grünflächen, übel riechende Verschläge, bewohnt von Hausbesetzern, brennenden Autos und gescheiterten Biografien. So

werden die Projekte des sozialen Wohnungsbaus zum leichten Ziel einer Tabularasa-Regierungspolitik, die die Städte mit umfangreicher öffentlicher Finanzierung anspornt, komplette Quartiere des sozialen Wohnungsbaus der 1960er Jahre abzureißen. Zur gleichen Zeit leidet Frankreich paradoxerweise an einem erheblichen Mangel an Sozialwohnungen.

Das gegenwärtige Phänomen brennender Vorstädte ist keine Erscheinung eines neuen sozialen Unbehagens. Alle Randbezirke der großen französischen Städte haben seit den 1980er Jahren vereinzelt Ausbrüche urbaner Gewalt erlebt – urbane Enklaven, in denen ärmliche Lebensbedingungen, chronische Arbeitslosigkeit und Armut vorherrschen. Die Behörden sehen sich heute der Entstehung einer neuen Form des Wi-

"Today, several decades after the ideologies of the 1960s, architects have a new awareness, which is once again focused towards the movements of the avant-garde and their modes of interventions. The protagonists – architects and designers of the radical movement in Britain, in Austria, in Italy – produced instruments for contesting realities destined for the citizen, and have opened the urban space as one for utopias and experimentation." Claire Petetin

„Heute, mehrere Jahrzehnte nach den Ideologien der 1960er Jahre, haben Architekten ein neues Bewusstsein, das wieder auf die Avantgarde-Bewegung und ihre Interventionsmethoden fokussiert ist. Die Protagonisten – Architekten und Designer der radikalen Bewegung aus Großbritannien, aus Österreich, aus Italien – haben Instrumente geschaffen, die für den Bürger vorgesehene Realitäten in Frage stellen und haben den städtischen Raum als Raum für Utopien und Experimente geöffnet."

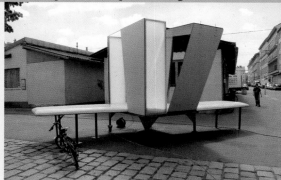
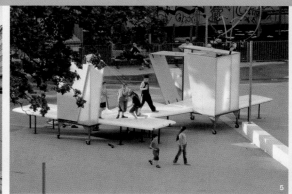

[1-2] Paris Sousbois, 2006, photos: Petetin and Grègoire

[3-5] "Paracity"-Installations, Vienna 2005, Petetin and Grègoire. Urban educational project, with students from the Ecole Nationale Supérieure de Création Industrielle and from Nicolas Pisani, School of Architecture of Paris-Charenton / „Paracity"-Installationen, Wien 2005, Petetin and Grègoire. Urbanes Studienprojekt in Zusammenarbeit mit Studenten der Ecole Nationale Supérieure de Création Industrielle und Nicolas Pisani, School of Architecture of Paris-Charenton. Photos: Petetin and Grègoire

It is just such an explosive cocktail of events that the world needed in order to take notice of this state of profound crisis that the French themselves do not want to acknowledge: the crisis of widespread urban misery. These city ghettos – that were always taken for granted – have all banded together in a way, to assert their right to live, their right to decide their own futures.

Reflecting on the future of post-war social housing projects and what is to become of them is a question of ethical, political and economic responsibility. It is a question of giving the population in these marginalised parts of the city the new tools of modern life to allow them to take part in the transformation of society and communications already taking place in the rest of the world.

Urban planners and architects who work within the parameters of state-financed building projects have few opportunities to position themselves pragmatically or effectively with respect to these issues. Concerted and carefully planned action is required: If nothing is done to de-ghettoise these areas, violent uprisings will recur with increasing vehemence.

For several years now, we have been trying to define our own areas of investigation and new strategies of intervention: replacing the model of an architect-executive with one of an architect who accompanies the transformation of spaces. Our architectural projects are predominantly experimental tools that allow us to bring intangible aspects of the contemporary city to light. Rather than realise *finished* architectural products, we seek to open breaches between the assumptions of the public authorities and the urban realities of those who live their daily lives in the city. We concern ourselves particularly with marginal urban spaces beyond the programmes of transformation affecting other parts of the city. Our projects become measuring instruments, pedagogical tools, whose purpose is to create protocols for co-operation between decision-makers, on the one hand, and citizens, on the other.

Today, several decades after the ideologies of the 1960s, architects have a new awareness, which is once again focused towards the movements of the avant-garde and their modes of interventions. The protagonists, architects and designers of the radical movement, in Britain, in Austria, in Italy, produced instruments for contesting realities destined for the citizen, and have opened the urban space as one for utopias and experimentation.

Our practice of architecture aims to look with fresh eyes at the cycles of transformation in the city, taking different time frames into consideration, and to contemplate an intentionally short-term urban plan, one that lends itself more readily to renewal – an urban plan of incremental steps, more flexible, more fluid, more responsive, in touch with the major changes in society. We want to create an axis of reflection, to delimit the pockets of empty urban territory within the city, determined by the cycles of short-term occupation, within which a utopia becomes possible, even indispensable.

derstandes gegenüber: dem Ausbruch eines sozialen „Virus" von bisher ungekanntem Ausmaß.

Offenbar war eine derart explosive Mischung nötig, um der Welt die tiefe Krise vor Augen zu führen, die die Franzosen selbst nicht sehen wollen: das weit verbreitete Elend dieser Vorstädte. Diese städtischen Ghettos, die einfach immer nur hingenommen wurden, haben sich gewissermaßen zusammengeschlossen, um ihr Existenzrecht und ihr Recht, über ihre eigene Zukunft zu entscheiden, einzufordern.

Wenn man Überlegungen zu der Zukunft der Nachkriegswohnungsbauprojekte und was aus ihnen werden soll anstellt, stellt sich die Frage der ethischen, politischen und ökonomischen Verantwortung. Man muss den Bewohnern dieser Enklaven neue Werkzeuge des modernen Lebens an die Hand geben, damit sie Teil haben können an den Kommunikationsmitteln und den Umwälzungen der Gesellschaft, die bereits auf der ganzen Welt stattfinden.

Stadtplaner und Architekten, die innerhalb der Parameter von staatlich finanzierten Bauprogrammen arbeiten, haben wenig Möglichkeiten, pragmatisch und effektiv zu diesem Thema Stellung zu beziehen. Solange jedoch nichts unternommen wird, um diese Gebiete zu de-ghettoisieren, werden sich die gewaltsamen Aufstände immer vehementer wiederholen.

Wir sind seit mehreren Jahren dabei, unsere eigenen Untersuchungsgebiete zu definieren und neue Interventionsstrategien zu wählen: Die Rolle des lediglich ausführenden Architekten wird ersetzt durch einen die Transformationsprozesse der Stadt begleitenden Planer. Unsere Architekturprojekte sind in erster Linie Versuchswerkzeuge, die es uns erlauben, den schwer erfassbaren Zustand der modernen Stadt sichtbar zu machen. Anstatt fertige architektonische

Produkte zu realisieren, versuchen wir die Brüche in den Vorstellungen aufzudecken, die in den Behörden vorherrschen, aber nicht den urbanen Realitäten derer entsprechen, die ihren Alltag in der Stadt leben. Dabei interessieren uns vor allem für die marginalen urbanen Räume, weitab der staatlich gelenkten Stadterneuerungsprogramme in anderen Teilen der Stadt. Unsere Projekte werden so zu Messinstrumenten, zu pädagogischen Werkzeugen, deren Zweckbestimmung es ist, Verhandlungsgrundlagen für die Zusammenarbeit zwischen Entscheidungsträgern einerseits und den Bürgern andererseits in Gang zu setzen.

Heute - einige Jahrzehnte nach dem Scheitern der Ideologien der 1960er Jahre - haben Architekten ein neues Bewusstsein, das sich wieder auf die Konzepte der Avantgarde und ihrer Interventionsmethoden richtet. Die Protagonisten - Architekten und Designer der radikalen Bewegung aus Großbritannien, Österreich und Italien - haben Instrumente entwickelt, um die für den Bürger bestimmte Realität anzufechten und haben den Stadtraum für Utopien und Experimente zugänglich gemacht.

Unsere Praxis der Architektur zielt darauf ab, die Zyklen der Transformationen in der Stadt mit anderen Augen zu betrachten, unterschiedliche Zeiträume in Betracht zu ziehen und eine absichtlich kurzlebigere urbane Planung zu entwickeln, die sich besser für eine Erneuerung eignet - eine urbane Planung der kleinen Schritte, flexibler, fließender, auf die Menschen eingehend und in steter Verbindung mit den großen Veränderungen der Gesellschaft. Wir möchten eine Reflektionsebene kreieren, um die leeren urbanen Territorien innerhalb der Stadt abzugrenzen, deren Zyklen durch kurzzeitige Benutzung definiert sind und in denen eine Utopie nicht nur möglich, sondern sogar unentbehrlich wird.

Edge condition: inner-city highway access / *Innerstädtischer Schnellstraßenzubringer*, Quito, Ecuador, 2002, photo: Arwed Messmer

Architects on the Edge

Der Architekt am Rand The French architecture critic and consultant Valéry Didelon says it is time for architects to reclaim the border territories and invade suburbia – but under new terms of engagement. Für den französischen Architekturkritiker und -berater Valéry Didelon ist es an der Zeit, dass Architekten die städtischen Peripherien zurückfordern und „Suburbia" erobern – aber unter veränderten Bedingungen ihres Engagements.

In today's world where urbanisation reigns supreme, the town centre has paradoxically slipped from the spotlight. Around the globe, people, wealth and knowledge are concentrated in major urban areas – metropolisation – but their forms and functions are spreading ever further into suburbia – suburbanisation. This process of centralisation and decentralisation began in the U.S. in the 1920s before advancing

> **Although the edge condition is increasingly debated the architect's place in the blueprint is little discussed.**

across Europe in the 1950s and 60s and then continuing to spread worldwide. New York City now has only 30 percent of the population in its inner city, Paris barely over 20 percent and the cities of Germany's Ruhr region under

6 percent.[1] The traditional city as well as pristine natural areas, have become isolated islands in a sea of suburbia extending to the horizon. In 1964, Melvin M. Webber dubbed this phenomenon the "Nonplace Urban Realm".

Although the edge condition is increasingly documented and debated these days, the architect's place in the blueprint is little discussed, probably because it is so limited. Suburban structures seem better described as construction than as architecture. Quality is poor, and few spend the resources to actually build. Buildings are often purely functional, designed with little care and lacking durability. Residential developments set themselves apart by their mediocrity and homogeneity, factories and offices are blindingly unimpressive and commercial buildings are borderline shoddy structures. One common thread in the suburban development process is that it all generally occurs without input from architects, who have been relegated to the sidelines.

In einer Zeit, in der die Urbanisierung ihren endgültigen Triumph feiert, steht die klassische Innenstadt paradoxerweise nicht mehr im Fokus dieser Entwicklung. Zwar konzentrieren sich durch den weltweiten Metropolisierungsprozess Menschen, Vermögen und Wissen in den wichtigsten urbanen Ballungszentren, doch verlagern sich deren Formen und Funktionen in einem Prozess der Suburbanisierung immer weiter in die Vororte. Dieser Prozess der Zentralisierung und gleichzeitigen Dezentralisierung begann in den Vereinigten Staaten in den 1920er Jahren, bevor er in den 1950er und 1960er Jahren auf Europa und seither auch auf den Rest der Welt übergriff. In New York City leben nur 30 Prozent der Bevölkerung in der Innenstadt, in Paris sind es kaum 20 Prozent, in den Städten des deutschen Ruhrgebiets nicht einmal 6 Prozent.[1] Die traditionellen Städte sind - ebenso wie die unberührte Natur - zu isolierten Inseln geworden in diesem suburbanen Meer, das sich bis zum Horizont erstreckt. Melvin M. Webber bezeichnete dieses Phänomen 1964 als „Nonplace Urban Realm".

Diese Entwicklung hin zum Rand wird mehr und mehr dokumentiert und diskutiert, doch die Rolle des Architekten ist dabei kaum noch ein Gesprächsgegenstand; wahrscheinlich weil Architektur hier kaum noch eine Rolle spielt. Die suburbanen Strukturen sollte man in der Tat eher als als „Konstruktionen" denn als Architektur beschreiben. Die Qualität ist schlecht; nur selten wird in echtes Bauen investiert. Die Gebäude sind oft rein funktional, ihr Design gedankenlos, die verwendeten Materialen minderwertig. Wohngebiete zeichnen sich durch Mittelmaß und Gleichförmigkeit aus, Fabriken und Büros sind von nicht zu überbietender Banalität und Unscheinbarkeit, Geschäftsgebäude sind ideenlose Konstruktionen. Der Gedanke drängt sich auf, dass Architekten im suburbanen Entwicklungsprozess scheinbar gar keine oder nur eine untergeordnete Rolle spielen.

So war es bei weitem nicht immer: Nach dem Zweiten Weltkrieg bekamen die Vertreter der Moderne ihre Chance. Die Stadtrandgebiete waren für sie ideale Experimentierflächen - Frankreichs massive Neubau-

[1] "The Edge Condition", photo: Benedicte Grosjean [2–4] Photos: Thorsten Klapsch

However, this was not always the case. After World War II, the leaders of the modernist movement had their chance. Areas on the fringe were a blank canvas for their experiments, as illustrated by France's massive housing projects. This was but a brief moment of glory, as architects fled the suburbs amidst jeers, victims of their own arrogance. In response, they abandoned these frontiers. In the 1970s and 80s, as suburbanisation spread in Europe, architects championed the postmodern *rétour à la ville* movement in Italy, France and Belgium. They were so unwilling to acknowledge the spread of progress to the suburbs that it escaped them alto-

Will architects be forced to choose between resisting and fading into extinction or acquiescing and perishing in the sea of banality?

gether. Instead, they seemed to link their fate to that of the historic city, and embellishing and improving city centres and the surrounding neighbourhoods became the only legitimate focus of their profession. The architect's territory was thus limited to the "downtown area" where even today, most continue to base their offices.

But here at the start of the 21st century it is no longer possible to ignore the issue of the suburbia as it infringes upon the historic city. City-dwellers' lifestyles are increasingly similar to those of suburban residents, peripheral architecture is creeping toward city centres and suburban developments are becoming the model for shaping downtown areas of old. With each passing day, architects are more confronted with the edge condition. The triumph of suburbia, the fall of the traditional city, and the decline of the traditional values of order and harmony arise, along with a major crisis in the architectural profession.

What position should architects take with regard to this interloper that has relegated them to the sidelines and challenged their legitimacy? Upon first glance, it seems that they must choose between two evils: One is to fight against suburbia, holding tight to their values and even counter-attacking, with the movement to "urbanise suburbia", as has been recently heard in France.[2] However, in doing so they miss what is going on in the outskirts, they stay detached from their development. The second is to embrace suburbia, incorporating its mode of propagation, accommodating its aesthetic and participating in its expansion, but with this choice they run the risk of watering down their art and struggling to justify their contribution. Will architects be forced to choose between resisting and fading into extinction or acquiescing and perishing in the sea of banality?

Not necessarily, if we take a historical look at how they were able to conquer worlds that escaped them. At the end of the 19th century, development of big-city industrial landscapes – coal yards and steel mills, ports and ware-

viertel zeugen davon. Aber dies war nur ein kurzer Moment des Triumphs, denn die Architekten verließen die Vorstädte unter Buhrufen und wurden Opfer ihrer eigenen Arroganz. Daraufhin wandten sie sich anderen Arbeitsgebieten zu. Während in den 1970er und 80er Jahren die Suburbanisierung überall in Europa weiter an Boden gewann, setzte man sich in Italien, Frankreich und Belgien für die postmoderne „Rückkehr in die Stadt" ein („rétour à la ville") ein. Man verkannte komplett – oder war auch unwillig einzugestehen –, dass sich das Geschehen inzwischen in die Randbezirke verlagerte. Die Architekten schienen sich ganz dem Schicksal der historischen Stadt zu verschreiben, ihr Berufsstand meinte, seine alleinige Legitimität aus der Verschönerung und Aufwertung der Stadtzentren und der stadtnahen Gebiete beziehen zu können. Damit reduzierte sich ihr Wirkungskreis auf das „Downtown", wo auch heute die meisten Architekten ihr Büro und im Wesentlichen auch ihr Betätigungsfeld haben.

Doch heute, zu Beginn des 21. Jahrhunderts, kann die Frage der städtischen Randzonen nicht länger ignoriert werden, denn das Phänomen „Suburbia" dringt ins Zentrum der historischen Stadt: Die Lebensformen der Städter, der „city-dwellers", orientieren sich zunehmend am Stil der in den Vorstädten lebenden Menschen, die architektonischen Typologien der Vorstädte greifen auf die Stadtzentren über und suburbane Strukturen werden zu Modellen für die Neustrukturierung alter Stadtkerne. Die Architekten werden jeden Tag stärker mit der Vorstadtsituation konfrontiert: Der Triumph von „Suburbia", die Krise der historischen Stadt und der Verfall der traditionellen Werte von Ordnung und Harmonie

gehen einher mit einer tiefen Krise des Architektenberufs.

Wie können Architekten zu dieser Entwicklung Stellung beziehen, die dazu geführt hat, dass sie dieser nur tatenlos zusehen können und sie mit Fragen nach ihrer eigenen Legitimität konfrontiert werden? Auf den ersten Blick könnte man meinen, dass nur zwischen zwei Übeln zu wählen ist: Entweder man stellt sich der Suburbanisierung entgegen, beruft sich auf die bewährten Werte und geht vielleicht sogar zum Gegenangriff über, – zur „Urbanisierung von Suburbia", wie vor kurzem in Frankreich vorgeschlagen wurde.[2] Das hieße aber, die Gegebenheiten der städtischen Randgebiete vollkommen außer Acht zu lassen und sich für deren Entwicklung nicht zu interessieren. Die andere Option wäre, in die Vorstädte zu gehen, sich deren Ausbreitungsmodus zu Eigen zu machen, sich auf deren Ästhetik einzulassen und dieser Ausdehnung zuzuarbeiten. Dabei besteht dann aber die Gefahr, dass der eigene künstlerische Ansatz, die eigene Arbeit verleugnet wird und man nicht hinter dem Ergebnis steht. Sind Architekten also dazu verurteilt, entweder Widerstand zu leisten und auszusterben oder aber an der Suburbanisierung zu partizipieren und im Meer der Banalitäten unterzugehen?

Nicht unbedingt. Denn haben es die Architekten nicht in der Vergangenheit auch verstanden, gerade solche Welten zu erobern, die sich ihnen zunächst entzogen? Am Ende des 19. Jahrhunderts veränderte sich die Industrielandschaft in den Kohle- und Stahlregionen, in den Häfen und in den Randzonen der Großstädte unter dem bestimmenden Einfluss der Ingenieure. Architekten interessierten sich nur wenig für die-

houses — was presided over by engineers. These filthy realms were eschewed by architects, who focused instead on embellishing bourgeois urban centres. Architects snubbed this new reality and buried their heads in the sand of the declining Beaux-Arts culture. The revival was thus led by avant-garde thinkers who took interest in the urban fringe. In 1913, the pioneer Walter Gropius made use of grain silos seen in North America,[3] and was imitated by Le Corbusier in 1923 in *Vers une architecture*. Following in their footsteps, many modern architects undertook to outfit raw industrial areas in the fabrics of their art. In the late 1960s, a similar process occurred when intellectuals like Reyner Banham and architects like Denise Scott Brown and Robert Venturi left the beaten path to explore the commercial realm so disdained by their contemporaries.[4] Here, they discovered a "low culture" full of vitality with the ability to breathe new life into their aging "high culture". They learned from this vernacular landscape, not reproducing it, but rather introducing it into the academic culture. By reconnecting with the city as it *is*, rather than how it *should* be, they wanted to restore the legitimacy compromised by the profession's elitist attitude. Like their predecessors, it is only by venturing outside of the city and away from the architectural culture that the Venturis managed to strengthen their art.

However, none of these innovators actually transformed iron into gold. Although they may have brought new vitality to their art, they did not com-

pletely succeed in reforming their profession and never gained a permanent foothold in these areas. They remain foreigners to the edge condition. They are spectators rather than participants and seem resigned to their impotence, as illustrated by Rem Koolhaas' statement: "Urbanism will not only, or mostly, be a profession, but a way of thinking, an ideology: to accept what exists. We were making sand castles. Now we swim in the sea that swept

It is too humiliating for them to set the goal of an ideal city only to witness its inevitable decomposition under all the existing constraints.

them away."[5] Architects and urbanists are now like sailors set adrift without a helm. As Denise Scott Brown suggests, they'd best change their strategy: "The sailor may occasionally turn surfer, [and] ride the waves as they break."[6]

How can they accept and participate in this suburban phenomenon, that has spread out of control? In matters of city planning, this requires the admission that "the city no longer exists" and that the new reality requires abandoning the "twin fantasies of order and omnipotence" to embrace "staging of uncertainty".[7] Architects must let go of grand visions as it is too humiliating for them to set the goal of an ideal city only to witness its inevitable decomposition under all of the existing constraints.

se schmutzigen Gebiete, sie waren mit der Verschönerung der bürgerlichen Metropole beschäftigt, schauten mit Verachtung auf diese neue Realität und verschlossen sich in ihrer dem Untergang geweihten schöngeistigen Kultur. Es waren die Pioniere ihres Berufsstandes, die sich für die städtischen Randzonen interessierten und eine neue Entwicklung einleiteten. Walter Gropius bezog sich 1913 auf Getreidesilos, die er in Nordamerika gesehen hatte,[3] Le Corbusier eiferte ihm 1923 in „Vers une architecture" nach. Zahlreiche moderne Architekten folgten ihnen und machten sich daran, die rauen Industriegebiete mit den Mitteln ihrer Gilde auszustaffieren. So hielten es Ende der 1960er Jahre auch Intellektuelle wie Reyner Banham und Architekten wie Denise Scott Brown und Robert Venturi: Sie verließen die ausgetretenen Pfade und erforschten das von ihren Zeitgenossen so geschmähte Reich des Kommerz.[4] Hier entdeckten sie eine „low culture" voller Vitalität, die ihrer verstaubten „high culture" neues Leben einhauchte. Sie studierten diese traditionelle Alltagsarchitektur und machten sie, ohne sie zu kopieren, in ihrer akademischen Kultur salonfähig. Ihr Ausgangspunkt war die Stadt, wie sie war, und nicht, wie sie sein sollte; sie wollten dem Architektenberuf, der durch das elitäre Auftreten ihrer Berufskollegen an Bedeutung verloren hatte, zu einer neuen Legitimität verhelfen. Scott Brown und Venturi folgten dem Beispiel ihrer Vorgänger: Sie wagten sich aus der Stadt heraus und überschritten die Grenzen der architektonischen Kultur – eben um dieser Kunst wieder neue Kraft zu verleihen.

Und doch hat keiner dieser Erneuerer Stroh in Gold verwandelt. Auch wenn sie zur Revitalisierung ihrer Disziplin beitru-

gen, konnten sie ihren Berufsstand doch nicht ganz rehabilitieren und in diesen Randgebieten wirklich Fuß fassen. Auch heute noch wehren sich die Vorstädte gegen Architekten und Stadtplaner, die sich eher in der Rolle von Zuschauern als von Akteuren befinden und sich mit ihrer Ohnmacht abgefunden haben. Dies beschreibt auch Rem Koolhaas: „Stadtplanung wird nicht nur oder größtenteils ein Beruf sein, sondern eine Denkart, eine Ideologie: Es gilt, das Bestehende zu akzeptieren. Wir haben Sandburgen gebaut. Jetzt schwimmen wir in dem Meer, das sie weggespült hat."[5] Architekten und Stadtplaner gleichen Seefahrern, die in Booten ohne Steuerruder auf dem Ozean dahintreiben. Denise Scott Brown spricht von der Notwendigkeit eines Strategiewechsels: „Der Segler könnte zuweilen zum Surfer werden, der auf den sich brechenden Wellen reitet."[6]

Wie können sich Architekten der Vorstadtsituation stellen, die sich jeglicher Kontrolle entzieht? Vom städtebaulichen Standpunkt aus muss man einfach zugeben, dass „die Stadt nicht mehr existiert", dass die neue Realität den Verzicht auf die „Fantasievorstellung von Ordnung und Allmacht" erzwingt und sich eher einer „Inszenierung des Ungewissen" zuwenden.[7] Architekten müssen von ihren außergewöhnlichen Plänen Abstand nehmen. Es ist zu demütigend, das Ziel der idealen Stadt zu setzen und anschließend zu erleben, wie dieses Projekt von den vielfältigen Zwängen demontiert wird. Wenn man keine oder nur noch wenig Macht hat, sollte die „Form" das Ziel und nicht der Ausgangspunkt sein.

Im Umfeld von Utrecht in den Niederlanden hat die Architektengruppe Maxwan einen vergleichbaren Versuch gestartet: „Die

When one has little or no control, it is better to see form as a destination rather than a starting point. In the suburbs of Utrecht in the Netherlands, the Maxwan firm had a similar experience:

"Leidsche Rijn is an urbanism of negotiation, and proud of it. The negotiations were not done in order to get the design realised; the design was made to negotiate with, to get the city built. The most important ingredient of this story is that the urban designers ... had no real power at all. They did not even have a strong and stable power base to operate from. ... Having no power themselves, their freedom of movement was not defined by the limits of their mandate." [8]

For architecture, the same applies. Rather than fighting against all odds to impose refined construction that partners are unable or unwilling to build, it might be preferable to develop a specific architecture from the edge condition. Consider the example of limited budget: Instead of a stifling factor, it can be a source of creativity, as regularly shown by Anne Lacaton and Jean-Philippe Vassal. Similarly, mass-production of building components is not such a tragedy if one is inspired and makes them a central feature in the design like Jacques Ferrier. And there are a thousand other ways to incorporate the edge condition into the very heart of the design process.

The nature of buildings and cities is dependent upon the social, technical and cultural context surrounding those who design them. In today's world, the architect's place is on the edge. That is,

the architect no longer has a central place in society, and architecture is no longer the focal point in the urbanised field. The collectivity has other priorities. Still, our environment changes daily and architects and urbanists remain major players in this process. We can only hope that, from the edge, they will capture the spirit of their time as unwelcoming as it may be, creating their own unique and noteworthy interpretation.

1 F. Moriconi-Ebrard, *De Babylone à Tokyo*, Ed. Ophrys, Paris, 2000, p. 317.

2 During the unrest in France in autumn 2005, architects and politicians agreed on the necessity of "civilizing the youth" and "urbanizing suburbia", Renzo Piano.

3 Walter Gropius, "Die Entwicklung moderner Industriebaukunst", *Jahrbuch, Deutscher Werkbund*, 1913.

4 Reyner Banham, *Los Angeles: The Architecture of Four Ecologies*, Harper & Row, New York, 1971.
Robert Venturi, Denise Scott Brown and Steven Izenour, *Learning from Las Vegas*, MIT Press, Cambridge, 1972.

5 Rem Koolhaas, "What Ever Happened to Urbanism" *SMLXL*, 010 Publishers, Rotterdam, 1995.

6 Robert Venturi and Denise Scott Brown, *Architecture as Signs and Systems: For a Mannerist Time*, The Belknap Press, Cambridge, 2004.

7 Rem Koolhaas, ibid.

8 Crimson Architectural Historians, "Orgware", *Big Soft Orange*.

„Leidsche Rijn" ist eine Stadtplanung, die aus der Verhandlung heraus entstanden ist, und sie ist stolz darauf. Die Verhandlungen dienten nicht der Durchsetzung eines Designs; vielmehr diente das Design selbst der Verhandlung und Vermittlung, mit dem Ziel, die Stadt zu bauen. Der zentrale Punkt dieser Geschichte ist, dass die Stadtplaner ... eigentlich überhaupt keine Macht hatten. Sie hatten nicht einmal eine starke oder stabile Grundposition, von welcher aus sie agieren konnten. ... Ohne jede Macht, war ihre Bewegungsfreiheit aber nicht durch die Grenzen ihres Mandats definiert." [8]

Die gleiche Problematik betrifft auch die Architektur: Anstatt allen Widerständen zum Trotz kunstvolle Gebäude durchsetzen zu wollen, die die Partner nicht mehr umsetzen können oder wollen, sollte man vielmehr dazu beitragen, aus der Vorstadtsituation heraus eine auf die realen Gegebenheiten abgestimmte Architektur zu entwickeln. Die ökonomische Verwendung begrenzter finanzieller Mittel muss kein alles im Keim erstickender Zwang sein, sie kann auch erfinderisch machen, wie die französischen Architekten Anne Lacaton und Jean-Philippe Vassal regelmäßig beweisen. Die Massenproduktion von Bauteilen ist nicht zwangsläufig eine Tragödie, wenn man sie wie Jacques Ferrier ins Zentrum seiner Projekte stellt. Es gibt Tausende anderer Beispiele, wie dieser „Randzustand" ins Zentrum des Schaffensprozesses rücken könnte.

Das Wesen der Bauten und der Städte hängt vom sozialen, technischen und kulturellen Umfeld derjenigen ab, die sie gestalten. In der heutigen Welt ist der Platz des Architekten die Peripherie, der Rand: Er steht nicht mehr im Zentrum der Gesell-

schaft, so wie Architektur nicht mehr im Zentrum urbanisierter Gebiete steht. Die Gesellschaft setzt heute andere Prioritäten. Und doch entwickelt sich die uns umgebende Welt mit jedem Tag weiter und Architekten und Städteplaner werden weiterhin sehr wichtige Akteure in diesem Prozess sein. Man kann nur hoffen, dass sie sich ihre Epoche – und sei sie noch so undankbar – von Rand her aneignen und sie auf ihre Weisen bemerkenswert und einfallsreich neu interpretieren und gestalten.

1 Vgl. F. Moriconi-Ebrard, *De Babylone à Tokyo*, Verlag Ophrys, Paris, 2000, S. 317.

2 Während der Unruhen, die im Herbst 2005 in ganz Frankreich aufflammten, waren sich Architekten und Politiker einig, dass „die Jugend zivilisiert" und „die Vorstädte urbanisiert" (Zitat Renzo Piano) werden müssen.

3 Walter Gropius, „Die Entwicklung moderner Industriebaukunst", in: *Jahrbuch, Deutscher Werkbund*, 1913.

4 Vgl. Reyner Banham, Los Angeles: The Architecture of Four Ecologies, Harper & Row, New York, 1971.
Robert Venturi, Denise Scott Brown & Steven Izenour, *Learning from Las Vegas*, MIT Press, Cambridge, 1972.

5 Vgl. Rem Koolhaas, „What Ever Happened to Urbanism" in: *SMLXL*, 010 Publishers, Rotterdam, 1995.

6 Vgl. Robert Venturi and Denise Scott Brown, *Architecture as Signs and Systems: For a Mannerist Time*, The Belknap Press, Cambridge, 2004.

7 Vgl. Rem Koolhaas, ibid.

8 Crimson Architectural Historians, "Orgware", *Big Soft Orange*.

Micro-topias
Tuning, Customising, Design-It-Yourself

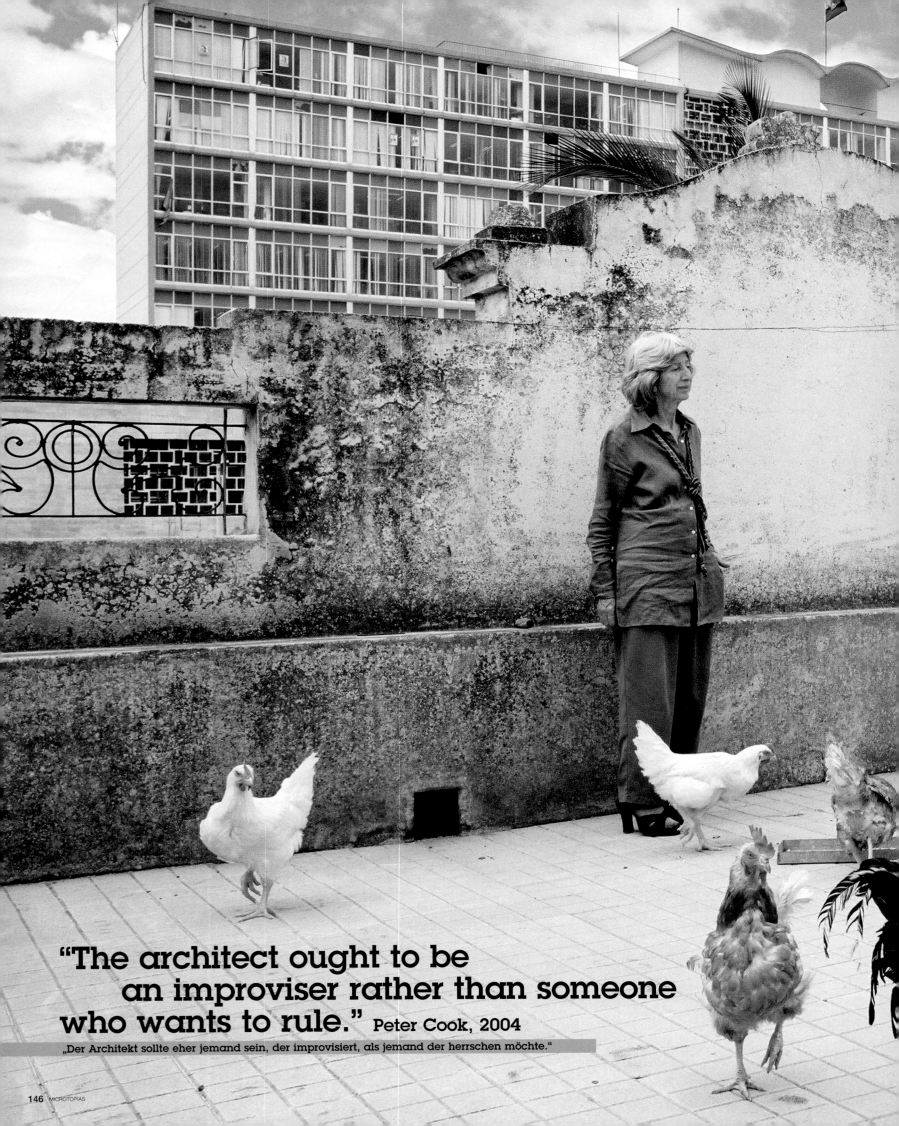

"The architect ought to be an improviser rather than someone who wants to rule." Peter Cook, 2004

„Der Architekt sollte eher jemand sein, der improvisiert, als jemand der herrschen möchte."

Quito, Ecuador 2002, photo: Arwed Messmer

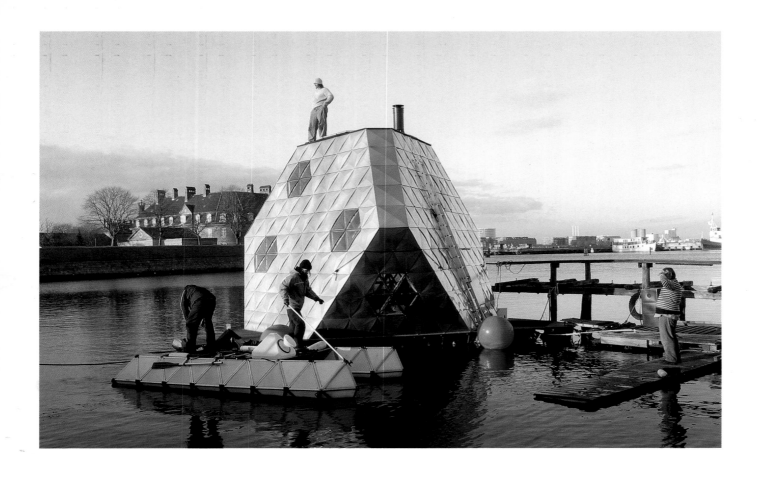

Micro-Dwellings

The Danish team N55 (founded by Ion Sørvin and Ingvil Hareide Aarbakke) are concerned with modular/social/public architecture. Driven by a politicised desire for devolution of power and thereby choice to the individual they deliver "low cost, small scale, do-it-yourself" suggestions rather than solutions. Das dänische Büro N55 (gegründet von Ion Sørvin und Ingvil Hareide Aarbakke) beschäftigt sich mit modularen öffentlichen Gebäuden und Sozialbauwohnungen. Motiviert durch politisches Denken setzen sie sich für die Dezentralisierung von Macht ein und somit für die freien Wahlmöglichkeiten des Individuums – sie liefern deshalb eher preisgünstige, kleinformatige „Do-it-yourself"-Anregungen, als dass sie Lösungsvorschläge anbieten.

[↑] "Public Things", Fort Asperen, The Netherlands 2001, photo: N55
[←] "N55 Spaceframe" and "Modular Boat", Quintusholmen, Copenhagen 2003, photo: N55
[↙] "N55 Spaceframe", interior / *Innenraum*, 2003, photo: N55

Architecturally, N55 are mainly interested in generating ideas for "small pockets in the cities that are in some kind of transition or areas in general where there is less control; like water areas, rooftops, or old industrial areas." Their micro-dwellings, for example are mobile housing modules that can plug together in innumerable configurations on land, underwater and above water, using both hi- and low-tech solutions. The dwellings consist of equal sized polyhedral units in a variety of shapes, made of durable and low-cost materials.

"To build something is a fantastic thing that anyone should be allowed to experience. The design of small communities should come from within, from the people living there, not from above, from politicians, the building industry mafia, investors or architects or urban planners."

"Many of the 1960s and 70s projects using the technologies and geometries that we are into as well were very ideological. They had this optimistic idea that mass-production was the answer to all basic needs, no matter if they were used for capitalist or socialist purposes. Our starting points are language, facts and logical relations; individual rights and the fact that large concentrations of power tend not to respect those rights ... We have also focused on low tech in order to have as little to do with industry as possible."
Ion Sørvin

N55 wollen vor allem Ideen für „kleine Nischen in städtischen Lagen entwickeln, die sich in irgendeiner Art von Umbruch befinden, oder an Stellen, die weniger restriktiven Auflagen unterliegen, zum Beispiel Wasser- und Dachflächen und verlassene Fabrikgelände." Ihre „Mikrobehausungen" sind zum Beispiel mobile Hausmodule, die sich zu unzähligen Konfigurationen zu Lande, zu Wasser und unter Wasser zusammensetzen lassen, wobei sowohl High-Tech- als auch Low-Tech-Lösungen und -Teile zum Einsatz kommen. Die Häuser sind vielflächige, gleichgroße Einheiten bestehend aus verschiedenen Formen, die aus robusten, preiswerten Materialien hergestellt werden.

„Etwas zu bauen ist eine fantastische Erfahrung, die allen Menschen ermöglicht werden sollte. Der Entwurf kleiner Gesellschaften sollte von innen heraus kommen, das heißt von den Bewohnern, und nicht von oben, das heißt nicht von der Politik, der Bauindustrie-Mafia, Investoren, Architekten oder Stadtplanern."

„Viele der Bauten aus den 1960er und 70er Jahren, die mit denselben Techniken entstanden sind, mit denen wir uns beschäftigen, waren ideologisch motiviert. Ihre Planer waren optimistisch in ihren Ansichten, dass die Massenproduktion die Lösung zur Befriedigung sämtlicher Grundbedürfnisse des Menschen sei - egal, ob sie für kapitalistische oder sozialistische Zwecke eingesetzt wurden. Unsere Ausgangspunkte sind: Sprache, Fakten und logische Wechselbeziehungen, die Rechte des Einzelnen und die Tatsache, dass die „Mächtigen" dazu neigen, diese Rechte zu missachten. Wir beschränken uns dabei auf einfache Bautechniken, um uns so wenig wie möglich mit der Großindustrie auseinandersetzen zu müssen." Ion Sørvin

Nohotel

With their project "Nohotel" Tobias Lehmann (Berlin) and Floris Schiferli (The Netherlands) have created an ingenious and somewhat ironic plug-in, a private living space, that applies individuated space to abandoned architectural structures and their decay of meaning. It empowers people to be always capable of making a simple, but useful shelter and is a good example of a pragmatic "clean" approach to occupying space that does not damage or leave spaces. "Nohotel" can be viewed as an evolutionary development of squat culture. Mit ihrem Projekt „Nohotel" haben Tobias Lehmann (Berlin) und Floris Schiferli (Niederlande) eine erfinderische und leicht ironische Variante eines architektonischen „Plug-Ins" entworfen, die ein schnelles und unkompliziertes Einbauen von individuellem Wohnraum in verlassene und bedeutungsleere Architekturen ermöglicht. „Nohotel" gibt dem Menschen die Möglichkeit, überall einen genügsamen, aber ausreichenden Schutzraum aufzubauen. Es ist ein gutes Beispiel für einen pragmatischen, „sauberen" Weg, Raum temporär zu besetzen, ohne ihn zu beschädigen. „Nohotel" kann als Evolutionsstufe der Hausbesetzerkultur gelten.

"'Nohotel' is about making vacant space usable, it came about from looking at what the *Antikraak* organisation was doing in the Netherlands (*kraak* means 'squat' in Dutch). Antikraak takes vacant buildings that are in danger of being squatted and leases them to people as places to live or work in. Antikraak's work inspired us to see the huge amount of space that is lying empty as a resource. Should 'Nohotel' be run as part of an event such as a film festival, you could find buildings in advance that best suit the requirements of a particular group of visitors. Whilst 'Nohotel' is running, these buildings would enjoy an increased degree of attention. This means that 'Nohotel' also works as an advertising campaign for vacant properties." Lehmann/Schiferli

„Bei ‚Nohotel' geht es um die Nutzbarmachung leer stehender Räume. Das Projekt entstand aus der Betrachtung der Aktivitäten der Antikraak-Organisation in den Niederlanden (kraak bedeutet auf Niederländisch ‚Hausbesetzung'). ‚Antikraak' übernimmt leer stehende Häuser, bei denen die Gefahr besteht, dass sie besetzt werden, und vermietet diese als Wohn- oder Arbeitsräume. Die Arbeit von ‚Antikraak' hat uns dazu angeregt, die Vielzahl an leer stehenden Räumen als Ressource zu sehen. Wenn ‚Nohotel' als Teil einer Veranstaltung wie beispielsweise eines Filmfestivals betrieben wird, könnte man vorab nach Gebäuden suchen, die den Anforderungen der jeweiligen Besuchergruppe am besten entsprechen. Während ‚Nohotel' läuft, würden diese Gebäude einen höheren Grad an Aufmerksamkeit erfahren. Das bedeutet, ‚Nohotel' funktioniert gleichzeitig als Werbekampagne für leer stehende Bauwerke." Lehmann/Schiferli

"A lot of people, like myself, who had been involved, one way or the other, with this 'fringe' activity in the 1970s, have since become politicians in power or influential architects and planners. This group has since begun turning their experiences over the past thirty years – experiences of dealing with public space, of activating people to implement projects – into 'official' urban processes, in which multiple stakeholders, from investors to temporary users – are all taking their part in creating some very successful urban environments." Kees Christiaanse

„Viele derjenigen, die wie ich in den 1970er Jahren auf die eine oder andere Weise in diese ‚Randaktivitäten' involviert waren, sind mittlerweile Politiker oder einflussreiche Architekten und Planer geworden. Diese Gruppe hat seither damit begonnen, aus den eigenen Erfahrungen der letzten dreißig Jahre – Erfahrungen im Umgang mit dem öffentlichen Raum, mit der Aktivierung von Menschen zur Umsetzung von Projekten – in ‚offizielle' urbane Prozesse umzuwandeln, bei denen viele Interessengruppen von Investoren bis zu temporären Nutzern gemeinsam sehr erfolgreich ihre städtische Umwelt mitgestalten."

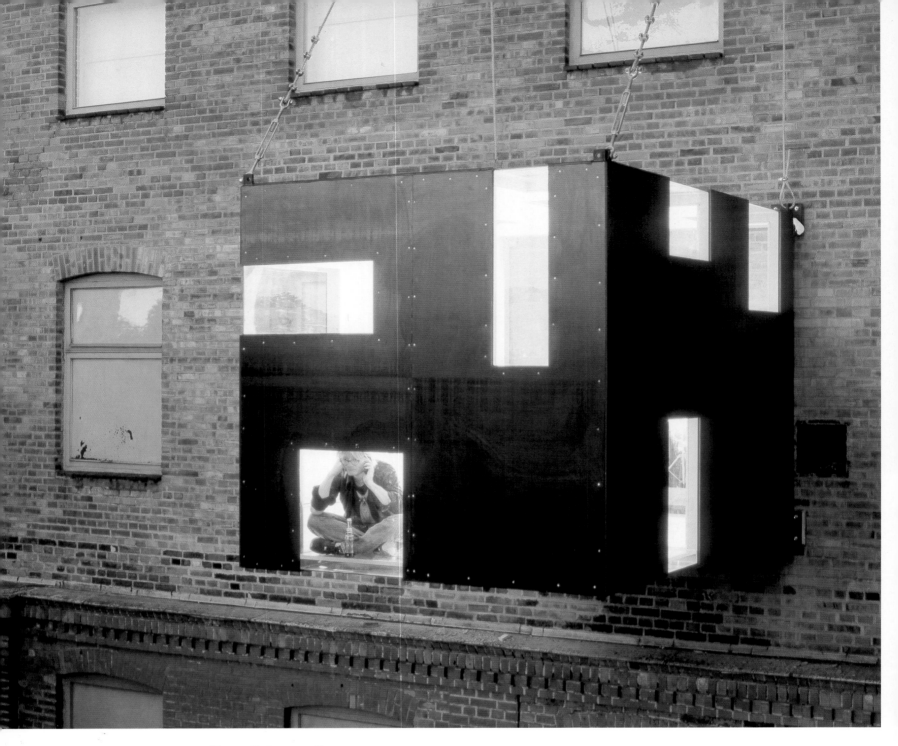

Docking On

With his Rucksack House, the German artist Stefan Eberstadt seeks to explore territories where sculpture can function outside the art space by involving certain social necessities and architectural issues such as flexibility and mobility. His "mini house" functions like a rucksack in that it hangs by steel cables from its "host" and provides it with a personal and enclosed space in a public environment. Fold-out furnishings such as desk, shelves and sleeping/reading platform are concealed in the walls and power is tapped from the host building. Mit seinem „Rucksackhaus" will der Künstler Stefan Eberstadt erforschen, wie weit die Bildhauerei außerhalb des Kunstkosmos' an Einfluss gewinnen kann, wenn sie zeitgenössische soziale Bedürfnisse und architektonische Fragestellungen wie die nach Flexibilität und Mobilität in Betracht zieht. Sein „Miniaturhaus" funktioniert nach dem Prinzip eines Rucksacks: es hängt sich mit stählernen Kabeln an seinen „Wirt" und „versorgt" diesen mit einem persönlichen und abgeschlossenen Raum, trotz dessen eher exponierten Lage. In den Wänden sind ausklappbare Möbel verborgen, wie etwa ein Tisch, Regale und eine kombinierte Schlaf- oder Sitzplattform; den nötigen Strom zapft es vom Gebäude, an dem es hängt.

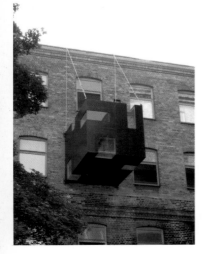

[↑] "Rucksackhaus", Leipzig, 2004, photo: Claus Bach

[↖] "Rucksackhaus", Leipzig, 2004, photo: Silke Koch

[→] "Non-Side Zoom: Open Reality", Tainan 2005, photo: Chen Chian Pai

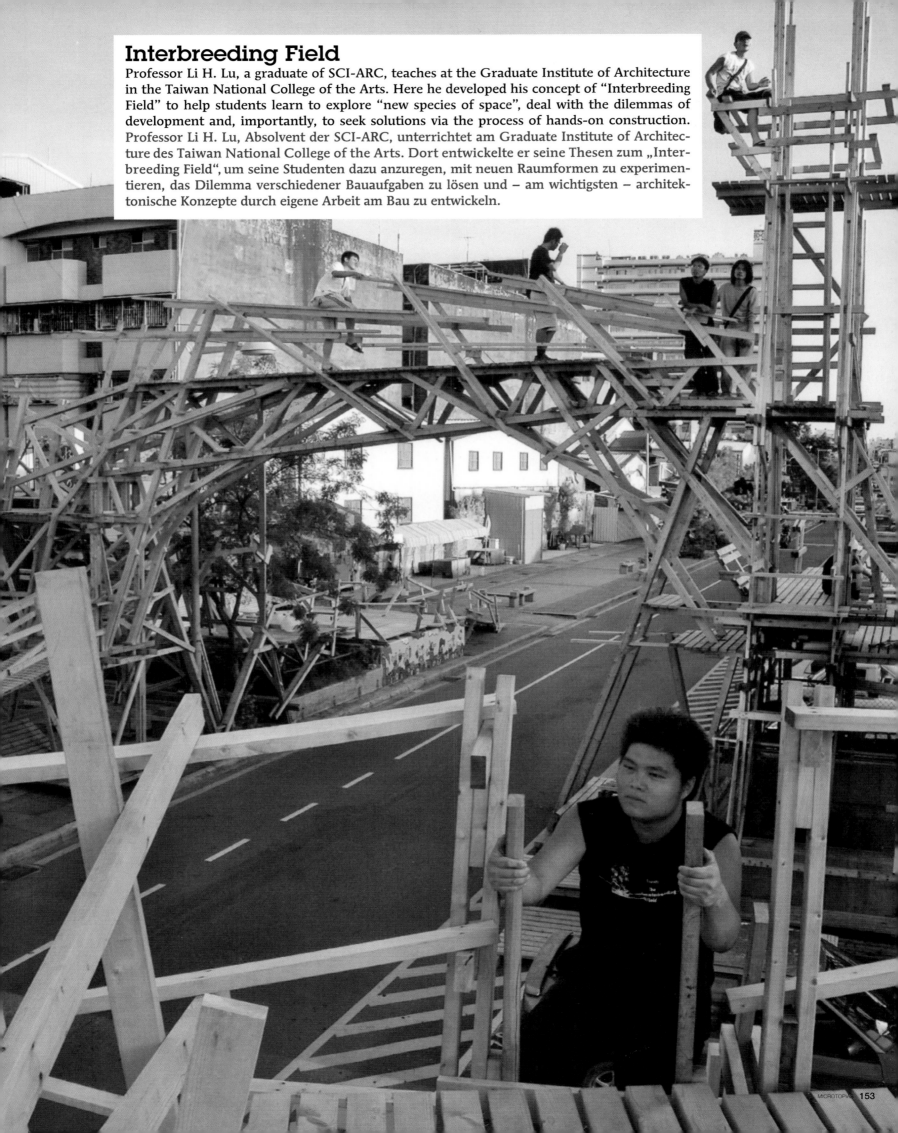

Interbreeding Field

Professor Li H. Lu, a graduate of SCI-ARC, teaches at the Graduate Institute of Architecture in the Taiwan National College of the Arts. Here he developed his concept of "Interbreeding Field" to help students learn to explore "new species of space", deal with the dilemmas of development and, importantly, to seek solutions via the process of hands-on construction. Professor Li H. Lu, Absolvent der SCI-ARC, unterrichtet am Graduate Institute of Architecture des Taiwan National College of the Arts. Dort entwickelte er seine Thesen zum „Interbreeding Field", um seine Studenten dazu anzuregen, mit neuen Raumformen zu experimentieren, das Dilemma verschiedener Bauaufgaben zu lösen und – am wichtigsten – architektonische Konzepte durch eigene Arbeit am Bau zu entwickeln.

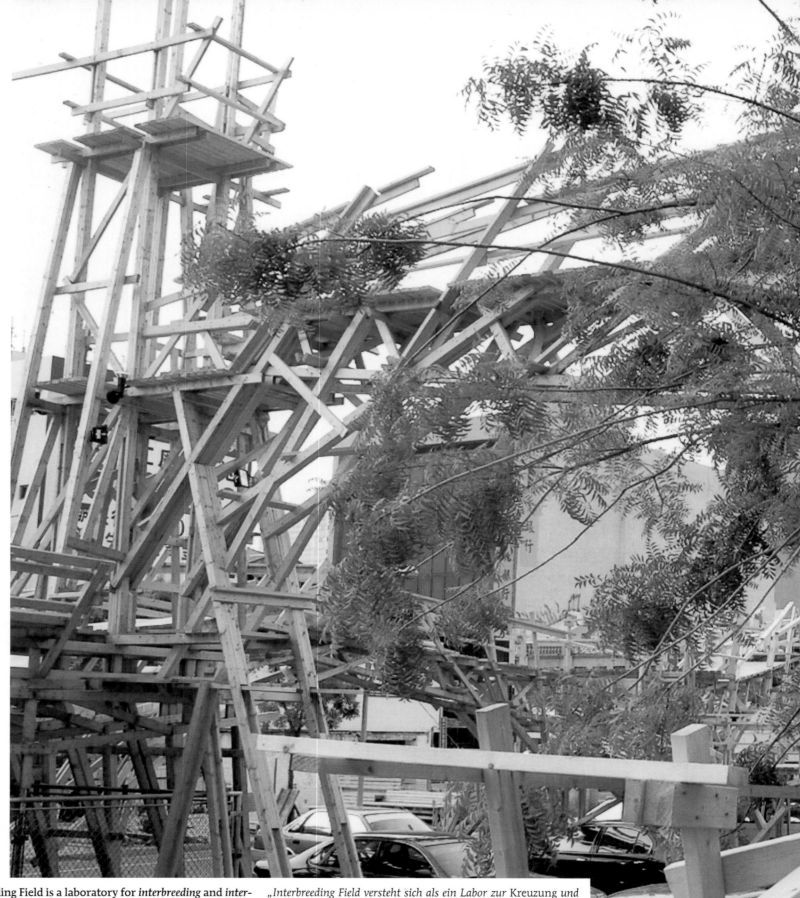

"Interbreeding Field is a laboratory for *interbreeding* and *interfering*. Regular features of various cities in Taiwan are the illegal attic balconies and pigeon lofts that have been built on the top of buildings. The most spectacular are the ubiquitous glass, container-like bitternut shops."

"We are interested in the gap between the low and high architecture aesthetics that interbreed in the contemporary city."
Li H. Lu

„Interbreeding Field versteht sich als ein Labor zur Kreuzung und Einmischung. Übliche Charakteristika in verschiedenen Städten in Taiwan sind die illegalen Dachbalkone und Taubenhäuser, die auf den Häusern errichtet wurden. Die spektakulärsten sind die überall verbereiteten, containerartigen Glasbuden, in denen Bitternüsse verkauft werden."

„Wir interessieren uns für die ästhetische Kluft zwischen offiziell geplanter Architektur und illegalen Konstruktionen, die sich in der zeitgenössischen Stadt mischen." Li H. Lu

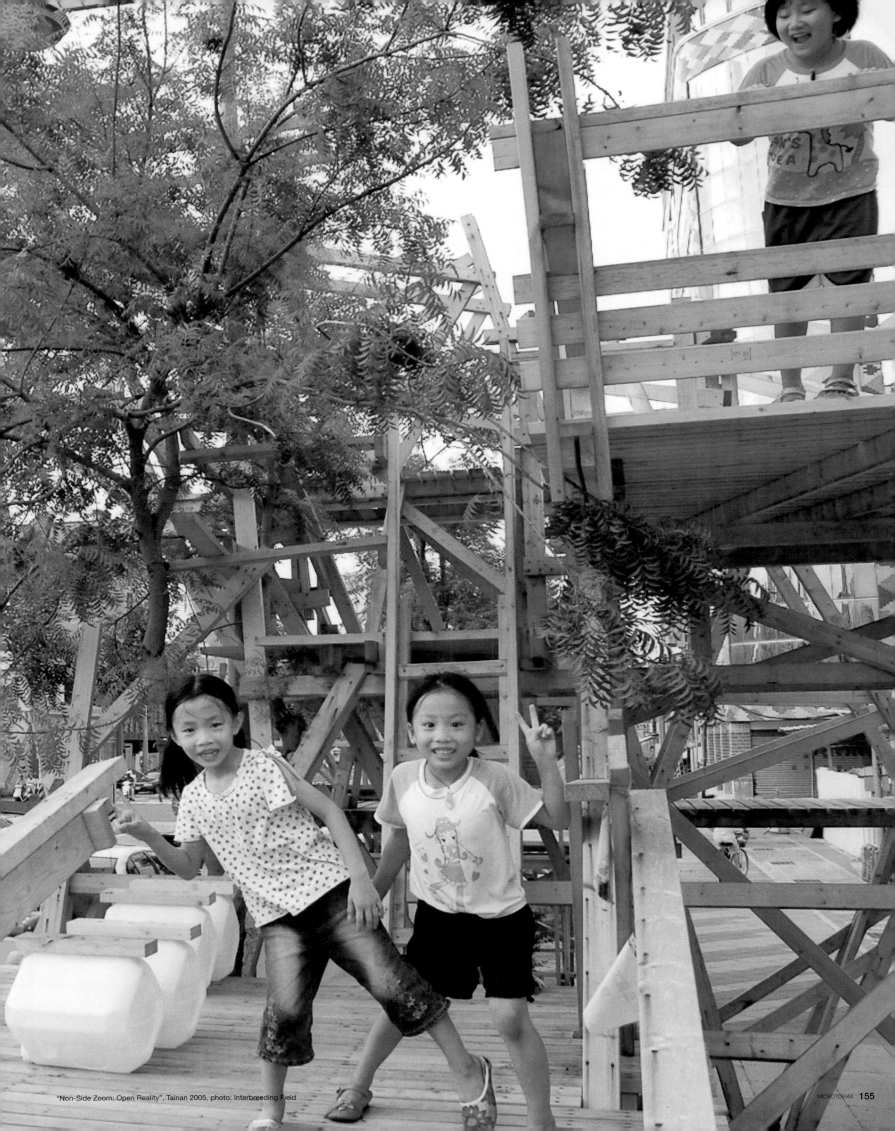

"Non-Side Zoom: Open Reality", Tainan 2005, photo: Interbreeding Field

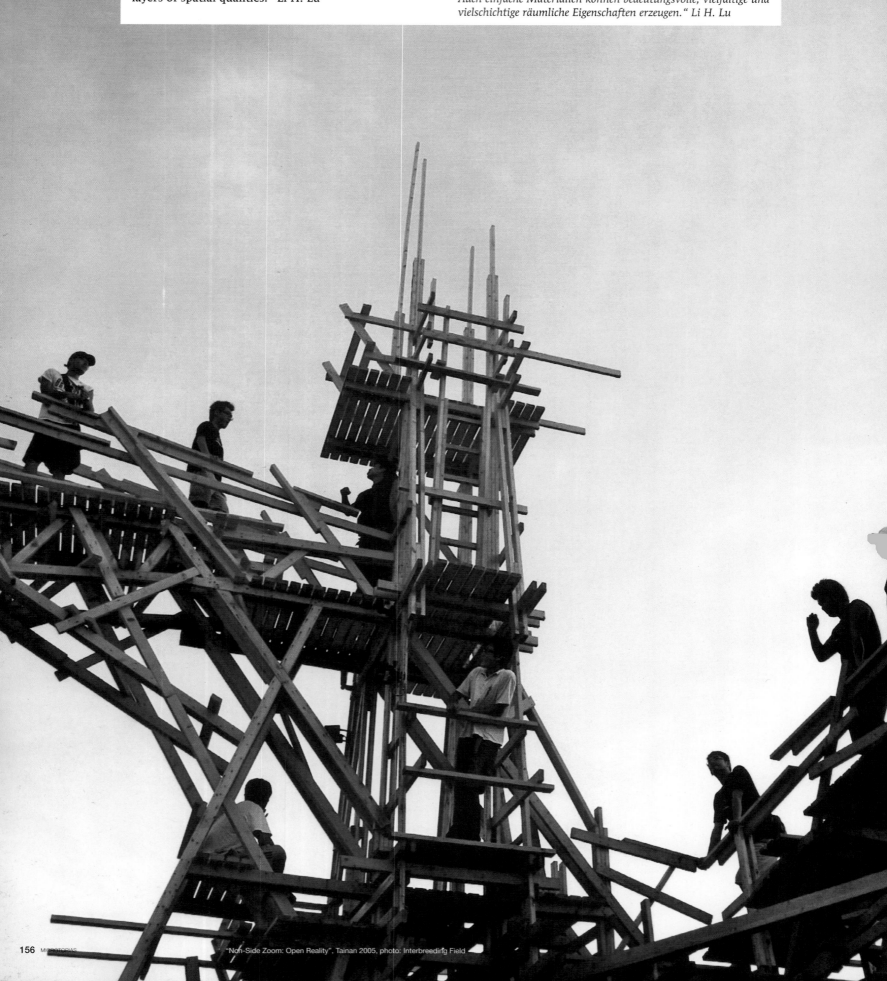

"Interbreeding Field's aim is to reflect the phenomena that exist in our daily lives. To reach this point it is necessary to interfere in the process of placing a settler into a new environment, or transfer a certain environment into a subordinated one within our created field. We use mass-produced industrial materials to explore the dignity of object value. Simple materials can also reveal rich and multiple layers of spatial qualities." Li H. Lu

„Interbreeding Field hat sich zum Ziel gesetzt, die Phänomene unseres Alltags zu reflektieren. Um diesen Punkt zu erreichen, ist es notwendig, sich in den Vorgang der Ansiedlung eines Menschen in einer neuen Umgebung einzumischen oder eine bestehende Umgebung in ein Umfeld zu verwandeln, das sich unserem neu geschaffenen Feld unterordnet. Wir verwenden industrielle Baustoffe und -teile, um die Würde und den Wert dieser Dinge zu untersuchen. Auch einfache Materialien können bedeutungsvolle, vielfältige und vielschichtige räumliche Eigenschaften erzeugen." Li H. Lu

"Non-Side Zoom: Open Reality", Tainan 2005, photo: Interbreeding Field

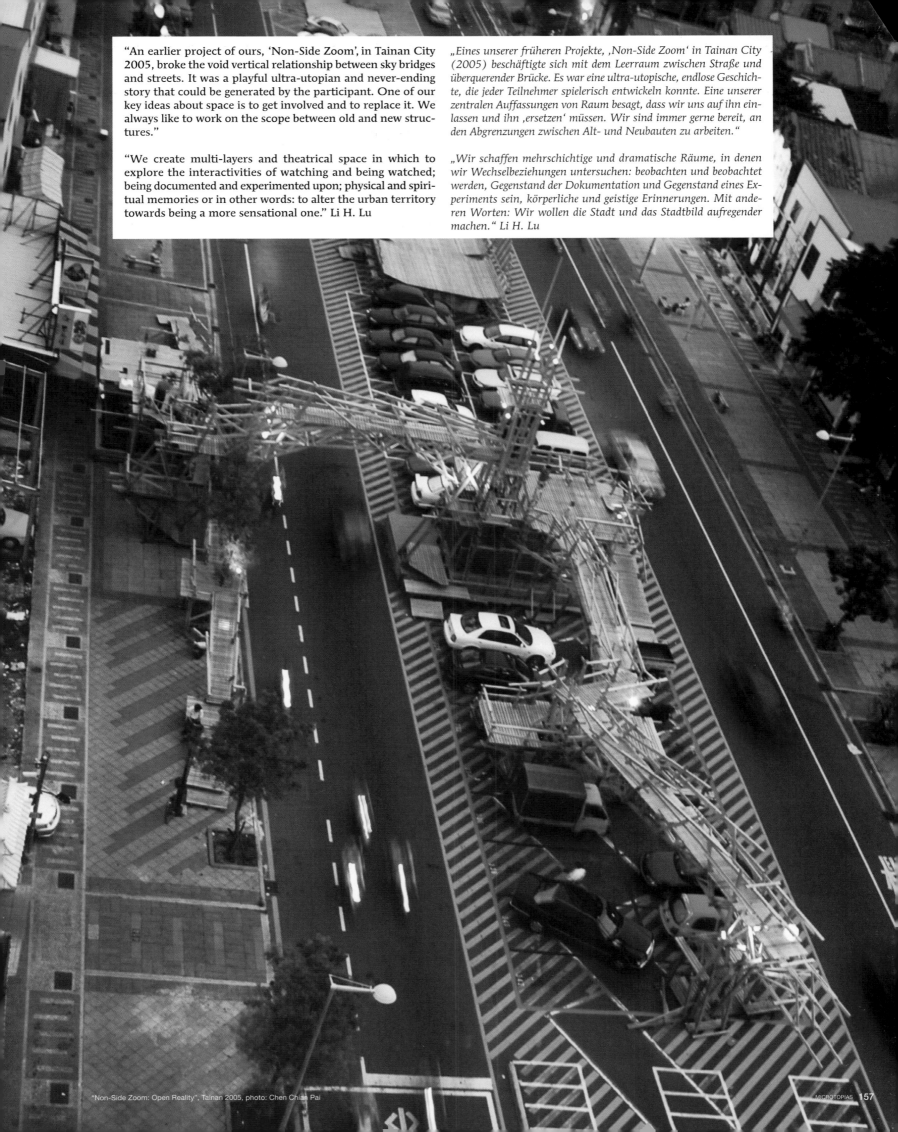

"An earlier project of ours, 'Non-Side Zoom', in Tainan City 2005, broke the void vertical relationship between sky bridges and streets. It was a playful ultra-utopian and never-ending story that could be generated by the participant. One of our key ideas about space is to get involved and to replace it. We always like to work on the scope between old and new structures."

"We create multi-layers and theatrical space in which to explore the interactivities of watching and being watched; being documented and experimented upon; physical and spiritual memories or in other words: to alter the urban territory towards being a more sensational one." Li H. Lu

„Eines unserer früheren Projekte, ‚Non-Side Zoom' in Tainan City (2005) beschäftigte sich mit dem Leerraum zwischen Straße und überquerender Brücke. Es war eine ultra-utopische, endlose Geschichte, die jeder Teilnehmer spielerisch entwickeln konnte. Eine unserer zentralen Auffassungen von Raum besagt, dass wir uns auf ihn einlassen und ihn ‚ersetzen' müssen. Wir sind immer gerne bereit, an den Abgrenzungen zwischen Alt- und Neubauten zu arbeiten."

„Wir schaffen mehrschichtige und dramatische Räume, in denen wir Wechselbeziehungen untersuchen: beobachten und beobachtet werden, Gegenstand der Dokumentation und Gegenstand eines Experiments sein, körperliche und geistige Erinnerungen. Mit anderen Worten: Wir wollen die Stadt und das Stadtbild aufregender machen." Li H. Lu

"Non-Side Zoom: Open Reality", Tainan 2005, photo: Chen Chian Pai

Derelict

Verwaist Dan Pitera and his team at the Detroit Collaborative Design Center (DCDC) provide architectural and design services for community organisations and non-profit organisations. Their Firebreak project in Detroit involved reanimating and engaging some of the many burnt-out abandoned buildings on the city's periphery in temporary actions involving the local community. Here Pitera discusses with two other team members, Jana Cephas and Margot Lystra, the nature of dereliction in Detroit and their interventions there. Dan Pitera und sein Team (im Gespräch hier: Jana Cephas und Margot Lystra) vom Detroit Collaborative Design Center (DCDC) bieten Planungs- und Entwurfsleistungen für kommunale Institutionen und gemeinnützige Organisationen an. Mit ihrem Projekt „Firebreak" belebten und erneuerten sie unter Bürger- und Anwohnerbeteiligung viele ausgebrannte und leer stehende Gebäude in der Peripherie von Detroit.

<u>Dan Pitera:</u> We are at the end of the industrial period: places like Detroit, Cleveland, Pittsburgh, St. Louis, in the United States, must re-invent themselves. The physical space of these cities, the gaps, becomes the visual symptom, [indicating] that change must occur. Let's start thinking of density beyond structures and people, about density of landscape, density of activities. As designers we often only focus on that one aspect of density in urbanism, but we will have to expand our thoughts about the urban environment. Can the decay be a strategy for development? Can shrinking be development?

Emptiness provides opportunity and actually begins to be the culture of the people, as they begin to co-opt that space in another way. In the cities like Detroit, the gaps have become the dominant space.

<u>Dan Pitera:</u> *Wir leben im ausgehenden Industriezeitalter. Städte in den USA wie Detroit, Cleveland, Pittsburgh und St. Louis müssen sich neu erfinden. Die sichtbaren Räume und Orte, die Lücken in diesen Städten werden zu visuellen Symptomen, [die darauf hinweisen] dass eine Veränderung stattfinden muss. Beginnen wir also, an Verdichtung jenseits von Gebäuden und Bevölkerungsdichte zu denken, an Verdichtung von Landschaft, Verdichtung von Aktivi-*

täten. Als Architekten beschäftigen wir uns häufig nur mit dem einen, stadtplanerischen Aspekt von Stadtverdichtung, wir müssen aber lernen, darüber hinauszudenken. Kann Verfall zur Entwicklungsstrategie werden? Kann Schrumpfen ein Entwicklungsprozess sein?

Leere bietet Möglichkeiten und gehört inzwischen zur Alltagskultur der Menschen, die sich die leeren Räume auf neue Weise zu Eigen machen. In Städten wie

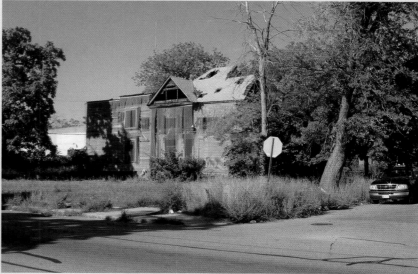

Margot Lystra: It's emptier [in the suburbs] than a lot of the spaces in the city because it is literally paved, like the enormous parking lots that are planned into suburban spaces, whereas in the city the emptiness is filled much more with the opportunistic life of plant species, animal species, and human beings who are using those spaces in much richer ways than what occurs in the more accepted, more structured suburban design.

DP: The basis of our work is always to look at the spaces that are often not seen as a space of development or the space of capitalism. And then it is finding ways to interact, animate and interpret them with. In this process it is absolutely necessary do to that through a group of people who are not all designers.

ML: In the time of "Firebreak", we were filling these spaces with all this life, but it's not applied, it's life that's already surrounding those houses: our activity just catalyses and brings it together for a period of time. That is the idea of what we call the *generative moment* – and it's such an alternate vision of what a full space is. It's very much an alternative to a more structured, more capital-based, more market-driven occupation of those spaces.

DP: Through the "Firebreak" project, the city has come by and has taken down these houses. But we don't see that as negative – we see our acts as very temporal. It is not about the houses, it is about people coming together, and so it has generated sometimes very surprising outcomes.

Our projects certainly change the perspective of looking at destroyed houses: If you walk through a forest you will find a dead tree, you find the foliage. That is part of the regenerative act of growth and of the building of a forest. I see the antithesis of that happening in cities that are trying to re-develop from shrinking populations. They're essentially creating Disneyland, removing all the death around them. As long as the burned house just stands there, the people who walk by look at it with wonder, but not in the sense of a place to be, a place to inhabit, and all of a sudden now, through our activities, that space is seen very differently, through someone engaging with it on a very small scale.

Jana Cephas: All these houses simply indicate change ... and our society really resists that a lot. We're so focused on creating this illusion of permanence. In Detroit there is this idea that there is this intentional destruction that's really negative, when in reality a lot of the emptiness and the decaying is just in the process of industrialism, and what's happening in its dying moments. Through outsourcing and the globalisation of jobs we see the dying of industrialism on a larger scale, but I feel like the burnt houses are that same thing on a much finer grain, neighbourhood scale.

ML: Industrial growth is not just an insistence that things have to be permanent but even that they have to keep growing. But spaces and houses, whole cities live in a cycle of building up, and dying back and as designers we have to start to work with that.

DP: What we do as architects and designers is entirely nomadic, because we want to put ourselves out of business. If there is anything to take away from the "Firebreak" project, it is the activity of analysing, looking, and understanding the context in which we are operating, and then operate within that context. Then we move to another location. Constantly moving and changing your context to re-think the urban context you work in.

Detroit sind Brachen inzwischen die vorherrschende Form von städtischem Raum.

ML: Das Gebiet [der Vorstädte] ist leerer als viele Stadtlagen, weil alles buchstäblich gepflastert und versiegelt ist – wie die riesigen Parkplätze in Randlagen – während leere Räume in der Stadt viel eher opportunistisch genutzt werden, sei es von Spontanvegetation, Tieren und Menschen; die Möglichkeiten sind einfach vielfältiger als in den ordentlicheren, beliebteren Vororten.

DP: In unserer Arbeit nähern wir uns ganz grundsätzlich den Orten an, die nicht als viel versprechende Stadtentwicklungsflächen oder Orte für das Kapital gelten. Dann müssen wir Möglichkeiten finden, sie zu beleben, neu zu interpretieren und umzugestalten. Dabei ist es essenziell, das mit einer Gruppe von Leuten zu tun, die nicht alle Architekten sind.

ML: Als wir am Projekt „Firebreak" arbeiteten, füllten wir all diese Räume mit neuem Leben, und zwar nicht mit Aktivitäten, die wir von außen einführten, sondern mit solchen, die eigentlich schon im Umkreis der leer stehenden Häuser vorhanden waren. Unsere Initiative hat sie nur für eine bestimmte Zeit hier versammelt. Das nennen wir das erzeugende Moment. Das bedeutet eine ganz andere Auffassung von städtischer Dichte, von einem ausgefüllten Raum – eine Alternative zu den normalen, stärker strukturierten, vor allem auf Kapital basierenden und marktorientierten Nutzungen solcher Räume.

DP: „Firebreak" führte dazu, dass die Stadt sich besann und die Häuser abreißen ließ. Wir sehen das nicht als negativ; unsere Aktionen sind zeitlich immer sehr begrenzt. Es geht nicht so sehr um die Häuser, sondern darum, dass die Menschen sich zusammentun, was manchmal zu ganz überraschenden Ergebnissen führt. Unsere Projekte verändern tatsächlich die Sicht auf diese zerstörten Häuser. Wenn man durch einen Wald geht, sieht man Blattwerk, aber auch tote Bäume. Beides gehört zum regenerativen Wachsen eines Waldes. Den entgegengesetzten Vorgang beobachte ich in den Städten, die aufgrund schrumpfender Bevölkerungszahlen versuchen, auf andere Art zu wachsen. Im Wesentlichen schaffen sie eine Art Disneyland, indem sie alles Abgestorbene entfernen. So lange die ausgebrannten Häuser einfach nur so da stehen, werden die Passanten sie staunend anschauen, allerdings nicht als Orte wahrnehmen, in denen sie sich aufhalten und leben möchten. Durch unsere Eingriffe – dadurch, dass sich jemand ein bisschen um sie gekümmert hat – werden sie nun plötzlich ganz anders gesehen.

JC: Alle diese Häuser sind schlicht Anzeichen für Veränderung ... und die meisten Leute haben eben etwas gegen Veränderung. Allgemein konzentrieren wir uns zu sehr darauf, die Illusion von Beständigkeit zu erzeugen. In Detroit herrscht die Meinung, das gezielte Zerstörung etwas Negatives ist – in der Realität sind Leere und Verfall jedoch ein Teil des Prozesses der Industrialisierung und dessen, was passiert im Moment des Vergehens. Infolge Ausgliederung und Globalisierung von Arbeitsplätzen erleben wir das Industriesterben zwar in größerem Maßstab, für mich sind aber die ausgebrannten Häuser das Gleiche in einem sehr viel feineren Maßstab, im Nachbarschaftsumfeld.

ML: Industrielle Entwicklung bedeutet nicht nur das Festhalten am Streben nach Dauerhaftigkeit und permanentem Wachstum. Räume und Flächen, Häuser und auch ganze Städte sind alle dem Kreislauf des „Werdens und Vergehens" unterworfen und als Architekten müssen wir anfangen, mit diesem Kreislauf zu arbeiten.

DP: Was wir als Architekten und Planer tun, ist „nomadenhaft", denn wir wollen uns selbst arbeitslos machen. Wenn wir etwas aus „Firebreak" gelernt haben, dann die Fähigkeit, das Umfeld, in dem wir uns bewegen, zu analysieren und zu verstehen und daran zu arbeiten. Danach ziehen wir weiter. Man muss den Kontext ständig wechseln, um für das städtische Umfeld, in dem man arbeitet, neue Ideen entwickeln zu können.

"There is a kind of complexity
that comes from taking an
otherwise completely normal,
conventional, albeit
anonymous situation and
redefining it, retranslating
it into overlapping and
multiple readings of
conditions past and present."
Gordon Matta-Clark, 1977

„Es gibt eine Form von Komplexität, die dadurch
entsteht, dass man sich eine ansonsten völlig
normale, konventionelle, wenn auch anonyme Situation
vornimmt und sie neu definiert, sie neu übersetzt in
überlappende und vielfältige Deutungen von Zuständen
der Vergangenheit und Gegenwart."

[↖] Film still from Gordon Matta-Clark's "Splitting" 1974, courtesy Galerie Thomas Schulte, Berlin,
photo: © VG Bild-Kunst, Bonn 2006

[↑] Gordon Matta-Clark: "Splitting" 1974, courtesy Galerie Thomas Schulte, Berlin,
photo collage © VG Bild-Kunst, Bonn 2006

Home Made in Alabama

Rural Studio, an architecture module within the School of Architecture at Auburn University, has designed and built more than one hundred and fifty community projects and charity homes in Alabama and educated more than four hundred architecture students. The Rural Studio founder Samuel Mockbee (1944–2001) was convinced that architects have an obligation to criticise the status quo in order to bring about structural changes, alter environment policy and initiate social changes. Their extraordinary buildings employ some of the cheapest leftover and recycled materials, illustrating the many possibilities of low-cost housing for poor rural areas, and highlighting the particular qualities of self-built structures. Rural Studio, eine Abteilung der Architekturfakultuät der Auburn University, hat über einhundertfünfzig Nachbarschaftszentren und Heime für sozial Schwache im Westen Alabamas entworfen und gebaut sowie mehr als vierhundert Architekturstudenten ausgebildet. Der Gründer des Rural Studio Samuel Mockbee (1944–2001) war der Überzeugung, dass Architekten dazu verpflichtet sind, den Status quo zu kritisieren, um Strukturveränderungen, umweltfreundliche Gesetze und gesellschaftlichen Wandel zu initiieren und durchzusetzen. Ihre außergewöhnlichen Bauten bestehen zum Teil aus billigsten Rest- und Altstoffen. Sie belegen, dass es viele Möglichkeiten gibt, für wenig Geld Wohnraum in armen ländlichen Gegenden zu schaffen, und beleuchten die besonderen Qualitäten von Häusern, die von den Besitzern selbst gebaut wurden.

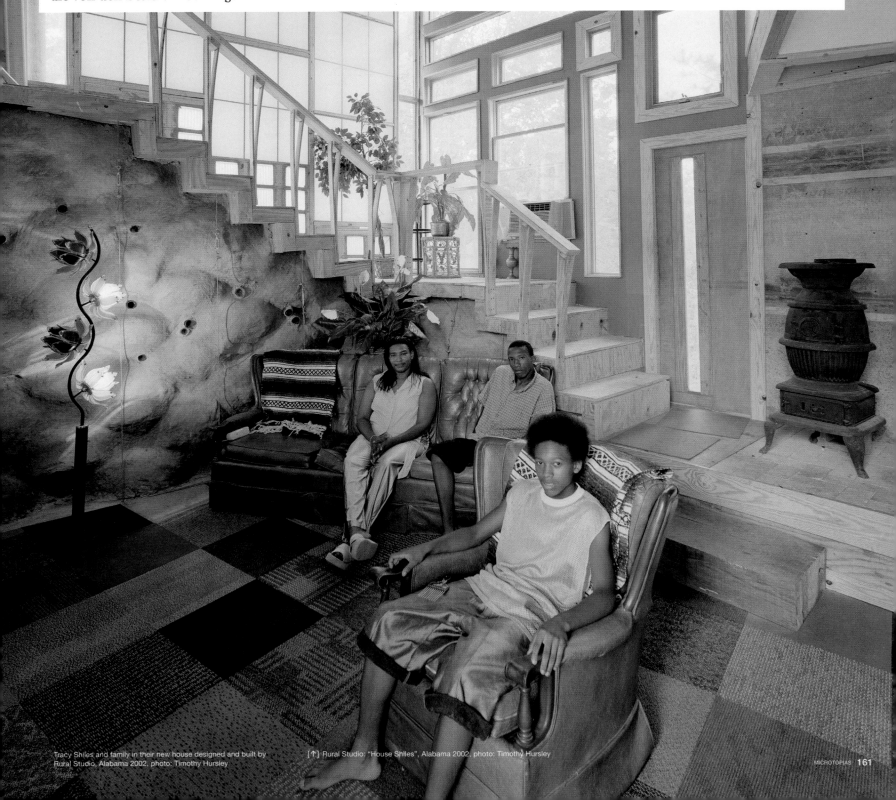

Tracy Shiles and family in their new house designed and built by Rural Studio, Alabama 2002, photo: Timothy Hursley

[↑] Rural Studio: "House Shiles", Alabama 2002, photo: Timothy Hursley

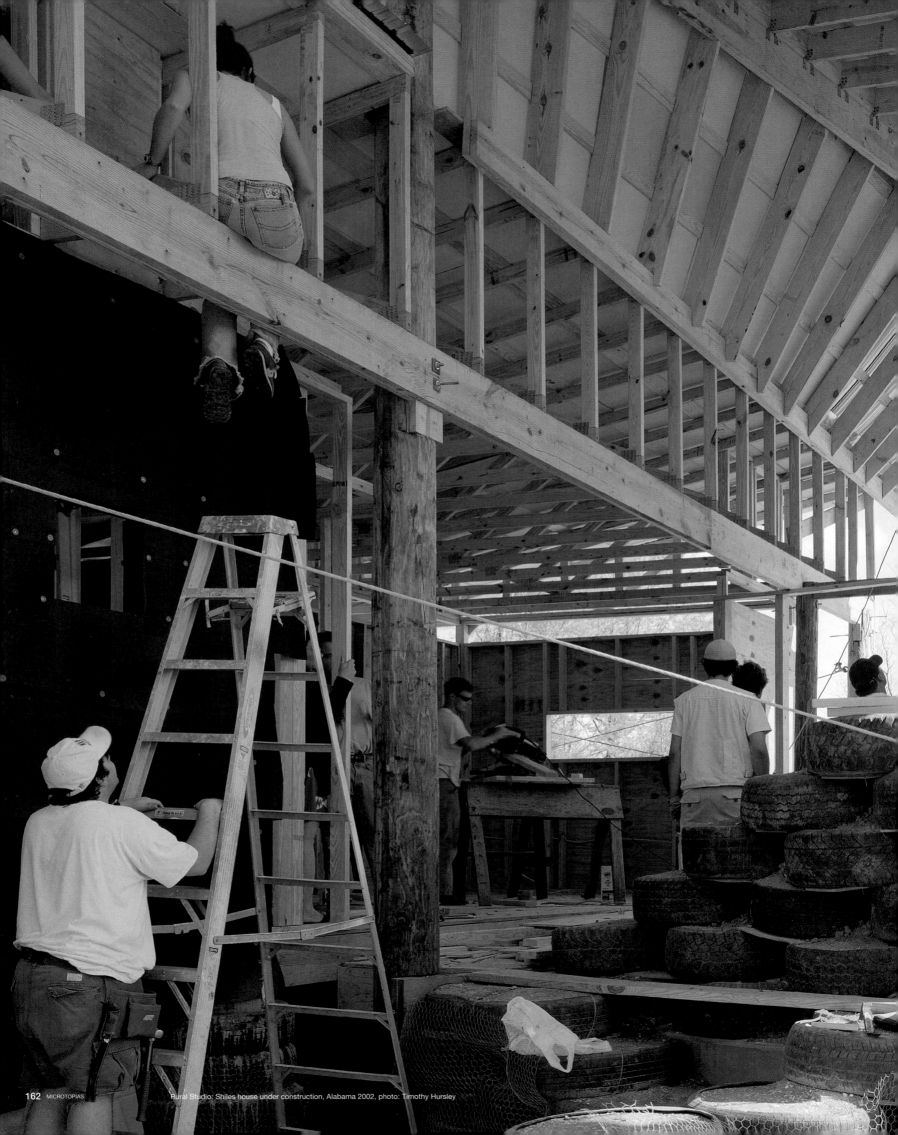

Rural Studio: Shiles house under construction, Alabama 2002, photo: Timothy Hursley

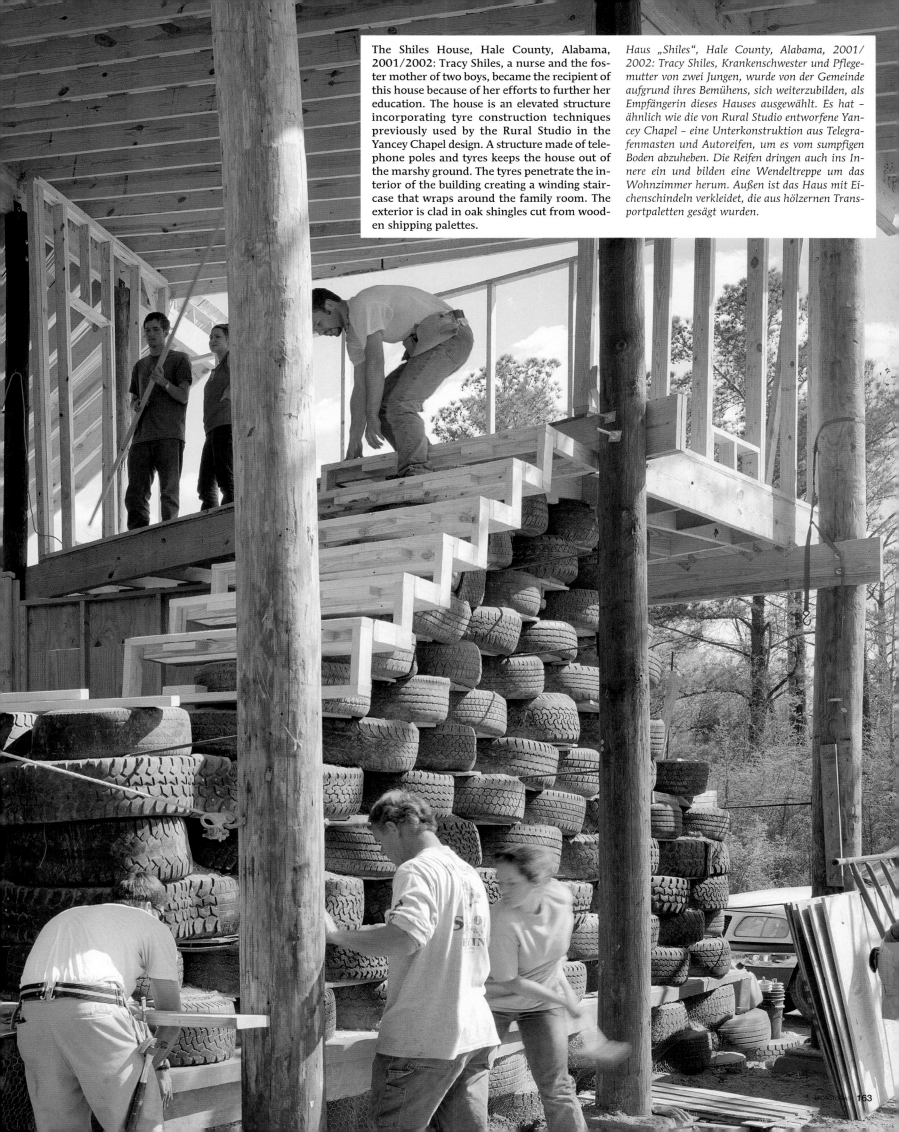

The Shiles House, Hale County, Alabama, 2001/2002: Tracy Shiles, a nurse and the foster mother of two boys, became the recipient of this house because of her efforts to further her education. The house is an elevated structure incorporating tyre construction techniques previously used by the Rural Studio in the Yancey Chapel design. A structure made of telephone poles and tyres keeps the house out of the marshy ground. The tyres penetrate the interior of the building creating a winding staircase that wraps around the family room. The exterior is clad in oak shingles cut from wooden shipping palettes.

Haus „Shiles", Hale County, Alabama, 2001/ 2002: Tracy Shiles, Krankenschwester und Pflegemutter von zwei Jungen, wurde von der Gemeinde aufgrund ihres Bemühens, sich weiterzubilden, als Empfängerin dieses Hauses ausgewählt. Es hat – ähnlich wie die von Rural Studio entworfene Yancey Chapel – eine Unterkonstruktion aus Telegrafenmasten und Autoreifen, um es vom sumpfigen Boden abzuheben. Die Reifen dringen auch ins Innere ein und bilden eine Wendeltreppe um das Wohnzimmer herum. Außen ist das Haus mit Eichenschindeln verkleidet, die aus hölzernen Transportpaletten gesägt wurden.

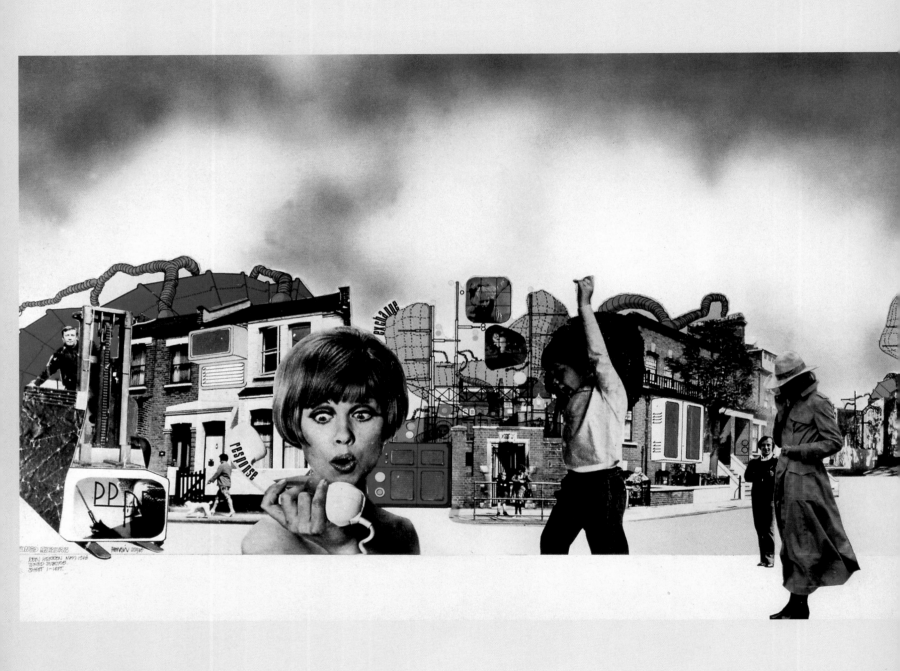

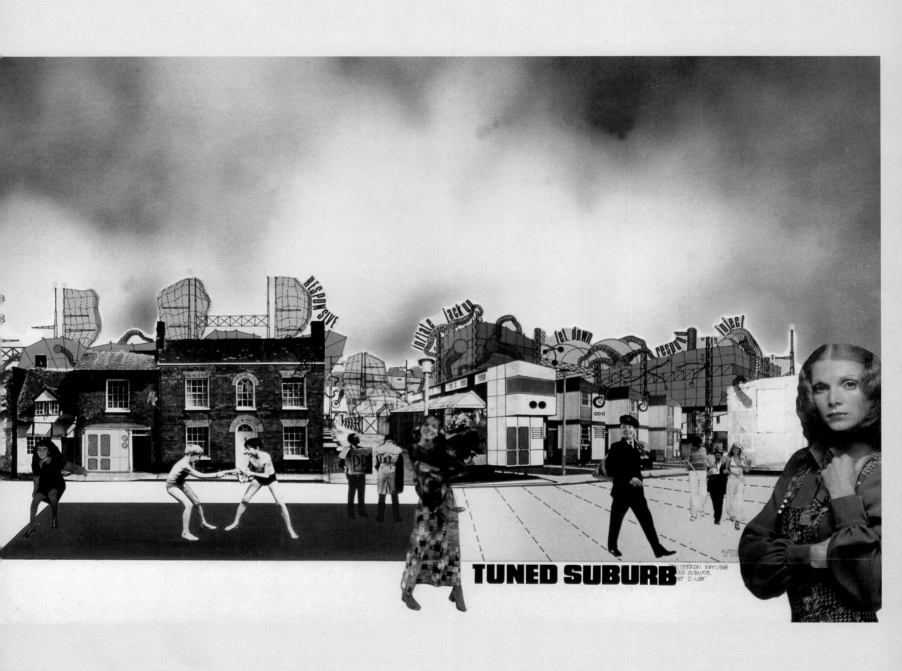

Archigram, "Tuned Suburb", 1968, collage: Ron Herron © Ron Herron Archives, London

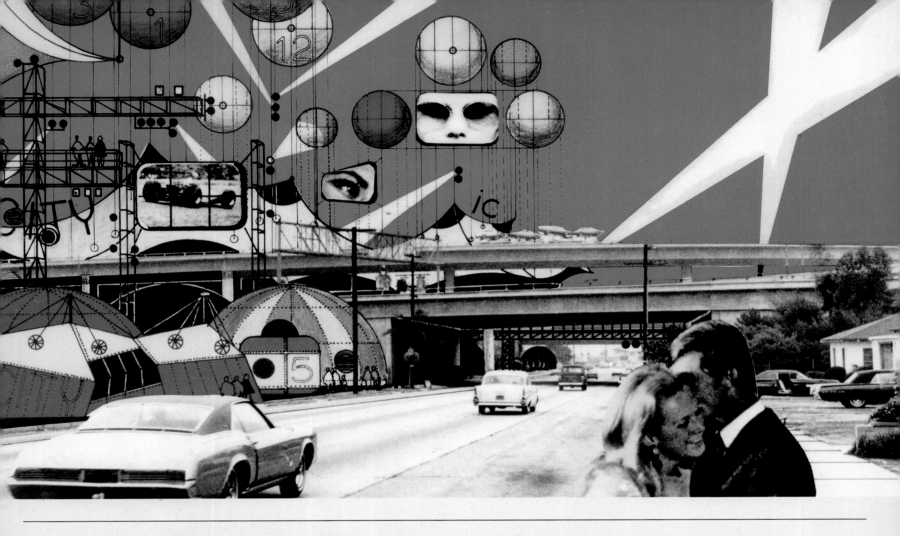

Guerilla Architecture

Guerilla-Architektur Dr. Simon Sadler researches experimental and radical architecture since World War II. Here he asks in what ways, if at all, architects have moved on from their 20th century inheritance and whether our future dwells with the itinerant. Dr. Simon Sadler beschäftigt sich mit experimenteller und radikaler Architektur nach dem Zweiten Weltkrieg. Im Folgenden stellt er die Frage, wie sich die Architekten, wenn überhaupt, von ihrem Erbe des 20. Jahrhunderts befreien konnten und ob unsere Zukunft im Unsteten verweilen wird.

After some two centuries of industrial modernity in the West, architects can approach the detritus of industrialisation much as architects once picked their way in and around classicism. As with the classical heritage, modernity is subject to nostalgia, reverence, anthropology and recovery, and architects who choose to meet the legacy enjoy a much more interesting postmodern condition than that announced thirty years ago, when modernist structures were often merely re-articulated with historicist devices. Architects choosing to sympathetically address industrial modernity through contemporary architecture acknowledge that we are still modern – more so than ever perhaps, still inclined to believe that architecture can continually reassess design problems rather than defer to past precedent – *and* they attend to the fact that architecture has never been truly modern, such that it might relate to circum-

stance, built-on-the-fly, dedicated single-mindedly to emancipation.

The spiritual ancestors of this ambiguous response to past modernities (and subject to renewed scrutiny in schools of architecture during the past decade) were the neo-avant-gardes of the 1960s – the likes of Team 10, the Situationist International, Archigram, Utopie, Coop Himmelb(l)au, Haus-Rucker-Co, Archizoom and Superstudio. Seeking the authority of the early moderns, and then attempting to align it with new wave politics hailing from anarchism and neo-Marxism at one end, free-market libertarianism at the other, the neo-avant-gardes of the 1960s intended to overturn a seemingly hegemonic, "orthodox" modernism. The neo-avant-gardes joined the pioneer avant-gardes at one of the two poles between which modernism has historically oscillated. The first avant-gardes of the early 20th century, such

Nach rund zwei Jahrhunderten industrieller Modernität können sich Architekten in der westlichen Welt den Überresten des Industriezeitalters annähern - ähnlich wie ihre Kollegen in früheren Zeiten der klassischen Antike. Genau wie das klassische Architekturerbe ist auch die Moderne Gegenstand nostalgischer Emotionen, ehrfürchtiger Bewunderung, anthropologischer Studien und denkmalpflegerischer Erhaltung. Architekten, die sich dieses Erbes annehmen, beziehen eine sehr viel interessantere postmoderne Position als noch vor dreißig Jahren ihre Kollegen, die moderne Bauten häufig nur mit historisierenden Mitteln nachempfanden. Wenn Architekten heute die Industriebauten der frühen Moderne wohlwollend und mit den Mitteln der zeitgenössischen Architektur behandeln, dann erkennen sie an, dass wir immer noch modern sind - vielleicht sogar mehr denn je, da wir immer noch zu glauben bereit sind, Architektur könne auf gänzlich neue Weise Designprobleme lösen statt auf Präzedenzfälle

zurückzugreifen. Sie berücksichtigen damit gleichzeitig die Tatsache, dass Architektur noch nie wirklich modern, das heißt bezogen auf die gerade herrschenden Verhältnisse, frei von allen historischen Einflüssen, allein der Emanzipation verpflichtet gewesen ist.

Die geistigen Vorfahren der aktuellen ehrgeizigen Reaktion auf historische Modernitäten (die in den letzten zehn Jahren auch an Architekturfakultäten zunehmend untersucht wurden) waren die neuen Architektur-Avantgardisten der 1960er Jahre - vertreten durch Gruppen wie Team 10, die Internationalen Situationisten, Archigram, Utopie, Coop Himmelb(l)au, Haus-Rucker-Co, Archizoom oder Superstudio. Sie strebten nach der Autorität der frühen Moderne und versuchten dann, sie mit der aus Anarchismus und Neo-Marxismus am einen und der individuellen Freiheit des freien Marktes am anderen Pol entstandenen „neuen Welle" auf eine Linie zu bringen. Die Neo-Avantgarde-Gruppen der 1960er Jahre

[↑] Archigram, "Instant City: Santa Monica and San Diego Freeway", 1969, collage: Ron Herron © Ron Herron Archives, London

as the Futurists and the Expressionists, aimed to amplify the energy of industrial modernity, and to express it through dynamic, irregular form; later avantgardes, archetypically that of the Bauhaus, preferred to temper modernism, aesthetically and ideologically, with regular forms emblematic of social rationality and directed technological development. This latter view was the one that prevailed from the 1920s to the 1960s, and is held up in history as the modernism that evacuated the urban of all spirituality. Into this, the neo-avant-gardes promised, a more permissive everyday life will one day re-erupt.

Architecture since the seventies atones for the sins of a couple of generations long since retired or dead.

With the passing of time this version of history is going to require revision. Four decades span the 1920s to the 60s, a substantial part of which was taken up by totalitarianism and its defeat, so that only the period from the late 1940s to the 60s can be held up as driven by modernist purism. Architecture since the 1970s thus atones for the sins of a couple of generations long since retired, or dead. Yet it remains reticent about matters of economy, even though it was the interactions between architecture and economy that gave us the archeology of modernity: slab blocks, urban freeways, bleak plazas, shopping centres and industrial estates were shaped in the offices of architect-planners, and underwritten through compromises with a mixed economy or outright capitalist accumulation.

Our understanding of the relationship between architectural culture and the economy hangs where it was left by Manfredo Tafuri in the early 1970s.

Indeed, while the last thirty years of architectural theory have witnessed strides forward in the understanding of architecture's role within culture and psyche, and while neo-avant-gardism has added the immaterial (light, sound, events, multimedia) to the palette of modern architecture, our understanding of the relationship between architectural culture and the economy hangs pretty much where it was left by Manfredo Tafuri in the early 1970s. Tafuri reissued Marx's memorandum that cultural superstructures (like architecture) cannot revolutionise the capitalist structure that supports them and all other cultural forms. And thus the physical-political strategies of the

new generation of itinerant architectures (flexible, adaptive, mobile and temporary) appear essentially as they

Find an opportunity in the economy, a crevice in the occupation of space or in time, and lock on like a limpet until washed aside by the market.

did in the 1960s: find an opportunity in the economy, a low-cost building fabric, a crevice in the occupation of space or (just as important) in time, and lock on like a limpet until washed aside by the market. Such, for instance, is the process of neighbourhood gentrification, from the initial opening of the gap (probably occupied by the artist's studio) to the opening of a Gap. One might even posit that the interconnected phenomena of post-industrial redevelopment, deregulation, privatisation, the retreat of the state and the rise of neoliberalism have afforded neo-avant-garde architecture with more opportunities than ever. Its quality as a free-floating signifier – a Trojan horse for anarchy, or a nimble command centre for redevelopment? – renders it as enigmatic today as it was in the 1960s.

Perhaps though it does not matter too much how architects account for their discipline within the political economy, because responsibility for the social programme attached to neo-avant-garde architecture is not solely that of the architect (architects must surely wish they had that degree of power). It is primarily that of its observers and potential users; it is to be decided by the *zoon politikon*. We live within a political economy, and almost all architecture requires chunks of our capital. It also needs space, which is subject, virtually relentlessly, to claims of ownership and jurisdiction. If the potential occupants of itinerant architecture decline the legitimisation of capital and regulation they may find themselves, far from occupying space, constantly on the run and as such denied their full rights to life and liberty, or more straightforwardly, schools and services. This at least has been the experience of Europe's Gypsies. The discourses around itinerant architecture as a spatial technology tend then to emphasise potential rather than programme, and typical of spatial technologies, itinerant architecture can be used to reproduce space as well as destabilise it.

The potential seen most clearly in the latest generation of itinerant architectures is the opposite of what one might expect from this, the most radical sub-species of building: it is restorative, stitching together spaces torn by insensitive projects, and planting seeds of occupation in land left as waste. And quite different perhaps to the escapism conventionally associated with itinerant architecture, it appears to stand vigil

wollten die Hegemonie der „orthodoxen Moderne" aufheben und schlossen sich den Pionieren dieser neuen Avantgarde an einem der beiden Pole an, zwischen denen die Moderne von Anfang an hin und her pendelte. Die ersten Avantgarde-Gruppen des frühen 20. Jahrhunderts, wie etwa die Futuristen und Expressionisten, wollten die Kräfte der Industrialisierung für die Modernisierung des Bauens mobilisieren und Modernität in dynamischen, unregelmäßigen Formen ausdrücken. Spätere Strömungen (archetypisch vertreten durch das Bauhaus) zogen eine stilistisch und ideologisch gemäßigte Moderne den regelmäßigen Formen vor. Sie stand für das gesellschaftlich Vernünftige ein und bestimmte die technische Entwicklung. Diese Auffassung herrschte von den 1920er bis in die 1960er Jahre vor und steht inzwischen in der Architekturgeschichte als die Art von Moderne, welche die Stadt jeglicher Spiritualität beraubte. Dem gegenüber versprachen die Neo-Avantgardisten, eines Tages werde sich ein freizügigeres Alltagsleben wieder durchsetzen.

Nun sind einige Jahre verstrichen und diese Version der Geschichte muss revidiert werden. Die vier Jahrzehnte zwischen 1920 und 1960 waren zu einem erheblichen Anteil von Totalitarismus und Krieg geprägt, so dass nur die Zeit nach 1945 als die von modernem Purismus geprägte Bauperiode gelten kann. Die seit den 1970er Jahren entstandene Architektur muss also die Bausünden mehrerer Generationen von Architekten sühnen, die inzwischen im Ruhestand oder tot sind. Die Zurückhaltung gegenüber wirtschaftlichen Aspekten aber ist geblieben, obwohl doch gerade das Zusammenwirken von Bauen und Wirtschaft diese „archäologischen Stätten der Moderne" hervorgebracht hat. In den Architektur- und Stadtplanungsbüros entstanden Gebäuderiegel, Stadtautobahnen, triste Plätze, Einkaufszentren und Gewerbegebiete, die durch Kompromisse mit dem öffentlich-privatwirtschaftlichen Sektor oder gänzlich kapitalistischer Raffgier bestätigt wurden.

In den letzten dreißig Jahren hat die Architekturtheorie im Verständnis der Rolle der Architektur für die Kultur und Psyche zwar Fortschritte verzeichnet und die Neo-Avantgarde hat die Palette der modernen Architektur durch das Immaterielle (wie Licht, Klang, Events, Multimedien) bereichert; unser Verständnis der Beziehungen zwischen Baukultur und Ökonomie ist aber ziemlich genau an dem Punkt hängen geblieben, den Manfredo Tafuri schon Anfang der 1970er erreicht hatte. Tafuri bekräftigte Karl Marx' Auffassung, dass kein „kultureller Überbau" (wie etwa die Architektur) eine Revolution der kapitalistischen Strukturen auslösen kann, auf denen sie und alle anderen Formen von Kultur fußen. Daher sehen die baulichen und baupolitischen Strategien, auf denen die neuen mobilen Baukonstruktionen (flexibel, anpassungsfähig, mobil und temporär) basieren, im Wesentlichen genauso aus wie die der 1960er Jahre: Man finde eine Marktnische, einen billigen Baustoff, ein leeres Grundstück oder Gebäude oder (ebenso wichtig) nutzungsfreie Zeit in einem Gebäude und halte an ihr fest wie eine Klette, bis der Markt einen wieder wegschwemmt. So

läuft das zum Beispiel während und nach der Gentrifizierung eines Wohnviertels – von dem Moment an, in dem sich eine Lücke – „the gap" – auftut (wahrscheinlich durch das Atelier des Künstlers besetzt) bis zur Eröffnung von The Gap. Man könnte postulieren, die wechselseitig voneinander abhängenden Phänomene – wie postindustrielle Bausanierung, Deregulierung und Privatisierung, Rückzug des Staates und aufkommender Neoliberalismus – hätten der neo-avantgardistischen Architektur mehr Möglichkeiten denn je zuvor eröffnet. Aufgrund ihrer Eigenschaft als frei schwebender Bedeutungsträger – trojanisches Pferd der Anarchie oder wendige Kommandozentrale der Sanierung? – erscheint sie heute ebenso rätselhaft wie in den 1960er Jahren.

Vielleicht ist es jedoch nicht von großer Bedeutung, wie Architekten ihre Tätigkeit im Rahmen der politischen Ökonomie bewerten, denn die Verantwortung für das mit der neo-avantgardistischen Architektur verbundene Sozialprogramm liegt nicht nur bei ihnen (die sich ein solches Ausmaß an Macht sicherlich wünschen würden). Die Verantwortung liegt vor allem bei den Beobachtern und potenziellen Nutzern, beim „zoon politikon". Wir leben in einer politischen Ökonomie und fast jedes Bauwerk verschlingt Teile unseres Kapitals. Außerdem braucht es Raum, der unweigerlich Eigentümeransprüchen und gesetzlichen Auflagen unterliegt. Wenn also die potenziellen künftigen Bewohner all dieser „itinerant architecture" (umherziehenden Architektur) deren Legitimation durch Kapital und Gesetz ablehnen, werden sie sich vielleicht – statt einen Ort dauerhaft zu besetzen – ständig auf Wanderschaft begeben müssen. So wird ihnen ihr Recht auf ein selbst bestimmtes Leben genommen und dazu noch – ganz konkret – der Zugang zu Schulen und öffentlichen Dienstleistungen verwehrt. Das erleben zumindest die europäischen Zigeuner. Der Diskurs über mobile Konstruktionen als bautechnische Raumgebilde neigt also dazu, statt des Programms eher das Potenzial zu betonen. Mobile Architektur kann aber Raum nicht nur reproduzieren, sondern auch destabilisieren.

Das Potenzial erkennt man am deutlichsten an der neuesten Generation umherziehender Architekturen: Es ist das genaue Gegenteil dessen, was man von dieser radikalsten architektonischen Unterart erwartet. Sie wirken nämlich restaurativ, indem sie von unsensiblen Bauprojekten zerrissene städtische Räume wieder zusammenflicken und auf Brachflächen die ersten Saatkörner neuer Bebauung aussäen. Im Gegensatz zu dem vielleicht üblicherweise mit dieser Architekturgattung assoziierten Eskapismus scheinen die neuen Bauprojekte dieser Art in der Architekturgeschichte eher die Wache zu halten. Modernität ist heute vielschichtig – das beweist die akademische Disziplin der Industriearchäologie – und eine neue Architektur scheint Zeit für eine spätere Neubewertung der aufgegebenen Strömungen der Moderne gewinnen zu wollen, in einer Art Hinhaltetaktik im sozialen Raumgefüge, um vermutlich später durch dauerhaftere Lösungen ersetzt zu werden. Diese könnten entweder Ereignischarakter

within history. Modernity is now layered – the academic discipline of industrial archeology proves this – and a new generation of architecture appears to buy time for abandoned modernisms such that they may yet be reappraised,

As well as acting as a technology of spatial occupation, itinerant architecture may then make the redundant built and spatial structures of modernity into objects of contemplation, and so into sources for a type of knowledge. Sitting

[↑] Haus Rucker-Co, "Yellow heart", Vienna 1968 / *Haus Rucker-Co, „Gelbes Herz", Wien 1968*, photo: © Ortner und Ortner

Itinerant architecture can be used to reproduce space as well as destabilise it.

a holding operation within social space to be later relieved, presumably, by more permanent solutions (which may be institutional as well as, or instead of, architectural – the inauguration of a festival or farmers' market, say). Itinerant architecture would *have* to be replaced in order to avoid becoming a parody of itself, another modernist archeology.

Conservationism can be conservative, and it can also be critical. To which conservationism will these architectures be co-opted? Will they curate industrial modernity much as the nineteenth-century picturesque

Stitching together spaces torn by insensitive projects and planting seeds of occupation in land left as waste.

brooded over an endangered rural life and, in turn, made nature into a luxury consumer product? The choicest of modern cities (Paris, New York, Los Angeles) have already been pickled and glazed with exemplary urban design for a white-collar clientele. For this clientele, itinerant architecture can be an addition to the arsenal of technologies for urbane micro-events. The sensible bets should be placed on this clientele picking up on itinerant architecture as a complement to premium small cars, mobile phones, BlackBerrys and Starbucks. We could though, imagine low-cost architecture and event programming as an obstacle, as something inimical to the sorts of big-box architecture that converts space-time into the perpetual present of redevelopment. Itinerant architecture could then occupy the industrial past much as British anarchists in the 1990s built treehouses in woods standing in the pathways of new roads. Itinerant architecture, seemingly the scion of the neoliberal space of

Sitting in our pods surveying the Ruhr, attending jamborees in the Rust Belt.

flows, could instead become the landing-craft of the space of places, building beachheads for one of modernity's finest upshots: metropolitan community.

The market may look like a rodeo meet, but its savviest operators very definitely plan their rides.

in our pods surveying the Ruhr, attending jamborees in the Rust Belt, we might address that old triumvirate of questions: Who are we? Where have we come from? Where are we going? And to do this would, one hopes, return us collectively to the public, political realm. Indeed, it might not be such a bad thing to one day reappraise the idea of public planning itself. Scorn for words like "planning" and "utopia" followed the perceived failure of post-war architectural reformism on the one hand, sixties radicalism on the other, but that rhetorical forgetting of politics potentially gives architectural students a misapprehension of the way the world works. The market, for example, may look like a rodeo meet, but its savviest operators very definitely plan their rides. As surely as the visitor to Wal-Mart can already see the next archeology (big boxes stacked within bigger boxes and hanging on the threads of the transportation costs) we might yet want to devise a plan for how and where we wish to live. Like the evolution of critical thought and social liberalism, our plans can be modified over time aided – it would be nice to imagine – by the stealth of itinerant architecture.

That degree of responsiveness will be needed, because projects as courageous and remarkable as the ones published alongside this essay, such as the Detroit Collaborative Design Center's "Firebreak" project (page 158) and the Building Initiative's "Bonfires of Urbanity" (page 133), will I fear discover the outermost programmatic limitations of architecture. It may be in tormented cities like Belfast or Detroit, where probably every known spatial and architectural strategy will be tried, that the architectural discipline capitulates to the fact that its work is only ever one constituent in a social ecology some elements of which (I think here of sectarianism, racism, patriarchy, capitalism) are bigger and more insidious than architecture. In human history, fires are older than architecture, detrimental to urbanity, and inimical to modernity; to see them as benevolent, I wonder, is to see them formally, as generalists, as outsiders, like an architectural planning redirected at liminal spaces and materials. But then the potential critical insight of such looking must be acknowledged too, because it can draw collective attention back to political embers in a way that the assuaging effect of another out-of-town big-box never can.

haben (zum Beispiel die Einführung eines Festivals oder eines Bauernmarktes) oder architektonischer Art sein. Die umherziehende Architektur würde dann ersetzt werden müssen, um nicht zur Parodie ihrer selbst und zu einem weiteren Ausgrabungsort der modernen Archäologie zu werden.

Denkmalpflegerische Erhaltung kann konservativ sein, aber auch kritisch. In welcher Form wird man diese verschiedenen Bauten konservieren? Wird man die Industriemoderne genau so kuratieren wie die Romantiker des 19. Jahrhundert über das gefährdete ländliche Leben grübelten und die Natur zum Luxusartikel erhoben haben? Die eindrucksvollsten modernen Städte (Paris, New York, Los Angeles) wurden bereits mit beispielhaften urbanen Bauten für ein Klientel aus Angestellten eingedeckt. Für dieses Klientel könnte die umherziehende Architektur eine Ergänzung zu dem Arsenal an Technologien für raumausgleichende Interventionen und urbane Mikro-Events sein. Man kann davon ausgehen, dass die Klientele von Kleinwagen, Handys, Blackberrys und Starbucks auch die umherziehende Architektur als solches annehmen wird. Wir können uns jedoch vorstellen, dass preiswerte Architektur und „Event-Programmierung" ein Hindernisgrund sein könnte: als etwas Feindliches gegen die Art von Big-Box-Architektur, die die Raumzeit in die ewige Gegenwart der baulichen Neugestaltung umwandelt. Mobile Architektur könnte dann die industrielle Vergangenheit besetzen, ähnlich wie britische Aktivisten in den 1990er Jahren Baumhäuser in Wäldern bauten, die neuen Straßen im Wege standen. Mobile Architektur – scheinbar der Ableger des neo-liberalen „Raums der Flüsse" (space of flows) – könnte stattdessen zum „Raum der Verortung" (space of places) – werden und somit die Entstehung eines der erstrebenswertesten Ziele der modernen Zeit begründen: einer metropolitanen Gesellschaft.

Die „umherziehende Architektur" fungiert nicht nur als eine Technologie der Raumbesetzung, sondern macht unter Umständen redundante Raumstrukturen der Moderne zum Gegenstand der Kontemplation und so zu Quellen für eine neue Art Erkenntnis. Während wir in unseren Kapseln sitzen und das Ruhrgebiet überblicken oder an Festen im „Rust Belt" (Schwer- und Metallindustriegebiet zwischen New York und Chicago) teilnehmen, könnten wir uns die berühmten drei Fragen stellen: Wer sind wir? Woher kommen wir? Wohin gehen wir? Das würde uns – hoffentlich – kollektiv wieder in den öffentlichen, politischen Raum zurückführen. Es wäre sicherlich nicht von Nachteil, eines Tages das Konzept

der öffentlichen Raumplanung an sich zu überdenken. Verachtung für Begriffe wie „Planung" und „Utopie" folgte einerseits auf das vermeintliche Versagen architektonischer Nachkriegsreformen und andererseits auf den architektonischen Radikalismus der 1960er Jahre, aber das rhetorische Vergessen der Politik bei diesen Entwicklungen vermittelt Architekturstudenten potenziell ein falsches Verständnis dafür, wie etwas funktioniert in unserer Welt. Der Markt, zum Beispiel, kann zwar wie eine unübersichtliche Ansammlung an gleich wirkenden Verkaufsveranstaltungen aussehen, aber der klügste Verkäufer plant sehr wohl jeden seiner Schritte im Voraus. So sicher wie Wal-Mart-Kunden schon das nächste Objekt archäologischer Forschung erkennen können (große Kästen in noch größeren Kästen, die an der Leine der Transportkosten hängen), so möchten wir doch einen Plan entwickeln, wie und wo wir leben wollen. Wie die Evolution des kritischen Denkens und des sozialen Liberalismus können auch unsere Pläne durch den Zeitfaktor verändert werden – es wäre schön, sich das so vorzustellen – von der leise fortschreitenden Entwicklung mobiler Architekturen.

Dieses Maß an Empfänglichkeit wird für die mutigen und bemerkenswerten Projekte dieser Publikation – darunter das „Firebreak"-Project des Detroit Collaborative Design Center (Seite 158) oder die „Bonfires of Urbanity" der Building Initiative (Seite 133) – benötigt werden, da sie, so fürchte ich, die äußersten programmatischen Grenzen der Architektur aufdecken werden. Vielleicht wird die Architektenschaft in problembeladenen Städten wie Belfast oder Detroit, wo wahrscheinlich jede nur denkbare planerische und architektonische Strategie ausprobiert wird, vor der Tatsache kapitulieren, dass ihr Wirken stets nur einen Teil im gesamtgesellschaftlichen Zusammenhang bildet, in dem andere Teile (ich denke hier an Sektierertum, Rassismus, Patriarchat, Kapitalismus) wichtiger und hinterlistiger sind als die Architektur. In der Menschheitsgeschichte kam das Feuer vor den Gebäuden. Feuer schädigt die Urbanität und ist der Feind der Moderne. Brände „wohltätig" zu nennen, hieße sie als Generalisten oder Außenseiter zu sehen oder als Planungen, die auf Schwellenräume und -materialien umgelenkt werden. Man muss aber auch die potenziell kritische Erkenntnis akzeptieren, die sich aus dieser Art des Betrachtens entwickelt, denn sie kann die kollektive Aufmerksamkeit in einer Art, wie es der beschwichtigende Effekt eines weiteren Großkastens außerhalb der Stadt niemals könnte, wieder auf noch glühende politische Aschehaufen lenken.

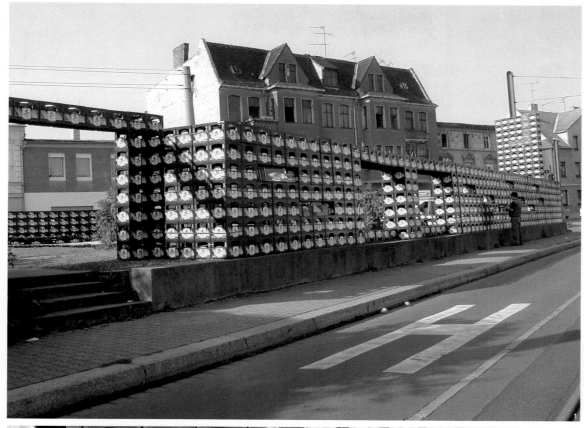

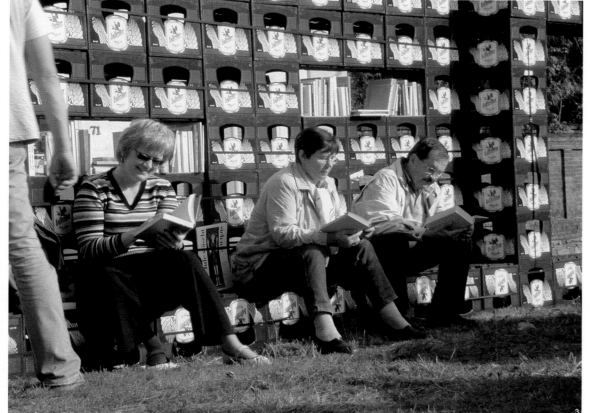

[1-3] "Bookmark for Salbke" / *Lesezeichen für Salbke*, Magdeburg 2005, photo: © Karo Architekten

Provisional Library

Antje Heuer, Stefan Rettich and Bert Hafermalz at the KARO studio in Leipzig concern themselves with communication, architecture and planning. For them, encountered reality is a resource and starting point for processes in an urban transformation situation such as their temporary library project "Bookmark for Salbke" (in cooperation with architektur+netzwerk) for reclaiming a derelict space on the former site of a local library in Magdeburg. Here beer crates were stacked to form a robust shelving system that locals were then invited to fill with books. A festival followed with poetry slams and readings and over 5,000 books were collected. Such was local enthusiasm that a local residents' library is now planned in a neighbouring building. Antje Heuer, Stefan Rettich und Bert Hafermalz vom Architekturbüro KARO in Leipzig beschäftigen sich mit Kommunikation, Architektur und Planung. Für sie ist ausschließlich die bestehende Realität Ressource und Ausgangspunkt für die Gestaltung von urbanen Übergangssituationen wie zum Beispiel ihrem zeitlich begrenzten Bibliotheksprojekt „Lesezeichen für Salbke" (in Zusammenarbeit mit architektur+netzwerk) auf einem leer stehenden Grundstück in Magdeburg, auf dem früher eine reguläre Stadtteilbibliothek stand. Bierkästen wurden aufeinander gestapelt, um ein stabiles Regalsystem zu schaffen, das die Stadtteilbewohner selbst mit Büchern füllen sollten. Ein Lesefest mit Poetry Slams und Lesungen folgte und mehr als 5.000 Bücher wurden insgesamt gesammelt. Die Begeisterung vor Ort war so groß, dass nun in einem benachbarten Gebäude eine Bibliothek für die Bewohner geplant ist.

"We belong to the endless signs of life in our cities, which are so often designed without wasting any thought on their residents. Stories of stone and pavement attempt to construct an image of stable austerity until we come along with our dirty fingerprints. We are everywhere and as contagious as a virus. In some utopian fantasies that I feel we are directly on the edge of fulfilling, I imagine cities so full of life that every surface bears its mark." SWOON

„Wir sind Teil der unendlichen Lebenszeichen in unseren Städten. Städte, die häufig so entworfen werden, ohne einen Gedanken an ihre Bewohner zu verschwenden. Mit Geschichten aus Stein und Straßenpflaster versucht man ein Bild stabiler Nüchternheit zu konstruieren, bis wir schmutzige Fingerabdrücke hinterlassen. Wir sind überall und so ansteckend wie ein Virus. In einigen utopischen Fantasien, von denen ich glaube, dass wir kurz davor stehen, sie wahr werden zu lassen, stelle ich mir Städte vor, die so erfüllt sind mit Leben, dass jede Oberfläche seine Spur trägt."

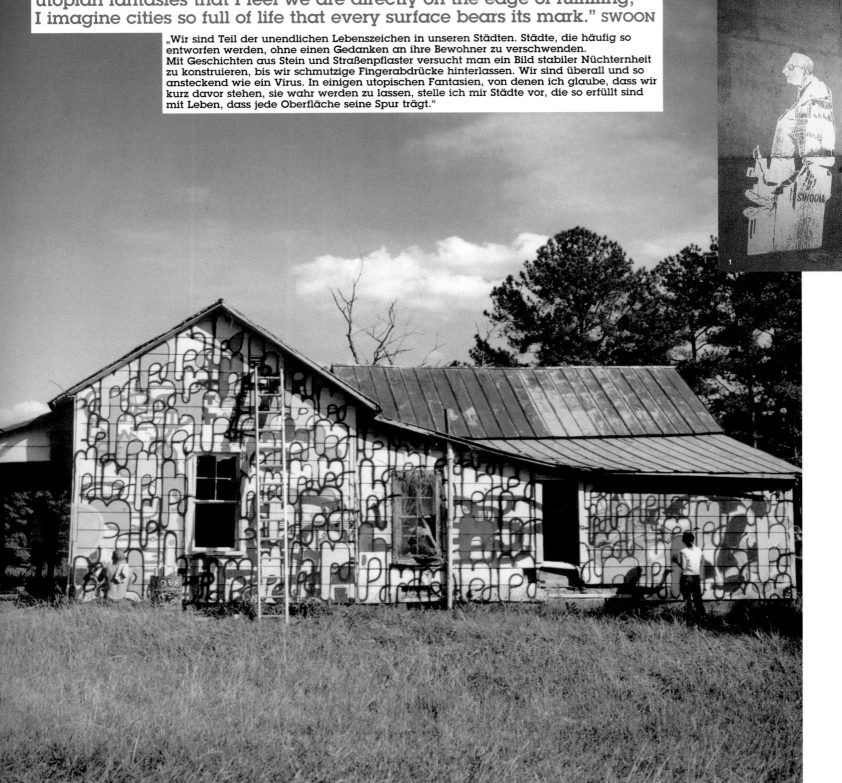

[↑] "Barnstormers", The Barnstormers are a collective of New York and Tokyo-based street artists who create large-scale collaborative paintings, films and performances. In 1999 some 25 of them travelled to the rural town of Cameron, North Carolina, where they painted dozens of old barns, tractor-trailers, shacks and farm equipment. The declining regional tobacco industry and modern metal silos had made many of these buildings obsolete. In contrast to urban property owners, locals welcomed the spray paint invasion for drawing attention to their decaying architecture. / *Die „Scheunenstürmer" sind ein Künstlerkollektiv aus New York und Tokyo, die gemeinsam großformatige Bilder, Filme und Performances erschaffen. 1999 besuchten sie die Kleinstadt Cameron in North Carolina und bemalten alte Scheunen, Traktoren, Schuppen und andere Bauernhofgeräte. Der Niedergang der örtlichen Tabakindustrie hatte viele dieser Gebäude und moderne Silos aus Metall obsolet werden lassen. Im Gegensatz zu vielen städtischen Immobilienbesitzern haben die Kleinstadtbewohner diese Künstlerinvasion willkommen geheißen, die die Aufmerksamkeit auf die verfallenen Architekturen lenkte.* Photo: Gion

[1-3] Swoon, "Cut-Out People", photos: Markus Mai

[4-6] Swoon, "Cut-Out People", photos: Swoon

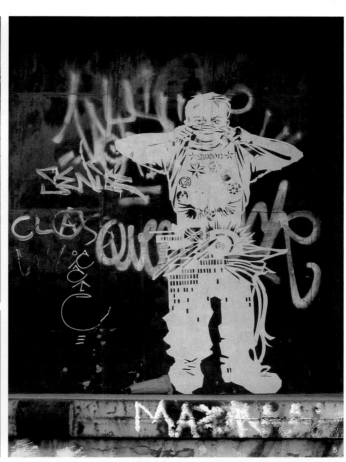

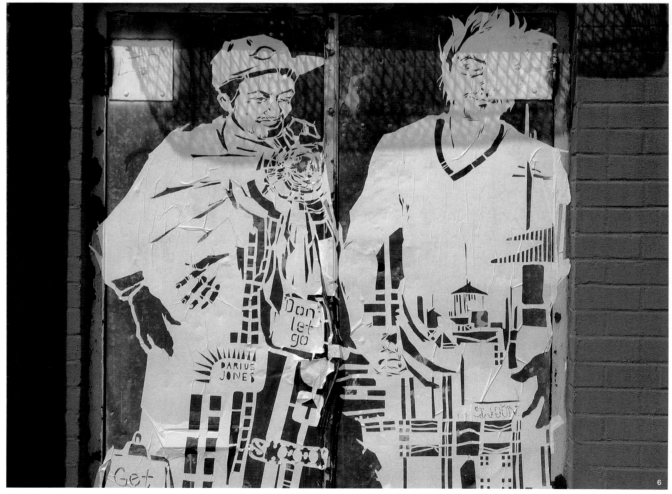

"When architecture optimises space
to encourage the human body and spirit to aspire to
whatever takes its fancy, graphic design can inhabit
the space to conduct its business of focussed
communication and uninterrupted approaches to any
or all of the five senses." RINZEN

„Wenn die Architektur den Raum optimiert, um den Körper und Geist dazu zu ermuntern,
nach dem zu streben, was ihm gefällt, kann die grafische Gestaltung den
Raum beleben und ihrem Geschäft der fokussierten Kommunikation und des
ungestörten Zugangs zu allen oder zu einem der fünf Sinne nachgehen."

[↑] Collage: Rinzen, 2006

Typography in Space

The Belgian artist Frédéric "Recto" Platéus arrived at urban iconography through skateboarding, music and graffiti. He is concerned with the ways in which urban subcultures invent identities and represent themselves. He designs and builds three-dimensional typefaces – graffiti in built form. Der belgische Künstler Frédéric „Recto" Platéus kam über Skateboardfahren, Musik und Graffiti zur Stadtikonografie. Ihn beschäftigt, auf welche Weise die städtische Subkultur Identitäten kreiert und sich selbst darstellt. Er entwirft und konstruiert dreidimensionale Schriftzüge – Graffiti in gebauter Form.

"Even simple graffiti is already based on the design of letters in relation to space. Combining the use of the spray can with one's particular technique means getting involved in giving those letters an effect of perspective, speed, glow or even something out of one's own life experience in order to provide them a particular presence. At some stage, I just thought that instead of paint, other materials could be used too. And in 3D I am able to bring the characters to life, to take graffiti to the next level." Recto

„Auch einfache Graffitis basieren auf dem Design von Buchstaben im Bezug auf den Raum. Wenn man die Spraydose mit seiner eigenen Technik benutzt, bedeutet dies, den Buchstaben einen Ausdruck von Perspektive, Geschwindigkeit, Leuchtkraft oder sogar eine Spur der eigenen Lebenserfahrung zu geben, um ihnen eine besondere Präsenz zu geben. Irgendwann kam mir der Gedanke, dass ich statt Farbe auch andere Materialien verwenden könnte. In 3D kann ich die Buchstaben lebendig werden lassen und die Graffitikunst zur nächsten kreativen Ebene führen." Recto

[↑] Recto, "Cold-crusher05" 2005, photo: © Galerie Suzanne Tarasiève, Paris

[↗] Liège fairground / *Jahrmarkt in Lüttich*, 2004, photo: Fabrice D'Ascenzo

Reinickendorf [North]

NO

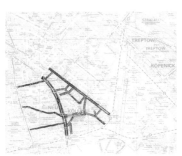

Neukölln [South]

SO

Mitte [East]

EA

WE
sissel tolaas
3ʳᵈ berlin bienna

℮ 250 ml. net wt.8.45
vaporisateur natural s

Charlottenburg [West]

WE

FÜR DIE **KARTOGRAPHIE DES DUFTES** BENÖTIGEN WIR EINFÜHLSAME KARTOGRAPHEN, UM NEUE WORTE ZU FINDEN, VON DENEN JEDES SO PRÄZISE WIE EINE LANDSCHAFTSINFORMATION ODER HIMMELSRICHTUNG IST.

Urban Olfactory

The Norwegian conceptual artist Sissel Tolaas concentrates on the issues of smell, language and communication. She captures and bottles the essence of city street smells to create her own "perfume cities". She has collaborated with various international firms, such as Comme des Garçons, to produce innovative fragrance ideas for their perfume collections. Tolaas has her own laboratory, in which she compiles her "smell archive" that contains over 7,000 smells.

Die norwegische Konzeptkünstlerin Sissel Tolaas konzentriert sich auf die Themen Geruch, Sprache und Kommunikation. Sie fängt die Essenz des Geruchs von Stadtstraßen ein und füllt sie in Flaschen ab. So kreiert sie ihre eigenen „Parfumstädte". Sie hat bereits mit verschiedenen internationalen Unternehmen wie Comme des Garçons bei der Entwicklung von innovativen Duftideen für deren Parfumkollektionen zusammengearbeitet. Tolaas hat ihr eigenes Labor, in dem sie ihr „Geruchsarchiv" mit über 7.000 Gerüchen sammelt.

REALITY I | Reinickendorf [North] tough · cold · hard · solarium · synthetic sun · Majorca
odies · bodybuilding · damping bodies · wheel-chairs · machine-body smell · stinky buildings · cold
ete · McDonalds · coke · pomme-frites · cheap alcohol | Neukölln [South] Istanbul · village of my
flower-oil · meat and bread · dry clean · chemical stuff · tobacco · cheap aftershave · bakery · sweet
rbing · freedom | Mitte [East] New Berliner · hip · cool · Starbucks · life-style magazines · fashion
G4s · titan · pan-Asia · sushi · modern optimistic · young · futureoriented | Charlottenburg [West]
rtable · cashmere · perfume · safe · cosmopolitan · spas · wellness · water · money · conservative.

REALITY II | breezily sexy · sexy · refreshing · out-of-the-shower · delicious · refreshing · vitalizing
ing fresh · stimulating · masculine sexy · energy · elegant · open · seductive addictive · dangerous
d · devastating effect · smooth · cookie-like · luscious · unusual · seductive · naked skin · the skin
the skin of a fallen angel · warm · soft · subtle · extremely sexy · man magnet · warm · sultry amber
y · satiny blend · extremely feminine · pretty woman · dazzlingly fresh · fresh · warm · modern
refreshing · cool · perfectly worn-in jeans · cashmere sweater · east meets west · warm · cold
onalisa's smile · peaceful · cold · compelling · exotic · sensually · sporty · new · clean · warm
churchy frankincense · delicate · intensely spiritual · paradise · quiet whisper of citrus · new
usk · un-sweet · not particularly floral · warm soft · seductive · comfortable · not overwhelming
rsp · white cotton sheet · impeccably groomed Hitchcock heroine · nothing · very clean
distinguished. elegant civilizéd · vibrant · sassy ripe · exotic fruit · sexy · passion-flower
usk · vivid · fresh · sparkling · reality-based · clean · light · charming · intoxicating feminine
flirtatious · gardenia · fresh · true · lush · clean · streamlined · minimalistic modern · fresh citrus
florals · sesame · leather · woods · amber · guava · warm · unmistakeably masculine · citrus · spice
s · refreshing · sensual · warm light · sensuous · cedar · sandalwood musk · amber · spice · whisper
te · elegant · masculine · mellow · second-skin sexiness · Berlin distilled · bitter · sweet · danger
olence · charm · deep mysterious · powdery · vanilla · musk · fresh · soapy smell
arm · musk · sudsy · masculine blend · attractive · clean.

REALITY III | NO = body · cold · chealp · oIl · cOke · cOld · cONc
dusty · garbage · hard · machiNe-b- · cheap · majOrka · pOmme-frites · sOlariu
NburNed bOdies · syNthetic suN · tOugh · wheel-chairs | SO = bakery · bread · chemi
shave · dry-clean · freedOm · iStanbul · kebab · meat · pOlyeSter · SunflOwer-Oil · Synthetic
der · Sweet · tObaccO · village Of my pareNtS | EA = cool · fAshion-shops · futurE-oriEntEd · G4s
E mAgAzinEs · modErn · nEw bErlinEr · optimistic · pAn-AsiAn · shoE-shops · stArbucks coffEE
young | WE = cashmErE · clEan · consErvativE · comfortablE · cosmopolitan · monEy · pErfumE
WatEr · WellnEss.

NOSO
sissel tolaas
3rd berlin biennale 2004
℮ 250 ml. net wt.8.45 oz
vaporisateur natural spray

NOSOEAWE
sissel tolaas
3rd berlin biennale 2004
℮ 250 ml. net wt.8.45 oz
vaporisateur natural spray

SOEA
sissel tolaas
3rd berlin biennale 2004
℮ 250 ml. net wt.8.45 oz
vaporisateur natural spray

EAWE
sissel tolaas
3rd berlin biennale 2004
℮ 250 ml. net wt.8.45 oz
vaporisateur natural spray

REALITY I The everyday / trivial language
[metaphorical / metonymical]

REALITY II The PR language [the common
terminologies used to make
PR texts for fragrances]

REALITY III NASALO, the fiction [future] language

without border
SISSEL TOLAAS

sissel@tolaas.com

Detail A cut a'-a"

Detail A cut b'-b"

Detail A

Detail A

Barriers

Living in Berlin – the divided city that became the building-site city – the industrial designer Andreas Bergmann understands the effect that walls, fences, hoardings and other pedestrian barriers can have on life in a city in a strong state of flux. His "Bauzaun" converts standard fencing into a bench and thus a barrier to be skirted into a transitory moment of stillness. Der Industriedesigner Andreas Bergmann lebt und arbeitet in Berlin, der ehemals geteilten Stadt, die zur „Baustelle Europas" wurde. In diesem Umfeld lernte er, Zäune, Mauern, Bauzäune und andere Sperrvorrichtungen auch als ein Zeichen permanenter Veränderungen zu lesen. Sein „Bauzaun" verwandelt einen normalen Bauzaun in eine Sitzbank und somit eine Absperrung in einen Moment des Innehaltens.

[↑] Drawing: Andreas Bergmann

[↗] Photo: Edgar Rodtmann © Andreas Bergmann

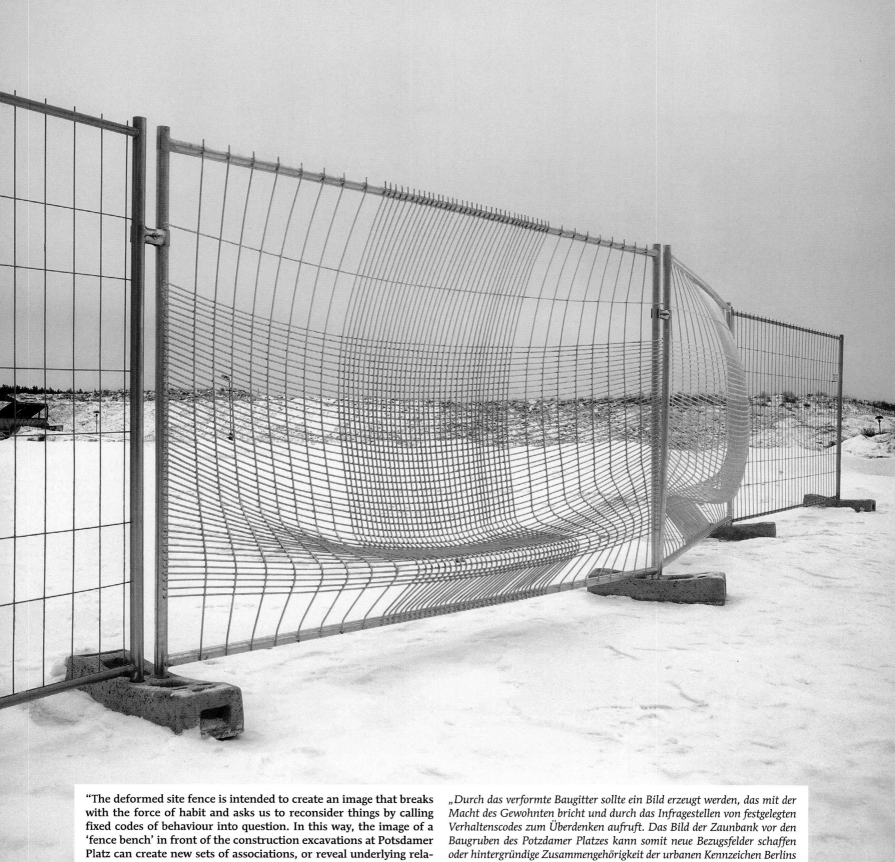

"The deformed site fence is intended to create an image that breaks with the force of habit and asks us to reconsider things by calling fixed codes of behaviour into question. In this way, the image of a 'fence bench' in front of the construction excavations at Potsdamer Platz can create new sets of associations, or reveal underlying relationships between the urban landmarks of Berlin."

"In addition to 'classical' areas of activity, from public design to window-dressing, an increasing number of non-architectural areas of design are cropping up in today's urban space: audiovisual media design, for example, and the conception of event spaces. The complexity of projects of this type, which are often based on new technologies, means that they can best be worked upon using network structures. In the designer's work, the relationship to the human scale is all-important. He is charged with the task of designing friendly adaptations of new technologies in the world that we live in, making them perceivable to the senses and addressing the intellect of the user." A. Bergmann

„Durch das verformte Baugitter sollte ein Bild erzeugt werden, das mit der Macht des Gewohnten bricht und durch das Infragestellen von festgelegten Verhaltenscodes zum Überdenken aufruft. Das Bild der Zaunbank vor den Baugruben des Potzdamer Platzes kann somit neue Bezugsfelder schaffen oder hintergründige Zusammengehörigkeit der urbanen Kennzeichen Berlins offen legen."

„Neben ,klassischen' Betätigungsfeldern von public design bis Schaufensterdekoration finden vermehrt auch nicht-architektonische Gestaltungsbereiche Einzug in den heutigen Stadtraum: zum Beispiel audiovisuelle Mediengestaltung oder ,Event-Raum'- Konzeption. Oft auf neuen Technologien basierend, lassen sich Projekte dieser Art aufgrund ihrer Komplexität bestmöglich in Netzwerkstrukturen bearbeiten. Für die Arbeit des Designers bleibt die Bezugsgröße Mensch maßgeblich. Ihm fällt die Aufgabe zu, eine freundliche Adaption neuer Technologien in unsere Lebenswelt zu gestalten, diese für die Sinne erfahrbar zu machen und dabei die Intelligenz des Benutzers anzusprechen." A. Bergmann

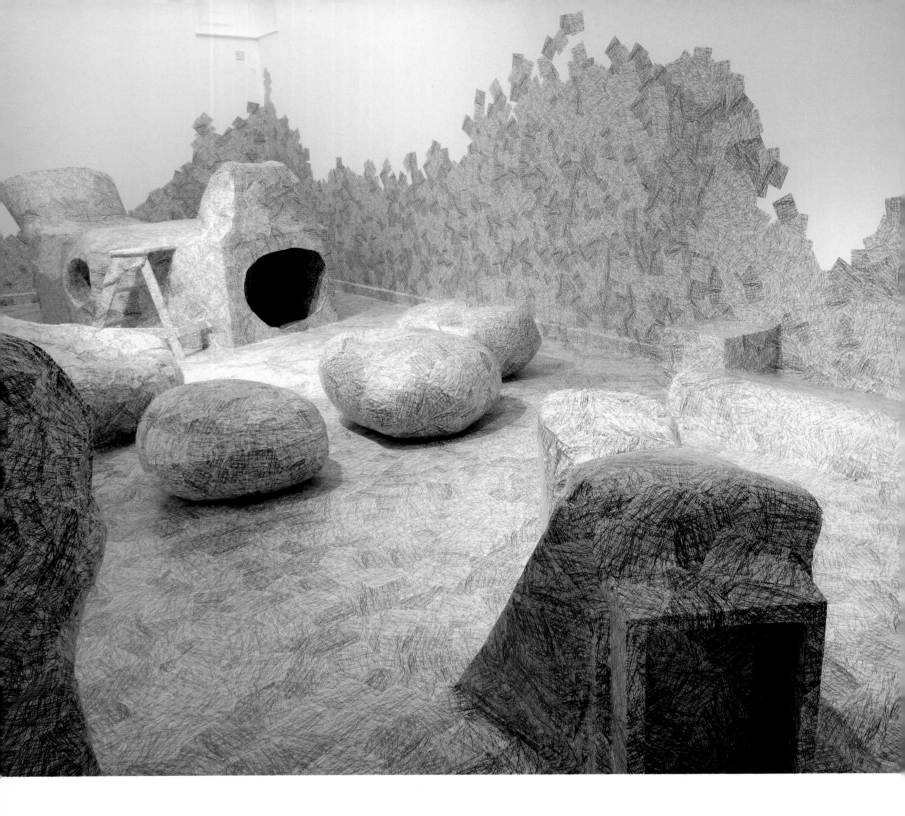

Design-It-Yourself

Roberto Feo and Rosario Hurtado from London-based El Ultimo Grito use three-dimensional graffiti to re-appropriate architectural spaces. They define themselves as a way of thinking that can materialise in many different forms. Das Team El Ultimo Grito aus London (bestehend aus Roberto Feo und Rosario Hurtado) verwenden dreidimensionale Graffiti für die Neueroberung architektonischer Räume. Sie selbst definieren ihre Arbeit als eine Denkweise, die in vielen verschiedenen Formen zum Ausdruck kommen kann.

"We like to imagine cities that are not subjected to planning, where people do whatever they feel is necessary: Where they create their spaces according to their own needs, reflecting their individual creative instincts."

"In our vision, the city consists of sediments, layers of materials and actions, we are able to appropriate and rearrange bits of the city to give them another life. That is why we like to work with stickers and tape as immediate tools to render any object or space real, and we use their graphic qualities as a secondary layer of meaning. We like the ephemeral character of these constructions, you can change it constantly: if you're tired of the colour or even the form, you simply add another layer. When it breaks, you fix it with more padding and tape or more stickers or whatever. Through layers you can create a truly individual object."

"We understand design as a way of thinking, it is a transferable skill that can be applied to anything. If everyone was complacent, everything would remain the same. If you have a problem, you try to find a solution. Design is a survival instinct."

"Acceptance of what's on offer means acceptance of someone else's values, definitions of normality, culture or desires. To claim responsibility for what is around oneself is the only way to safeguard our individuality."

"Through understanding and through trying to design and create and generate your own objects, you start resisting this idea of the global concept of living, of how things are. Change is not impossible." Feo/Hurtado

„Wir stellen uns gern Städte vor, die keiner Planung unterliegen, wo Menschen das tun, was sie für notwendig halten. Wo sie ihre Räume entsprechend ihren Bedürfnissen gestalten und sich ihre individuellen kreativen Instinkte widerspiegeln."

„In unserer Vorstellung besteht die Stadt aus Sedimenten, aus Schichten von Materialien und Handlungen. Wir sind in der Lage, uns Teile der Stadt anzueignen und sie umzugestalten, um ihnen ein anderes Leben zuzuweisen. Aus diesem Grund arbeiten wir gern mit Aufklebern und Klebeband als unmittelbares Instrument, um ein Objekt oder einen Raum real werden zu lassen und wir verwenden ihre grafischen Eigenschaften als zweite Bedeutungsebene. Uns gefällt der kurzlebige Charakter dieser Konstruktionen, man kann sie ständig verändern. Wenn man der Farbe oder gar der Form überdrüssig geworden ist, bringt man einfach eine weitere Schicht auf. Wenn es kaputt geht, kann es durch mehr Polsterung und Klebeband oder weitere Aufkleber oder sonstiges Material repariert werden. Durch Schichten kann man ein wahrhaft individuelles Objekt erschaffen."

„Wir verstehen Design als eine Denkweise, es ist eine übertragbare Fähigkeit, die auf alles angewendet werden kann. Wenn jeder zufrieden wäre, bliebe alles beim Alten. Wenn man ein Problem hat, versucht man eine Lösung dafür zu finden. Design ist ein Überlebensinstinkt."

„Die Akzeptanz des vorhandenen Angebots bedeutet Akzeptanz der Wertvorstellungen, der Definitionen von Normalität, der Kultur und der Wünsche eines Anderen. Verantwortung für das zu übernehmen, was uns umgibt, ist die einzige Möglichkeit, unsere Individualität zu bewahren."

„Durch das Verständnis und durch den Versuch, eigene Objekte zu entwerfen, zu kreieren und zu erschaffen, beginnt man, sich dieser Idee eines globalen Konzepts des Lebens und der Dinge, wie sie sind, zu widersetzen. Veränderung ist nicht unmöglich." Feo/Hurtado

[↖] "Tagged Environment", photo: Gareth Gardener © El Ultimo Grito
[↑] "Tape Sofa", photos: Gareth Gardener © El Ultimo Grito

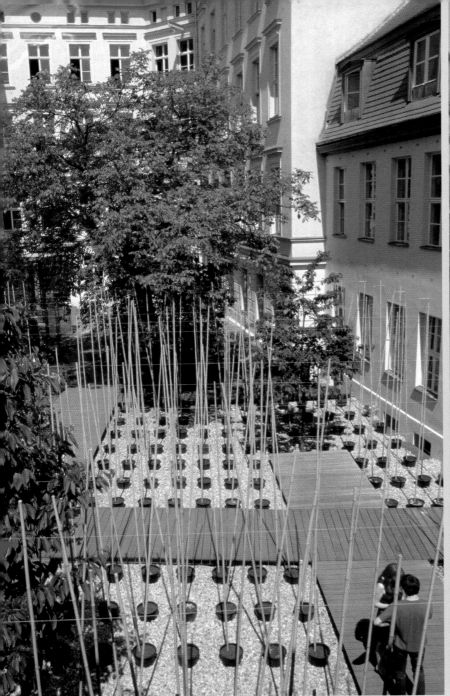

Gap Horticulture

WoistderGarten? Atelier le Balto is a team of garden architects based in Berlin and Paris and comprises Marc Pouzol, Laurent Dugua, Véronique Faucheur and Mark Vatnel. Their gadens are often informal, temporary fast-growing spaces of encounter carefully planted with wasteland weeds. Principal projects include: "Jardin Sauvage", Palais de Tokyo, Paris; "Hofgarten", Kunst-Werke, Berlin and "WhereIsTheGarden?", gardens in several residual spaces in Berlin. Das Atelier le Balto ist eine Gruppe von Gartenarchitekten mit Sitz in Berlin und Paris. Dazu gehören Marc Pouzol, Laurent Dugua, Véronique Faucheur und Mark Vatnel. Ihre Gärten sind oft informelle, rasch wachsende Orte der Zusammenkunft, die sorgfältig mit Brachland-Unkräutern bepflanzt wurden. Zu den wichtigsten Projekten zählen: „Jardin Sauvage" und „Palais de Tokyo", Paris; „Hofgarten", Kunst-Werke, Berlin und „Woistdergarten", Gärten auf verschiedenen Brachflächen in Berlin.

Véronique Faucheur in a conversation with Talking Cities *Véronique Faucheur im Gespräch mit Talking Cities*

<u>Talking Cities:</u> Do you work to commission or more in guerilla actions where you occupy derelict spaces?

<u>Véronique Faucheur:</u> The project "WhereIsTheGarden" in Berlin was self-initiated. We organised it and we approached the owners of the plots, ex-

<u>Talking Cities:</u> *Fühlt ihr euch eher als Auftragnehmer oder sind es eher Guerilla-Aktionen, bei denen ihr brach liegende Räume besetzt?*

<u>Véronique Faucheur:</u> *Das Berliner Projekt „Woistdergarten?" entstand aus eigener Initiative. Wir haben es organisiert und sind dann auf die Eigentümer zugegangen,*

[↑] "KW.02", Kunst-Werke e.V., Berlin 2002, photo: © Atelier le Balto [↑] "WhereIsTheGarden? – katen garden" (*„Woistdergarten?" – Katen-Garten*), Berlin 2005, photo: © Hiepler-Brunier

[↑ ↗] "WhereIsTheGarden? – Blackboard-garden" / „WoistderGarten? – Tafel-Garten", Berlin 2005, photo: © Atelier le Balto

[↑] "Temporary gardens – alu-clearing"/ „Temporäre Gärten- Alu-Lichtung", Berlin 1997, photo: Yam Monel

plained the project and asked if we could use them. The whole thing took place in a completely official framework.

TC: What drove you in this direction? And why Berlin?

VF: It is the constant changes of the cityscape here that attract us so much. You also have a much better quality of life in Berlin than in Paris.

TC: Do you need Berlin to make your gardens?

VF: Yes, I think that all these empty spaces do inspire us, we recognise their qualities and want to work with them. We have just had a similar experience in Tallinn in Estonia. The inner city has been smartened up for the tourists but when you go into the courtyards and backyards you see that the city is not so well-kept after all and there are also just as many derelict spaces. We reacted in the same way there as in Berlin.

TC: Do you need cities with history; aged, crumbling areas for your gardens, or would the concept work in a new town, say?

VF: We work in empty plots because we are in Berlin. If we were in a new town, we would definitely develop something else. Marc developed this idea of temporary gardens when he was in Japan because there the use of these interstitial spaces is very well developed.

TC: It could be said that people occupy empty urban spaces in Berlin of their own accord anyway: building dens, setting up tables or having bonfires. Why do you think you need to plan these gardens?

VF: I think we use the tools of architects to plan the spatial qualities or the alterations. When we create something then we know how it will develop. When we plant something we do it in the knowledge of how it will look in

one or two month's time. Often when people build something for themselves, they build something that they need functionally – not because they want to achieve a particular quality of light or shadow for example.

TC: You say that visitors are part of your gardens. Do they change the gardens when they are there?

VF: They never damage anything, there is respect for the garden – or perhaps for a place that is a gift to them. Occasionally there are smaller surprises where seeds are sown, or plants are exchanged or removed.

TC: What does "temporary" mean for you?

VF: Actually the term refers to a project that Marc did in 1997, before Atelier le Balto, that lasted only two days and two nights. But we often use annual plants that grow quickly to emphasise the changing forms more.

TC: You could say that your gardens are not only "temporary", but "fast".

VF: A colleague once said: "gardens are never temporary, they are provisional". By definition, a garden is always in a process of change.

TC: Do they have to be even faster because they are in the city?

VF: No, not necessarily, we have used these techniques often recently because we wanted to have this effect over a few months. But in the Jardin Sauvage, in Paris, for example there is not one single annual plant – they are all perennials.

TC: What does "urban" mean for you?

VF: For me it has something to do with the density of people. More people means you have to do more for them – like restoring the relationship with nature.

haben ihnen das Projekt erklärt und gefragt, ob wir die Grundstücke verwenden dürften. Die ganze Angelegenheit fand in einem vollkommen offiziellen Rahmen statt.

TC: Wie sind Sie darauf gekommen? Und wieso Berlin?

VF: Es ist die sich ständig verändernde Stadtlandschaft hier, die uns so anzieht. Ich denke, dass uns all diese freien Räume inspirieren, wir sehen ihre Vorzüge und wollen mit ihnen arbeiten. Auch die Lebensqualität ist in Berlin viel besser als in Paris. Wir haben gerade erst in Tallinn, Estland, etwas Ähnliches erlebt. Das Stadtzentrum wurde für die Touristen herausgeputzt, aber wenn man in die Innen- und Hinterhöfe schaut, erkennt man, dass die Stadt doch nicht so gepflegt ist und dass es ebenso viele brach liegende Räume gibt. Dort haben wir genauso reagiert wie hier in Berlin.

TC: Braucht ihr für eure Gärten Städte mit einer Geschichte, also gealterte, bröckelnde Umgebungen, oder würde das Konzept auch in einer neuen Stadt aufgehen?

VF: Gerade weil wir in Berlin sind, arbeiten wir mit brach liegenden Grundstücken. Wenn wir uns in einer neuen Stadt befänden, würden wir sicher etwas anderes entwickeln. Marc entwickelte die Idee der temporären Gärten, während er in Japan war, weil dort diese Zwischenräume zu einem hohen Grad genutzt werden.

TC: Man könnte sagen, dass die Menschen in Berlin bereits aus eigenem Antrieb ungenutzten urbanen Raum besetzen, indem sie Verschläge bauen, Tische aufstellen oder im Freien Feuer machen. Warum glaubt ihr diese Gärten planen zu müssen?

VF: Wir verwenden die Mittel von Architekten, um die räumlichen Eigenschaften oder die Veränderungen zu planen. Wenn wir etwas erschaffen, wissen wir, wie es sich nachher entwickeln wird. Wenn wir etwas anpflanzen, tun wir es in dem Wissen, wie es in einem oder zwei Monaten aussehen wird. Wenn Menschen sich selbst etwas schaffen, dann ist das oft etwas, das sie funktionell gebrauchen kön-

nen – und nicht etwa, weil sie zum Beispiel eine bestimmte Licht- oder Schattenqualität erreichen wollen.

TC: Sie sagen, Besucher seien ein Teil Ihrer Gärten. Verändern sie die Gärten, wenn sie da sind?

VF: Sie beschädigen nie etwas. Sie zeigen Respekt für den Garten – oder vielleicht für einen Ort, der ein Geschenk für sie ist. Manchmal gibt es kleine Überraschungen, wenn Samen ausgesät wurden oder Pflanzen ausgetauscht oder entfernt wurden.

TC: Was bedeutet „temporär" für Sie?

VF: Dieser Begriff bezieht sich eigentlich auf ein Projekt von Marc aus dem Jahre 1997, noch vor der Zeit des Ateliers le Balto, das nur zwei Tage und zwei Nächte dauerte. Aber wir verwenden oft einjährige Pflanzen, die schnell wachsen, um die sich verändernden Formen stärker hervorzuheben.

TC: Man könnte sagen, die Gärten von Atelier le Balto sind nicht nur „temporär", sondern auch „schnell wachsend".

VF: Ein Kollege sagte einmal: „Gärten sind niemals temporär, sie sind vorläufig." Per Definition befindet sich ein Garten stets in einem Prozess der Veränderung.

TC: Müssen sie dann nicht sogar noch schneller wachsen, weil sie sich in der Stadt befinden?

VF: Nein, nicht notwendigerweise, wir haben diese Methoden in der letzten Zeit öfter angewendet, weil wir diese Wirkung für ein paar Monate haben wollten. Aber im Jardin Sauvage in Paris, zum Beispiel, gibt es keine einzige einjährige Pflanze, sondern nur mehrjährige.

TC: Welche Bedeutung hat das Wort „urban" in eurer Arbeit?

VF: Für mich hat das etwas mit der Bevölkerungsdichte zu tun. Mehr Menschen bedeutet, man muss mehr für sie tun – wie die Wiederherstellung der Beziehung zur Natur.

The Uncommon Solution

Yuli Toh and Takero Shimazaki set up Toh Shimazaki Architecture in 1997 to apply their experience in international projects to individualised houses, design studios and restaurants focusing on intricate and context responsive solutions that enrich the lives of the inhabitants. 1997 gründeten Yuli Toh und Takero Shimazaki das Büro Toh Shimazaki Architecture, um ihre Erfahrungen mit internationalen Bauprojekten für individuelle Einfamilienhäuser, Designbüros und Restaurants umzusetzen und sich dabei auf komplexe und kontextbezogene Lösungen zu konzentrieren die das Leben der Bewohner bereichern.

"Architecture must be diverse and specific, not a common solution. … The idea of a city as a vehicle for social interaction has metamorphosed from a physical conglomerate to a digital framework. The "Fun Palace" foretold this new talking city, where we now agree to meet. Where then is the architecture of the physical city? We propose it has dispersed to the personalised place and architecture can now become unapologetically non-universal but intelligently specific to the individual – the uncommon solution."

"We often work with these ideas, drawing inspiration from topics as diverse as text graphics, the stacking of wood or the pattern of a generic row of terrace houses to the weave of textiles. We seek out these systems – these emotional grids – and then it frees us. Alignment, thickness, direction, depth of relief and 'chances' of distortion all become a part of this language."

"Architecture and urban conditions are constantly in flux. People make urban conditions and people change them, adjust them and destroy them in return. Behaviour is an important generator in our buildings where user interaction is encouraged as much as possible."
Toh/Shimazaki

„Architektur muss vielfältige und spezifische Lösungen bieten, und nicht eine allgemeine … Die Auffassung von Stadt als Vehikel der gesellschaftlichen Interaktion ist vom greifbaren Gebäudekonglomerat zum digitalen Rahmen übergegangen. Der „Fun Palace" hat diese neue sprechende Stadt vorausgesagt, in der wir uns heute verabredet haben. Wo aber ist die tatsächlich gebaute Stadt geblieben? Wir meinen, dass sie sich in personalisierte Räume aufgeteilt hat und dass Architektur jetzt – ohne sich dafür entschuldigen zu müssen – nicht mehr universal sein muss, sondern auf intelligente Weise spezifisch werden darf, dem Individuum, das heißt der ungewöhnlichen Lösung entsprechend."

„Wir arbeiten häufig auf der Basis dieser Ideen und beziehen Anregungen aus so unterschiedlichen Quellen wie Textgraphiken, Holzstapeln, identischen Reihenhäusern oder Stoffen. Wir suchen nach diesen Mustern, diesen ‚emotionalen Rastern', die uns frei machen. Lineare Anordnung, Dicke, Ausrichtung, Relieftiefe und Gelegenheiten zur ‚Verformung' gehören sämtlich zu unserer Formensprache."

„Die Architektur und die Verhältnisse in der Stadt befinden sich in einem konstanten Fluss. Die Stadt wird von Menschen gemacht – und auch von Menschen verändert, erweitert und wieder zerstört. Menschliche Verhaltensweisen sind wichtige Faktoren für unsere Projekte, denn wir wollen, dass Gebäude und Nutzer sich so viel wie möglich gegenseitig beeinflussen." Toh/Shimazaki

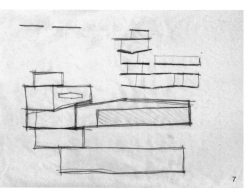

[1] "A House", photo: © Toh Shimazaki Architecture
[2,3] from / aus: Lloyd Kahn "Shelter" © 1973 Lloyd Kahn and Shelter Publications, California, USA
[4,5] "Osh House", sketch by / Skizze von Toh Shimazaki Architecture
[6] "Rhythmic Lantern", Calbourne Road, London 2004, photo: © Toh Shimazaki Architecture
[7] "Osh House", sketch by / Skizze von Toh Shimazaki Architecture
[8] "Rhythmic Lantern", Calbourne Road, London 2004, photo: © Toh Shimazaki Architecture
[9] Photo: Toh Shimazaki Architecture
[10-12] "Osh House", sketch by / Skizze von Toh Shimazaki Architecture

Partners and Related Events

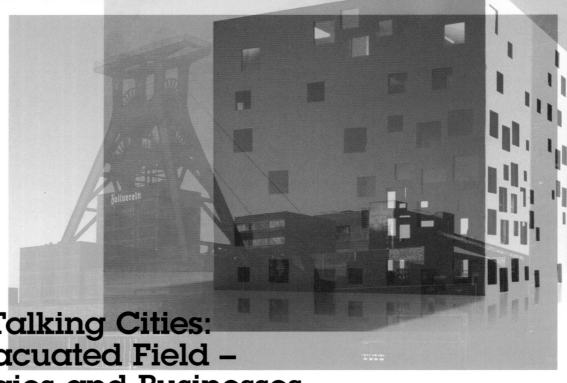

Symposium at Talking Cities: Entering the Evacuated Field – Inspiring Strategies and Businesses

Urban wasteland, empty buildings, disused products, and forgotten brands ... "Evacuated Fields" are valuable resources that can be awakened to new life, fresh use, and unexpected revaluation. Unconventional transformation processes open up new opportunities and create new business sectors in abandoned areas.

The joint symposium planned by urban drift productions and the Zollverein School of Management and Design will focus on unusual strategies in challenging situations. International speakers from the world of business, academia, architecture, and design present samples of best practice and multidisciplinary strategies for a successful revitalisation of "Evacuated Fields".

Ole Bouman, editor-in-chief of *Archis/Volume*, will give a keynote speech about the challenges inherent in dealing with "Evacuated Fields". The Talking Cities exhibitors el ultimo grito from London and the Tokyo-based Atelier Bow Wow (to be confirmed) will give an insight into creative recycling strategies and the micropolitics of space. Fritz Straub, managing director of Deutsche Werkstätten Hellerau, shows how he transformed a forgotten brand into a self-confident partner for innovative interior design. Muck Petzet, a Munich-based architect, will speak about innovative uses for allegedly disused resources. Boris Sieverts campaigns for a pioneering spirit in the cultural context of the Ruhr area. The researchers, urban planners, and architects Hubert Klumpner and Alfredo Brillembourg from Caracas highlight strategies of economic adaptation in resource-free space and open up future fields for architecture and design in the most unexpected ways.

Symposium
Friday, 29 September 2006, 10 a.m. to 6.30 p.m.
Zollverein School of Management and Design (SANAA building)
The Zollverein world heritage site, Essen

Sideline events
Visit to the Talking Cities exhibition with curator Francesca Ferguson
Special Ruhrarea Tour with BuddyGuides from the Zollverein School

The symposium is based on curator Francesca Ferguson's ENTRY exhibition Talking Cities and will be held in English.

For programme details and registration, please send an e-mail to contact@zollverein-school.de. The symposium is part of the 2006 Zollverein Summer School.
For more information, see www.zollverein-school.de

Städtische Brachen, ungenutzte Gebäude, ausgediente Produkte und vernachlässigte Marken ... „Evacuated Fields" sind wertvolle Ressourcen, die zu neuer Nutzung und unerwarteter Aufwertung geführt werden können. Unkonventionelle Transformationsprozesse erschließen neue Komplexe und Geschäftsfelder in verwaisten Bereichen.

Das von urban drift productions Ltd. und der Zollverein School of Management and Design gemeinsam geplante Symposium widmet sich ungewöhnlichen Strategien in herausfordernden Situationen. Internationale Referenten aus Wirtschaft, Wissenschaft, Architektur und Design präsentieren „best practice"-Beispiele und interdisziplinäre Strategien für eine erfolgreiche Neuordnung von „Evacuated Fields".

Ole Bouman, Chefredakteur von *Archis/Volume* wird in seiner Keynote über die Herausforderungen im Umgang mit „Evacuated Fields" referieren. Die Talking-Cities-Aussteller el ultimo grito aus London und Atelier Bow Wow aus Tokio (angefragt) geben Einblick in kreative Recycling Strategien und die Mikropolitik des Raumes. Fritz Straub, Geschäftsführer der Deutschen Werkstätten Hellerau, zeigt, wie er aus einer vergessenen Marke einen selbstbewussten Partner für innovativen Innenausbau machte. Muck Petzet, Architekt aus München, wird über den innovativen Umgang mit vermeintlich ausgedienten Ressourcen referieren. Boris Sieverts wirbt für Pioniergeist im kulturellen Kontext Ruhrgebiet. Die Forscher, Stadtplaner und Architekten Hubert Klumpner und Alfredo Brillembourg aus Caracas veranschaulichen Strategien ökonomischer Adaption im ressourcenfreien Raum und eröffnen auf unerwartete Art Zukunftsfelder für Architektur und Design.

Symposium
Freitag, 29. September 2006, 10:00–18:30 Uhr
Zollverein School of Management and Design (SANAA-Bau)
Weltkulturerbe Zollverein, Essen

Rahmenveranstaltungen
Besuch der Ausstellung Talking Cities mit der Kuratorin Francesca Ferguson.
Sonderführung im Ruhrgebiet mit BuddyGuides der Zollverein School.

Das Symposium ist angelehnt an den von Francesca Ferguson kuratierten ENTRY-Ausstellungsbeitrag Talking Cities und findet in englischer Sprache statt.

Programmdetails und Anmeldung unter: contact@zollverein-school.de.
Das Symposium ist Teil der Zollverein Summer School 2006.
Weitere Informationen: www.zollverein-school.de

Zollverein School
International professional development and training in management and design

Management and Design

The Zollverein School considers design to be a central corporate tool that allows companies to survive global competition. Design offers new opportunities in times when classical methods of product design and marketing are reaching their limits. But design also creates new challenges for companies: the integration of the design process requires changed organisational structures and additional know-how from product development to communication at the interface with the public.

> "Design is a key skill for professionals who have to make decisions regarding the design of products, services, organisations, and business models in their professional life." Prof. Dr. Ralph Bruder, President of the Zollverein School of Management and Design

Designers and Managers

The educational and research programme at the Zollverein School is aimed at managers who would like to integrate design successfully into their companies. At the Zollverein School, managers learn all about design and opportunities for making the most of it, while designers learn about management and how to lead a company. At the end of the course, graduates will be in a position to plan innovation processes and transform them into concrete business models.

> "In an ever-changing market environment, change is the only constant. My professional goal is to identify and display impending changes and to translate these changes into innovative business designs and comprehensive branding interfaces." Werner Bossenmaier, Interbrand Zintzmeyer & Lux / Zollverein School MBA 2006

Postgraduate Education

The Zollverein School offers full- and part-time postgraduate Master's degree courses and a doctoral programme. The first course, which kicked off in February 2005, leads to a Master of Business Administration degree (MBA). The second group of students began their studies in March 2006. The 18 students in the first year (a group of architects, designers, and economists) are currently busy writing their Master's theses and will complete their studies in June of this year. Additional seminars and lectures, as well as the annual Summer School, are aimed at a broad range of people including entrepreneurs and students.

Design and Architecture

In the summer of 2006, the Zollverein School will move into its new home: a spectacular new building on the grounds of the Zollverein world heritage site in Essen. The building, a bright cube, was designed by Kazuyo Sejima and Ryue Nishizawa of the Tokyo-based architectural studio SANAA. The new Zollverein School will be an outstanding structure offering a high degree of flexibility and variability. Its openness will allow for different forms of communication and cooperation. The inside of the building is divided into five levels, each of which is of a different height and has an open room plan. This means that the building will have a myriad of new paths, meeting places, and workstations that reflect the dynamic spirit of the Zollverein School in the fields of tuition, research, and practice.

Further information:
www.zollverein-school.de
contact@zollverein-school.de

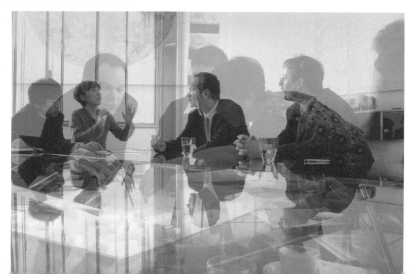

Zollverein School
Internationale Weiterbildung in Management und Design

Management und Design

Die Zollverein School versteht Design als zentrales unternehmerisches Instrument, um im weltweiten Wettbewerb bestehen zu können. Design bietet neue Chancen, wenn klassische Methoden in Produktentwicklung und -vermarktung an ihre Grenzen stoßen. Design stellt Unternehmen aber auch vor neue Herausforderungen: Die Integration des Designprozesses erfordert veränderte Organisationsstrukturen und zusätzliches Know-how – von der Produktentwicklung bis zur Vermittlung an der Schnittstelle zur Öffentlichkeit.

> „Design ist eine Kernkompetenz für Professionals, die in ihrem beruflichen Umfeld Entscheidungen zur Gestalt von Produkten, Services, Organisationen und Geschäftsmodellen zu treffen haben." Prof. Dr. Ralph Bruder, Präsident Zollverein School of Management and Design

Designer und Manager

Das Weiterbildungs- und Forschungsangebot der Zollverein School richtet sich an Führungskräfte, welche die Innovationskompetenz des Designs erfolgreich in ihr Unternehmen integrieren wollen. Manager lernen die Besonderheiten von Design und dessen Einsatzmöglichkeiten kennen, Designer machen sich mit Management und Unternehmensführung vertraut. Nach Abschluss der Ausbildung ihres Studiums an der Zollverein School sind die Teilnehmer in der Lage, Innovationsprozesse zu planen und in konkrete Geschäftsmodelle umzusetzen.

> „In einem sich ständig wandelnden Marktumfeld ist die einzige Konstante die Veränderung. Mein berufliches Ziel ist es, sich abzeichnende Veränderungsbewegungen sichtbar zu machen und für Unternehmen in innovative Geschäftsmodelle sowie relevante Kundenschnittstellen und Markenkontaktpunkte zu übersetzen." Werner Bossenmeier, Interbrand Zintzmeyer & Lux / Zollverein School MBA 2006

Postgraduate Education

Die Zollverein School bietet postgraduale Master-Studiengänge in Voll- und Teilzeit sowie ein Doktorandenprogramm an. Der erste Studiengang zielt auf den Abschluss „Master of Business Administration" (MBA) und startete erstmals im Februar 2005. Im März 2006 hat der zweite Jahrgang sein Studium aufgenommen. Die 18 Studierenden des ersten Jahrgangs – darunter Architekten, Designer und Wirtschaftswissenschaftler – bereiten derzeit ihre Master-Thesis vor und werden ihre Studien im Juni 2006 abschließen. Ergänzende Seminare und Vorträge sowie die jährlich stattfindende Summer School richten sich darüber hinaus an ein breites, interessiertes Publikum – vom Unternehmer bis zum Studenten.

Design and Architecture

Ab Sommer 2006 bezieht die Zollverein School einen spektakulären Neubau auf dem Areal des Weltkulturerbes Zollverein in Essen: ein heller Kubus, entworfen von Kazuyo Sejima und Ryue Nishizawa, dem Büro SANAA aus Tokio. Die neue Zollverein School wird ein Raumgefüge darstellen, das ein hohes Maß an Flexibilität und Variabilität vorsieht und in seiner Offenheit unterschiedliche Formen der Kommunikation und Kooperation zulässt. Die innere Struktur besteht aus fünf Ebenen mit jeweils unterschiedlichen Raumhöhen und einem offenen Raumprogramm. So entstehen ständig neue Wege, Treffpunkte und Arbeitsplätze, die den dynamischen Geist der Zollverein School in Lehre, Forschung und Praxis widerspiegeln.

Weitere Informationen:
www.zollverein-school.de
contact@zollverein-school.de

Zollverein School
of management and design

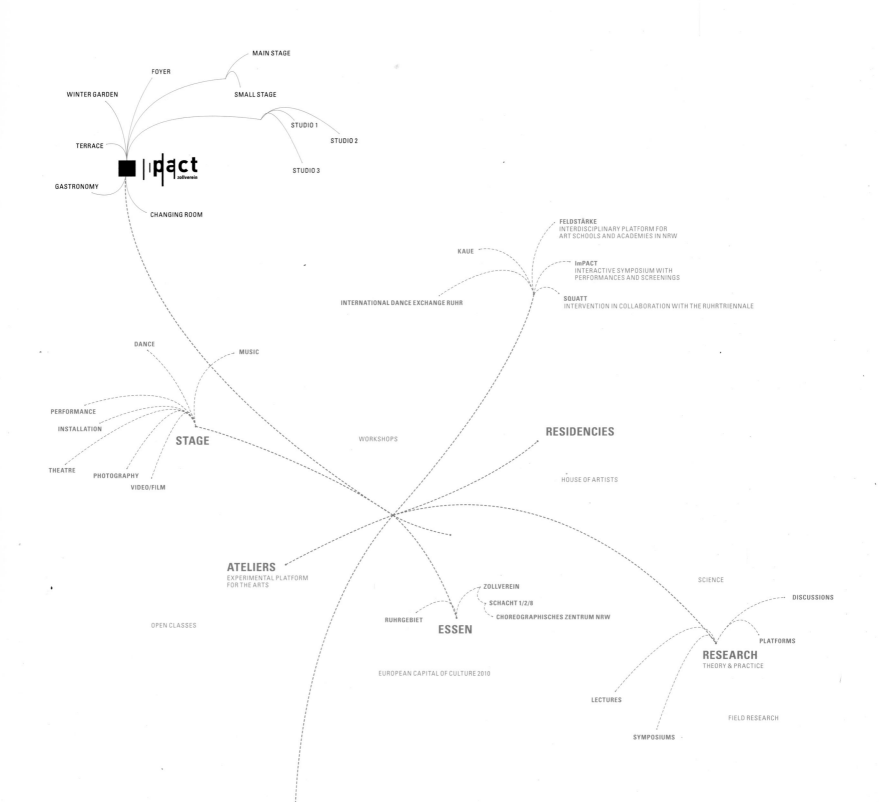

MAIN STAGE

FOYER

WINTER GARDEN SMALL STAGE

 STUDIO 1

TERRACE STUDIO 2

GASTRONOMY ■ ||■pact
 zollverein STUDIO 3

 CHANGING ROOM

 FELDSTÄRKE
 INTERDISCIPLINARY PLATFORM FOR
 ART SCHOOLS AND ACADEMIES IN NRW

 KAUE ImPACT
 INTERACTIVE SYMPOSIUM WITH
 PERFORMANCES AND SCREENINGS

 INTERNATIONAL DANCE EXCHANGE RUHR SQUATT
 INTERVENTION IN COLLABORATION WITH THE RUHRTRIENNALE

DANCE

 MUSIC

PERFORMANCE

INSTALLATION
 WORKSHOPS RESIDENCIES

STAGE
 HOUSE OF ARTISTS

THEATRE

PHOTOGRAPHY

VIDEO/FILM

 SCIENCE
 DISCUSSIONS
ATELIERS
EXPERIMENTAL PLATFORM
FOR THE ARTS ZOLLVEREIN
 PLATFORMS
 SCHACHT 1/2/8
 RUHRGEBIET RESEARCH
OPEN CLASSES CHOREOGRAPHISCHES ZENTRUM NRW THEORY & PRACTICE
 ESSEN

 LECTURES

 EUROPEAN CAPITAL OF CULTURE 2010
 FIELD RESEARCH

 SYMPOSIUMS

PACT FÜR DAS **RUHRGEBIET**
Kulturhauptstadt Europas 2010

Choreographisches Zentrum NRW wird gefördert von

 NRW.

Tanzlandschaft Ruhr ist ein Projekt der

KULTUR RUHR GmbH

Gestaltung www.labor b.de

PACT ZOLLVEREIN/CHOREOGRAPHISCHES ZENTRUM NRW
BULLMANNAUE 20, 45327 ESSEN, FON 0049.(0)201.289 47 00, FAX 0049.(0)201.289 47 01, INFO@PACT-ZOLLVEREIN.DE

WWW.PACT-ZOLLVEREIN.DE

Talking Cities Radio

The exhibition will feature its own radio station: Talking Cities Radio (TCR), Talking Cities conceived in cooperation with the architecture journalist Dirk Meyhöfer. Talking Cities Radio is a dialogue about our cities, made audible to the listener in the form of a concentrated collage of statements by the exhibition's protagonists – this makes the radio station one of the main points of access to the topics addressed in the exhibition: heterogeneous, multi-disciplinary and micropolitical.

In the "Talking Cities Audio Lounge" visitors to the exhibition can choose from four channels with different profiles:

TCR 1 is "Ruhrpott radio" – the authentic sound of the industrial Ruhr area. The composer Matthias Kaul will be developing an exclusive sound composition, closely linked to the local Zollverein coal mine and the coal washery.

TCR 2 is the urban music channel. Visitors can hear pieces of music related to the exhibition's themes, selected by the architects, designers and artists of Talking Cities.

TCR 3 delivers the cultural programme, it provides a four-part feature on the future of the city: ravaged, fragmented, a failure – and in spite of that we find a way out of the dilemma!

TCR 4 summarises all the important information, like an urban magazine programme, with statements, news and interviews.

Die Ausstellung bekommt eine eigene Radio Station: Talking Cities Radio (TCR) – konzipiert in Kooperation mit dem Achitekturjournalisten Dirk Meyhöfer.
Talking Cities Radio, das ist der Dialog über unsere Städte, der durch eine dichte Collage aus Statements sämtlicher Ausstellungsprotagonisten hörbar gemacht wird – damit bildet die Radiostation einen zentralen Zugang zu den Themen der Ausstellung: heterogen, transdisziplinär und mikropolitisch! In der „Talking Cities Audio Lounge" kann der Ausstellungsbesucher aus vier Radiostationen mit unterschiedlichen Hörfarben wählen:

TCR 1 ist das „Ruhrpottradio" – ein richtiges Stück Ruhrgebiet. Der Komponist Matthias Kaul wird eine exklusive Hörkomposition entwickeln, lokal verbunden mit Zollverein und der Kohlenwäsche.

TCR 2 ist der urbane Musikkanal. Der Besucher hört themenbezogene Musikstücke, ausgewählt von den Architekten, Designern und Künstlern der Talking Cities.

TCR 3 ist das Kulturprogramm, es liefert ein vierteiliges Feature zur Zukunft der Stadt: Sie ist gescheitert, geschunden, fragmentiert und trotzdem finden wir Auswege aus dem Dilemma!

TCR 4 bietet wichtige Informationen im Überblick – ein urbanes Nachrichtenmagazin mit Statements, Nachrichten und Interviews.

Dirk Meyhöfer; freelance architecture journalist / freier Architekturjournalist, Hamburg
Editorial and production assistance / Redaktions- und Produktionsassistenz: Betsy Greiner
Composer/Komponist: Matthias Kaul

Talking Cities Audio Lounge

The interactive Audiolounge provides the framework for Talking Cities Radio, designed exclusively for Talking Cities. The Lounge will be realised in cooperation with students from the "Hybrid Space" project group of Prof. Frans Vogelaar, Academy of Media Arts, Cologne. Just as our cities are crossed by infrastructure, transportation and utility networks, the four sculpted audio seating areas are traversed by broad bands, each carrying the audio signal of one of the four radio stations. By means of little cable spools in which loudspeakers are integrated, visitors can go to any point along a band and listen to the programme of that particular radio station in German, or in English.

Die interaktive Audiolounge bietet den Rahmen für Talking Cities Radio. Speziell für TCR gestaltet, wird die Audiolounge in Kooperation mit Studierenden der Kunsthochschule für Medien in Köln, Projektgruppe „Hybrid Space" unter der Leitung von Prof. Frans Vogelaar, realisiert. Skulpturale Elemente, die von Netzwerken, ähnlich den Leitungs-, Transport- und Versorgungssystemen unserer Städte, überzogen sind, dienen als Träger der Tonadern der vier Radiostationen. Jede der vier Radiostationen von TCR versorgt eine unterschiedliche Zone innerhalb der Lounge. Mit tragbaren Tonabnehmern kann der Besucher an jeder Stelle dieser Module das Programm der jeweiligen Radiostation auf Deutsch oder Englisch abhören.

Prof. Frans Vogelaar, „Hybrid Space", Academy of Media Arts Cologne / Kunsthochschule für Medien Köln
Project management / Projektleitung: Christoph Haag und Ina Krebs
Project support team / Projektunterstützung: Andreas Muxel, Isabelle Niehsen, Therese Schuleit, Heiner Schilling, Michael Pichler, Mohamed Fezazi, Thomas Kulessa, Karin Lignau
Technical support / Technische Unterstützung: Martin Nawrath, Heinz Nink, Martin Rumori, Falco Sixel, Bernd Voss
The Audio Lounge is designed and realised in cooperation with the Cologne Academy of Media Arts, with the kind support of MOROSO.
Die Audiolounge wurde konzipert und realisiert in Kooperation mit der Kunsthochschule für Medien Köln und der freundlichen Unterstützung von MOROSO.

Don't ask what architecture can build for you; ask what it can do for you.

Don't wonder where you can find a client; ask where you are needed.

Don't cover architecture; discover it.

⋘⊕ ARCHITECTURE BEYOND ARCHITECTURE ⊕⋙

Think about situations and opportunities for architecture that nobody has yet thought of.

Think about an architecture that would no longer respond simply to what is given: an architecture that would not be reactionary but actively pursue its challenges.

Think about moments when architecture can make a difference, even without clients, a budget or specific locations, by intervening with decisive concepts and powerful scenarios to shift deadlocked discourse and role play.

Think about architecture as a strategic intelligence, a medium for developing cultural concepts, a mode of thinking, a tactic for social intervention, a strategy to mitigate conflict – a weapon to fight a battle, a metaphor for the rest of the world.

Think about an architecture liberated from building.

Now go practice unsolicited architecture.

⋙ Go to Archis Interventions and read all about it; www.archis.org ⋘

BEST OF DESIGNCITY
STADT.BAU.RAUM GELSENKIRCHEN 02.09–01.10.2006

EINE AUSSTELLUNG DES INTERNATIONALEN DESIGNFESTIVALS DESIGNMAI
ERÖFFNUNG 01.09.2006,19H BONIVERSTR. 30, WWW.STADTBAURAUM-NRW.DE

ENTRY 2006 Stadt Bau Kultur NRW

Udine, Italy T. +390432 577111 info@moroso.it www.moroso.it Foto A. Paderni - Studio Montanari Novajra

Agenturen:

Thomas Gräper
Plz 0+1+2+3
T. 05222-15985

Daniel Heimüller
Plz 4+5+6
T. 02858-9370

Hubert Essenko
Plz 7+8+9
T. 08053-4434

Showroom
Design Post Köln
Deutz-Müllheimer-Strasse 22A
50679 Köln
www.designpostkoeln.de

Fjord design Patricia Urquiola. Photography inside the Nordic Countries Pavillon at Giardini of La Biennale di Venezia.

MOROSO

DIE TECHNIK FÜR **BTL** VERANSTALTUNGEN

www.BTL.info

- Technische Konzeption und Planung
- Medientechnik für Museen und Ausstellungen
- Besucherführungssysteme
- Audioguide

Berlin

BTL Veranstaltungstechnik
Berlin GmbH
Besselstraße 14
10969 Berlin
Telefon 030-25 39 25 0
Telefax 030-25 39 25 99
info@btl-berlin.de

Düsseldorf

BTL Veranstaltungstechnik
Düsseldorf GmbH
Bochumer Straße 89
40472 Düsseldorf
Telefon 0211-90 449 0
Telefax 0211-90 449 444
info@btl-duesseldorf.de

München

BTL Veranstaltungstechnik
München GmbH
Lerchenstraße 14/2a
80995 München
Telefon 089-35 47 60 0
Telefax 089-35 47 60 29
info@btl-muenchen.de

Poznań

BTL Systemy-Medialne
Sp. Z.o.o.
Ul. Obornicka 253 A
PL 60-693 Poznań
Telefon 0048-61-84 20 954
Telefax 0048-61-84 20 953
biuro@btl-poznan.pl

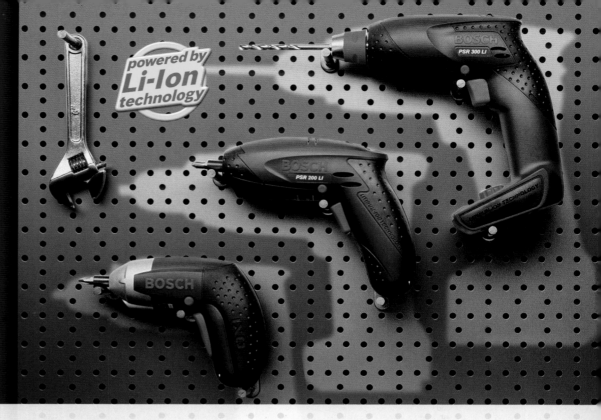

Small, light, powerful.
New lithium ion battery technology.

Kalle Krause GmbH

Live-Marketing:
Strategische Rauminszenierungen für Ausstellungen, Events, Messen, Bühnen

Konzept und Produktion von:

Ausstellungsbauten

Messeständen

Eventausstattungen

Kulissenbauten

Themen- und Erlebniswelten

Unternehmen wollen Botschaften vermitteln.
Menschen möchten Neues entdecken, sich begeistern lassen, intensive Erlebnisse teilen.

Wir, die Kalle Krause GmbH, bringen Botschaften und Menschen zusammen: als spezialisiertes Dienstleistungsunternehmen für Strategische Rauminszenierung und Live-Marketing.

Wir gestalten Kommunikation dreidimensional. Für Sie und mit Ihnen. Als Denkpartner, als Berater bieten wir Ihnen die gesamte Abwicklung Ihres Live-Ereignisses an: von der Gesamtkonzeption, der Produktion der Ausstattungen in unseren Werkstätten bis hin zur Durchführung vor Ort und der Erfolgskontrolle.

www.kallekrause.de

Kalle Krause GmbH Katernberger Str. 107 D-45327 Essen Fon +49 (0)201.74 700-0 Fax +49 (0)201.74 700-10 office@kallekrause.de

Contributors

Atelier Bow-Wow are Yoshiharu Tsukamoto (*1965) and Momoyo Kaijima (*1969), both based in Tokyo. Tsukamoto is associate professor of the Tokyo Institute of Technology and Kaijima is assistant professor of Tsukuba University. Since 2003 both are visiting professors at Harvard GSD. Their many books about their urban research practice, include: "Made in Tokyo" (Kajima Institute Publishing, 2001) and "Pet Architecture" (World Photo Press, 2001). www.bow-wow.jp

atelier le balto are Laurent Dugua (*1967) architect; Marc Pouzol (*1966), landscape architect; Véronique Faucheur (*1963), urban planner, and Marc Vatinel (*1967), landscape architect. The group was founded in 2001 and is based in Berlin and Paris. www.lebalto.de

Baukasten is a combination of seven different designers', architects', photographers' and artists' labels based in Berlin. They are: ethicdesign: Annett Zinsmeister (*1967); faltplatte: Cord Woywodt (*1964); lucks+vonrauch: Friederike von Rauch (*1967) and Stefan Wolf Lucks (*1967); karhard: Alexandra Erhard (*1967) and Thomas Karsten (*1966); Sankt Oberholz: Majken Rehder (*1969) and Ansgar Oberholz (*1972); superclub: Cornelius Mangold (*1968) and Florian Braun (*1969); s.wert design: Sandra Siewert (*1972), Dirk Berger (*1966) and Ingo Müller (*1972). www.baukasten-berlin.de

Bergmann, Andreas (*1970) is a designer based in Berlin. He studied Industrial Design in Braunschweig and Berlin. In 1999 his bench "Swords into Ploughshares - Fences to Sit" won first prize in a national competition called "Die Deutsche Bank". www.andreasbergmann-design.com

Building Initiative are John Duncan, photographer (*1968), Orla McKeever, architect (*1969); Conor Moloney, urban designer (*1968); Jürgen Patzak-Poor, architect (*1959) and Dougal Sheridan, architect, (*1971). Project collaborators include Antje Buchholz, architect (*1967); Mark Hackett, architect (*1967); Michael Matuschka, architect (*1964) and Deidre Mc-Menamin, architect (*1974). They are based in Belfast, Berlin and London. Building Initiative is supported by the University of Ulster and the Arts Council of Northern Ireland's Special Initiative for Architecture and Built Environment. www.buildinginitiative.org

Cera, Nuno (*1972) is an artist based in Berlin and Lisbon. He graduated in advertising at the IADE, Lisbon, 1995 and attended the Maumaus Photography workshop – School of art and photography, Lisbon. www.nunocera.com

Conder, Simon is an architect based in London. He studied architecture at the Architectural Association School of Architecture, London and industrial design at the Royal College of Art, London. Simon Conder Associates work in the community, residential and workplace sectors and abroad with designs for sites in Australia and Singapore. They have completed projects in Germany, Japan and the USA. www.simonconder.co.uk

Deleu, Luc / T.O.P Office are Luc Deleu (*1944), Laurette Gillemot (*1946), Steven Van den Berg (*1974) and Isabelle de Smet (*1973). Based in Berchem. T.O.P Office was founded in 1970 and specialises in architecture and urbanism. Their search is for another form of urban development, in particular one that is critical, sociological and ecological, that breaks with conservative attitudes. www.topoffice.to

Detroit Collaborative Design Center (DCDC) is a non-profit teaching centre located within the University of Detroit Mercy School of Architecture. It was established in 1995 as a multi-disciplinary centre, striving to renew the city through the interaction of students, professionals, faculty and community members. www.arch.udmercy.edu/design_center01.htm

Didelon, Valéry (*1972) is an architect based in Paris. He works as an independent consultant for architecture, town planning and exhibition design. He teaches design and history at the Ecole nationale supérieure d'architecture de Versailles. He is also an architecture critic for Werk, Bauen+Wohnen, AMC, Le Visiteur, EAV and D'architectures.

Eberstadt, Stefan (*1961) is an artist based in Munich where he teaches sculpture at the Academy of Fine Arts. He has had residencies in Edinburgh, London and New York.

el ultimo grito is the creative partnership of Roberto Feo (*1964) and Rosario Hurtado (*1966), founded in 1977, their Studio is currently based in London. Feo studied furniture design at the London College of Furniture and the Royal College of Art. Since 1999, he is a lecturer at the Design Products Department, Royal College of Art, London. Hurtado studied Cabinet making and furniture design at Kingston University. Since 1999 she is lecturer at the Design Department at Goldsmiths University in London. www.elultimogrito.co.uk

Ferguson, Francesca (*1967) based in Berlin, curator and initiator of urban drift, an international network for contemporary architecture and urban issues based in Berlin. In 2004 Francesca curated "Deutschlandscape - Epicentres at the Periphery", for the German pavilion at the 9th Architecture Biennale of Venice. From Autumn 2006 she will also be director of the Swiss architecture museum in Basel. www.urbandrift.org

Gennari Santori, Flaminia (*1968) is an art historian based in Rome. She is also project manager at the Fondazione Adriano Olivetti, where she curated Immaginare Corviale with Bartolomeo Pietromarchi in 2004-2005. She teaches architecture history and theory at the Kent State University and lectures at Cornell University. She has published in Italy, the UK and the US on art collecting, museum history and public art.

Prof. Dr. Hauser, Susanne (*1957) cultural scientist based in Berlin. She was a research member of the Landenburger Kolleg Projekt "Zwischenstadt" founded by the Daimler Benz Foundation and is professor for art history and cultural studies, faculty of architecture Universität der Künste, Berlin.

IaN+ are the Rome-based architects Carmelo Baglivo (*1964), Luca Galofaro (*1965) and Stefania Manna (*1969). Their multi-disciplinary agency aims to be a place where the theory and practice of architecture overlap and meet: to redefine the concept of territory as a relational space between the landscape and its human user. www.ianplus.it

Ingels, Bjarke (*1974) is an architect based in Copenhagen. He worked at OMA (1998-2000) and has been lecturer and guest critic at several universities. He founded PLOT in 2001 together with Julien De Smedt (*1975). PLOT has won several prizes, including the Golden Lion at the 9th Architecture Biennale of Venice and was nominated for the Mies van der Rohe Award in 2004. In 2006 Ingels also founded B.I.G (Bjarke Ingels Group). www.big.dk

Interbreeding Field (IF) is an experimental architecture factory, based in Tainan, Taiwan. The director Li H. Lu (*1961), a graduate of the Southern California Institute of Architecture, teaches at the Graduate Institute of Architecture in Tainan National University of the Arts. He initiated IF to develop experimental architecture and to form a new "biological" environment. In 2004, IF represented Taiwan at the 9th Architecture Biennale of Venice. www.interbreedingfield.com

Kaltwasser, Martin (*1965) based in Berlin. Artist and architect. He studied architecture at the Technische Hochschule, Berlin. In 1993 Kaltwasser founded the Winterakademie. He is currently curating the exhibition Industriestadtfuturismus (a project of the Kulturstiftung des Bundes). www.superbuero.de

KARO are the Leipzig-based Antje Heuer, architect (*1962); Stefan Rettich, architect (*1968) and architect and designer Bert Hafermalz (*1963). They formed their joint office in 1999. KARO is a founding member of L21, a group of architects in Leipzig who concern themselves with urban transformation processes. www.karo-architekten.de

Prof. Klussmann, Heike (*1968) is an artist based in Berlin. She studied at the Kunstakademie, Düsseldorf and at the Hochschule der Künste, Berlin. She has taught at the Art Center College of Design Pasadena, California, USA, and the BTU Cottbus, Faculty of Architecture. Klussmann is now a Professor at the Universität Kassel in the faculty of architecture, urban planning and landscape planning.

Kniess, Bernd (*1961) is an architect based in Cologne. He trained and worked as landscape gardener before studying architecture and urban planning in Darmstadt and Berlin. He has been a practising architect and urban planner since 1999, co-founding his company b&k+ (bernd kniess architecture urban planning) in 2001. He has held various teaching positions, including a professorship for planning methodology and design at the University of Wuppertal (2003-2005). www.berndkniess.net

Köbberling, Folke (*1969) is an artist based in Berlin. She studied Fine Art at the Universität der bildenden Künste, Kassel and the Emily Carr Institute of Art &Design in Vancouver/Canada. Since 1998 Köbberling & Kaltwasser have been concerned with exhibitions in public space and videos on issues such urban development and critique, economic globalization and social alternatives. www.folkekoebberling.de

Konrad, Aglaia (*1960) is an artist and photographer based in Brussels, Belgium. She studied at the Jan van Eyck Academy in Maastricht where she is now a consultant researcher. In 2003 Konrad received the Camera Austria Prize from the city of Graz.

Konrad, Karsten, (*1962) is an artist based in Berlin. Konrad studied at the Johannes Gutenberg-Universität, Mainz, at the Universität der Künste, Berlin and at the Royal College of Art, London.

Kreissl Kerber are the artists Alexa Kreissl (*1973) and Daniel Kerber (*1970), both are based in Berlin. They studied art together at the Ecole Nationale Supérieure d'arts de Cergy-Pontoise in France and at the Kunstakademie Düsseldorf. www.kreisslkerber.de

Lacaton & Vassal are Anne Lacaton, (*1955) Jean Philippe Vassal (*1954), architectural office based in Paris. Both graduated in 1980 from the École d'Architecture in Bordeaux. Their works include "Cité Manifeste" in Mulhouse 2004, the "Palais de Tokyo" 2001 (Paris), "House Cap Ferret" 1998 and the "University of Arts & Human Sciences" (Grenoble) – which was nominated for the Mies van der Rohe Award 1997.

Lagos Kalhoff, Leonhard (*1978) is an urban researcher based in Heiligenhaus. He studied architecture and urban planning and was a teaching assistant for planning methodology and design at the University of Wuppertal. He is now a fellow of the German Research Foundation (DFG) at the Technical University Hamburg-Harburg and works on "Topology of the Everyday City".

Land for Free are Boris Sieverts (*1969), based in Cologne, and Henrik Sander (*1970), Dirk E. Haas (*1961), Stefanie Bremer (*1969) and Päivi Kataikko (*1964), all based in Essen. Sieverts is an artist and founded the Büro für Städtereisen in 1997. Bremer and Sander are urban planners, with an office called orange.edge. In the same year Kataikko and Haas operate under RE.FLEX architects_urbanists. The three offices currently work together on several projects dealing with scale, images and aesthetics of regional urban landscapes. www.landforfree.de

Prof. Lederer, Arno (*1947), architect, is based in Stuttgart where he runs a joint studio with Jórunn Ragnarsdóttir and Marc Oei. Lederer is also professor at the University of Karlsruhe and at the University of Stuttgart. 2000-2005 he was a consultant for the German Museum of Architecture in Frankfurt/Main and curator at the Weissenhof Gallery of Architecture in Stuttgart. He is also a scientific consultant for the Ministry of Building-Trade in Berlin and a council member of the Technical University HfT in Stuttgart. www.archlro.de

Lehmann, Tobias (*1976), is an architectural designer based in Berlin. He studied architectural design at the Academy of fine Arts and Design in Enschede, the Netherlands.

Lewis, Peter (*1950) London, was senior lecturer in curating at Goldsmiths College, London until 2003. He is currently Research Fellow at Leeds Metropolitan University in Curating, Faculty of Art and Society; Independent Curator at Kunstverein, Bregenz, Austria; Director of Redux, Artists Space, London; recipient of an Arts Council Research Bursary at the University of Central England, and co-editor of the online journal of contemporary art, www.slashseconds.org

Lovell, Sophie (*1964) is an English writer and editor based in Berlin. She is the Germany editor for Wallpaper magazine and was founding architecture and design editor for the German lifestyle magazine Qvest. She has recently written two books for design publishers Die Gestalten Verlag: This Gun is for Hire - from personal to corporate design projects, and On Air - the visual messages and global language of MTV. www.sophielovell.com

Maier, Christian (*1969) based in Berlin. Sculptor. Christian Maier studied at the School of Art in Braunschweig. He works now on installations and sculptors.

Map Office are Laurent Gutierrez (*1966) and Valerie Portefaix (*1969), French architects and town planners, based and teaching in Hong Kong. Gutierrez is Assistant Professor at the School of Design, Hong Kong Polytechnic University and Portefaix is Adjunct Assistant Professor at the Department of Architecture, Hong Kong University. In 1997, they founded MAP Office - a collaborative studio involved in cross-disciplinary projects that incorporate architecture and the visual arts. They have participated in several local and international exhibitions, including the 7th Architecture Venice Biennial and the 1st International Architecture Biennial in Rotterdam, where they won an award for the best "Inspiration". www.map-office.com

N55 consists of architects Ion Sørvin (*1964) based in Copenhagen and Ingvil H. Aarbakke (*1970–2005). Both where educated at the Royal Danish Academy of fine Arts, 1991-1998. www.n55.dk

Petetin and Grégoire Philippe Grégoire (*1963) and Claire Petetin (*1963) are architects based in Paris. They founded their own agency in 1995. In 1997 they organised workshops at the Ecole d'Architecture de Paris-Villemin and from 1998 to 2000 Claire Petetin was assistant to Benoit Cornette at the Ecole d'Architecture de Bretagne.

Potrč, Marjetica (*1953) is an artist and architect, based in Ljubljana. Her work has been exhibited extensively, including solo shows at the Guggenheim Museum, New York and the PBICA, Lake Worth, Florida. She has taught at several institutions, including the Massachusetts Institute of Technology (2005), and has published a number of essays on contemporary urban architecture. www.potrc.org

Princen, Bas (*1975) is a designer and photographer for public space based in Rotterdam. He studied at the Design Academy Eindhoven and the Berlage Institute in Rotterdam and has exhibited in various international group and solo shows, contributed to the research project "Shrinking Cities" and the art project Atelier HSL. In 2004 he published his book "Artificial Arcadia" with 010 publishers. www.atelierhsl.nl

"Recto" alias Frédéric Platéus (*1976) is an artist based in Liège, Belgium. He qualified as a dental technician at the Ecole du Château Massart, Liège. Exhibitions include: "Sculpture Typographique", Ink Gallery, 2001 and "Airbrush show 2004", Milan Centro Congressi Quark(I). Commissions include: a typographic lighting display for MONT BLANC in Paris and the "Tatu tattoo" wall painting in Musée du cinquantenaire-MRAH 1000, Brussels. www.typoflex.com

Rural Studio is based in Auburn, USA. Founded in 1993 by Auburn University architecture professors D. K. Ruth and Samuel Mockbee (1944-2001) within the university's School of Architecture, the Rural Studio was conceived as a method to improve the living conditions in rural Alabama and to include hands-on experience in an architectural pedagogy. Current directors are Andrew Freear and Bruce Lindsey. www.ruralstudio.com

Prof. Sadler, Simon (*1968) is professor of Architectural and Urban History at the University of California. His research concentrates on the relationships between architecture, urbanism, and the neo-avant-garde since 1945. His publications include Archigram: Architecture without Architecture (MIT Press, 2005), The Situationist City (MIT Press, 1998) and Non-Plan: Essays on Freedom, Participation and Change in Modern Architecture and Urbanism (edited with Jonathan Hughes; Architectural Press, 2000). www.simonsadler.org

Schiferli, Floris (*1977) based in Schidam, the Netherlands. He works as an architectural designer called "Studio Peevish".

Seltmann, Gerhard (*1954) lives in Flechtingen. He is CEO of the Zollverein exhibition association and organiser of ENTRY 2006. Through his work in the building and commerce ministries of North Rhine-Westphalia und Saxony-Anhalt, as former deputy director of the IBA Emscher Park and former head of the EXPO- corresponding region Saxony-Anhalt, he has been greatly involved in the development of the region. He also has his own office for regional development, culture and tourism projects in Flechtingen. www.entry-2006.com

Stalker/Osservatorio Nomade are based in Rome. Founded in 2002 as an initiative of the Stalker Group, Osservatorio Nomade is a creative research network composed of artists, architects, video-makers and researchers of various disciplines from all over the world. They experiment with site research and specific territorial projects. www.osservatorionomade.net

studio.eu are the Berlin-based architects Paola Cannavò (*1966 Rome), Maria Ippolita Nicotera (*1966 Rome) and Francesca Venier (*1971 Milan). They have contributed to various international design competitions and lecture at several Universities in Europe and the USA. In 2001 they won the Mario Ridolfi Prize in Rome, in 2004 they received an Honorable Mention in Italy for cultural affairs and in 2005 they won the 1st Prize in the international design competition for their transformation of Caporale in Teramo. www.studioeu.net

Timorous Beasties Studio are the Glasgow-based designers Alistair McAuley (*1967) and Paul Simmons (*1967). Both studied at the Glasgow School of Art, and Paul Simmons went on to study at Royal College of Art. They design and manufacture their own fabric and wallpaper designs and run a shop on the Great Western Road in Glasgow. www.timorousbeasties.com

Toh Shimazaki Architecture was founded in London in 1995 by the architects Yuli Toh (*1961) and Takero Shimazaki (*1971). Yuli Toh studied at Bristol and Edinburgh and worked for the Richard Rogers Partnership 1988-95. Takero Shimazaki studied at the University of Wales, Cardiff and The Bartlett School of Architecture, London. He has worked for the practices of Itsuko Hasegawa Atelier and the Richard Rogers Partnership and is currently a visiting lecturer at Oxford Brookes University School of Architecture, University of East London and TU Graz, Austria. Toh Shimazaki is supported by the engineers Buro Happold's John Noel (*1979) and Franck Robert (*1971). www.t-sa.co.uk

Tolaas, Sissel (*1959), is an artist based in Berlin. She studied mathematics, chemistry and visual arts in Bergen, Warschau, Poszan, St. Petersburg and Oslo. Tolaas has concentrated on the issue of smell, language and communication since 1990. She lectures at various international universities.

Weiss, Srdjan Jovanovic (*1967), architect, is based in New York City. He is founder of the "Normal Architecture Office" (NAO). Weiss studied at the University of Belgrade and at the Graduate School of Design at Harvard University. From 1998-2003 he worked together with Sabine von Fischer as the "normal group for architecture". He is also a founding member of School of Missing Studies. www.thenao.net and www.schoolofmissingstudies.net

Zeidler, Cordula (*1978) is an architectural historian and journalist based in London. She writes for a number of European magazines and has curated exhibitions on architecture and town planning, including "Risky Buildings" for the Twentieth Century Society at the Clerkenwell Architecture Biennale 2004 in London.

Masthead / *Impressum*

Editor in Chief / *Herausgeberin*
Francesca Ferguson

Editors / *Redaktion*
Florian Heilmeyer, Sophie Lovell

Project Management / *Projektleitung*
Julia Albani

Editorial Consultant / *Redaktioneller Berater*
Jason Danziger

Editorial and Production Assistance /
Redaktions- und Produktions-Assistenz
Adeline Seidel

Translations / *Übersetzungen*
Tanja Cummings, Barbara Hahn, Karola Handwerker,
Mathias Jansen, Karin Liebscher, Ivette Löcker,
Richard Toovey, Julia Wardetzki, Annette Wiethüchter,
Darrel Wilkins, Caroline Wolf

Transcriptions / *Transkriptionen*
Adeline Seidel, Christiane Simon, Caroline Wolf

Copy Editor / *Lektorat*
Karola Handwerker

Graphic Design and Cover Illustration /
Grafische Gestaltung und Titelillustration
ITF Grafik Design

Image Editing / *Bildbearbeitung*
Achim Hatzius, Berlin

Special thanks to the following photographers /
Besonderen Dank an die folgenden Photographen:
Hans Blossey, Hamm (www.luftbild-blossey.de);
Christoph Buckstegen, Berlin (www.photocake.de);
Sarah Duncan, London (www.sarahjduncan.com);
Roland Halbe, Stuttgart (www.rolandhalbe.de);
Thomas Mayer, Neuss (www.thomas-mayer-photo.de);
Arwed Messmer, Berlin (www.arwedmessmer.de);
Ogando Fotodesign, Köln (www.ogando.de);
Joachim Schumacher, Bochum;
Torsten Seidel, Berlin (www.torstenseidel.de);
Manfred Vollmer, Essen (www.manfred-vollmer.de);

Picture credits / *Bildnachweis*
The editor has conscientiously endeavoured to identify and
acknowledge all sources and copyright holders.
We request that all those who hold picture copyrights
which have not been identified or credited here, please
contact the publisher / *Die Herausgeberin hat gewis-
senhaft versucht, alle Quellen und Urheberrechtsinhaber
zu ermitteln und zu kennzeichnen. Sie bittet etwaige Bild-
rechtsinhaber, die nicht ausfindig gemacht werden konn-
ten, sich mit dem Verlag in Verbindung zu setzen.*

The publication of the catalogue has been supported
by / *Die Publikation des Kataloges wurde unterstützt
von:*

ENTRY 2006

Zollverein School
of management and design

A CIP catalogue record for this book is available from the
Library of Congress, Washington D.C., USA.

Bibliographic information published by Die Deutsche Bib-
liothek. Die Deutsche Bibliothek lists this publication in
the Deutsche Nationalbibliografie; detailed bibliographic
data is available in the internet at http://dnb.ddb.de.

Publisher
Birkhäuser – Publishers for Architecture,
P.O. Box 133, CH-4010
Basel, Switzerland.
Member of Springer Science+Business Media

Printed in Germany

ISBN-10: 3-7643-7727-5
ISBN-13: 978-3-7643-7727-4

http://www.birkhauser.ch

Exhibition / *Ausstellung*

Artistic Director / *Künstlerische Leitung*
Francesca Ferguson

Realized by / *Realisiert durch*
urban drift productions Ltd., Berlin

Project Management / *Projektleitung*
Julia Albani

Special thanks for curatorial support to / *Besonde-
ren Dank für kuratorische Beratung an:*
Christine Hesse, Peter Lewis, Kieran Long, Sophie Lovell,
Jay Merrick, Marco DeMichelis, Markus Müller,
Kai Vöckler, Sabine Voggenreiter

Curatorial Assistants / *kuratorische Assistenz*
Jason Danziger, Florian Heilmeyer, Ilka Schaumberg,
Markus Schnierle

Production Assistant / *Produktionsassistenz*
Adeline Seidel

Exhibition architecture / *Ausstellungsarchitektur*
Thilo Fuchs und Kai Vöckler

Technical and Production Management / *Technische
und Produktionsleitung*
Christian Hiller

Graphic Design / *Grafisches Konzept*
grönland.berlin

Talking Cities Radio (TCR)
Dirk Meyhöfer

TCR Interviews
Francesca Ferguson, Florian Heilmeyer,
Dirk Meyhöfer

TCR Editorial and Production Assistance / *Redaktions-
und Produktionsassistenz*
Betsy Greiner, Adeline Seidel

TCR Composition / *Komposition*
Matthias Kaul

Audio Lounge (AL)
Prof. Frans Vogelaar, "Hybrid Space", Academy of Media
Arts Cologne / *Kunsthochschule für Medien Köln*

AL Project Management / *Projektleitung:*
Christoph Haag, Ina Krebs

AL Project Support Team / *Projektunterstützung:*
Andreas Muxel, Isabelle Niehsen, Therese Schuleit,
Heiner Schilling, Michael Pichler, Mohamed Fezazi,
Thomas Kulessa, Karin Lignau

AL Technical Support / *Technische Unterstützung:*
Martin Nawrath, Heinz Nink, Martin Rumori, Falco Sixel,
Bernd Voss

Press and PR / *Presse- und Öffentlichkeitsarbeit*
Julia Albani, Silke Neumann, Berlin
Karoline Newmann, London

Sponsoring
Julia Albani, Silke Neumann

Internships / *Praktikanten*
Emily Krämer, Torben Nuding

Website Design / *Gestaltung Website*
Datenflug, Berlin

Legal Advice / *Rechtsberatung*
Heller & Partner Rechtsanwälte, Berlin

Many thanks for advice and support to / *Ein herzlicher
Dank für den Rat und die Unterstützung geht an:*
Britt Angelis, Christian Bauschke, Frauke Burgdorff,
Peter Conradi, Kristin Feireiss, Karl Ganser, Bea Golla,
Ulrich Hatzfeld, Dirk Hesse, Stefan Hilterhaus,
Martin Heller, Thomas Herr, Olga Maria Hunger,
Rolf Kretschmer, Gunnar Luetzow, Matthias Mai,
Christiane Mitschker, Heinz-Jürgen Niemann,
Juliane Pegels, Wolfgang Roters, Ulrike Rose,
Antonino Saggio, Christiane Sauer,
Benedikta Scheibenzuber, Jonas Schmidt,
Christel Schwarz, Jörg von Stein, Ludwig Wappner

We thank the exhibiting participants for their support /
*Wir danken allen Ausstellungsteilnehmern für ihre Unter-
stützung*

The exhibition has been realised with the kind support
of / *Die Ausstellung wurde realisiert mit der
freundlichen Unterstützung von*

Partners / *Partner*

Sponsors / *Sponsoren*